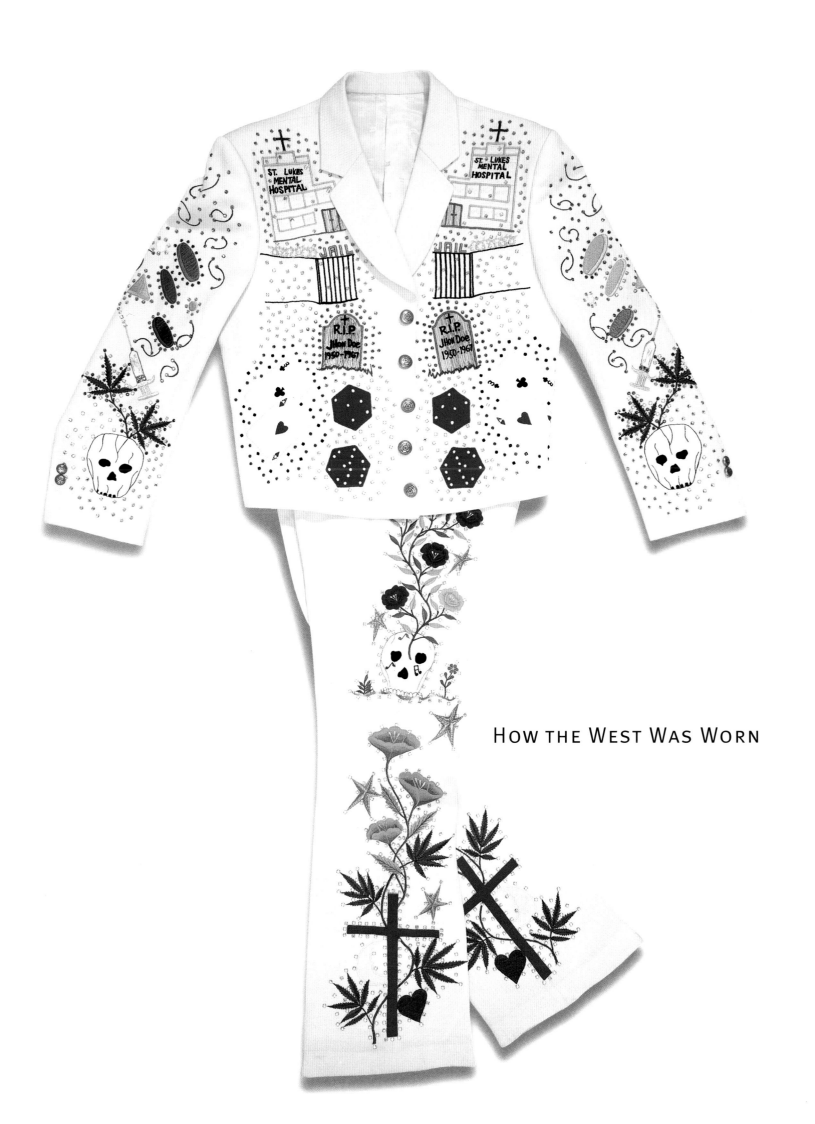

How the West Was Worn

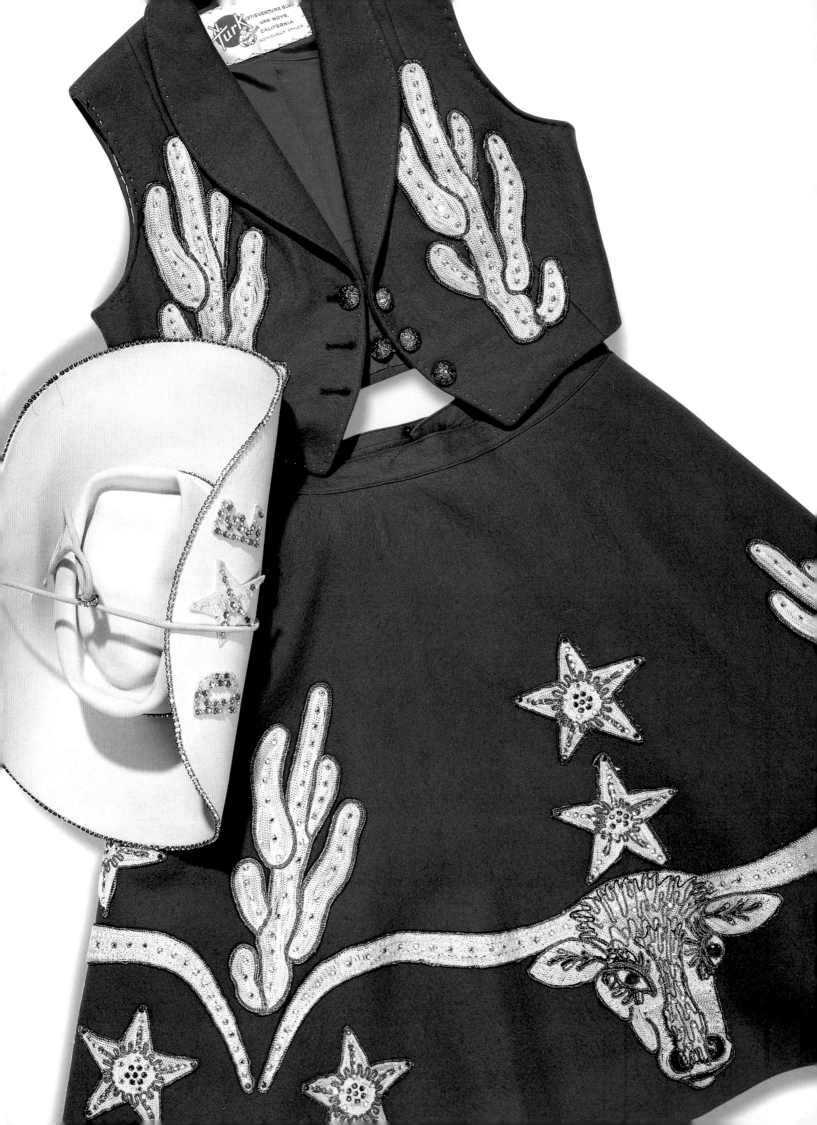

HOW THE WEST WAS WORN

Holly George-Warren and Michelle Freedman

Introduction by James H. Nottage

Foreword by Marty Stuart

Harry N. Abrams, Inc., New York,

in association with

Autry Museum of Western Heritage, Los Angeles

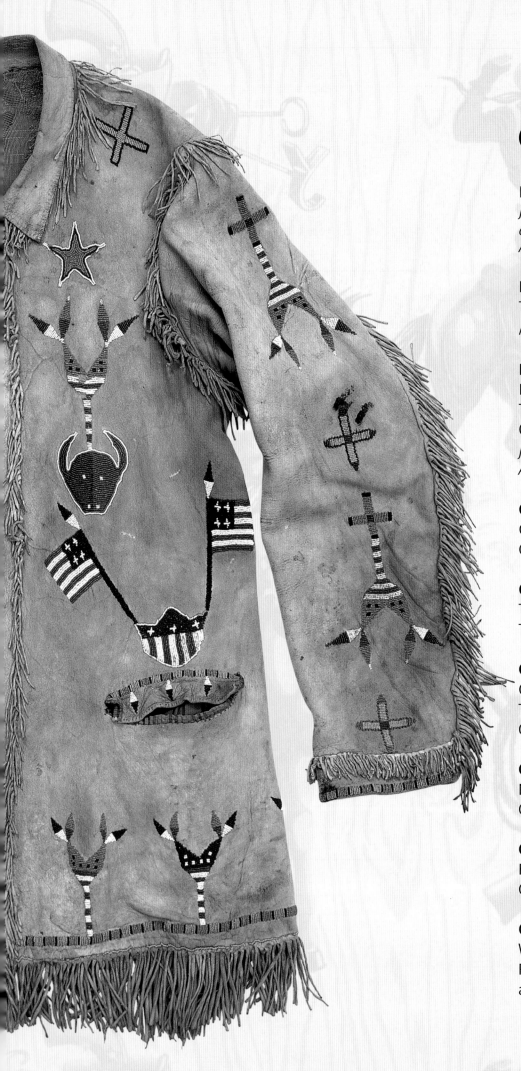

Contents

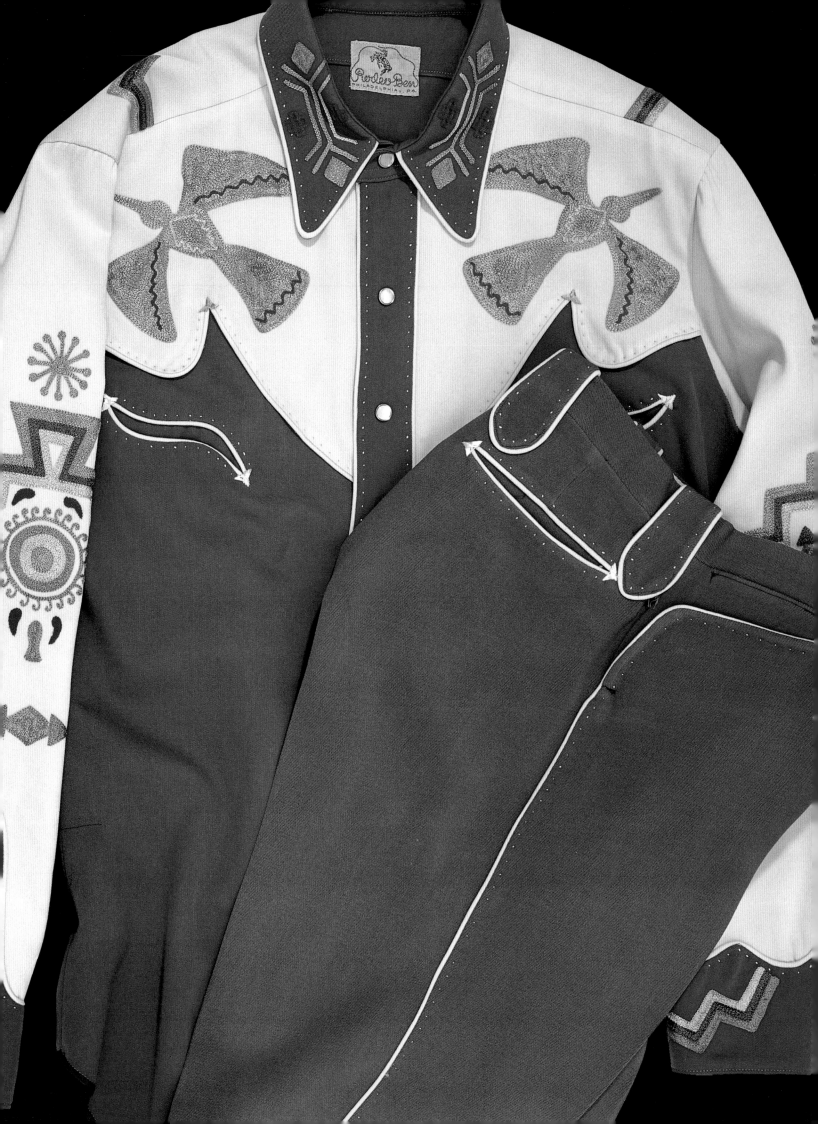

PREFACE

The exhibition *How the West Was Worn* is, without doubt, one of the liveliest ever organized by the Autry Museum of Western Heritage. It would be easy, I suppose, to characterize it as simply a romp through a gallery filled with dozens of mannequins, each decked out in a more outrageous outfit than the last. But though I relish the entertaining aspects of the exhibition, I would like to emphasize its serious underpinnings as well.

We have chosen to create an exhibition and a book on the evolution of Western clothing because it is a present-day expression of the Western experience very commonly embraced by people all over the world, from Los Angeles to Paris to Australia. This style of clothing has worldwide appeal not only because it is comfortable and distinctive, but also because it identifies us with virtues that are worthy of emulation—the virtues of the cowboy icon. Those characteristics—a commitment to hard, honest labor, loyalty to a strenuous ethical and moral code, persistence in the face of hardship, rugged individualism and personal freedom—speak to us to this day. To dress as a cowboy, even if it be only a denim work shirt and boots, is to identify oneself with those virtues, and the images that surround them.

Viewed in this light, those wild outfits worn by performers, with their sequins and rhinestones and multiple layers of fringe, which some consider aberrations or even prostitutions of cowboy style, are in fact intensely personal expressions of the individualism of those who designed and wore them.

As a public history institution, the Autry Museum is charged with connecting history to the lives of those who see our exhibitions, take part in our programs, and read our books. That immediacy, that connection, is both the point of and reward for our efforts. I hope that you enjoy this exhibition, and this book, but I also hope that you will find something here that enhances and enlarges your life, whatever you do, and wherever you live.

JOHN L. GRAY
Executive Director and Chief Executive Officer
Autry Museum of Western Heritage

In this **stage outfit worn by Gene Autry,** designer Rodeo Ben incorporated the singer's favorite thunderbird motif. Autry Museum of Western Heritage, Los Angeles. Donated by Mr. and Mrs. Gene Autry

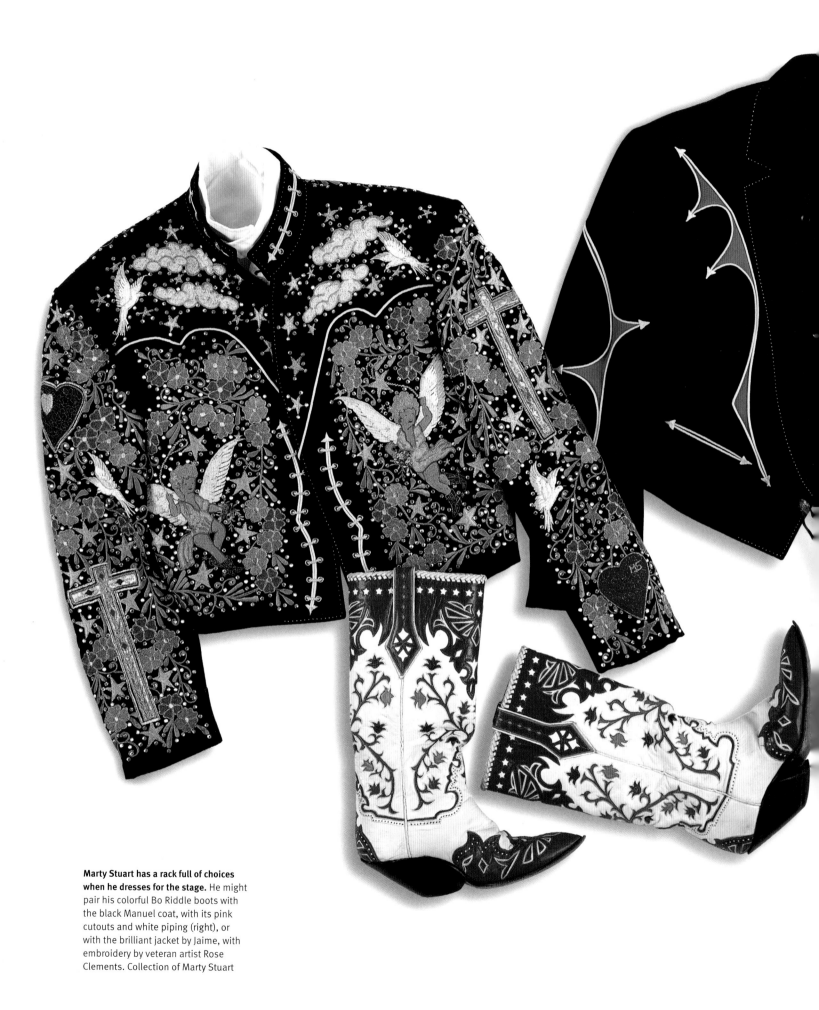

Marty Stuart has a rack full of choices when he dresses for the stage. He might pair his colorful Bo Riddle boots with the black Manuel coat, with its pink cutouts and white piping (right), or with the brilliant jacket by Jaime, with embroidery by veteran artist Rose Clements. Collection of Marty Stuart

FOREWORD: THE SPARKLE FACTOR

Cowboy cool first came riding into my life in the summer of 1967 when Ernest Tubb and the Texas Troubadours came to my hometown of Philadelphia, Mississippi, to perform at the county fair. They stylishly rolled into the fairgrounds in a green Silver Eagle bus, stenciled . . .

THE ERNEST TUBB SHOW
TEXAS TROUBADOURS, STARS OF WSM's
GRAND OLE OPRY AND DECCA RECORDS

When the band stepped out of the bus for the evening's performance, they wore matching red cowboy suits, boots, hats, belts, buckles, and ties. When Ernest appeared, he was wearing a black-and-white pinstripe suit with red piping all over it. He looked twelve feet tall and he was crowned with a snow-white Stetson. The costumes had a power that utterly transformed the musicians into larger-than-life characters. They dripped with attitude and style. They had an aura about them that gave me the feeling I was in the presence of royalty. During their performance, I remember looking at the Troubadours in their costumes and thinking, "This may be the prettiest sight I've ever seen in my life." That's when I fell in love with fancy cowboy clothes. It's been a lifelong love affair ever since.

Years later, after I moved to Nashville and got to know the Troubadours personally, I discovered that they had nicknames for all their costumes. There was Halloween, Pumpkin, Robin Hood, the Falstaff, San Antonio Rose, and Old Pink. Steel guitarist Lynn Owsley told me, "A real cowboy would never allow clothes like these in his closet. But what our suits are supposed to do is draw attention and set us apart. And they do a good job of doing that." A writer named Tom Piazza once wrote of country entertainers, "Getting dressed up, for these guys, is a form of warfare; total plumage warfare."

One of the moments that defines the allure of Western wear is the time that Tubb and the Troubadours were booked for a concert at the Keystone Club in San Francisco. The bus was too tired to make it up the hills in the city, and the driver finally had to surrender and park. The band walked six blocks to the venue, fully dressed in Old Pink. As they walked along the streets, people applauded, honked their horns, and followed them as if they were pied pipers. They literally stopped traffic. After that, the Troubadours changed Old Pink's name to the San Francisco.

The Western image is one of America's greatest calling cards. For the latter half of the twentieth century, the capital of Western fashion was the vicinity surrounding Lankershim Boulevard in North Hollywood, California. It was a creative atmosphere in which the images of some of America's most notable icons were designed and made, a boulevard where silver saddles and masked men were commonplace. It was the outer edge of taste and style, the bad boy of the fashion community, a world unto itself where artists created some of the most original and innovative designs America has ever contributed to fashion's center stage.

I've circled the globe more than once, and I offer this as a universal truth: there's a little cowboy in everybody. Whether it's in the middle of a city, a county fair, the stage of a honky-tonk, or the reflection of the silver screen, the art of Western wear has found its mark and struck a chord that resonates into the lives of people all around the world. This book shines a light on the talents of the enormously creative people who have helped define the Western styles that tell *How the West Was Worn*.

MARTY STUART
Nashville, Tennessee
May, 2000

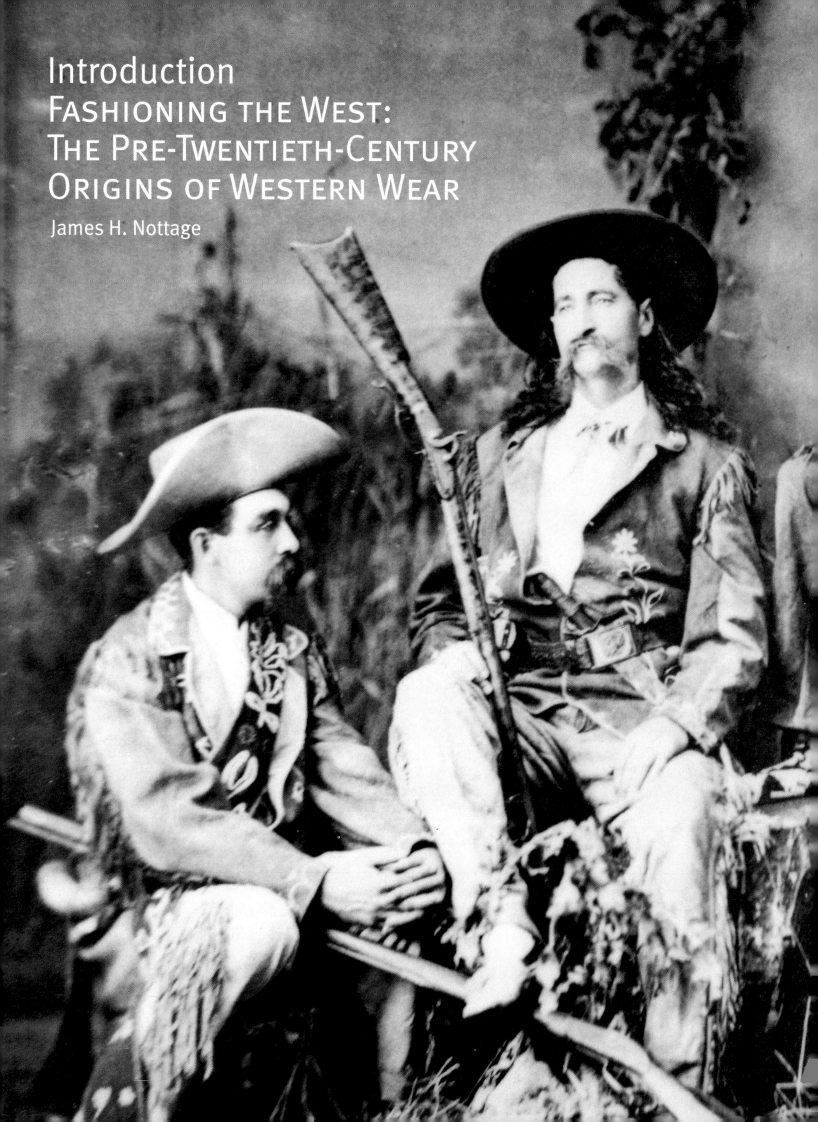

Introduction
FASHIONING THE WEST:
THE PRE-TWENTIETH-CENTURY
ORIGINS OF WESTERN WEAR

James H. Nottage

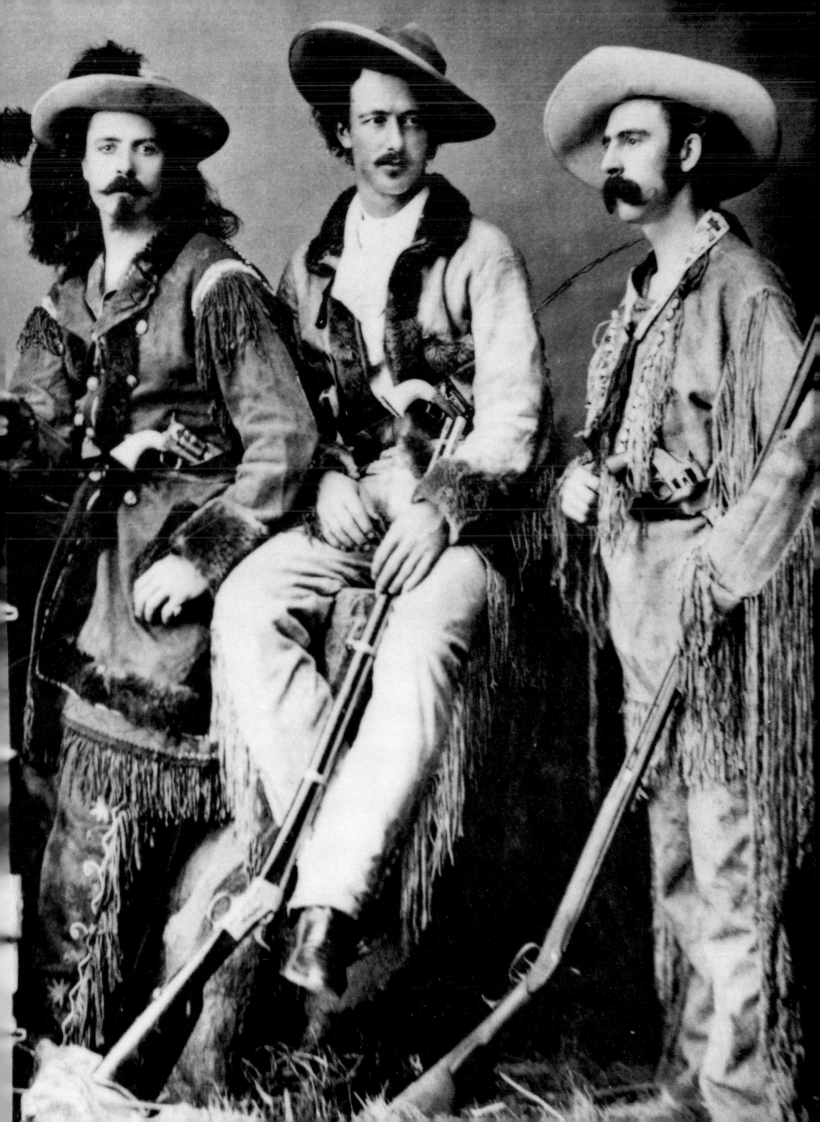

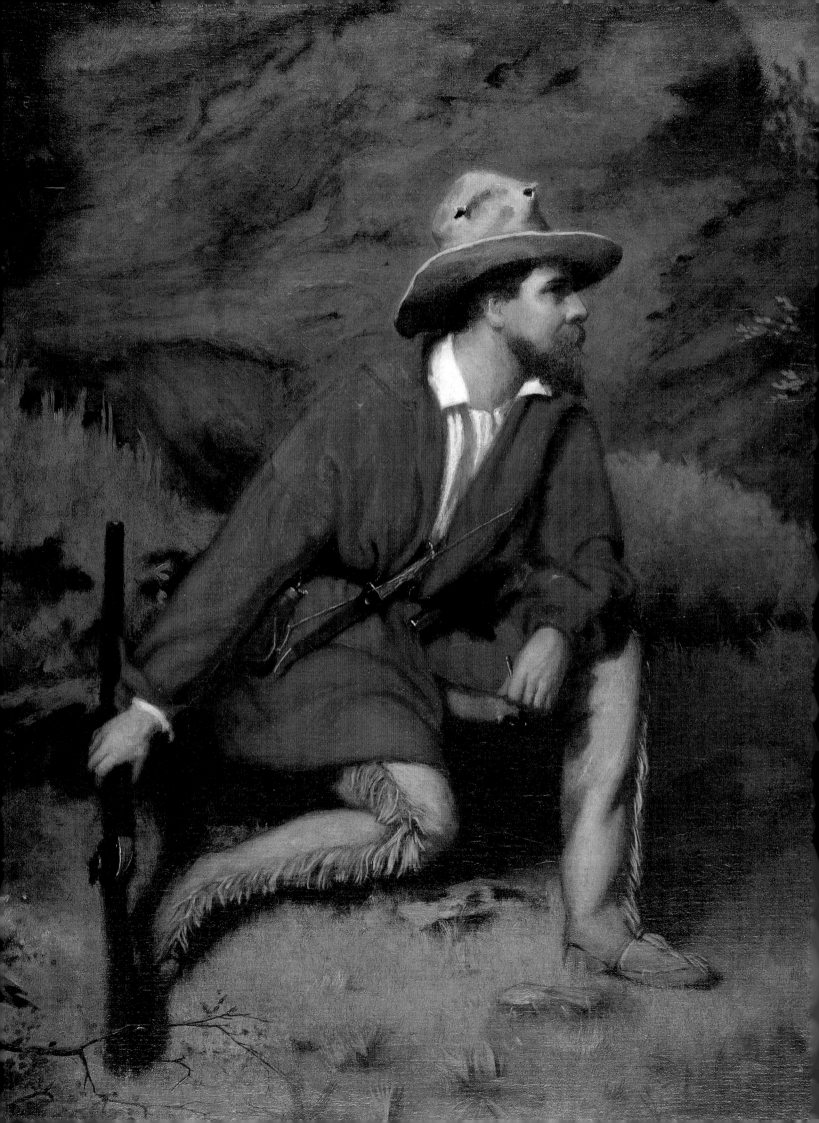

In the spring of 1849, thousands of eager emigrants converged in Missouri for the long overland journey to California and Oregon, most hoping to find gold in the West. At take-off points in St. Louis, Independence, and St. Joseph, wagon trains gathered. There was excitement in the air. Noting the great variety of languages spoken and range of people in bustling streets and businesses, one observer commented that it was "a perfect babel." Travelers from every state and territory, and many foreign countries, negotiated crowded streets and dodged slowly moving ox- and mule-drawn vehicles of every description. It was a great adventure, recorded by diarists, newspapers, and generations of chroniclers.

Missouri at that time was a true crossroads, with emigrants mixing with the resident Osage, Sauk and Fox, Iowa, and other native tribes. Some native peoples, including Cheyenne and Sioux, came down the Missouri River, adding their cultural traditions to the rich blend. Because the region was still the hub for both the mountain fur industry and the Santa Fe trade, included among the throng were bull whackers walking alongside freight wagons, and trappers and traders, sometimes wearing fringed leather shirts, leggings, and footwear. There were even tourists, bent on seeing the frontier and observing Indians, though some of them may have seemed a bit overdressed, having outfitted themselves in leather hunting shirts so they could feel a part of the Western experience before they even got there. Thus it was clear that the gold seekers in 1849 encountered frontier types whose dress and manner had already caught the attention of the world.

As early as 1803, when William Clark and Meriwether Lewis left St. Louis to explore the Louisiana Purchase, the then-frontiers of New York, Pennsylvania, and Kentucky had witnessed the influx of hunters, trappers, and traders in their distinctive dress. Some wore deerskin "short pants," or breeches, with cotton dress shirts and wool coats. The hunting shirt of fringed elk or deer hide, high standing collar, and layered cape was favored by young men on the edges of settlements. Frequently worn with matching fringed leggings and breechcloths, such shirts were influenced by French, British, and Indian styles. Woodsmen in such garb were among colonists fighting the British during the Revolution. As they marched west, so did the style.

Buckskin itself was a practical material that could be tanned in the field and fashioned into functional wear after woolen shirts and trousers were worn beyond use. It was, therefore, only natural for explorers and scientists entering the West to adopt such clothing when necessary, even though many of them disliked buckskin, which was uncomfortable when wet and stiff and abrasive after it dried.

The experience of William Drummond Stewart, a Scottish adventurer who traveled to the Rocky Mountains in 1833 with a well-stocked supply train, illustrates this point. Stewart began his hunting trip with Scottish *trews* (green, red, blue, and yellow plaid hunting trousers), a fine Panama hat, and a white leather hunting jacket from a London tailor. The ravages of travel, hunting, and general wear made it necessary for Stewart to replace his garments with new ones made by Crow women in the Rocky Mountains. Stewart's sense of practical and stylish wear on the frontier was recorded by Alfred Jacob Miller, a Baltimore painter commissioned to accompany the Scotsman when he went west again in 1837. Placed in the Rocky Mountain landscape by the artist, Stewart looks less the tourist and more the frontiersman. Stewart recorded his frontier experiences in his 1854 novel, *Edward Warren,* and Miller's paintings based upon his one trip West became a mainstay of his work; available paintings of the adventure could be ordered by any customers fascinated with the West. Some prints were also created, making the images available to a wider public.

During the same period, trapper Osborne Russell described typical trapper dress as "a flannel or cotton shirt (if he is fortunate enough to obtain one; if not, antelope skin answers the purpose of over- and undershirt); a pair of leather breeches with blanket or smoked buffalo skin leggings; a coat made of blanket or buffalo robe [and] a hat or cap of wool, buffalo or otter skin; his long hair falling loosely over his shoulders completes his uniform."

Such uniforms were adopted by many moving West, among them young Francis Parkman. The result of his 1846 trip was *The Oregon Trail*, a literary work of great popularity. An edition illustrated by Frederic Remington years later (1892) benefited from the addition of Parkman's

Pages 10–11: The year could have been 1873 or 1874. In the center of the image, a young showman, **William F. Cody, appears as the buckskin-clad plainsman** or scout. To his right is James Butler "Wild Bill" Hickok, and to his left, "Texas Jack" Omohundro. Hickok left the stage for death at a card table in Deadwood, South Dakota, in 1876. Texas Jack also died young, but not before he had become a successful showman. Their companions are not positively identified, but their plainsmen dress is unmistakable. Buffalo Bill Historical Center, Cody, Wyoming

Opposite page: **Samuel Washington Woodhouse** was a surgeon and naturalist who participated in scientific surveys of the West. This portrait, painted in 1857 by Edward Bowers, shows him in a worn felt hat, fringed buckskin leggings with moccasins, and both white and red pullover shirts. Such clothing typified many adventurers who headed west at the time. It was an outfit both practical and stylish, indicative of someone who had been on the frontier. National Portrait Gallery, Smithsonian Institution

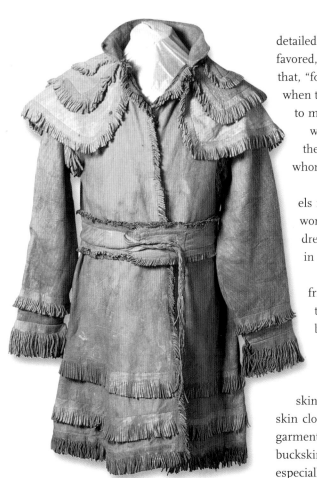

detailed description of his dress. He wrote to Remington that broad-brimmed felt hats were favored, although they became "rather demoralized" by the end of the journey. He noted also that, "for the first two months, or so," he "wore the frock and trousers of civilization and when these wore out, we got the squaws to make us fringed buckskin frocks, and trousers to match, with moccasins of the Sioux pattern." Parkman's frock was of European style with fringe, folding collar and wide-cuffed sleeves. The image his book created, that of the heroic frontiersman, enflamed the imaginations of thousands of readers, many of whom headed west in the late 1840s.

Other authors, such as Washington Irving and James Fenimore Cooper, wrote novels filled with descriptions of the well-dressed hunter or trapper. Editions of Cooper's work were illustrated by Felix Octavius Carr Darley with images of frontier characters dressed in fringed buckskins. The archetype of this character was thus well entrenched in American culture.

In truth, real Westerners sometimes did affect this look. A surviving coat with long fringe, floral embroidery, and black and red fabric triangles appears to have belonged to scout Kit Carson. Traditionally, this coat was said to have been made for the scout by Indians. Close examination, however, reveals that it is machine sewn. The travel account of William Napton written in 1857 indicates that Kit Carson's coat may actually have been of Hispanic origin. Napton visited New Mexico and described a factory in a large adobe ranch house near Las Vegas. He wrote of "an extensive buckskin tailoring establishment there, where they were manufacturing quantities of buckskin clothes of various patterns, and I was surprised at the skill displayed in making the garments. The clothes were made to fit with tailor-like precision and exactness. Clothes of buckskin were generally worn at that time by the inhabitants of New Mexico, by the natives especially." Could Carson's coat have been made in this or a similar establishment? The sewing machine had been invented in 1846 and examples were on the Kansas frontier by the end of the decade.

Contrary to practicality, the wearing of buckskins took on a symbolic role among those living on the frontier. By the time of the American Civil War, the border region of Kansas and Missouri was torn by differing views of slavery and states' rights. Some opposing Civil War military units adopted distinctive dress that reflected frontier styles. Members of William Clarke Quantrill's Confederate guerilla horde favored flamboyant floral-embroidered shirts.

Lined with polished cotton and wool, this style of **tanned buckskin hunting shirt**, with layered cape, waist belt, and standing collar, was popular from the late eighteenth century into the 1840s. This example dates from about 1820 and would have been familiar in communities from the Great Lakes to the Rocky Mountains. Autry Museum of Western Heritage, Los Angeles

Right: In 1837, Alfred Jacob Miller painted **William Drummond Stewart shooting a charging grizzly bear**. Stewart's fine white buckskins seem no worse for the wear. Autry Museum of Western Heritage, Los Angeles

Opposite page: Brass buttons, embroidery, geometric designs, and buckskin combined to make this the ideal **outfit for explorer and mountain man Kit Carson**. Courtesy of the Colorado Historical Society, Denver, Colorado

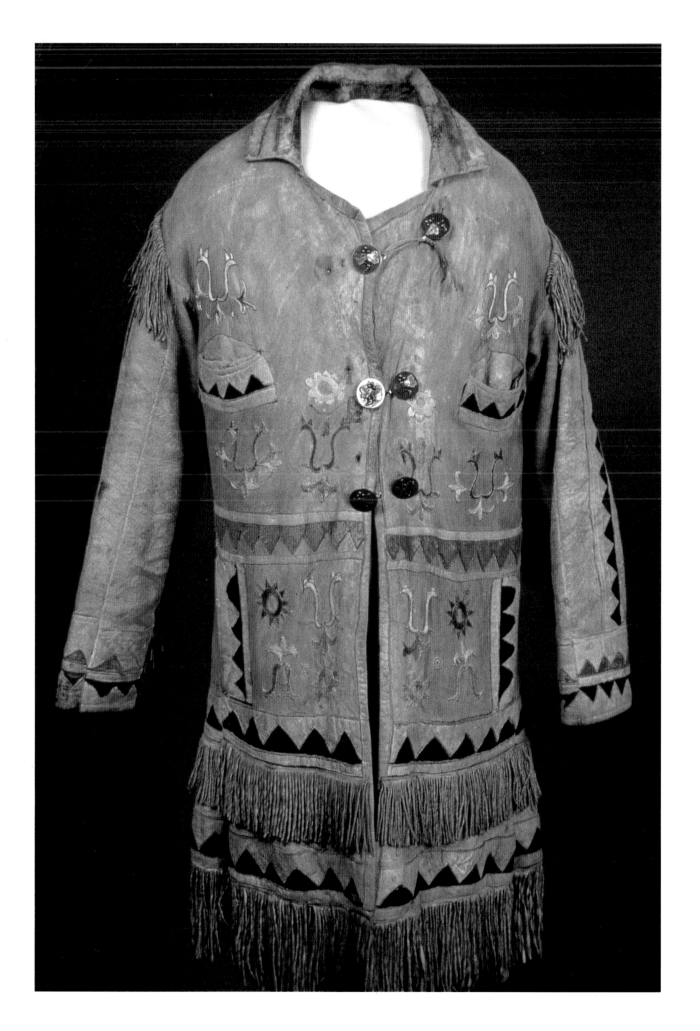

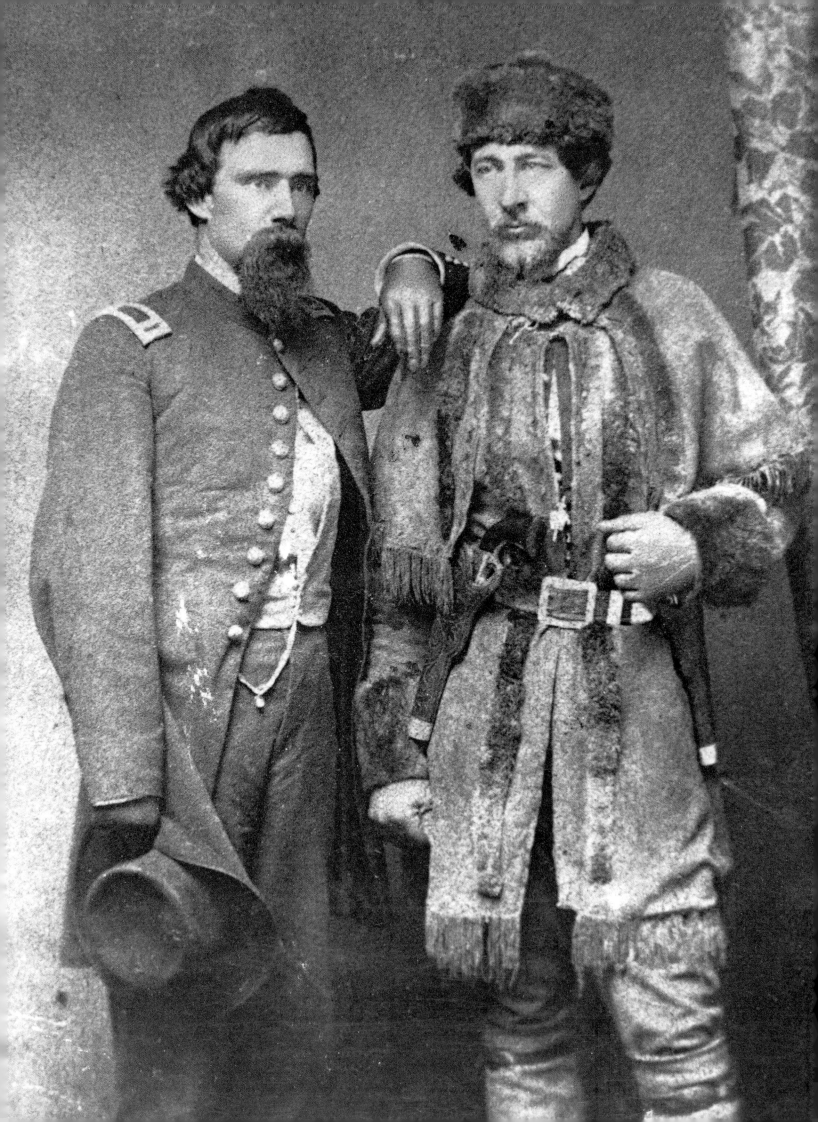

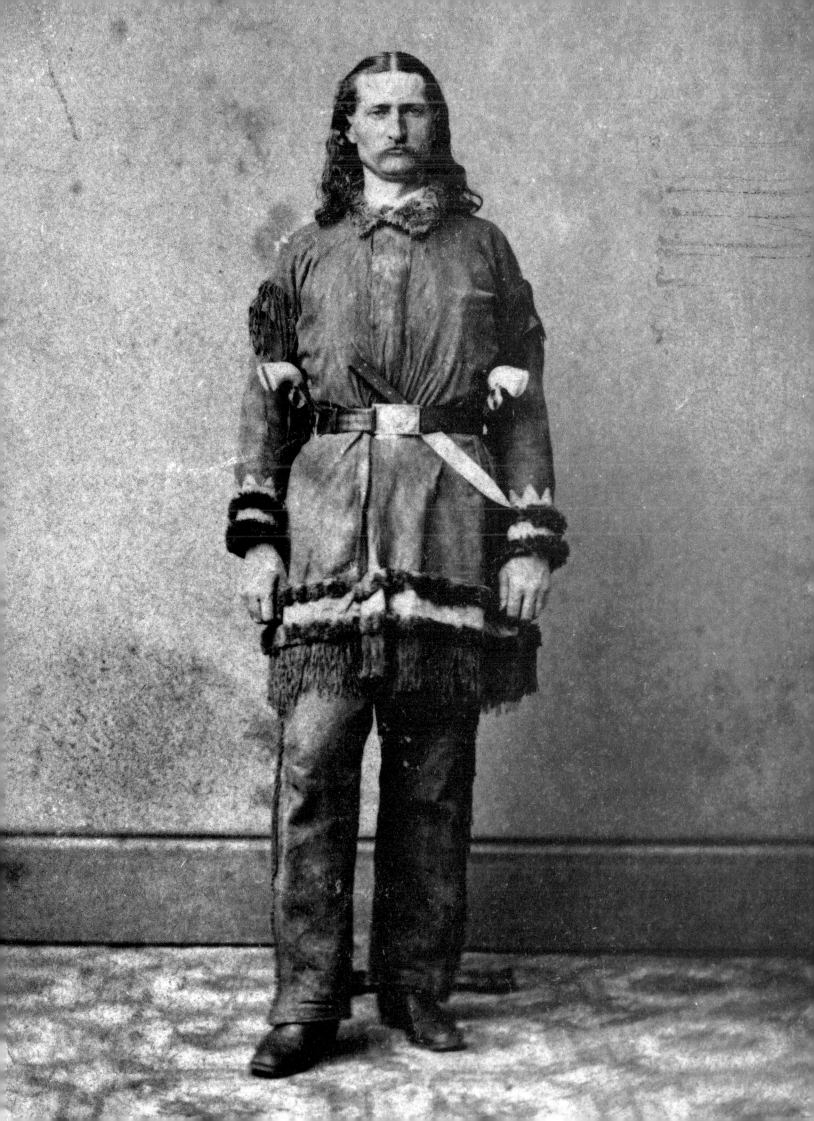

A photograph of one slain member, "Bloody" Bill Anderson, shows him wearing a favored embroidered shirt. On the Union side, the Fourteenth Kansas Cavalry included a company known as the Buckskin Scouts, led by William S. Tough. His scout uniform included leather leggings, fur cap, and fur-trimmed coat with fringe that reached to his knees.

With the addition of a broad-brimmed hat, this costume became the uniform of the Plains scout. By the late 1860s, it could be seen on the likes of famous frontiersmen such as William F. "Buffalo Bill" Cody, "Texas Jack" Omohundro, "Captain Jack" Crawford, and James Butler "Wild Bill" Hickok. That each of these individuals had participated in real Western adventures helped to make such outfits vital to the scout's image. Dime-novel tales of fictional adventures by these characters and illustrated newspaper articles recounting their real-life exploits spread images and written descriptions worldwide. Often, they were

Between 1883 and 1916, through various partnerships and permutations, Buffalo Bill Cody's Wild West Show traveled throughout the United States and Europe, introducing scouts, Indians, cowboys, and stories that would forever influence ideas of the West.

likened to latterday "Leatherstockings." The fact that all acted on stage as well helped entrench their costumes as the symbolic Western clothing of the post–Civil War frontier.

The most famous showman of the West was William F. Cody, whose long hair, mustache, and goatee became part of the expected look of the frontier scout. In 1871, General Henry Eugene Davies described seeing Cody: "The most striking feature of the whole was the figure of our friend Buffalo Bill riding down from the Fort to our camp, mounted upon a snowy white horse. Dressed in a suit of light buckskin, trimmed along the seams with fringes of the same leather, his costume lighted by the crimson shirt worn under his open coat, a broad sombrero on his head, and carrying his rifle lightly in his hand as his horse came toward us on an easy gallop, he realized to perfection the bold hunter and gallant sportsman of the plains."

As early as 1876, Cody had actually scouted for the 5th U.S. Cavalry, pursuing the Sioux and Cheyenne thought responsible for killing George Custer and his troops of the 7th Cavalry. In one well-known fight, Cody killed the Cheyenne warrior Yellow Hair and the scalp and other trophies he brought back traveled on exhibit afterward. In that battle, Cody had worn a theatrical outfit reflective of Mexican style, a black velvet shirt with scarlet and lace trim and silver buttons; later he wore it onstage, merging the real with the mythic. Beginning in 1883, William F. Cody took his Wild West show to the rest of the world.

Marketing the myth of the West had begun early in the nineteenth century. Aside from a vast literature of travel narratives and illustrated descriptions, live performances and demonstrations related to the West were exciting crowds even while Anglo-American newcomers were still exploring the wilds of the Plains and Rockies and confronting native inhabitants. Artists John Mix Stanley (1814–1872) and George Catlin (1796–1872) carefully documented native peoples, and then exhibited their paintings and collections of artifacts to enthusiastic audiences in the East. Catlin even took Indian dancers with his collections to England in the 1850s and, on a number of occasions, painted himself wearing buckskins. William Drummond Stewart transported live buffalo, Indians, plants, and Indian artifacts to his castle in Scotland in the 1840s. The ultimate showman, P. T. Barnum, took a herd of bison to Hoboken, New Jersey, in 1843 where a live show of roping the "ferocious beasts" thrilled audiences.

Despite Barnum's proficiency and imagination as a showman, it was Cody who made a real extravaganza of the West. Between 1883 and 1916, through various partnerships and permutations, Buffalo Bill Cody's Wild West Show traveled throughout the United States and Europe, introducing scouts, Indians, cowboys, and stories that would forever influence ideas of the West. His elaborate spectacles—including Custer's Last Stand, stagecoach attacks,

Page 16: **William Tough, of the Buckskin Scouts,** with his distinctive fur-trimmed coat with cape. Kansas State Historical Society, Topeka, Kansas

Page 17: **James Butler Hickok in the late 1860s.** The long hair, fur-trimmed and fringed coat, and brace of Colt revolvers clearly identify him as a plainsman. Kansas State Historical Society, Topeka, Kansas

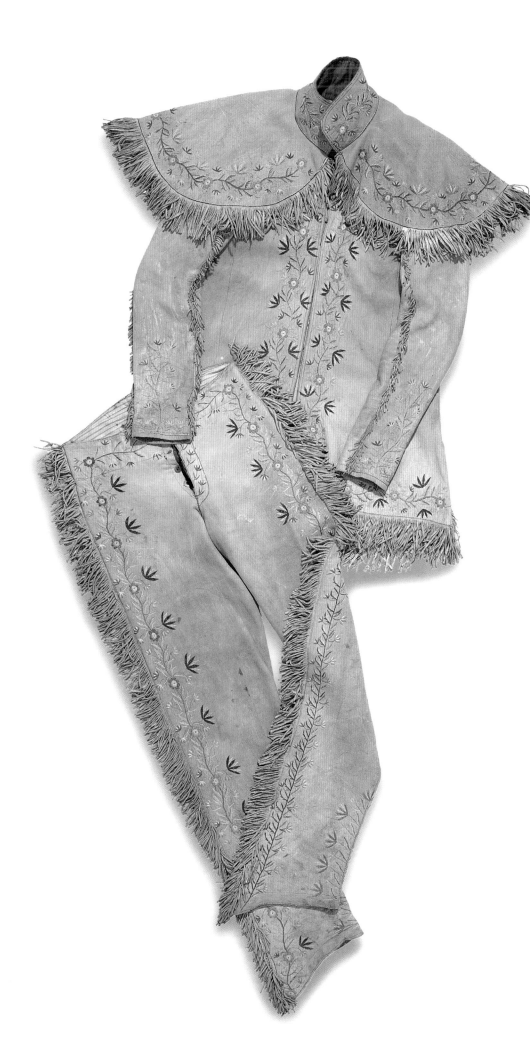

By the time they were removed by force to Indian Territory (present-day Oklahoma) in 1838–39, the eastern Cherokee had absorbed techniques of farming, printing, and building from people of Irish, English, and German ancestry. Some wore fringed buckskins with capes, much like the traditional hunting shirts of the frontiersman. Some Cherokee also participated in the California Gold Rush, though they usually wore the same kinds of wool and cotton clothing as did other gold seekers. Dating from the 1830s, **this Cherokee outfit features fringed cape, standing collar, and button-front fringed trousers.** Probably worn for dress occasions, the shirt's delicate embroidered-silk floral design includes gold beads in the centers of small flowers. It likely would have been worn with matching moccasins. Autry Museum of Western Heritage, Los Angeles

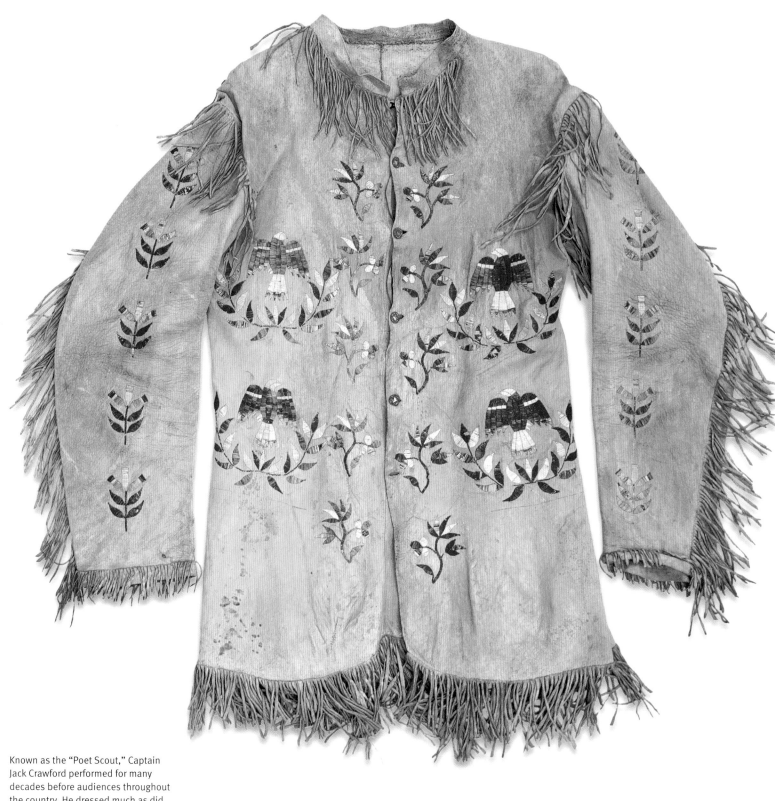

Known as the "Poet Scout," Captain
Jack Crawford performed for many
decades before audiences throughout
the country. He dressed much as did
Bill Cody and often favored **Indian-
made buckskin jackets**. This example,
from the 1890s, features porcupine
quillwork. Autry Museum of Western
Heritage, Los Angeles

Right: A. F. Tait never traveled to the West, but he created an enduring impression of the frontier in numerous paintings, many of which were made into prints by the firm of Currier and Ives. This 1852 painting is titled *The Prairie Hunter—One Rubbed Out!* Sometime after Tait's arrival in New York from his native England, he was photographed wearing fringed buckskin hunter's garb, with a rifle and other equipment in hand. He later used the photograph as a source for his paintings. The images that Tait created of the hunter on the Plains were no less fanciful and inspired others to dress for their own Western adventures. Autry Museum of Western Heritage, Los Angeles

Left: "Antelope" Ernst Bauman was a scout and buffalo hunter in the 1870s and 1880s. His **distinctive leather coat** was machine sewn. Bauman adopted the look of the plainsman and favored long hair, moustache, and goatee. Appropriately, he also became a showman and wore this outfit in stage performances. Most professional hunters favored overalls and plain shirts. Autry Museum of Western Heritage, Los Angeles

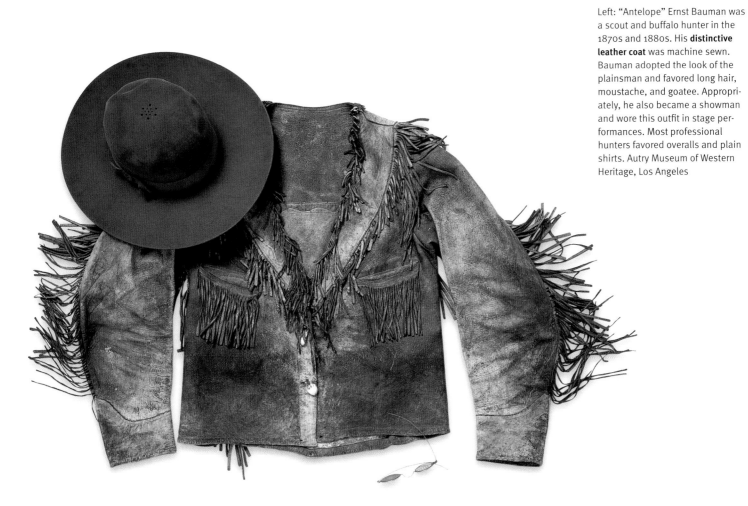

great feats of marksmanship, and demonstrations of roping and riding skill—were copied by competitors such as the Miller Brothers' 101 Ranch Real Wild West, Doc Carver, "Pawnee Bill," and May Lillie. Cody's costume was emulated by the leaders of many competing shows, and diehard fans could even buy Buffalo Bill–style wigs and whiskers by mail order (though, in truth, not many did).

Wild West shows also introduced Indians and their dress, which greatly interested viewers, but they had no strong influence on clothing style. Annie Oakley and other women became the darlings of many shows. They favored showy costumes, and Annie made her own, which included brilliant embroidery. But these styles were not necessarily Western, and as popular as she was, Oakley's fashion style did not set Western trends in fashion.

Ironically, at the same time that Buffalo Bill was selling the West to the world, most Western residents were going about their daily lives in very different dress. Theodore Roosevelt wrote about a typical town scene in the Dakotas during the 1880s:

> On the wooden sidewalks of the broad, dusty streets the men who ply the various industries known only to frontier existence jostle one another as they saunter to and fro. . . . Hunters come in from the plains and the mountains, clad in buckskin shirts and fur caps, greasy and unkempt. . . . The teamsters, surly and self-contained, wear slouch hats and great cowhide boots; while stage-drivers . . . proud of their really wonderful skill as reinsmen and conscious of their high standing in any frontier community, look down on and sneer at the "skin hunters" and the plodding drivers of the white-topped prairie schooners. Besides these there are trappers, and wolfers . . . and silent sheep-herders. . . . If the town is on the borders of the mountain country, there will also be sinewy lumbermen, rough-looking miners, and packers, . . . and mingled with and drawn from all these classes are desperadoes of every grade, from the gambler up through the horse-thief to the murderous professional bully.

Above: Bill Cody's wardrobe included shirts in buckskin, wool, and other fabrics. This **wool example** is typical of many made to the showman's specifications by professional tailors. Courtesy of Buffalo Bill Historical Center, Cody, Wyoming

Right: As a young man in Iowa, Missouri, and Kansas, William F. Cody would have seen scouts, frontiersmen, and boatmen wearing **floral-embroidered shirts**. Such finery was not uncommon. When Cody's wife, Louisa, created this stylish silk shirt for him in about 1870, she mixed both her own aesthetics and those of the time. Such elegance was ideal for social occasions and, ultimately, for the Wild West shows. Buffalo Bill Historical Center, Cody, Wyoming

Western merchants, manufacturers, trainmen, lawmen, saloon girls, teachers, and housewives did not look much different from their Eastern counterparts. Fashion and fashion sense were as important for people then as now. The announcement of the arrival of dry-good shipments by rail, boat, wagon, or stage was good news indeed in a Western community. Dressmakers and tailors could be found almost everywhere. And if you did not have a local source for your clothes, then proper dress was only as far away as mail-order catalogues. At times, small communities, far from supply lines, struggled to keep up with the latest trends established in San Francisco, New York, or even Paris; otherwise, they wore styles of clothing common to their economic, cultural, regional, or social stations. Gentlemen or ladies might pose proudly for a photographer with the certain knowledge that they were well dressed. Being fashionable conveyed the mark of civilization; "frontier" dress could imply lower social stature, backwardness, crudeness, romanticism, or even eccentricity.

Distinctively Western dress could most often be found in such communities as frontier forts, where it was not uncommon for officers and even enlisted soldiers going on campaign to purchase, with their own money, bib-front shirts, broad-brimmed hats, and fringed buckskins. Tailored buckskins, with embroidered, beaded, or quilled floral embellishments, came from the skilled hands of both

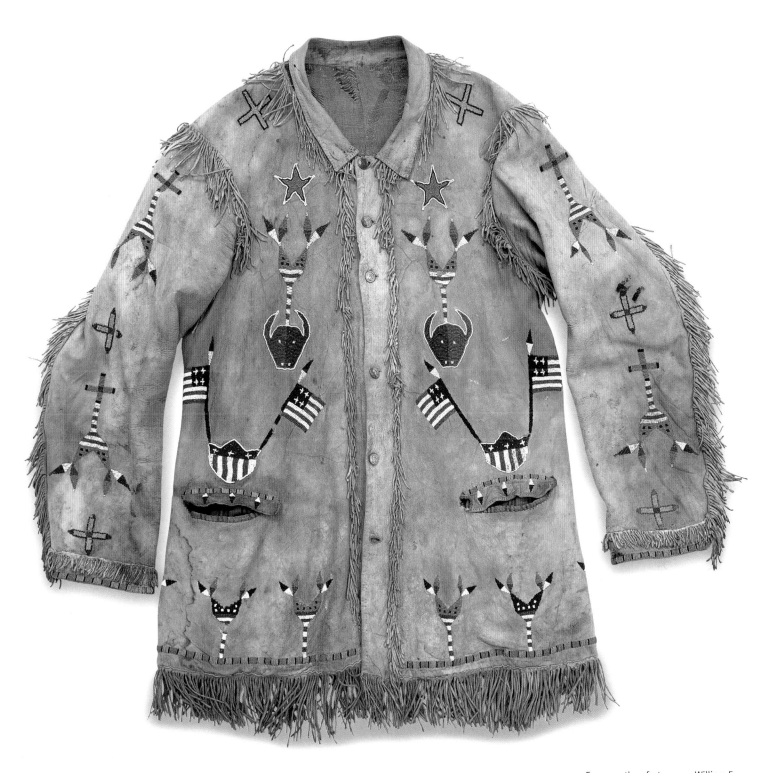

For more than forty years, William F. Cody appeared on stages and in arenas throughout the world. His **fanciful scout costumes** varied from season to season, and embroidered shirts or beaded or quilled jackets were often an important part of his costume. This example is Sioux made and dates from the 1890s. Autry Museum of Western Heritage, Los Angeles

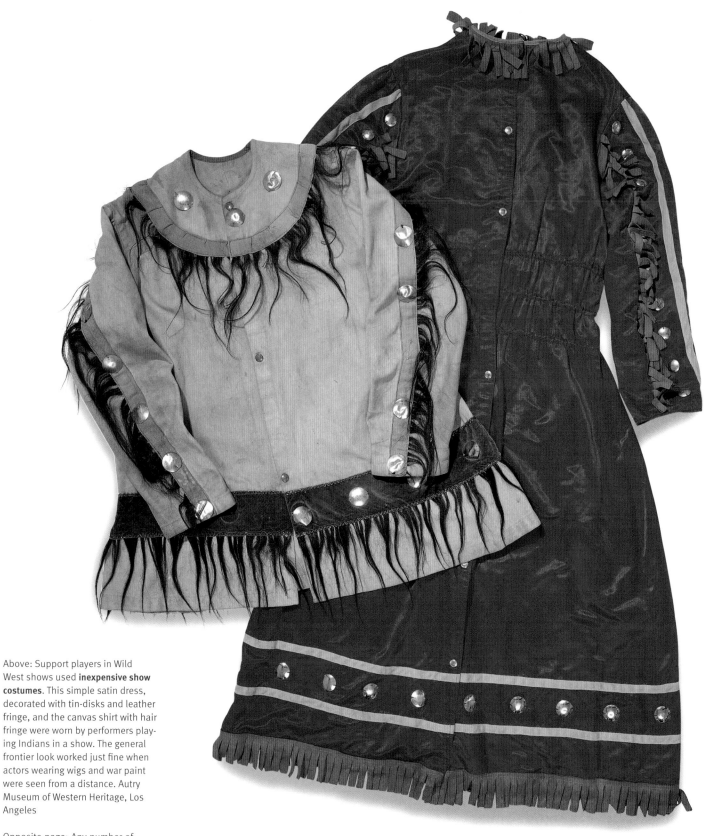

Above: Support players in Wild West shows used **inexpensive show costumes**. This simple satin dress, decorated with tin-disks and leather fringe, and the canvas shirt with hair fringe were worn by performers playing Indians in a show. The general frontier look worked just fine when actors wearing wigs and war paint were seen from a distance. Autry Museum of Western Heritage, Los Angeles

Opposite page: Any number of Western tailors could have made this **buckskin shirt** for a trader, tourist, Wild West–show performer, or someone who wanted to dress for a special occasion. The silk embroidery was first outlined in ink, then stitched. Autry Museum of Western Heritage, Los Angeles

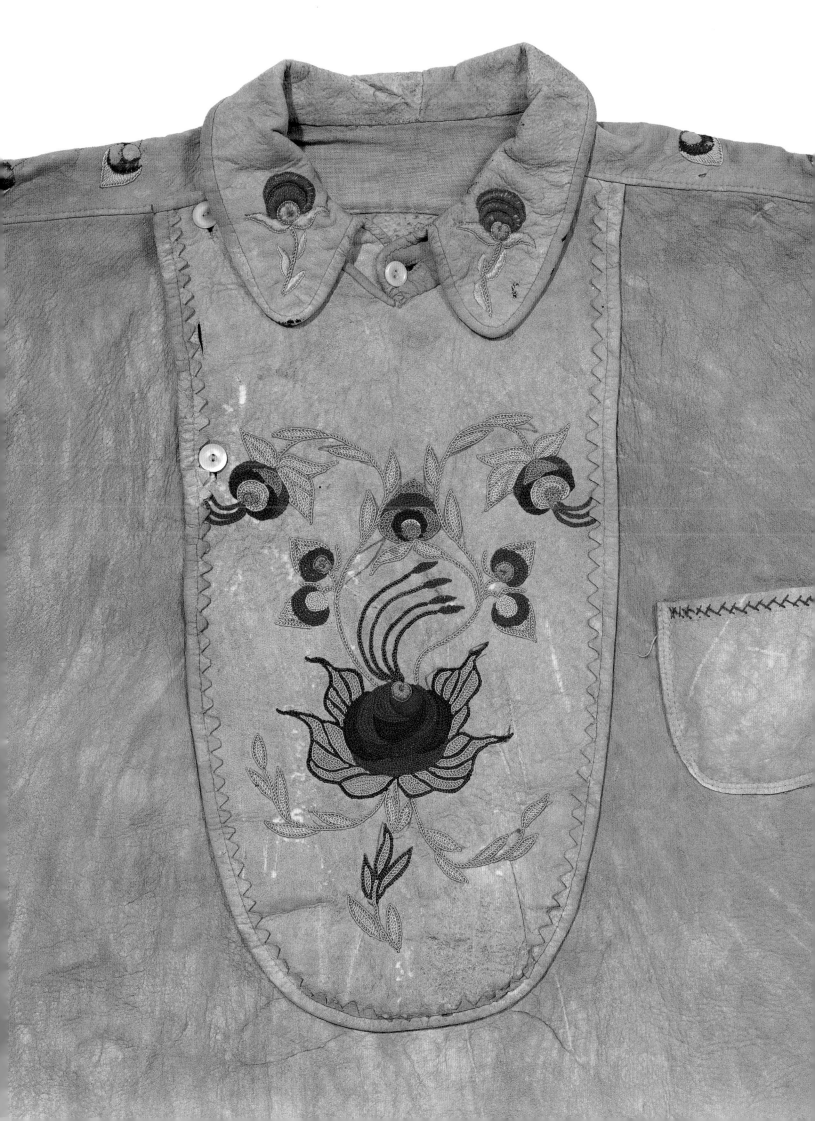

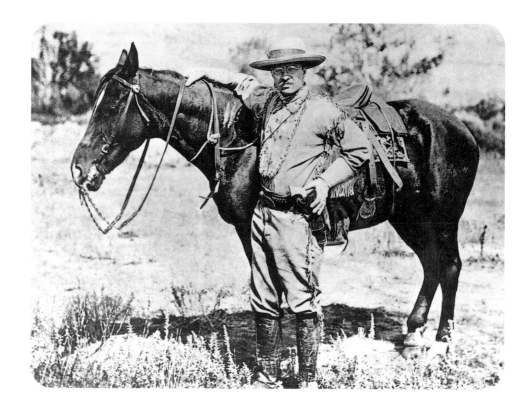

Right: Eastern dude **Theodore Roosevelt wears alligator hide leggings, fringed and embroidered buckskins,** and all the other paraphernalia appropriate to his notion of the Western look. Yale University Library

Above: Uncle Jim Miller may look eccentric today in all his finery. Most **stagecoach drivers,** however, adopted similar outfits, with broadbrimmed hats, gloves, caped coats, and tall boots. Miller embellished his with the hat, the tremendous watch and chain, and the fur vest. The silver- mounted whip was his badge of office. While such drivers were respected by the populace, their taste in dress did not create a fashion trend. Collection Wells Fargo

native artisans and Anglo tailors, who modeled shirts and pants after basic wool counterparts. Usually these garments were worn by tourists, Indian traders, or others wanting to affect a "Western" look.

Theodore Roosevelt had his own vision of how a Westerner should dress. Following the death of both his wife and his mother, he purchased a ranch in the Dakotas and equipped himself with leather goods from the finest shops in Cheyenne, Wyoming, exquisitely embellished firearms from the best engravers of New York, and a bowie knife from Tiffany and Company. His sealskin chaps, alligator leggings, fur cap, and other accessories came from various specialty vendors.

This Eastern dude, however, earned the respect of cowboys, hunting guides, law officers, and others with his energy and bravery. And, just like frontiersmen of an earlier generation, Roosevelt adopted fringed buckskins, often made in the West. He recalled that "the best buckskin maker I ever met was, if not a typical frontierswoman, at least a woman who could not have reached her full development save on the border. She made first-class hunting-shirts, leggins, and gauntlets." She acquired her deer hides from local Indians. The fronts of Roosevelt's shirts were embroidered with floral designs.

Roosevelt's writings of the West in *Century Magazine,* published in book form in 1888 as *Ranch Life and the Hunting Trail,* did much to publicize his view of the West as a land of manly independence. But Roosevelt's romantic vision was not unique. At about the same time, a young Charles M. Russell (1861–1926), working as a Montana cowboy, had taken on Western garb that included a fringed and embellished leather shirt. Philadelphia painter Thomas Eakins (1844–1916) visited the Badlands of North Dakota in 1887 and, a year later, produced a painting titled *Home Ranch,* which depicts a bearded cowboy leaning back in a chair, decked out in hat, boots with spurs, fringed leather chaps, and fringed and embroidered buckskin shirt, his guitar in his lap.

Lawmen captured the public's imagination through lurid tales in the *Police Gazette,* local newspapers, and dime novels. Except for their badges and guns, however, lawmen were difficult to distinguish from others on the basis of dress, although a surprising number wore blue or black police uniforms similar to those used in the East. Otherwise, their working clothes were mostly boots with wool pants, pullover shirts, vests, and broad-brimmed hats.

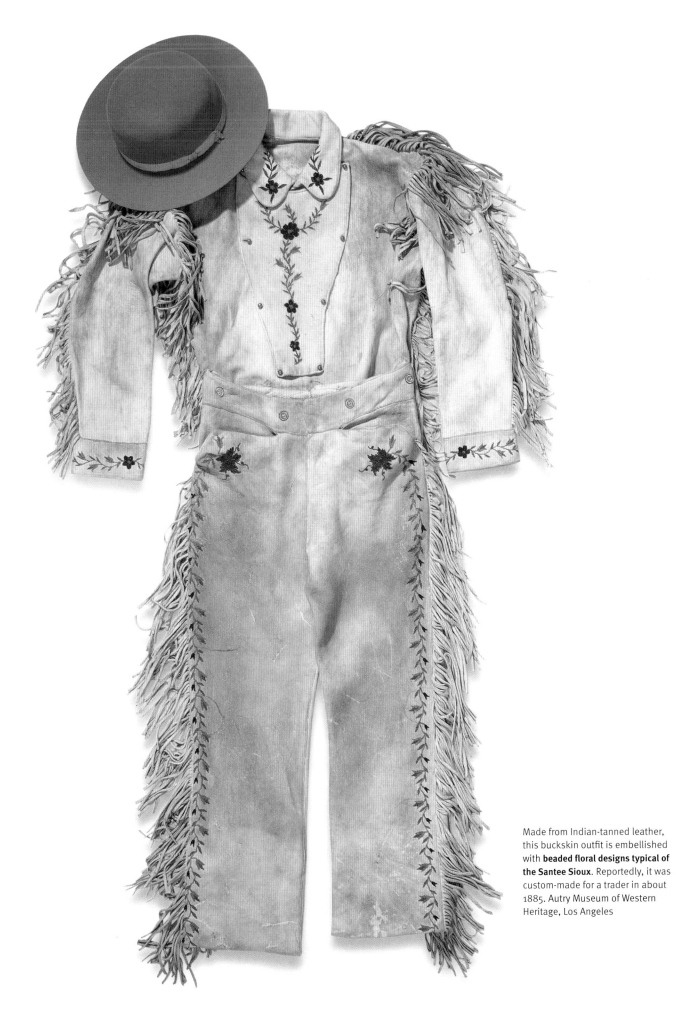

Made from Indian-tanned leather, this buckskin outfit is embellished with **beaded floral designs typical of the Santee Sioux**. Reportedly, it was custom-made for a trader in about 1885. Autry Museum of Western Heritage, Los Angeles

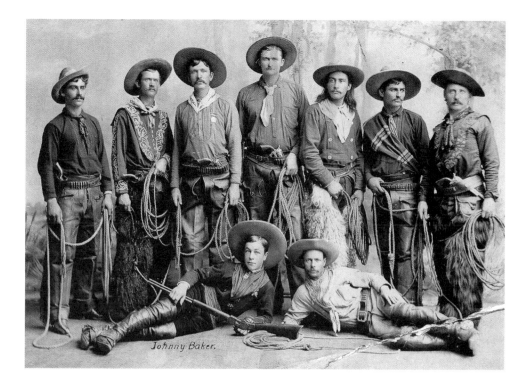

Right: Most of these cowboys would fit just fine with the crew on a ranch in the 1890s, but embroidered shirts, medals, and extra-tall boots help to identify them as **cowboys with Buffalo Bill's Wild West show in 1886**. Trick riding, roping, and other daring stunts made them and their colleagues great heroes to the show-going public of the time. They helped to establish cowboy style and to identify the cowboy as an American archetype. Buffalo Bill Museum and Grave, Lookout Mountain, Golden, Colorado

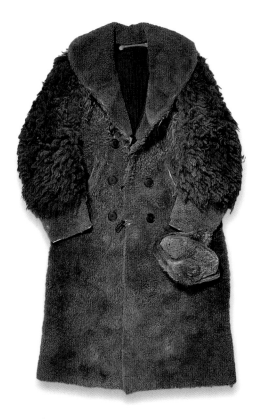

Above: A **buffalo overcoat and muskrat cap** from the 1870s are typical of those worn by the military and civilians alike to keep warm in frigid winter weather. Unfortunately, most hides went to waste, and only a few Westerners wore these heavy coats. Autry Museum of Western Heritage, Los Angeles

Opposite: In 1861, Jeanette Sherlock Smith converted to Mormonism and emigrated from her native Scotland to Salt Lake City, Utah, where she married and made her home before later moving to Wyoming. **This mid-1860s dress** was painstakingly crafted by Smith to reflect the latest fashions of the time. Autry Museum of Western Heritage. Donated by Michael Fox in memory of Janet S. Payne

Because the West demanded much of women, some were willing to liberate themselves from fashion norms. In 1860, Lavinia Porter headed west and wrote later that "fortunately I had some short wash dresses which I immediately donned, tied my much betrimmed straw hat up in the wagon, put on a big shaker sun-bonnet and my heavy buckskin gloves, and looked like the ideal emigrant woman." As with pioneer men, Lavinia's preference for work clothing overcame concern for looking fashionable.

Some forms of clothing automatically associated with the West in fact did not originate there. So-called prairie dresses, worn by women whose faces were shaded by bonnets, seem like a frontier type, yet in reality they were simple day dresses just as commonly worn in the East. Although now forgotten, some daring women on the Oregon Trail had worn shorter skirts with bloomers, giving themselves greater freedom of movement. For the most part, though, bloomers were an Eastern fad, not a Western style.

One rare example of fashionable nineteenth-century women wearing clothing with a Western theme was recorded by a woman describing a dress made for a masked ball at the Gem Saloon in Deadwood, South Dakota. One day she visited a seamstress where the dress was being displayed: "The gown was of heavy black satin with a wide skirt that swept the floor all around and was finished with a lavish double ruffle. . . . But the distinctive thing about it was the rich embroidery of cattle brands interspersed with roses, that covered the entire gown. . . . It was very heavy embroidered and gorgeous with all the shades of red, blue, green, and purple. Not a cowboy who rode riotously into Deadwood and found his way to the Gem, nor a cattleman looking for a little diversion when he came to town, but could find the brand of his own cows on that gown." In retrospect, the creator of such an eccentric gown can be viewed as something of a visionary. The dress was an aberration, not appropriate for proper ladies of the time, but it clearly forecast things to come. Fancy Western wear would not truly be "invented" until the next century.

"I see by your outfit that you are a cowboy."
—*The Cowboy's Lament,* sung about 1886

Though today he is accorded near-mythic status, the nineteenth-century cowboy worked long, hard hours, riding, roping, branding, fixing fences, and, alternately freezing in winter,

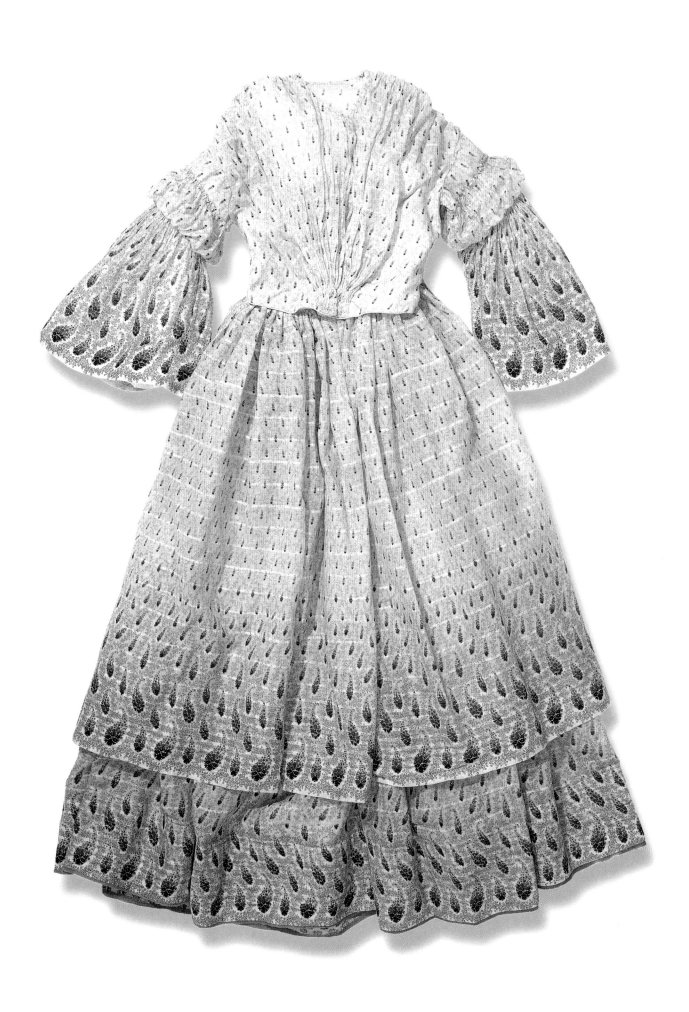

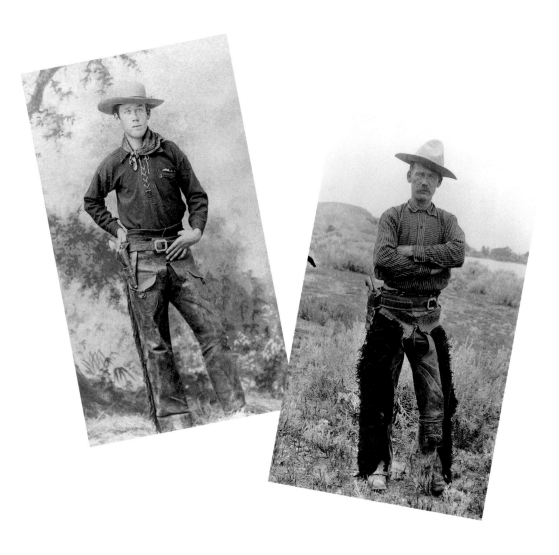

Near right: At seventeen, **D. J. O'Malley** was not the youngest cowboy on the range—most cowboys started early in life. O'Malley was working as a horse wrangler in Montana when this photograph was taken in 1884. Fringed shotgun-style chaps, striped trousers, and a pullover laced-front shirt, along with boots, spurs, silk bandanna, Colt revolver, and flat-brimmed hat complete the outfit of this ambitious young man, dressed in stylish working cowboy fashion. Montana Historical Society, Helena

Far right: Twelve years later, a **seasoned D. J. O'Malley** posed for a photographer near Miles City, Montana. Though he has aged, his dress has changed only slightly. The heavy wear of his Angora chaps proves they were not just for looks. The striped shirt is still a pullover and the gun and trousers are basically the same. O'Malley was a modest but accomplished poet. A phrase of his composition, "After the Roundup," noted, "See, I'm a puncher,/Dressed most in rags." Montana Historical Society, Helena

baking in summer, going without amenities most people would consider necessities, being dirty, overworked, and underpaid. How did the cowboy become a fashion role model?

When overland emigrants arrived in California during the early winter of 1849, they scattered in search of gold. Among the residents they met, whose lives they forever changed, were the descendants of Spanish settlers who had first begun to arrive in 1767. The great land-grant ranches, vast herds of cattle and horses, and the lifestyle they supported had flowered under influences from Spain, Mexico, and even Morocco. The flourishing cattle culture of California gave birth to the *vaquero*. Everything of that culture, from riding and herding traditions to clothing, tools, and equipment, provided a firm foundation for generations of American cowboys. Indeed, the term *buckaroo* is a modification or slang term taken from the word *vaquero*.

The newcomers seeking gold interacted with the *rancho* and *vaquero* culture by both suppressing it and overwhelming it. When it came to dress, miners paid little attention to local culture, wearing what prospectors favored anywhere—tall work boots, woolen pullover shirts, and coarse wool or cotton pants with suspenders. One bold individual in the 1850s did pose for his picture wearing a shirt printed with silhouettes of miners and crossed picks and shovels. Still, many of these newcomers appropriated elements of *Californio* culture compatible with their own needs, including horse equipment and herding techniques, to create a herding culture of their own. For a brief time, a few adopted *botas*, a type of tooled leather legging tied at the knee and flaring out like a bell-bottom pant, which was designed to protect the lower leg from brush. These they usually wore over work pants, rather than taking on full *Californio* outfits, which included embellished short jackets with silver buttons and pants split along the side with a row of silver buttons running down the outside seam. By the late

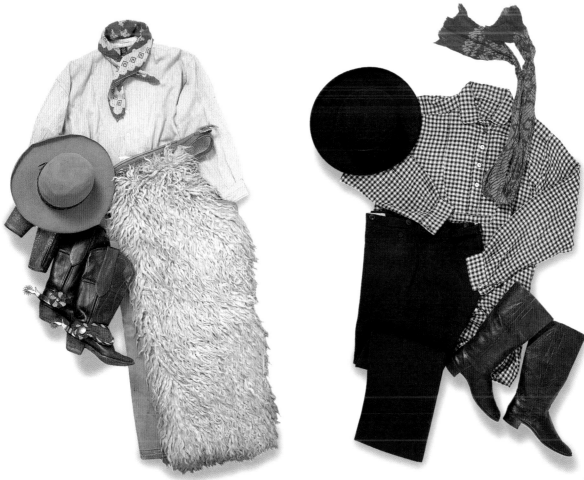

nineteenth century, annual fiestas such as one held in Santa Barbara included Hispanics and non-Hispanics alike wearing Spanish-style dress.

Similarly the Spanish and Mexican influence on the dress of drovers in Texas is specifically evident in Southwestern-style leather leggings, or *chaparreras,* which were worn to protect the rider's legs from brush and cactus. Broad-brimmed hats, or *sombreros,* and colorful woven shawls known as *sarapes* (later Anglicized as serapes) were adopted by some Anglo newcomers. Rapidly, however, their own culture intruded into the Southwest, and styles in the post–Civil War years in the form of boots, pants, shirts, hats, and equipment began to blend with and overwhelm ethnic predecessors.

Yankee ingenuity brought leather products, clothing, and tool manufacturing to new urban centers in San Francisco and to the fringes of cattle country elsewhere. Soon, spurs of Mexican style and origin were being made at factories in places like New Jersey. The basic California saddle of the 1840s was rapidly modified by union laborers working for California manufacturers. The shape, style of tooling, and long stirrup covers, or *tapaderos,* of their product made the California saddle a distinctive style desired and copied for cowboys on the ranges of Oregon, Montana, Wyoming, Colorado, and Kansas. The flat-brimmed, short-crowned hat favored by vaqueros was reflected in styles manufactured by J. B. Stetson in Philadelphia and distributed through dry-good dealers and by mail order. Scarves or bandannas of cotton or silk became a standard part of the cowboy uniform.

Saddle shops also generated other equipment specifically for the laboring cowboy. Leather cuffs that protected wrists from rope burns were considered stylish on some ranges. Leather chaps in many styles were adopted throughout cow country. On northern ranges, where there was less brush and cactus, the chaps gave extra warmth and protection from the

Above left: The cowboy who wore this outfit covered a lot of ground during his trail-riding days. The spurs were made in Texas but used in Wyoming. The **Colorado-made Angora chaps** were stylish from the turn of the century to the 1920s. Called "hair pants," they provided a little extra warmth in early morning or late afternoon. The cotton pullover shirt was worn without its separate collar. A cotton bandanna or "wipe" could be used to protect the mouth and nose from dust. The stamped leather wrist cuffs protected him from rope burns, and the hat, from the sun. Altogether, this is the outfit of a laboring man, unmistakably identifying him as a cowboy. Autry Museum of Western Heritage, Los Angeles

Above right: Cowboys generally were a proud group. When he went to town to socialize, the working cowboy was likely to bathe, shave, and dress to impress the ladies. **This outfit of the 1880s** reflects someone of both pride and stature. He might have worn the black wool pants, fine French calf boots, checkered pullover wool shirt, black Stetson hat, and red silk scarf when he had his picture taken. They could have been purchased at a local dry goods store or by mail. Autry Museum of Western Heritage, Los Angeles

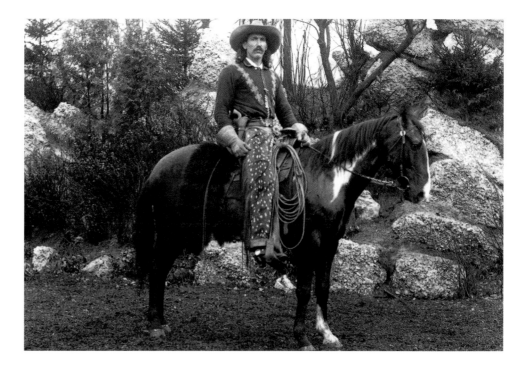

The first performer to be billed as **"King of the Cowboys," Buck Taylor** gained worldwide fame as a star attraction with Buffalo Bill's Wild West show. His embroidered shirt, sealskin chaps, and long hair marked him as something other than a working cowboy. His riding, roping, and shooting skills would have made him at home on the range, however. Denver Public Library Western History Department

wind. In early California, chaps were made from bear hide, with the fur left in place for extra protection from sharp, spiny plants. Later, this form was transformed into "woolies" on the icy winter ranges of Montana and elsewhere. Made with Angora goat hair, these "hair pants" were both stylish and extra warm.

Men's work boots with high tops, round toes and sometimes with decorative stitching were common throughout the country in the early part of the nineteenth century. Centers of boot manufacturing developed in San Antonio, Texas, Olathe, Kansas, and San Francisco, to serve cowboys herding cattle. Responding to riders' needs, boots evolved. Heels were made higher to hook onto stirrups and the shapes of toes were narrowed to fit in stirrups. Decorative stitching styles were developed. By the mid-1880s, the cowboy boot was a recognizable type.

The tools of the trade—hats, boots, spurs, scarves, gun belts, and chaps—were what really identified a man as a cowboy. As Teddy Roosevelt wrote in 1887, "The cowboys resemble one another much more and outsiders much less." In fact, accounts of the late-nineteenth-century cowboy reveal him as acutely style-conscious and proud. E. C. "Teddy Blue" Abbott left a telling account of his life as a cowboy in his memoir, *We Pointed Them North, Recollections of a Cowpuncher*. Writing of the year 1879, he reminisced about stopping in North Platte, Nebraska, receiving his pay, and buying a new outfit in preparation for a visit to his family to the east. "I had a new white Stetson hat that I paid ten dollars for and new pants that cost twelve dollars, and a good shirt and fancy boots. They had colored tops, red and blue, with a half-moon and star on them. Lord, I was proud of these clothes! They were the kind of clothes top hands wore, and I thought I was dressed right for the first time in my life. I believe one reason I went home was just so I could show them off." Abbott was disappointed and furious when his sister told him to pull his pants out of his boots and to put on a coat. She thought he looked like an outlaw.

Another fashion-conscious young man who went to Wyoming in 1884 was Reuben Mullins. Arriving in Cheyenne, Mullins observed "hordes of young men tramping the streets. Practically all wore white felt hats with a broad brim. Some had hat bands of leather, while others used something resembling a snake hide. Most all wore high-heeled boots with trousers tucked in at the tops and spurs with small chains dangling from their boot heels. Many wore leather trousers [chaps] . . . while great, large revolvers hung from belts buckled about their waists." Later, Mullins adopted a similar outfit.

Cowboy clothing through the 1880s and 1890s included various styles of shirts, including pullover shirts with or without collars. Ordered from catalogues, lace-up or button-front bib shirts similar to firemen's shirts, including many made of silk, were often favored. For dressing up and going to town, some cowboys actually bought tooled leather collars, leather bib fronts and matching cuffs to trim their outfits. The laced shirts, often marketed as "bicycle shirts," were available in many different colors, or in striped or checked fabrics. Many cowboys favored wearing a vest over the shirt. Vests provided warmth without the encumbrance of sleeves, and extra pockets to hold necessities. In the early days, many cowboys also kept wool army coats or buffalo-fur coats for cold weather. Starting in 1881, the yellow Fish Brand pommel slicker manufactured by Abner J. Tower spread rapidly through cow country and was widely copied. The cowboy embraced it as both stylish and necessary, yet it never caught on with the general populace. A hundred years later, Australian dusters, popularized by movies and the fashion industry, did catch on, falsely persuading some that this was a genuine American cowboy garment.

Pants worn by the cowboy were usually woolen. Describing his outfit of the 1880s, "Teddy Blue" Abbott wrote, "we had a high-crowned white Stetson hat, fancy shirts with pockets and striped or checked California pants made in Oregon City, the best pants ever made to ride in." He also wore light gray California pants that often had seats reinforced with a double layer of fabric for longer wear. Such pants were advertised and sold by saddle and dry-good shops in cattle country. Through the nineteenth century and well into the twentieth, California pants remained popular. Denim pants, or "overalls," such as those made by Levi Strauss, did not catch on quickly and were not common on most ranges until the 1920s, despite some Levi Strauss ads at the turn of the century, which included paintings of working cowboys by H. W. Hansen and proclaimed: "All over the west they wear Levi Strauss & Co's. copper riveted overalls."

Cowboys created their own image to satisfy themselves. Their dress had its origins in their work, their environment, their tools, and the traditions they adopted. It was a reflection of both occupation and attitude. In turn, as established settlements replaced the frontiers, the cowboy supplanted the frontiersman as the Western symbol of freedom and individualism.

Art and literature again contributed to the transition. Theodore Roosevelt's *Ranch Life and the Hunting Trail* was the first major work illustrated by Frederic Remington (1860–1909). Through his own writing and thousands of illustrations, paintings, and sculptures, Remington went on to depict the cowboy as the tough individualist, as did his colleague Charles M. Russell. The same can be said of Owen Wister in his book, *The Virginian*, released in 1902. His first description of his main character is telling. "Lounging there at ease against the wall was a slim young giant, more beautiful than pictures. His broad, soft hat was pushed back; a loose-knotted, dull-scarlet handkerchief sagged from his throat, and one

Above: The **son of a rancher at the turn of the nineteenth century** typically would have worn a miniature Stetson "Boss of the Plains" hat, cotton shirt, vest, and suspenders. By the time he grew up, his own children would have learned similar ranching traditions, but their outfits would have more closely resembled that of the young buckaroo in the vintage picture. Autry Museum of Western Heritage, Los Angeles

Below left: **Working cowboys in the nineteenth century liked to wear vests** because they provided warmth while leaving the arms unencumbered and had extra pockets for tobacco or other personal belongings. These examples span the 1870s and 1890s. The fanciest would have been saved for wearing to town. Autry Museum of Western Heritage, Los Angeles

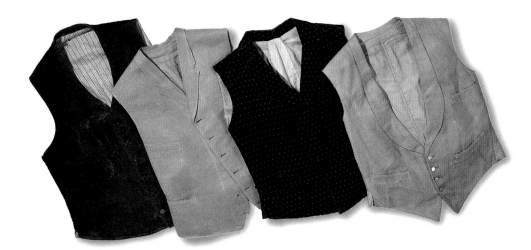

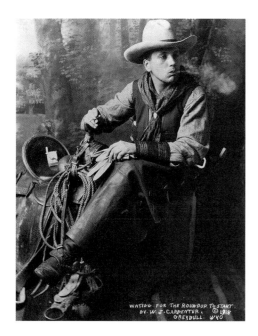

This advertising photograph for Camel cigarettes in 1918 used **a real Wyoming cowboy**. Any dude copying this man's look would have fit right in. In reality, he had a strong Swedish accent and his name was Edward H. Bohlin. Within ten years he was in Hollywood, California, designing and manufacturing fine silver-mounted cowboy and horse gear that has influenced the next two generations of real and pretend cowboys. Wyoming State Archives, Division of Cultural Resources, Department of Commerce

casual thumb was hooked in the cartridge-belt that slanted across his hips. He had plainly come many miles from somewhere across the vast horizon, as the dust upon him showed. His boots were white with it. His overalls were gray with it. The weather-beaten bloom of his face shone through it duskily, as the ripe peaches look upon their trees in a dry season. But no dinginess of travel or shabbiness of attire could tarnish the splendor that radiated from his youth and strength."

That splendor simultaneously sprang forth in Buffalo Bill Cody's show arenas, now filled by working cowboys. Buffalo Bill's cowboys generally dressed in a fashion that would have been at home on the range with "Teddy Blue" Abbott. Some show personalities, however, such as Cody's star Buck Taylor, "King of the Cowboys," added elaborate accouterments. At one point, Taylor sported an embroidered shirt, jaguar-skin chaps, silver-mounted holster, shoulder-length hair, and white silk scarf. Other riders with Cody, such as George Gardiner, continued to work as cowboys in the off season and many of them became active on the rodeo circuit. Gardiner is even credited with helping develop the rules for competitive bronco riding, in which he became a world champion.

Cody's cowboys were popular for their horsemanship, their skill in roping cattle, and for the romantic notions spawned by the spectacle of the arena. Their hats, bandannas, chaps, boots, spurs, and other accessories were distinctive. As Cody presented the cowboy to the world, it was through the cowboy that the world began to embrace Western clothing style. The cowboy style moved from the pages of dime novels and the arenas of the Wild West show to the movies and the world of high fashion.

Buffalo Bill's show career lasted until well into the twentieth century. Among his competitors, the 101 Ranch Real Wild West, headed by Joseph, Zack, and George Miller, was the most successful. Beginning with a show at their Oklahoma ranch in 1905 and then traveling through much of the United States, Canada, and Mexico, the 101 brought the cowboy and the cowgirl in full force to the United States. The Millers' interests made them a major economic force in Oklahoma, and the jobs they offered attracted many of the best riders in the country.

After a grueling national tour in 1911, the 101 wintered at Venice, California. Soon, in partnership with the fledgling New York Motion Picture Company, the Millers formed the Bison 101 film company. In time, film audiences could view the greatest riders and performers of the 101 in their cowboy splendor in theaters around the country. Lucille Mulhall laid the groundwork for the cowgirls who would follow with her extraordinary riding and roping. Bill Pickett, the black cowboy who invented the sport of bulldogging, was filmed in Mexico City in the 1920s and made movies with all-black casts for the Norman Film Company. Tom Mix got his start with the 101 and became one of the greatest Western stars of all time. Other cowboys, including Buck Jones, Hoot Gibson, and Ken Maynard, worked as cowboy performers for the 101. Each set a different fashion trend for film, which influenced public dress and ultimately affected the dress of working cowboys.

The evolution of the iconic cowboy baffled many of the old cowboys. Charles Russell often painted the cowboy of his day wearing California pants, flat-brimmed and low-crowned hat, plain bandanna around his neck, boots and spurs, gunbelt, tooled-leather California-style saddle, his yellow slicker tied to the back of the saddle and his rope strapped to the front. Russell wrote to a friend in 1915 that "this species is almost extinct but he once ranged from the timber rims in the east to the shores of the Pacific, from Mexico north to snow-bound land. He knew horses an [*sic*] could tell you what a cow said to her calf." Pictured on the front of the same letter was a cowboy on horseback shooting his gun in the air, wearing a tall hat with silver trim on the hatband and on the horse's breast collar and bridle. He is wearing orange wooly chaps and a red or pink shirt. Russell simply commented that "this kind I dont know hes not down in natural history."

Cowboys usually did not think of themselves as anything more than men who worked hard from the back of a horse. In the turbulent years between Buffalo Bill's first Wild West Show in 1883 and the advent of silent films before World War I, public perceptions of the cowboy were strongly influenced by art, literature, shows, and film. New states such as

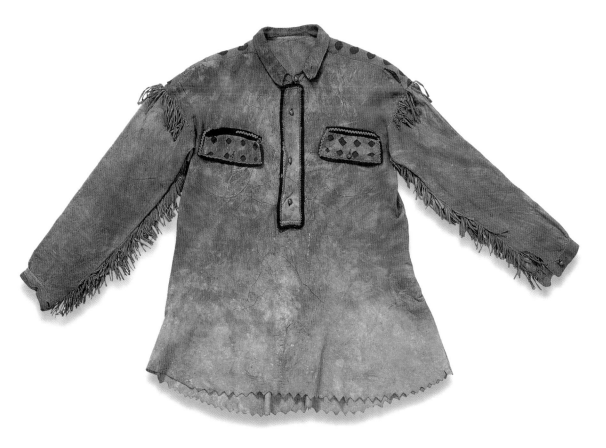

Left: The cavalry sergeant who wore this shirt had it custom-made. The **tailor was an Apache Indian** and the style of cutouts, wool inserts, and other elements clearly reflects its Apache characteristics. Soldiers often adopted such dress in the field. Autry Museum of Western Heritage, Los Angeles

Below: The owner of this outfit is unknown. The **custom tailoring, fringed seams, and gilded buttons from a Grand Army of the Republic uniform**, along with the Stetson hat creased into a "Montana Peak," is what might have been seen at a social event in Montana or Wyoming prior to World War I. The leather is brain tanned, and may have been obtained through trade with an Indian. Autry Museum of Western Heritage, Los Angeles. Donated by Johnny Zamrzla

Wyoming and Montana promoted their natural resources, industries, and ideas of how up-to-date they were in transportation, communications, and styles of all kinds. By the early twentieth century the Western states began to associate themselves more and more with their Western identities. The cowboy became a symbol, and the states advertised themselves as distinctively Western, rugged, and individualistic. Tourism and annual celebrations with parades and rodeos added to the marketing of Western style.

Buffalo Bill stayed in the business long enough to make movies in the early silent era and the characters he gave the world influenced how other filmmakers dressed their performers. One actor, Hobart Bosworth, portrayed both Kit Carson and Davy Crockett in movies made prior to 1910. The fringed leather shirts and pants he wore would have looked at home in Cody's show. Once upon a time, they would not have looked foreign to overland travelers fashioning the West.

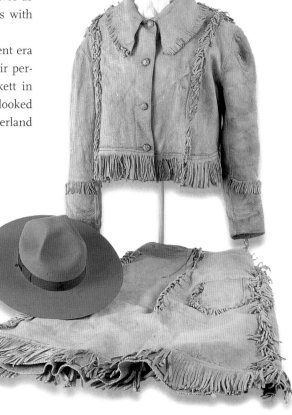

> With angora chaps en carnival hats,
> Checked shirts en handkershiefs loud,
> Come straddle yer horse en ride with us,
> Come ride with the Wild West crowd!
> —*Las Vegas Reunion*, N. Howard Thorp, published 1908

The crowd grew with the passage of time. Every generation would have its own taste makers, designers, and trend setters. An abiding interest in the West and how it was symbolized in clothing spread worldwide. Western style, from the buckskin-and-fringe-dressed frontiersman of the 1820s to the sparkling rhinestone cowboy of the 1960s, was always a matter of display and attitude rather than function. Soon, it would not matter what kind of work you did—if you got yourself the right outfit, you could be a cowboy, too.

SNAP BUTTONS on Cuffs and Down Front

CUSTOM FITTED

4 COLORS:— TAN—LEATHER— POWDER BLUE—DUSTY GREEN

$5.95 POST PAID

No. 1230 Top Quality Finest Spun Gabardine. Custom fitted Pleated Back. Harmonizing Contrast Piping. Set in Pockets. This Shirt has everything: Style, Comfort, Quality. **Sizes: 32- 38 Bust.**

2-TONE PIPED RAGLAN
SET-IN 2-COLOR PIPED POCKETS

$2 POST PAID

COLORS: RED BLUE WHITE

No. 1214 Lustrous Rayon fashioned into well fitted Raglan model. Set-in Arrow Pockets. Piped all over with a new two-color effect that is attractive and distinctive. And shank buttons to complete this effective style. **Sizes: 32-40 Bust.**

DOBBS COWGIRL

Handsome
★
Comfortable
★
Flattering

BUCKSKIN COLOR with Brown Leather Band and Chin Strap attached

No. 1733 DOBBS inimitable styling in a REAL cowgirl's model —not a made-over men's style. And DOBBS Finer Fur Felt insures lasting good looks.

No. 1733 $10 POST PAID

GABARDINE$
SADDLE STITCHED SET-IN POCKETS

4 COLORS
Buff Tan
Leather
Powder Blue
Dusty Green

No. 1221 Finest Spun Gabardine, Flatter Serviceable. Tailored with Deep Y in Pockets with button down Flaps, 3-Butto Cuffs. Real Pearl Shank Buttons. SADDLE-S all around in a harmonizing shade. A shirt for outdoor sports wear as well as f and Rodeo. You'd expect to pay will want one of every color. Siz

SHEER SILK
CONTRAST COLOR SADDLE STITCHING $3 POST PAID

7 HANDSOME COLORS:
WINE BLUE GOLD GREEN
RED WHITE BLACK

No. 1215 Sheer soft silk. Neckband collar, fitted three-button cuffs. Two flap pockets, pearl shank buttons. And—Contrasting SADDLE-STITCHING over all, as shown. A handsome, distinctive style. **Sizes: 32 to 40 Bust.**

SUEDETTE-SATIN BOLERO

No. 272 Bright Satin with contrast Suedette design. Colorful, Comfortable inexpensive. **Sizes: 32 to 40 Bust.**
BLUE RED GOLD
BLACK WHITE

Only... $1 POST PAID

FINE STRIPE SKIRT CORDUROY

Soft light weight Dress Corduroy. Attractive. Split-Skirt Style. Trimmed with Suedette loops, pockets and fringe. Side Zipper opening. Complete with Belt. **Sizes: 12 to 20.**
BUCK-TAN, Brown Trim
LEATHER-BROWN, Tan Trim
RICH-WINE, White Trim

No. 274 $5 POST PAID

Ladies' RIDERS' STYLE

2 Colors: Rum Brown—Buckskin

No. 1077 Shaped and Laced Front with nickel conchas. Snaps on and off at sides. 3 inches wide around back. Striking, flattering. **Sizes: 24 to 32.**

Specify choice of color $2 POST PAID

SATIN RAGLAN
SET-IN EMBROIDERED STEERHEAD POCKETS

$2.65 POST PAID

SIX COLORS
RED GOLD BLUE PURPLE
WHITE GREEN

No. 1217 Finest Sparkling Celanese Satin. Launders or dry cleans as any fine satin. The Raglan Shoulders insure perfect fit. Embroidered Steerhead Pockets and Contrasting Piping makes a beautiful Western style. Pearl Shank Buttons. **Sizes: 32 to 40 Bust.**

RAYON Raglan
EMBROIDERED ARROW PATCH POCKETS CONTRASTING PIPING AND BUTTONS

FOUR COLORS $1.65 POST PAID

RED BLUE GOLD WHITE

No. 1207 Lustrous Rayon in colorful bright shades. Raglan Shoulders. Two Patch Pockets with embroidered "Ride 'Em Cowboy" welts. Contrasting Piping and Buttons. **Sizes: 32 to 40 Bust**

ARROW Pockets

Lustrous Rayon $1.50 POST PAID
3-Button Cuffs
RED BLUE
GOLD

No. 1224 Bright, colorful Rayon. Set-in Arrow Pockets. 3 - button cuffs. Mannish tailoring to correct women's proportions. You'll look and feel "right" in these. **Sizes: 32 to 40 Bust.**

DRESSING THE EARLY WESTERNER

While styles, fabrics, and design elements eventually distinguished the brands favored in the West, early clothing preferred by working Westerners was similar to that of their eastern counterparts. The earliest examples of commercially manufactured Western apparel in the twentieth century were wool-flannel button-down work shirts and corduroy or denim pants known as trousers, or "overalls."

Denim work pants were favored by Westerners, as were Western frontier riding pants first on the market in the mid-1880s. Originally intended for stockmen and Western riders, frontier pants differed from the classic English-style riding breeches in that they more closely resembled gentlemen's dress pants, with wider pant legs worn over cowboy boots. Women's Western wear emerged after the turn of the century and included ladies' frontier trousers, denim overalls, and leather riding skirt and vest ensembles.

Perhaps the most recognized pant style associated with the working cowboy was Levi Strauss & Co.'s "waist overalls." A fortuitous partnership between former dry-goods wholesaler Levi "Loeb" Strauss and Reno-based tailor Jacob Davis led to the May 20, 1873, patent of their process for "Improvement in Fastening Pocket-Openings." By applying copper rivets to the stress points on the pocket corners and fly of canvas work pants, Strauss and Davis created a garment that could withstand rough-and-tumble wear. No other work-wear manufacturer could claim the durability guaranteed by this invention. The pants, also known as copper-riveted overalls, originally had a watch pocket, back waist cinch, suspender buttons, and one back pocket with the "Accurate Stitching" design (a second back pocket was added in 1905). By 1886, the Two Horse Brand leather patch had been added to the pant waistband, and in 1890, the lot number 501 first appeared, followed by belt loops in 1922.

Western work trousers were also made and advertised by Montgomery Ward, Sears, Carhart, Oregon City Woolen Mills, and the lesser-known Rodeo Brand Wear's "Rodeo Booger Reds." While these brands were popular, Levi had an exclusive product until 1909, when its patent for riveted clothing expired. The company again led

the market in 1915 with overalls of nine-ounce denim, bought exclusively from Cone Mills, which set the standard for denim Western overalls, rendering wool and canvas versions virtually obsolete. By the 1920s, Levi Strauss overalls had become a staple in nearly every Westerner's wardrobe.

Work-wear manufacturers continued to develop the look of Western denim trousers. In 1924 the H. D. Lee Mercantile Company (established in 1889) introduced the "101" Cowboy Pant, which they claimed was the first denim pant designed specifically for cowboys and rodeo riders. Advertised as "the best all-round cowboy pant for good looks, long wear, and real comfort," Lee's eleven-and-a-half-ounce denim trousers came with a "guarantee for absolute satisfaction" and sported five pockets, "scratch-proof" hip-pocket rivets, a back yoke, belt loops, and waist cincher. In addition, Lee jeans featured a unique hot iron-branded "hair-on-hide" label and a "U-shaped saddle crotch," making them the "ultimate in denim riding apparel."

As Western pant styles matured by the 1920s and 1930s, so did the Westerner's shirt. Wool flannel two-pocket plain or plaid button-up shirts were not much different from the typical men's work shirt of

Dressing Western was as simple as picking up **a mail-order catalogue**, dreaming about the latest fashions and gear, saving your money, and splurging on a new outfit. Even the cover illustrations made the ease of doing business evident. You could choose outfits like those the illustrated models were wearing and have almost immediate satisfaction, thanks to the postal department. Autry Museum of Western Heritage, Los Angeles

Opposite page and below: Catalogues catered to women as well as men and children. In the summer of 1941, both stockmen and -women could order clothing from **Stockman-Farmer Supply Company** in Denver, Colorado. Autry Museum of Western Heritage, Los Angeles

Right: **Just before and after the Great Depression,** Western manufacturers and marketers were still selling Western apparel and equipment to a wide range of clientele. For Eastern dudes, Western ranchers, Hollywood pretenders, and many others there were ample choices for what was in style at the time. An interesting innovation of Levi's occurred in 1938 when the company launched Lady Levi's 701 fitted denim pants for women, featuring pink selvage thread rather than the standard red. Autry Museum of Western Heritage, Los Angeles

Below: Advertising for denim jeans has gone through as many changes as the products themselves. This **window-display figure** depicts the way a stylish cowboy would have dressed throughout the 1950s. The Levi Company also produced banners and posters to advertise its products. Autry Museum of Western Heritage, Los Angeles

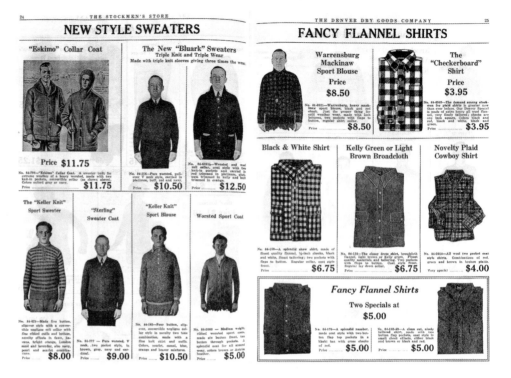

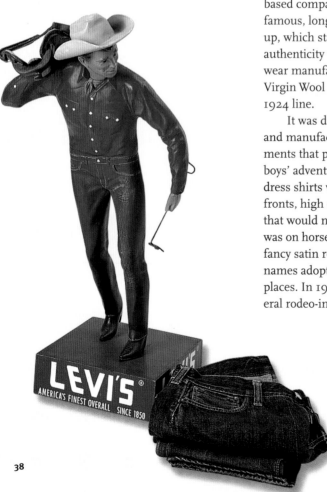

the 1920s, but certain brands were beginning to be associated with the Westerner's wardrobe. In particular, Pendleton Woolen Mills offered a popular product for the working Westerner as well as the outdoor enthusiast. Originally the manufacturers of Indian blankets and robes, the Oregon-based company's affiliation with the famous, long-running Pendleton Round-up, which started in 1910, gave it an authenticity that many other early Western-wear manufacturers lacked. The Pendleton Virgin Wool Shirt debuted in the company's 1924 line.

It was during this time that retailers and manufacturers began to develop garments that played on the appeal of cowboys' adventuresome lifestyles. Western dress shirts with yokes, full button-down fronts, high cuffs, and longer shirt-tails that would not pull loose when the wearer was on horseback became popular, as did fancy satin rodeo and riding shirts with names adopted from Western culture and places. In 1927, Pendleton introduced several rodeo-inspired styles for men, such as

the Round-up Vest, Buckaroo Shirt, and Buckaroo Pants. Proclaiming that "world champions should wear Pendletons," the 1928 catalogue featured rodeo star Bob Crosby in a red-plaid ten-ounce wool shirt. His convincing endorsement left little doubt that this was a Western-worthy brand: "So far [over the course of] my many combats on the range and the rodeo, I've always managed to come out with a whole shirt. Part of this may be due to luck, but I credit a good deal to the wonderful quality in Pendleton virgin wool fabrics." By 1929, the company had introduced a full line of men's sportswear, and its brand had achieved status along with Levi and Lee as a staple of the Westerner's wardrobe.

Smaller, specialized Western mail-order catalogues distinguished themselves from the large commercial books like Sears and Montgomery Ward by offering complete Western wardrobes, including clothing, accessories, gear, and equipment, as early as 1905. Pages were filled with Western imagery, colloquial narratives, and detailed descriptions of trims, fabrics, and the superiority of this merchandise over that of competitors. Several of the catalogues derived from retail stores bearing the same name, while others assembled their assortments strictly with merchandise purchased from Western-wear manufactur-

ers. The beauty of these catalogues was that they appealed to the authentic cowboys and cowgirls as well as new consumers who were purchasing items for Western vacations or to emulate a Western lifestyle. They also were favored by famous Hollywood cowboys such as Buck Jones, who bought clothing, hats, and boots from the same mail-order catalogues as did working cowboys from Montana and Nevada. Retailers capitalized on the popularity of celebrities, who became synonymous with fashionable Western apparel.

As Western finery became increasingly decorative throughout the century, a difference in opinion arose between cowboys who dressed for show and those who went for the practical, durable traditional style. "Everything a cowboy wears has been developed for a purpose," argued Luis B. Ortega in the January–February 1947 issue of *Western Horseman*. "Some of them prefer the gaudy, fancy elaborate type of wearing gear, but you will find the rider who makes an honest living on the range equipped with plain clothes and a riding outfit built to suit his needs and to stand the vigorous usage it has to be put through in his daily work. I never saw a real buckaroo wearing fancy-pocketed shirts or fancy pants. . . . The cowboy wore his white shirt or black sateen and waist overalls, shined up his

boots, and with his big hat was ninety-nine times just as picturesque as the 'pretty boy' with all his modern do-dads and fancy stuff with silver trimmings."

Twenty-odd years later, rodeo rider Milt Hinkle, in a 1969 issue of *Old West* magazine, described *his* rodeo generation's dress code: "Our dress and gear were in keeping with the times. We liked our vests, colored bandanas, loud shirts, long sleeves, our Fish brand yellow slickers, our goat hair chaps or leather batwing chaps, and the big rowel spurs." Regardless of outlook, however, everyone could agree that Western wear was here to stay.

Above: Working cowboys from **the late 1890s** would have recognized and favored these these shirts and suspenders, which could have been ordered by mail. Autry Museum of Western Heritage, Los Angeles

Below left: This **shirt, scarf, and Stetson hat from about 1958** were worn by James N. Tibbals, a prominent rancher near Boulder, Wyoming. Tibbals's shirt was custom made by Front Union Depot in Los Angeles and features the same virgin wool favored by designers like Nathan Turk. Autry Museum of Western Heritage. Donated in memory of James N. Tibbals, Boulder, Wyoming

Below right: By the twentieth century, fringe had become a purely decorative element, adding pizazz to simple Western garments. This **plaid wool jacket made by Hamley's** in Pendleton, Oregon, in the 1940s is crafted from blanket material likely woven at the Pendleton mills. Collection of Michelle Freedman

Celluloid Style:

COWBOY FASHIONS IN THE REEL WEST

Every July the Western Film Preservation Society (WFPS) of North Carolina holds an old-time Western film festival. For the first gatherings back in the 1960s, Milo Holt, the festival's founder, showed his collection of 16-millimeter "oaters" on a window shade in his Silver City, North Carolina, mobile home. Of the roughly three hundred, mostly fifty-ish folks who attended, some remember watching B-Westerns on television as kids, and a few recall seeing their favorite cowboys at the silver-screen matinee every Saturday. Society president Edgar Wyatt, now in his eighties, still prefers silent Westerns. He is the author of *More than a Cowboy*, about Fred Thompson, FBO studio's 1920s answer to Tom Mix. "The clothing style back in the 'silents' was more authentic, more like the cowboys actually dressed," Wyatt explained in 1999. "Then, ex-circus star Tom Mix came along and brought flashy clothes to the silents." Occasionally festivals like this one hold Western-film-star look-alike contests. Jerry Campbell, who usually projects the films during WFPS gatherings, tells of a fellow who is the spitting image of William Boyd and dresses like Hopalong Cassidy, down to his distinctive black outfit and gleaming white hair.

Tom Mix decorated his home with a wide variety of collectibles. His white wool suit trimmed with black leather was styled for wear around town, just as his Western tuxedo was designed for evening wear. Academy of Motion Picture Arts and Sciences

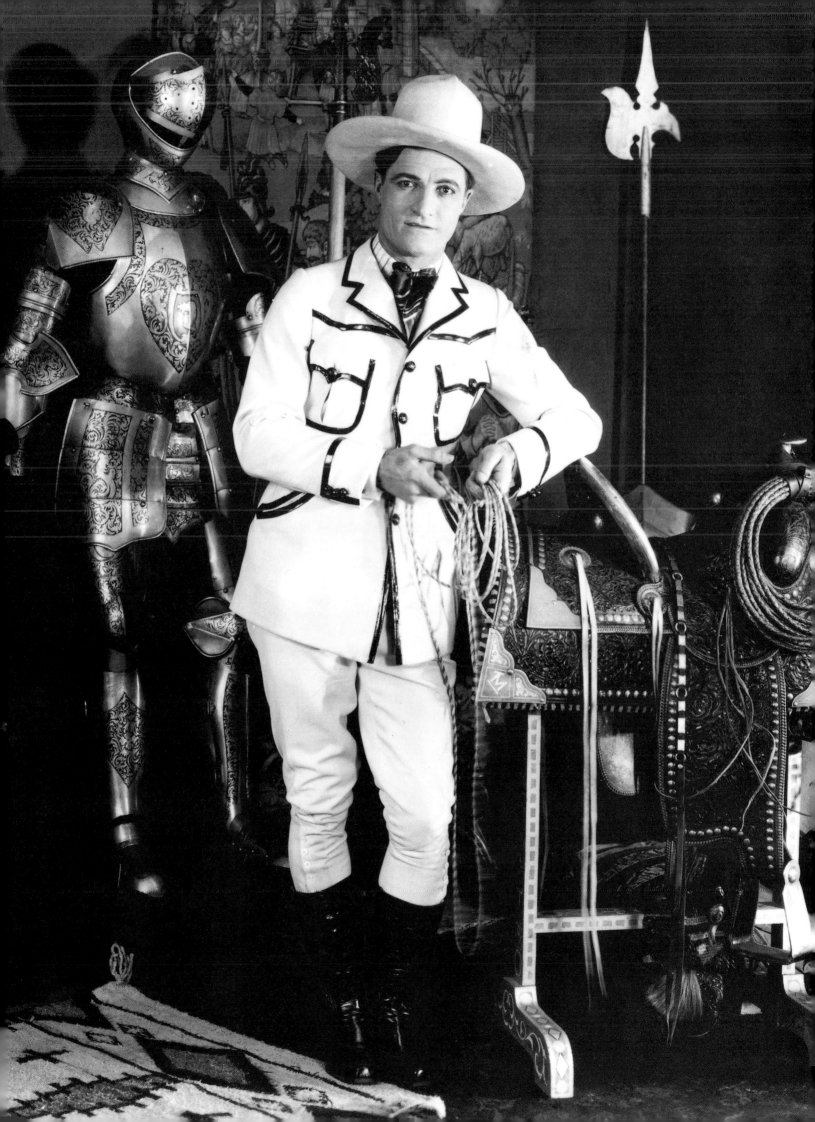

William S. Hart is shown in **one of his typical costumes**, with woven sash, wrist cuffs, cotton bandanna, and laced-front pullover shirt. The flat-brimmed hat with Montana-style crease is appropriate to the dress of an 1890s cowboy from that region. Autry Museum of Western Heritage, Los Angeles

Since the earliest Westerns, celluloid cowboys' wardrobes have defined their personalities on-screen, and sometimes off-screen too. Such stars as William S. Hart, Tom Mix, Fred Thompson, Ken Maynard, Hoot Gibson, Buck Jones, John Wayne, and William Boyd each developed his own unique take on cowboy clothing, altering the archetypal cowboy look forever.

Prior to the 1920s, few major film studios employed staff costume designers. Most screen actors wore their own clothing or garments left over from earlier films and retrieved from studio stockrooms or rented from theatrical costume companies. Early Westerns, including the first—1903's *The Great Train Robbery*—were filmed in the East with casts of cowboys dressed in Eastern interpretations of Westerners' garb. Western star G. M. "Broncho Billy" Anderson appeared briefly in *Train Robbery* and went on to make pictures for Vitagraph and Polyscope. Eventually Anderson teamed up with George K. Spoor to form Essanay Studios, where he created the prototypical Western character Broncho Billy. According to William Everson's authoritative film history, *The Western*, Anderson's on-screen style was largely inspired by images of Westerners he'd seen on the covers of dime novels and pulp magazines: "He wore a simple and modestly colored shirt, often a waistcoat . . . and leather cuffs, adorned with a single star, around his lower arms." Broncho Billy also donned woolly Angora chaps, a style adopted in later Westerns and by overzealous dude ranchers. Subsequent Western film stars preferred less cumbersome leather chaps.

The first major Western star, William Surrey Hart, arrived in Hollywood in 1914 at the age of forty-six. Though his movie career lasted only from 1914 to 1925, he appeared in twenty shorts and fifty features. Originally a theater actor, Hart was cast in 1905 in his first Westerner role, playing "a mean skunk of a cowboy," Cash Hawkins, in *The Squaw Man* on Broadway. A publicity photograph of Hart as Hawkins shows him in light-colored hair chaps, a leather vest over a pull-on shirt, a large muffler loosely tied around his neck, leather-fringed cuffs with star-appliquéd gauntlets, and a light ranger-style hat that eventually became part of his signature look. Hart seized the opportunity to create a new image, going on to play Westerners in theatrical productions of *The Virginian* and *The Barrier*.

In 1914 and 1915, Hart starred in his first films, Thomas Ince's *The Bargain* and *On the Night Stage*, which Hart helped to write. Widely popular, Hart gained the clout to maintain

creative control over his projects, eventually directing most of his pictures. On-screen, Hart became the Western's austere realist, a "two-gun man," and a serious actor. He often incorporated authentic details of a working cowboy's wardrobe into his movie outfits, including a French-Canadian sash worn under his gun belt.

"Hart brought . . . unprecedented personal charisma" to his roles, according to Diane Kaiser Koszarski in *The Complete Films of William S. Hart.* "His physical presence incarnated Western virtues: he was tall and lean (6'2", 180 pounds), he wore the rumpled, bulky costume of the cowhand or prospector or faro dealer with authority and grace." Hart, who took pride in his knowledge of the West and the respect he earned from "real" cowboys, once described the role of his movies in their depiction of Western garb: "One of the many things you have to thank the movies for is that they have about banished the old 'stage' cowboy. The real cowboy clothes are all made for utility, not for effect. Even the silk handkerchief he wears round his neck has its uses. When he's herding cattle, he doubles the handkerchief corner-wise and puts it over his face just beneath the eyes to keep the dust out of his nose and mouth. . . . A cowboy is usually a bit of a dandy and likes a silk handkerchief because silk is soft to the face and neck. This he fastens with a valuable ring when he can afford one; when he can't he'll use a poker-chip. Have you ever seen a stage cowboy with a vest on? I don't reckon so, for these creatures have to look romantic, and a vest's a prosaic affair."

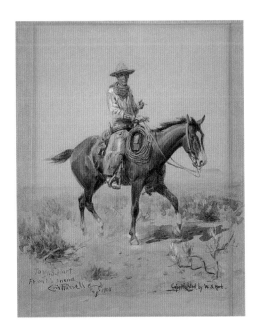

Above: **William S. Hart, as painted by Charles M. Russell.** While the image is factual in depicting how the actor dressed, Hart's notions of how the cowboy should look were not exactly accurate, even though in many ways he modeled himself after the authentic cowboy that Russell himself was. Watercolor, 1908. William S. Hart Park, Los Angeles County Museum of Natural History

Left: Joe De Yong learned about art as Charlie Russell's protégé. This and his experience as a working cowboy made him an ideal costume designer for directors such as Cecil B. De Mille. This **watercolor, one of thousands De Yong created for filmmakers over a career of many decades,** reflects his knowledge of the historical West as well as the demands of character and interest for film. Autry Museum of Western Heritage, Los Angeles. Donated by Rosemary Ruddick

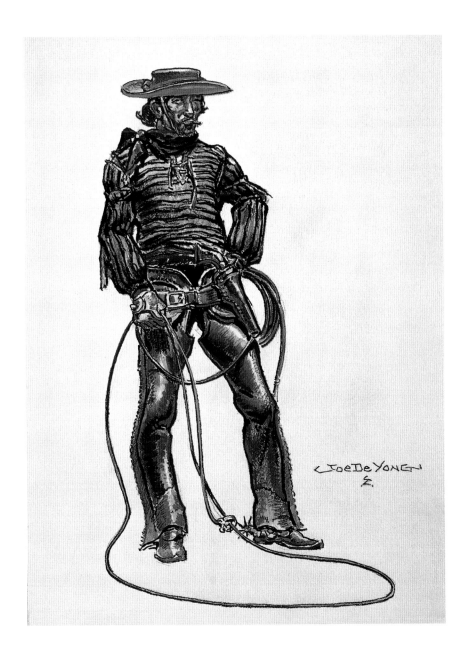

At the time, Hart stood alone in his celluloid depiction of a realistic cowboy and in his interpretation of his characters' outfits. "William S. Hart's insistence on authenticity in all matters pertaining to the West extended especially to his costume," Everson wrote. "Because of this, Hart frequently looked far from neat, but he never once took on the slick 'circus' appearance of so many other 'cowboys.' Hart wore drab frock coats, often shiny with use and dusty from much traveling, and the cheap, sturdy, gaudily colorful shirts that the old frontiersmen loved so much." In the 1915 film *Every Inch a Man*, for example, Hart wears a white laced-front shirt with bulldogging strings tied around his sleeves, a black low-cut brocade vest with white binding outlining the lapel and four front pockets, and pants tucked into tall narrow black riding boots. In the film, to show his devotion to the parson's daughter, Hart swaps his rugged cowboy garb for a rumpled, yet proper, single-breasted sport coat.

Hart's realistic yet romanticized costume style was greatly influenced by the Western paintings of Charles Russell, whom he first met when he was still in the theater. One of Hart's prized possessions, reportedly, was a portrait Russell painted of him in cowboy garb. Russell despised Hollywood's portrayal of the cowboy, but did affiliate himself with some of the players in the Western film industry, many of whom became his patrons. A protégé of Russell's, Joe De Yong, who had lived with Charlie and his wife, Nancy, for eleven years, accompanied them in 1924 to Los Angeles, where he was introduced to their friends—an impressive circle of Western artists, actors, musicians, writers, and filmmakers. Inspired to pursue a career in California, De Yong eventually became a costume and set designer and illustrator for the movie industry. His first job in Hollywood was costuming Cecil B. De Mille's *The Plainsman* (1936), starring Gary Cooper and Jean Arthur in the roles of Wild Bill Hickok and Calamity Jane.

Dubbed "the Beau Brummell of the West," Tom Mix was the first cinema cowboy to carefully create a flamboyant on-screen—and off-screen—clothing style.

Above: Nothing spells success like fine clothes and accessories. Tom Mix could afford both. A friend recalls that Mix did some embroidery himself and suggests that this shirt, the one Mix was wearing on the day he was killed, was decorated by the actor himself. Whatever the case, in the tradition of Buffalo Bill, **Mix was the first film star to decorate his shirts with a floral motif,** starting a trend that would grow like kudzu. The fine white Stetson hat, handmade boots, and gold and silver spurs by Edward H. Bohlin are emblematic of Mix's screen style. Autry Museum of Western Heritage, Los Angeles. Boots donated by Duke Lee

Opposite page: **Embroidery detail of Tom Mix's shirt.** Autry Museum of Western Heritage, Los Angeles. Donated by Gary Allen

Hart is credited with giving L. L. Burns, founder of Western Costume, the preeminent movie-wardrobe supply house, his first break. Burns, who carved out a living as an "adventurous Indian trader," came to Los Angeles in 1912 with a collection of Indian costumes he'd gathered while traveling throughout the West. During a chance meeting with Hart, Burns suggested to him that the costumes worn by the Indian extras in Hart's films were inaccurate. Burns, who had set up a small costume shop at Seventh and Figueroa known as "the hole in the wall," then became the official supplier of Indian clothing for Hart's pictures. By the 1920s, Burns's business had grown successfully into the Western Costume Company, perhaps the largest costuming organization in the world today.

Off-camera, Hart rarely dressed Western. "This 'rough and ready terror of bad men' I discovered in a regular civilized office in his studio in Hollywood, ready to pack up and go on location in the Mojave Desert," wrote Ray W. Frohman for the *Evening Herald* in 1919. "He was wearing 'store clothes'—a clean white shirt, neat gray pants, plain black shoes. The son of a gun . . . was actually riding a swivel chair. Unless you consider the lack of a coat and collar as the mark of a plainsman, there was nothing of the wild and woolly about this quiet and polite gentleman with the light brown hair, high cheek bones, firm lips with thoughtful lines around them, and strong jaw. Except that he averaged one 'damn' and one 'hell' a minute, he might have been his own gentle pinto pony with the feedbag on . . . "

Dubbed "the Beau Brummell of the West," Tom Mix was the first cinema cowboy to carefully create a flamboyant on-screen—and off-screen—clothing style. His spectacular outfits helped win him the moniker "King of the Cowboys." At the height of his career in 1925, he

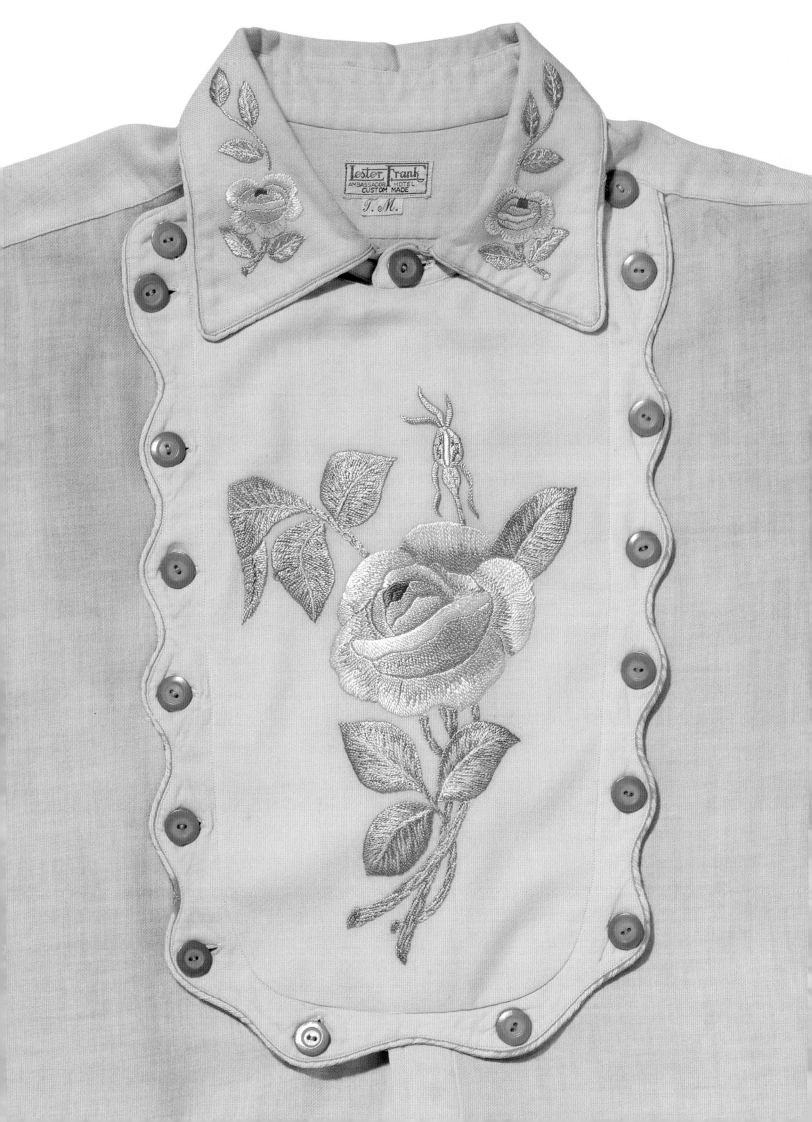

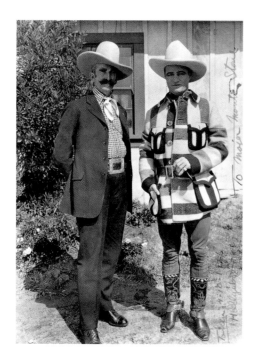

Standing with Wild West show associate Tex Cooper in 1926, **Tom Mix wears a coat fashioned from wool blanket fabric.** As early as the 1920s, Mix endorsed garments made by the Pendleton Company. Autry Museum of Western Heritage, Los Angeles. Donated by Mrs. Monte Stone

reportedly toured with an entire baggage car devoted to his wardrobe. That same year, Mix contracted with Stetson to endorse his signature white five-inch-brim, seven-inch-crown hat, which popularized the phrase, "ten-gallon hat."

Born in 1880, in Mix Run, Pennsylvania, Mix developed a flair for style early in life. In 1935 his mother, Mrs. Elizabeth Mix, recalled that "when he was twelve years old, he made his own first cowboy suit. He sewed some old rick-rack along the legs of his trousers. Then he cut off his coat and made a jacket which he trimmed with fringe from a red broadcloth table cover."

Mix was one of the first major stars who had worked as a buckaroo before moving into the movies, but his dress was far more inclined toward Wild West show costume than the working cowboys' drab attire. After a stint at a dude ranch, Mix performed with Colonel Zack Mulhall's Wild West Show, then in 1906 joined the more prestigious Miller Brothers 101 Ranch and Wild West Show, earning the title World Champion Cowboy in 1908. Mix broke into the movie business in 1909 when William Selig's Polyscope Movie Company used the Miller Brothers' Oklahoma ranch as the location for the pseudo-documentary *Ranch Life in the Great South West*. Originally hired to supervise off-screen activities, Mix wound up performing trick riding and fancy shooting in the film, which led to featured roles in one- and two-reel Polyscope films. In 1917, Mix signed with William Fox Studios, after the studio boss had seen him working on a picture the year before. "Every morning for a week," William Fox recalled in 1933, "this . . . figure was waiting, always in a different [cowboy] costume, each one louder than the last, until my curiosity was aroused. One day he approached me and said: 'My name is Tom Mix. I made up my mind I wouldn't work for any other company until I saw you, Mr. Fox.'" Mix went on to make seventy-eight pictures with Fox.

Mix's witty on-screen personality went hand in hand with his interpretation of Western costume, influencing his fellow players to dress the part as well. In the aptly named *Local Color* (1916), Mix, playing a ranchhand, wears a denim work shirt, leather chaps, a muffler around his neck, and a tall wide-brimmed hat. When a city gal named Vicky arrives on her uncle's ranch, planning to write about her Western "experiences," she's dressed as a typically high-fashion "Easterner," in a black-and-white velvet outfit featuring a long coat with large black pom-pom buttons and matching cloche. By the next day, she is duded-up in a plaid Western shirt, rodeo-style fringed leather split-skirt, cowboy boots, a big white Western hat with the front brim turned up, and a silk muffler tied loosely into a triangle over her shoulders.

Mix's vivid style took the colorful cover illustrations of dime-novel cowboys one step further, via his circus and rodeo influences. Besides setting a standard of dress that would create an industry for custom Western tailors and commercial Western apparel manufacturers, Mix inspired many future film stars, including Gene Autry, to create their own lavish on-screen looks. Mix popularized, for example, the archetypal pointed-yoke Western shirt with high-button cuffs and arrowhead-stitched "smile" pockets. One of the earliest appearances of a Western shirt with arrow embroidery was in *Mr. Logan, USA* (1920), in which Mix wore a light pinstripe button-down shirt, accented with reinforced arrow-stitched breast pockets, tucked into denim trousers. The next year, in *The Texan*, he donned a white button-front shirt with five-button cuffs and smile pockets, gambler-striped pants tucked into cowboy boots, a ten-gallon hat, gun belt, and leather gloves, the latter of which Mix also popularized among celluloid cowboys. A pointed-yoke shirt made its debut in 1924's *Teeth*, in which Mix wore a windowpane-plaid Western shirt with piped pointed yokes and six-button cuffs. The wardrobe of *Riders of the Purple Sage*, produced a year later, personifies the definitive Tom Mix look. Dashing and dapper, Mix dressed in a black shirt with white-piped pointed yokes, smile pockets with embroidered arrows, and high five-button cuffs; a loosely tied silk bandanna; and tight black riding breeches with a double seat outlined in white. Needless to say, Mix commanded undivided attention when he strolled into a bar filled with cowboys in copper-riveted coveralls and single-pocket jumpers.

Also in 1925, Mix starred in *Dick Turpin*, his only Fox film not a Western. Audiences reacted so negatively to Mix's Douglas Fairbanks–style swashbuckler frock coat, cravat, knee

breeches, tall riding boots, wide brimmed hat with a feather, and black mask that he was never cast in a noncowboy role again.

Mix was wooed away by FBO Studios in 1928, at which time he was reportedly Hollywood's highest paid actor, earning $7,500 a week. According to the National Cowboy and Western Heritage Museum magazine, *Persimmon Hill*, Mix "lived in a $40,000 Hollywood mansion with a mile-long driveway and gates that flashed his initials in neon lights. His wardrobe was spectacular, including dozens of white cowboy suits, ten-gallon hats, hand-tooled and diamond-studded belts, and pearl-[handled] pistols. His cars were just as flashy and costly."

Mix saved his most unusual outfits for off-screen appearances, according to Bud Norris, author of *The Tom Mix Book*. He owned a purple tuxedo, which he wore with a classic bow tie and his ten-gallon white hat, and he carried a fancy walking stick. Norris speculates that "it was custom-made for him. Maybe since he was Hollywood royalty and purple was the color of royalty, he thought that would make him stand out from everyone else!"

One 1928 photograph of the cowboy star standing next to Mayor Jimmy Walker on the steps of New York's City Hall shows Mix in the epitome of a formal Western business suit: a double-breasted white sport coat, embellished with large black buttons and smile pockets finished with embroidered black arrowheads; gaucho-style riding breeches tucked into ornately stitched and inlaid cowboy boots; a fairly conservative white spread-collar button-down shirt with a standard tie; and white gloves. Mix was the first to wear such highly decorative riding pants, which were typically trimmed in bold black outlines along the side seams and reinforced seat, with a series of leather straps fastened with fancy silver buckles down the outside of both legs at the knee. The effect was "like a car manufacturer putting an extra piece of chrome on a car," according to Norris. The straps and buckles "didn't serve any useful purpose, but made him look different from anyone else."

Early movie studios were constantly searching for the next Tom Mix or Bill Hart. In 1923, FBO hired Fred Thompson to compete with Mix. Thompson, an accomplished athlete, didn't attempt to imitate authentic Western wardrobe. Typically, his clothing consisted of rather plain Western shirts, either black open-collar styles with white buttons, or plaid versions with patch pockets; a scarf tied around his neck; and tight riding breeches tucked into his cowboy boots. Like most other cinema cowboys, Thompson favored a particular hat style that became his signature. He usually wore a Stetson with a high rounded-off crown, encircled by a leather band with inlaid diamond shapes.

Thompson was never as popular as Mix or Hart or such box-office competitors as the dashing buckaroo Ken Maynard and cowboy comedian Hoot Gibson. Wild West show veteran Maynard lit up the silver screen with fancy trick riding on his palomino "Tarzan," while Gibson made Westerns characterized by his quick wit. Both were clean and neat in their appearance, always donning a scarf around the neck and occasionally wearing leather chaps, fairly large Stetsons, and checkered or piped shirts. Maynard, who briefly operated a Western Circus, wore frontier pants with stirrups and buckled straps along the side to keep the pant legs from coming out of his boots when he rode. By the 1940s, both their styles tended more toward the flashy, embroidered outfits popularized by Mix and his acolytes, the singing cowboys, particularly during public appearances.

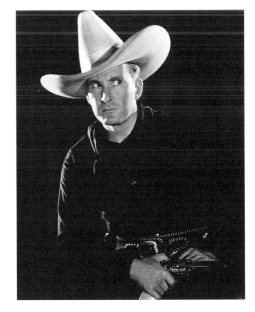

Above: **Colonel Tim McCoy** worked as a cowboy, served as an advisor on Indian culture for film, and became one of the great stars in the silent and early sound eras of the movies. Not as flamboyant as Tom Mix, McCoy lent an aura of authenticity and great sympathy toward the Indian. McCoy's dark, yet plain costume with a tall white Stetson was typical. Autry Museum of Western Heritage, Los Angeles

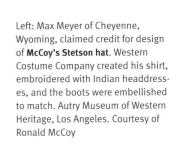

Left: Max Meyer of Cheyenne, Wyoming, claimed credit for design of **McCoy's Stetson hat**. Western Costume Company created his shirt, embroidered with Indian headdresses, and the boots were embellished to match. Autry Museum of Western Heritage, Los Angeles. Courtesy of Ronald McCoy

Another enormously successful early cowboy star was Buck Jones, who worked at Fox with Mix and Maynard in the 1920s. Born Charles Fredrick Gebhart in Vincennes, Indiana, in 1891, Jones got started in show biz with the 101 Ranch Real Wild West Show. In fact, Mix befriended Jones when he became an extra at Fox, leading to Jones's being signed to the studio in 1920. Jones's clothing style owed much to the rodeo cowboy of the time, but he had a whimsical touch that showed the influence of Hoot Gibson. Jones altered his clothing style from picture to picture, donning lace-front pullover frontier-style shirts, bib-front shirts, and, later, more ornate plaid shirts with smile pockets and high cuffs. His shirt collars frequently were embellished with embroidered horseshoes, perhaps alluding to his childhood nickname "Buckaroo," given him because he loved horseback riding.

Mrs. Buck "Dell" Jones, a gifted and courageous rider, met her future husband while the two were with the 101. "One of the girls in the [101] was a seamstress, and she made a lot of our clothing," she recalled in 1992. "She made this coat, and I just loved it. I had long red hair at the time, and when I rode into the show arena I could feel my hair blowing in the wind and that fringe with the beads gently tapping me on the back." Dell Jones's store-bought clothing for the 101 show—split skirts and Western hats—came from Kansas City, Missouri, saddlery C. P. Shipley, purchased when the troupe hit Kansas City or via the company's mail-order catalogue. Buck endorsed Stetsons, which appeared in the Shipley catalogue, and bought fringed leather trousers from the store. According to Dell, who eventually became a stunt double in the movies, her husband favored Hamley and Company of Pendleton, Oregon, from whose catalogue he ordered chaps, bridles, saddles, and Western apparel. In the 1940s, Jones endorsed his own line of cowboy shirts, marketed by the Arizona Shirt Company.

Buck Jones worked in movies for three decades, making the transition into "talkies" with

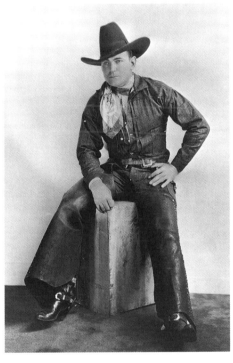

Left: Buck Jones did not gravitate toward fancy shirts. He favored **laced-front garments,** including one by Nathan Turk (left) and another by Conqueror (right), which was adorned with Jones's trademark horseshoe embroidery on the collar. Autry Museum of Western Heritage, Los Angeles. Donated by the family of Gene Bear

Above: At the beginning of his movie career, **Buck Jones** wore the kind of Western dress that had been stylish at any rodeo or roundup in the West. Autry Museum of Western Heritage, Los Angeles. Donated by Mrs. Buck Jones

more ease than did Tom Mix, who retired from pictures in 1933. After starring in a 1935 serial, Mix bought a circus that lasted only a couple of years. According to Robert Heide and John Gilman, authors of *Box Office Buckaroos,* when Mix died in a 1940 car crash, he was wearing his "sweeping ten-gallon Stetson, cream-colored cowboy suit, the coat lined and corded with scarlet; patent leather boots stitched in red, white, and blue; and his diamond-studded platinum belt buckle with the famous brand that marked everything from his underwear to his horses—a big 'M' with the first bar crossed to make a 'T.' He was driving his big custom-built Cord roadster with longhorns mounted on the radiator from Tucson to Phoenix. A bend in the road revealed a road crew working out a detour. He swerved to miss them, careened into a gully, and overturned. A metal suitcase came crashing onto his head, breaking his neck and killing him instantaneously."

In the mid-1930s, Westerns were beginning to wane in popularity, though Buck Jones and Ken Maynard were still top box-office draws. Then along came a new generation of talking cowboys, including John Wayne. Born Marion Morrison in 1907, Wayne fashioned his rugged and plainly dressed image after his idol, cowboy star Harry Carey, who had begun in Westerns in 1910. Wayne, who got started in 1927, usually donned cuffed denim pants with a rugged vest and nondescript shirt, a bandanna around his neck and a moderately sized hat. According to his son Michael Wayne, the authenticity of John Wayne's garb meant a great deal to his father. Michael recalls that the Wayne family frequently vacationed on Southern California's Catalina Island just prior to his father's work on a new motion picture. It became a ritual that the children would help their dad wad up his pants and shirts to be worn in the film, tie them with a rope and throw them in the sea, securing the rope's end to a pier. After three days or so, they'd pull in the "stone-washed" clothing, which would be sufficiently broken in to look like the wardrobe of Wayne's rough-riding character. "We thought everyone did that to their clothes!" says Michael Wayne. From *Stagecoach*'s Ringo Kid to *True Grit*'s Rooster Cogburn, the strapping "Duke" generally dressed to convey his own illusion of a Westerner; he will always personify the American cowboy to fans worldwide.

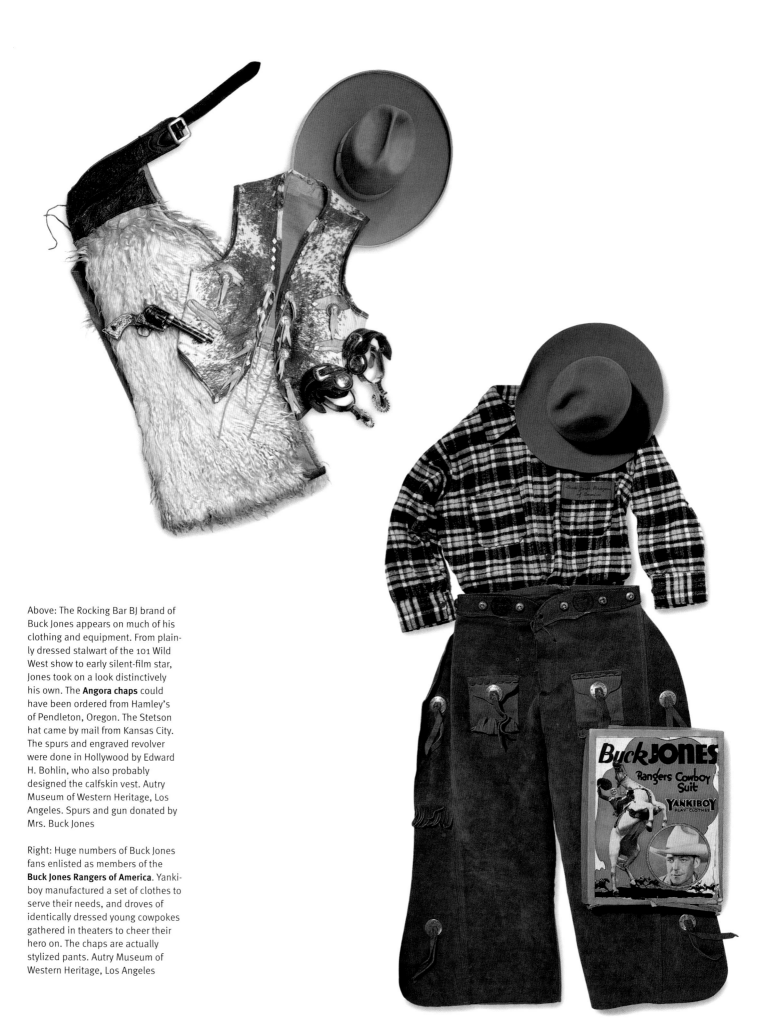

Above: The Rocking Bar BJ brand of Buck Jones appears on much of his clothing and equipment. From plainly dressed stalwart of the 101 Wild West show to early silent-film star, Jones took on a look distinctively his own. The **Angora chaps** could have been ordered from Hamley's of Pendleton, Oregon. The Stetson hat came by mail from Kansas City. The spurs and engraved revolver were done in Hollywood by Edward H. Bohlin, who also probably designed the calfskin vest. Autry Museum of Western Heritage, Los Angeles. Spurs and gun donated by Mrs. Buck Jones

Right: Huge numbers of Buck Jones fans enlisted as members of the **Buck Jones Rangers of America**. Yankiboy manufactured a set of clothes to serve their needs, and droves of identically dressed young cowpokes gathered in theaters to cheer their hero on. The chaps are actually stylized pants. Autry Museum of Western Heritage, Los Angeles

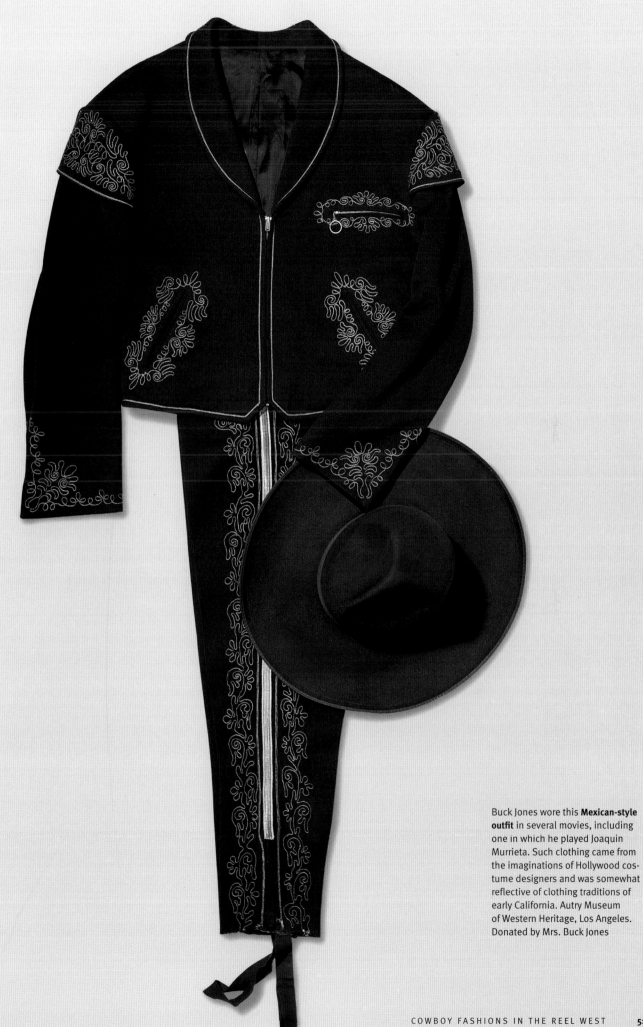

Buck Jones wore this **Mexican-style outfit** in several movies, including one in which he played Joaquin Murrieta. Such clothing came from the imaginations of Hollywood costume designers and was somewhat reflective of clothing traditions of early California. Autry Museum of Western Heritage, Los Angeles. Donated by Mrs. Buck Jones

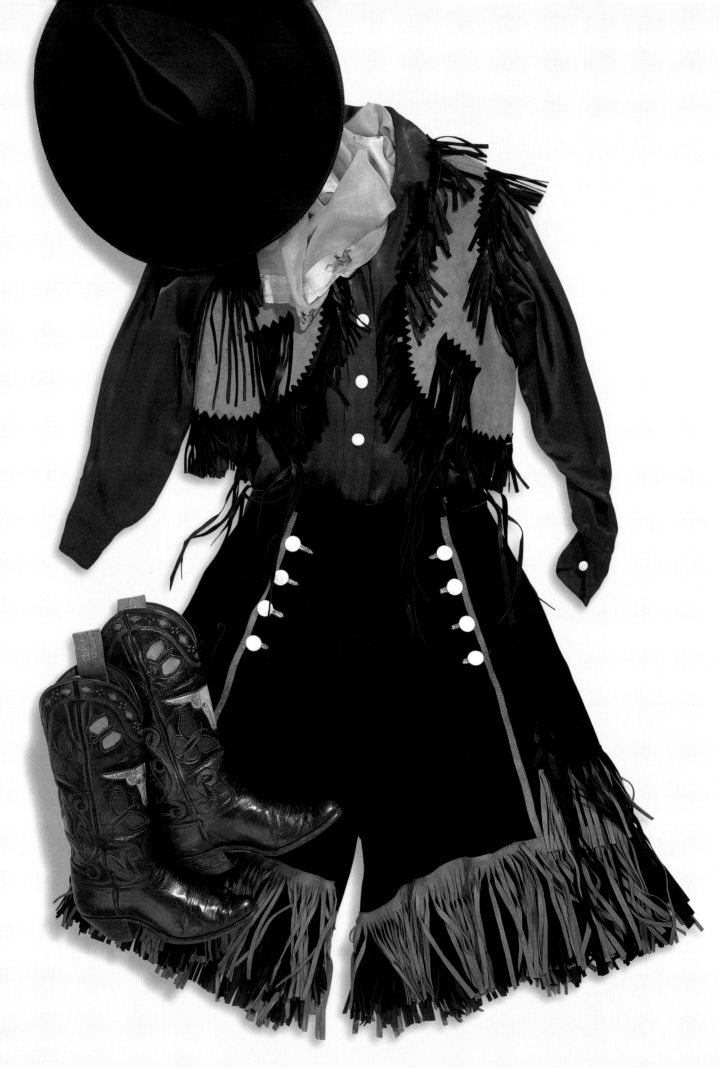

Above: Odille (Dell) Jones left home at age fourteen and joined the 101 Ranch Real Wild West show in 1914. Another female performer in the show, who also sewed on the side, made the **show jacket**. Autry Museum of Western Heritage, Los Angeles. Donated by Mrs. Buck Jones

Left: Dell Jones is shown in her typical **fringed split skirt** with finely fashioned Olathe boots, cotton blouse, and Stetson hat. Autry Museum of Western Heritage, Los Angeles. Donated by Mrs. Buck Jones

Opposite page: When Dell Jones moved to Hollywood with her husband, Buck, in about 1917, she was doing stunt-double work for performers like Douglas Fairbanks. **On the set of Western films and in arenas** where she rode, her outfits bore the look of the day. This entire outfit could have been ordered by mail from Kansas City. Autry Museum of Western Heritage, Los Angeles. Donated by Mrs. Buck Jones

Right: In 1939, young **John Wayne** appeared in *Stagecoach* in the style of costume that he would favor for the rest of his Western film days. Autry Museum of Western Heritage, Los Angeles

Below: John Wayne found some success as a star of low-budget Westerns in the 1930s and dressed the part in the fashion of the time. After 1939, his wardrobe for Western films matured into a look still associated with him. These shirts were used in films such as John Ford's *The Searchers*. The **plain-button bib fronts**, which had some historical precedence, were part of what lent authenticity to Wayne's films. Autry Museum of Western Heritage, Los Angeles

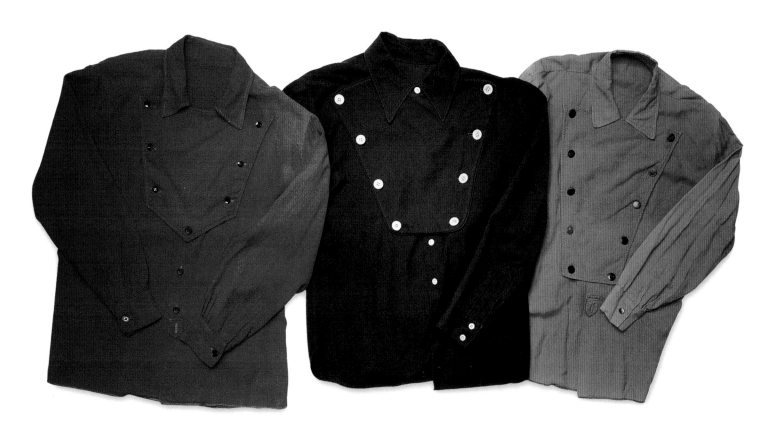

Another star with a long acting career was William "Hopalong Cassidy" Boyd, who started as a silent-film star with director Cecil B. DeMille. In 1935, at the age of forty, Boyd was cast in his first Hoppy role. Grace Boyd, William Boyd's widow and wife of thirty-five years, remembers that Hoppy's famous black costume had been "absolutely planned" by Boyd himself. The movie character was based on Clarence Mulford's original Hopalong Cassidy stories, set in the 1890s. Mulford's Hopalong was more farmer than cowboy, wearing rolled-up shirt-sleeves, sporting a red, scraggly mustache, and chewing tobacco. Boyd's creative interpretation of Hopalong, however, resulted in the original "Man in Black." Grace Boyd describes her late husband's classic costume as "an all-black outfit. He wanted to keep it simple, and black was a powerful color. The pants were like a 'mourning trouser' and had a little stretch to them. He had a strap on the bottom, like you would with dancer tights, that would keep them from pulling out of his boots, which he also did with his shirts—he had that panel that buttoned front to back [at the crotch] which kept the shirts down inside, no matter what he was doing. The concha on his scarf was actually a bone from the spine of a bull." Manufactured by Western Costume, the shirt and the pants were in fact a dark blue that photographed black, but the effect was cinematically spectacular. "The outfit was black and the horse was white," she recalls. "It was a perfect combination."

Edith Head, studio costume designer for Paramount from the 1920s to the late 1960s, is credited as the costume designer for Boyd's first Hoppy film, as well as outfitter for such other notable Western stars as John Wayne, Gary Cooper, Cary Grant, Robert Redford, and Paul Newman. According to her autobiography, she frequently rented entire wardrobes for "B pictures and horse operas" from Western Costume. Other studio designers, including Howard Greer at Famous Players–Lasky, Travis Banton at Paramount, Adrian at M-G-M, and Walter Plunkett, all outfitted their share of players in Western films too.

As technology evolved and a new breed of Western stars appeared on the scene, most of the silent stars of black-and-white oaters were rendered obsolete. And as the talking pictures created new box-office buckaroos, so did color film and musical Westerns open the doors for costumers, rodeo tailors, and cowboy stars to create dazzling Technicolor wardrobes befitting future kings and queens of the West.

William Boyd was known to the world **as Hopalong Cassidy**. The black Stetson worn with dark blue shirt and pants from Western Costume Company helped make the white-haired actor a hero to film and television audiences for several decades. Autry Museum of Western Heritage, Los Angeles

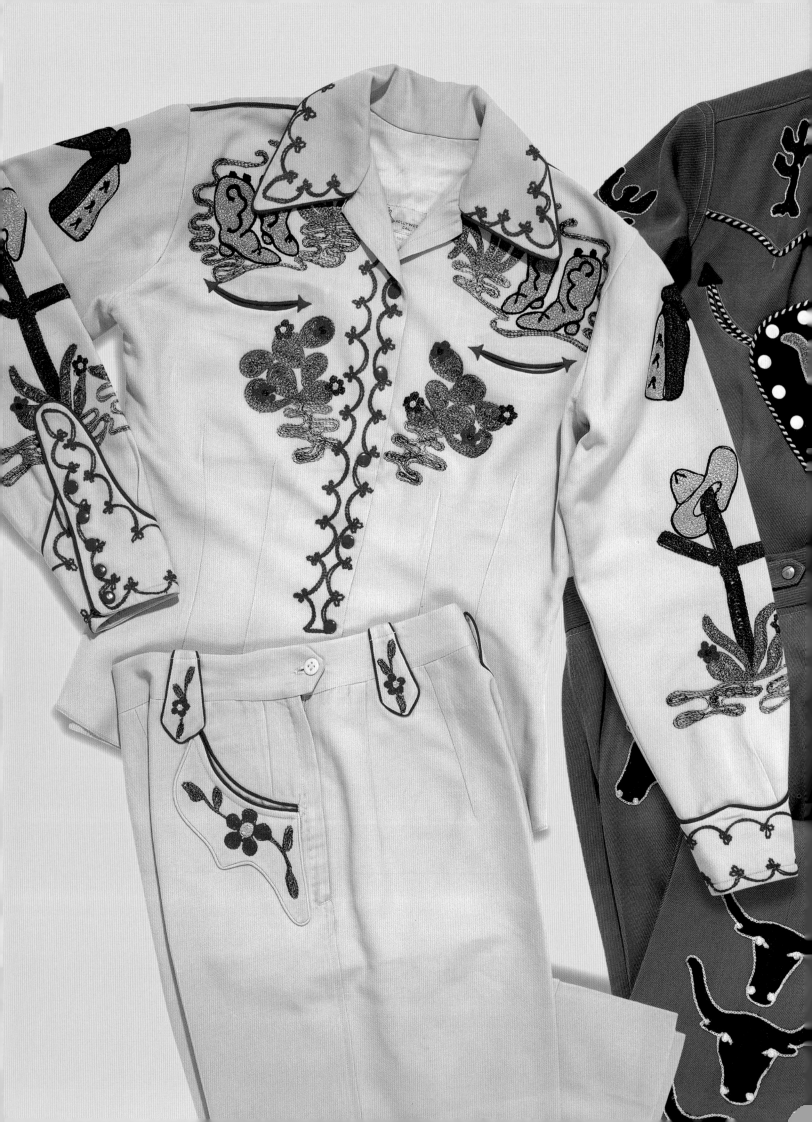

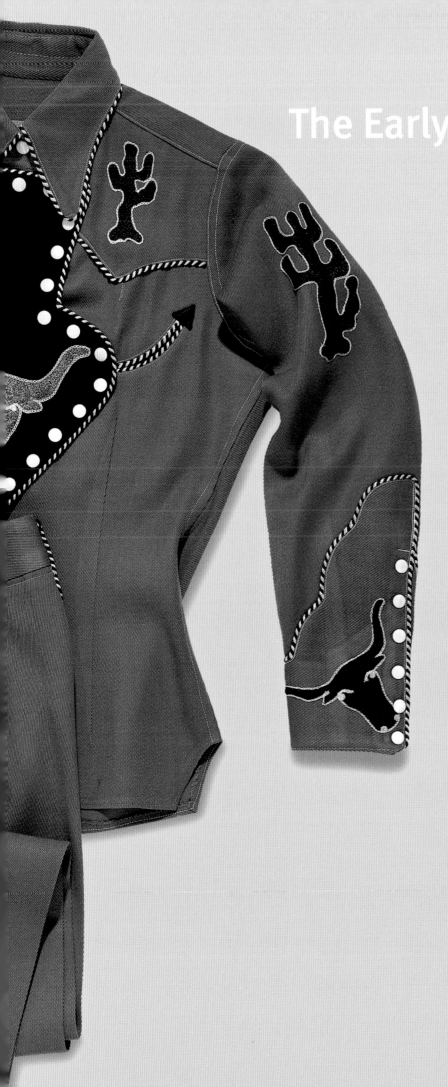

The Early Masters of Western Wear:

TURK AND RODEO BEN

Flipping through the pages of a family photograph album, Jean Simon, eighty, and Pearl Schulman, seventy-five, point to pictures from the 1930s, 1940s, and 1950s of their late father, Nathan Turk, in his Van Nuys, California, custom Western-wear shop. Asked about inspirations for their father's exquisite Western designs, made famous by Roy Rogers, Gene Autry, Rose Maddox and the Maddox Brothers, and other celebrities, Jean suddenly remembers a book that sat on her father's bookshelf. She finds Turk's copy of *National Costumes of Austria, Hungary, Poland and Czechoslovakia*, with his notes scribbled on the book jacket: "heart along top trousers, back sides of leg, front and back curving into pocket." Sure enough, pictured in the colorfully illustrated book is a traditional Polish folk dress embellished with hearts entwined with flowers, reminiscent of those decorating the outfits Turk designed for Rose Maddox and her brothers in the 1940s. Lo and behold, out falls a fifty-year-old fragment of a tracing-paper sketch for an outfit their father designed, which now hangs in the Country Music Hall of Fame in Nashville, Tennessee.

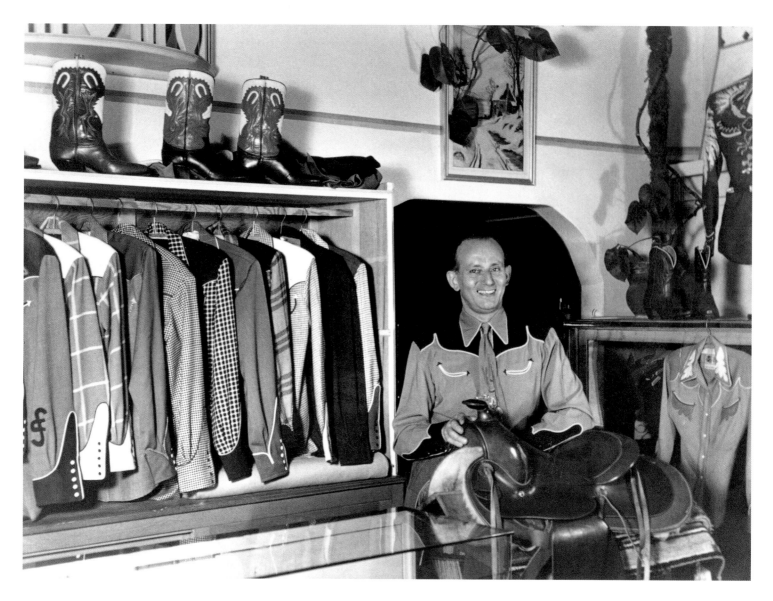

Above: Nathan Turk in his **California shop**. Collection of Jean Simon and Pearl Schulman

Previous page, left: This fabulously embroidered ranch scene decorated both men's and women's outfits **by Nathan Turk**. Johnny Horton wore the men's style in the 1950s; the women's version featured curlicue red embroidery (rather than piping) around the collar, cuffs, and placket. The back of the shirt can be found on page 61. Collection of Michelle Freedman

Previous page, right: This spectacular embroidered suit made **by Rodeo Ben** came in both men's and women's versions and in various color combinations. Modeled in the catalogue by Rodeo Ben, Jr., the men's version (with matching jacket) was described as "an attractively styled three-piece Western show ensemble. . . . Front has special removable bib which can be taken off to produce a novel effect of a new style." Autry Museum of Western Heritage, Los Angeles. Donated by Michelle Freedman

Nathan Turk, who set up shop in 1923, and his East Coast counterpart, Rodeo Ben, of Philadelphia, who opened his doors in 1930, merged Old Country embroidery and tailoring traditions with North American cowboy style to create an entirely new type of decorative garment. The two pioneering tailors established the blueprint for the ornate Western wear that adorned film, recording, and rodeo stars beginning in the 1930s. Similarities abound between the two masters of needlecraft: Born within a few years of one another, each of these young Jewish boys emigrated to America early in the twentieth century from small villages in Poland. Starting as tailor's apprentices, each learned the business from the inside out before focusing on Western wear and building successful family-run businesses. They each built a niche within the early Western-wear business—Turk, for the movies and riding posses, and Rodeo Ben, for rodeo stars and Wrangler jeans. The best-dressed cowboys of all, Gene Autry and Roy Rogers, gave them both huge amounts of business and popularized their designs. Both Turk and Rodeo Ben brought unique artistry and vision to their innovative Western approaches, creating exquisitely made garments that have stood the test of time.

Nathan Turk was born to Yoyna and Pearl Teig on May 10, 1895, in the tiny village of Torshaw, outside Minsk, Poland. He learned to sew at age ten, when at his family's behest he was apprenticed to a tailor in Warsaw, a time he later recalled as "very scary." When he was a teenager, he sailed to New York, taking the last name Turk, which his two sisters had adopt-

ed upon coming to America a few years earlier. Though he found employment doing piecework in a Lower East Side sweatshop, he dreamed of becoming a professional musician and learned to play violin. One day, in Prospect Park, Brooklyn, he met the lovely Bessie Farowitz, who had been born in Russia on April 15, 1898. "She was playing ball with a girlfriend," recounts Jean Simon, "and the ball rolled to my dad and he picked it up and went over and met the two young ladies. He went home with her and met my grandmother, then they started dating." The two married and, in 1919, Bessie, who worked as a seamstress, gave birth to their first child, Jean. Nathan briefly worked as a waiter at Grossinger's Resort in the Catskills. When Jean was one year old, the family moved to Los Angeles.

"My dad had a lot of bronchitis, pneumonia, and so on," says Jean, "and they decided the cold winters were bad for him and that the warmth of the West would be good. And, I think in his mind, too, he thought he could break into the movies." In 1923, the year second daughter, Pearl, was born, the Turks built a shop, with living quarters behind it, at 13711 Ventura Boulevard, in the then-rural San Fernando Valley village of Van Nuys. Located between the Republic Pictures studio and the ranches and locations where Western stars lived and worked, the original Turk business offered dry cleaning and alterations as well as traditional tailoring.

An early client, actor Paul Muni, "was a big athlete in those days and wanted jodhpurs for riding," according to Pearl Schulman. "So Daddy went to the library to find out what they looked like—and that's how he learned to make the different types of English and Western riding clothes in the beginning. He made English riding skirts for the ladies, including Carole Lombard."

Before long, the name of the business changed to Turk's Riding Apparel, and then to Turk's English and Western Apparel Shop, featuring primarily Western styles in the storefront window. By the late 1930s, singing cowboys Gene Autry and Roy Rogers had discovered Turk. It's uncertain who became a Turk customer first, but according to Bessie Turk, aged 101 in 1999 and living in a Studio City nursing home, the first fancy embroidered shirt was created for Roy Rogers. "He looked so handsome in it and wore it to the studio and got the part he wanted," she recalls. An autographed picture from Rogers displayed in Turk's shop read, "Thanks for the outfit for my first picture."

Eventually, Turk replaced a simple N. Turk label with a pictorial one designed by a friend, showing a little Turkish man wearing a fez, seated on a flying carpet, and sewing. A neon sign with the same logo eventually hung outside the storefront. Regular customers addressed the rather reserved tailor as "Nate," or "Mr. Turk."

Bessie Turk's excellent finishing techniques and Nathan Turk's imaginative designs and eye for color and fabric were an unbeatable combination. Piped collars, yokes, and gracefully shaped cuffs, cut from one piece of fabric and attached to the sleeve so that they curved up toward the elbow, usually adorned with five snaps made of pearl or color-coordinated metal, were Turk hallmarks. Traditional dressmaking techniques, such as hand-stitched arrowheads to reinforce seams and pockets, were transformed into Western-style accents. A specialty of Bessie's, these beautifully sewn arrowheads adorned the ends of curved pockets. Arrowheads in contrasting thread began and ended vertical saddle-stitched lines along shirt and jacket fronts, backs, and sleeves. Also responsible for buttonholes and interior pant finishing, Bessie recalls that she and her husband would experiment with style details, finally arriving upon innovative looks that pleased them. Another Turk trademark was the use of decorative insets of contrasting fabric, sometimes embroidered, piped, and accented with whip-stitched or metal eyelets and lacing.

Movie studios commissioned Turk to design costumes for Westerns, and today his daughters enjoy picking out their father's garments in videos of Gene Autry and Roy Rogers

Above: Nathan Turk consulted books such as **National Costumes of Austria, Hungary, Poland, and Czechoslovakia** to glean ideas for decorative motifs for the garments he made. The pencil sketch was found inside the book. Collection of Jean Simon and Pearl Schulman

Below: While plaids were typically used for Western clothing, mixing checks and solids in the same garment did not appear in Western style until the early twentieth century. This **1940s woman's two-tone wool outfit** by Nathan Turk illustrates the designer's understated and sophisticated interpretation of this style. Collection of Michelle Freedman

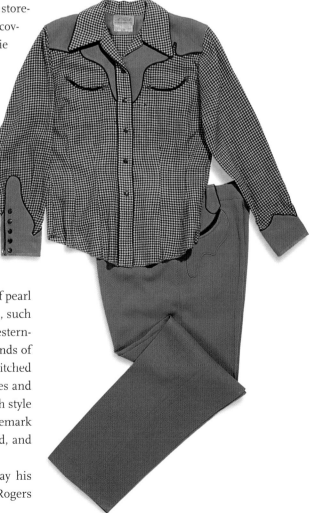

movies from the 1930s and 1940s. In his first films, Rogers usually wore Turk's simple, plaid Western shirts and snug, light-colored ranch pants. B-Western actor Jock Mahoney claimed that a triple-fringed shirt Turk made him inspired those that later became Rogers's signature style. Turk also perfected placing vertical darts in the shirt backs so they fit tightly without billowing out or coming untucked; a horizontal seam along the waist prevented puckering above the belt. For embroidery-adorned yokes and cuffs, Nathan "would cut the shirt and draw on it or draw a picture of what he wanted," and take it to local embroiderers. Pearl remembers, after the embroidery was finished, her father picking up the garment and then "putting the thing together." A Mrs. Resnick was one of Turk's regulars; the most accomplished of the embroiderers was Viola Grae, who later worked for the designer Nudie and eventually opened her own custom tailoring shop in North Hollywood.

Turk's daughters also recall their father's love of fabric. "Daddy's biggest joy was to take the train to Cleveland to the woolen mills and to New York's garment district," Pearl remembers. "He loved fabrics—gabardines and wools," says Jean. "He could just feel something and know whether it was the real McCoy or not." When he got carried away and bought "a hundred yards of material at a time," wife Bessie, who wrote the checks, "had a fit, and she'd say, 'We can't afford that' and, 'What did you buy so much for?'"

In the 1940s, business increased as dude ranches and rodeo parades grew more popular. Sheriffs' posses in cities like Los Angeles and Bakersfield required their members to dress in over-the-top Western attire, much of it supplied by Turk. "For twelve or fourteen years, the Long Beach Posse rode in the Rose Parade, wearing Daddy's outfits," says Jean. "Every time they added somebody he had to make another outfit." He also created custom, matching serapes, or woolen blankets, for the riders' horses.

In response to dude ranch and cowgirl fever, the cover of the April 22, 1940, issue of *Life* magazine featured a "dudeen" decked out in a sophisticated Turk outfit: a yoked pullover top with lacing and piping, and ranch pants with piping accenting the legs. Around this time, trick rider and roper Montie Montana became a Turk regular, eventually acquiring numerous suits, pants, shirts, and lavish parade outfits. Writer Barbara Hirschberg-Lituchy, who interviewed Montana, recalled that "he once admired the look of the strips of leather Tom Mix had sewn on the outside of his pant legs between his calf and knee. Mix explained that they acted like belts and tightened the fabric around his leg to prevent it from bunching up above his knee when he rode. Montie went to Turk, who proceeded to make a trademark look for all of Montana's riding pants. Because of his athletic riding style, they weren't just decorative, they were functional."

Also in the 1940s, Western swing and hillbilly-boogie musicians began frequenting Turk's Western and English Apparel, which had again changed its name as Western wear became the rage. Jimmy Wakely, Spade Cooley, Ernest Tubb, and Hank Thompson were among the earliest of his musical customers. In 1947, Thompson and his wife were married in outfits

Above: Worn by actor Jock Mahoney, this **Nathan Turk shirt** was created in the late 1940s or early 1950s. Mahoney claimed that he inspired the tiered-fringe look prior to its adoption by Roy Rogers, but the story is not substantiated. Autry Museum of Western Heritage, Los Angeles

Opposite: This embroidered ranch scene is the back of the shirt on page 56 designed **by Nathan Turk**. Johnny Horton wore the men's style in the 1950s; the women's version featured curlicue red embroidery (rather than piping) around the collar, cuffs, and placket. Collection of Michelle Freedman

Overleaf: This **Turk outfit with palm trees and cacti** set off with rhinestones was custom-made for B. L. Lake, who began riding in equestrian events such as the Tournament of Roses Parade in the early 1950s. Lake matched the outfit with full silver-mounted spurs and horse equipment. Autry Museum of Western Heritage, Los Angeles. Donated by Larry D. Lake

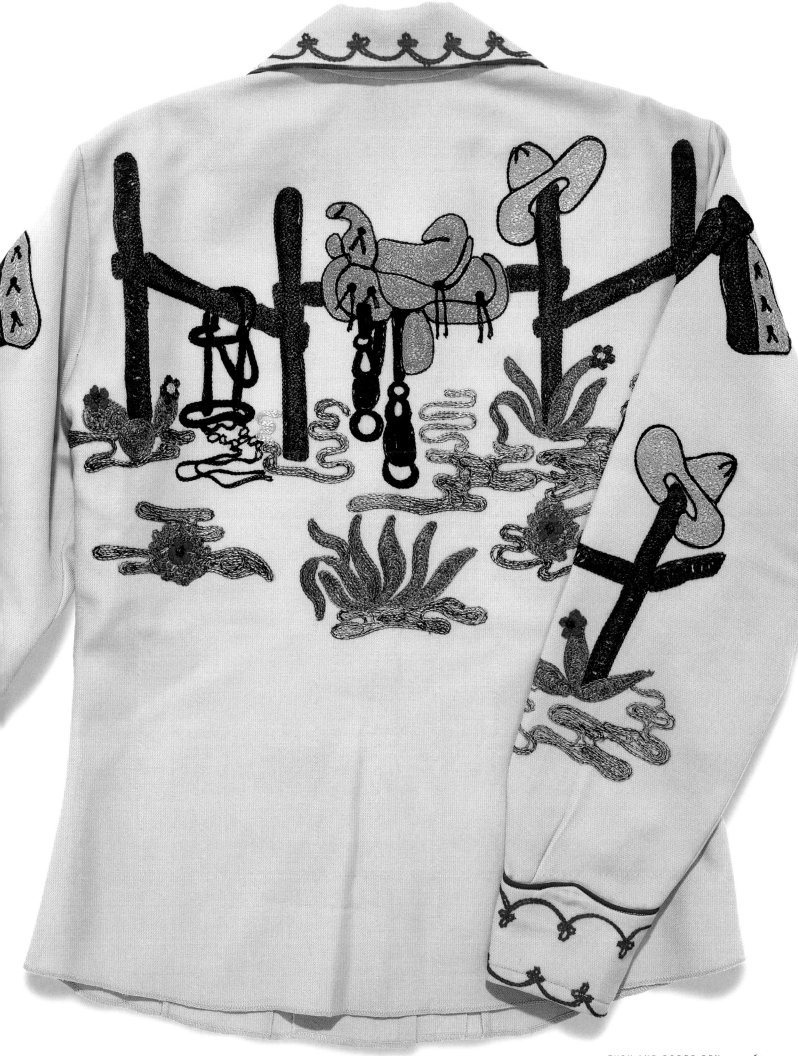

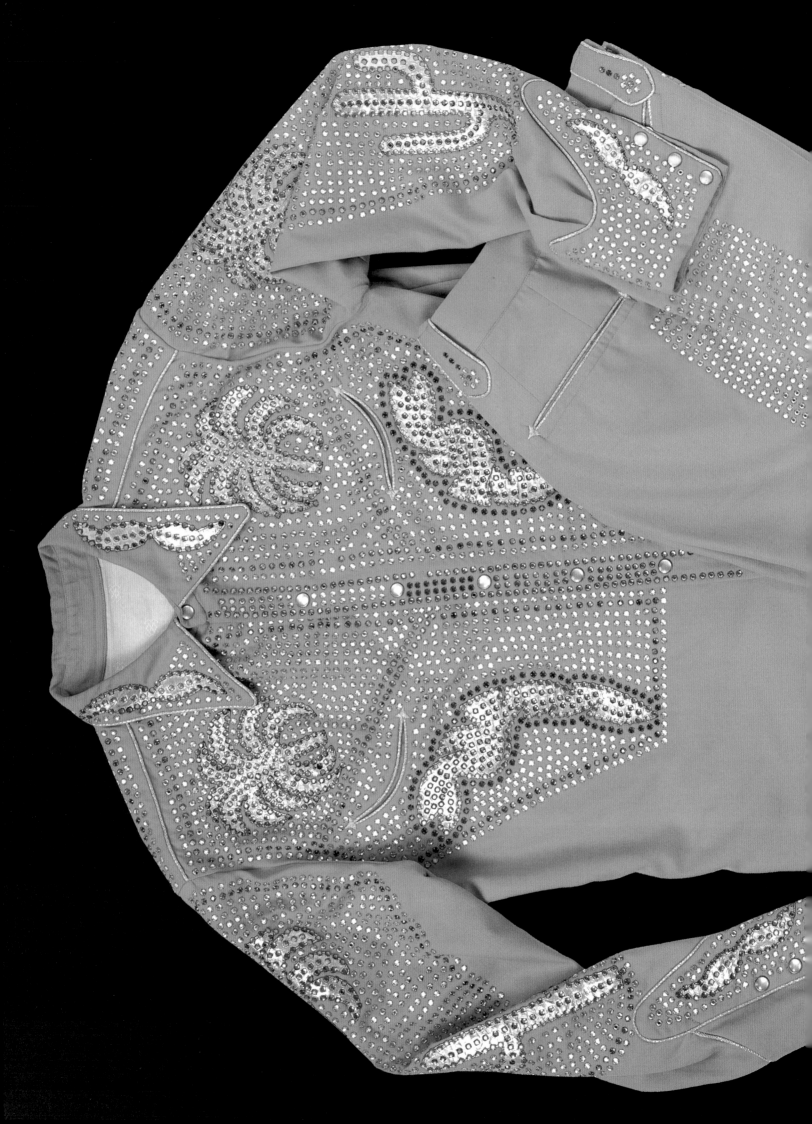

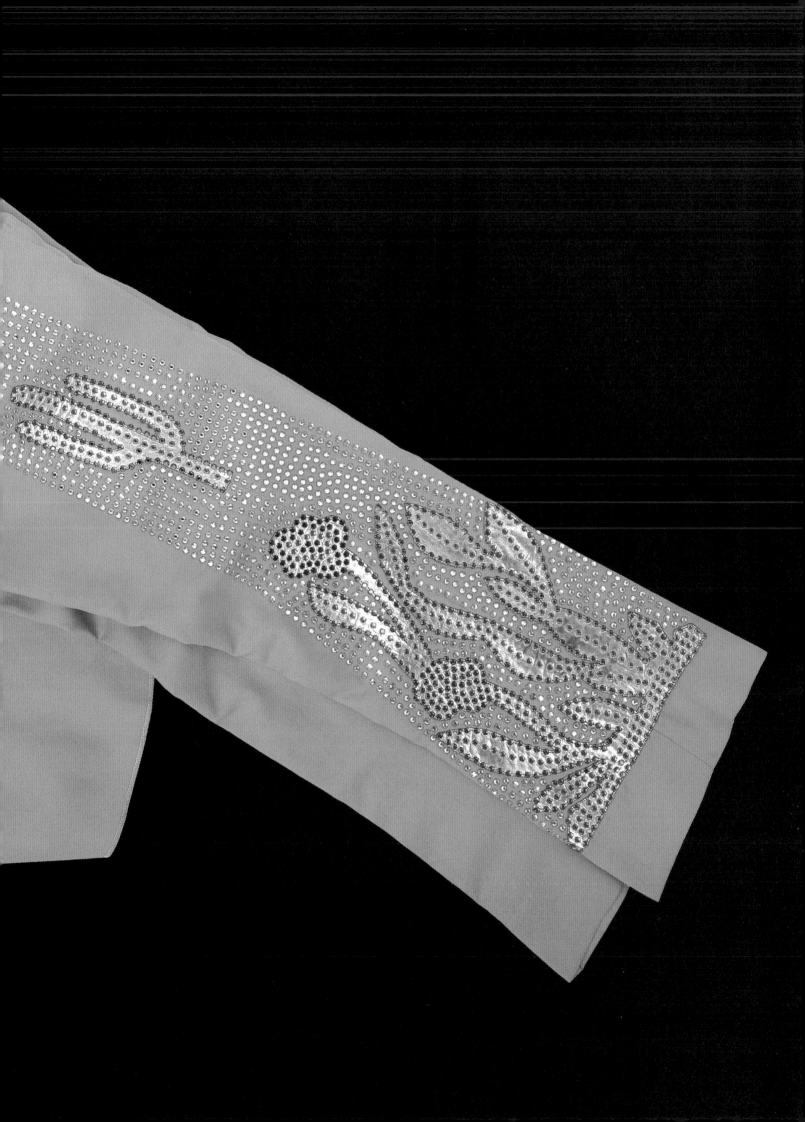

tailored by Turk. "Mine was a black wool gabardine, with little insets of gray and piped in red," Thompson recalled in 1999. "It was very attractive—I wore the suit an awful lot. I eventually had two suits from Turk and they were $125 a piece, which was a tremendous amount of money in 1947. Turk was very expensive. I had to work a week or two to pay that kind of price. When I got those two suits, I thought I was really doing something. I got a few more embroidered things from Turk—a heavy shirt with a rainbow and pots of gold embroidered on it and one with an Indian head with all the feathers." Turk's bib-front shirts were very popular—John Wayne wore them and so did Spade Cooley, and later Wild Bill Elliot.

Up-and-coming singing cowboy Monte Hale was featured in a 1947 fan magazine as "a real Texas cowboy from Houston," who's "always dressed Western style." "[W]hen Monte Hale had a hankering for a new fall shirt, he visited Turk's on Ventura Boulevard, headquarters for Western haberdashery," the article continued. "Fancy shirts like the one he has on set him back about $30 a piece. In ordering his first custom-tailored suit, Monte's following the new trend away from gaudy embroideries to finer, more durable fabrics."

Around this time, Turk expanded his shop a bit by moving next door to 13715 Ventura Boulevard, and at times he employed up to nine people. Jean's husband, Irwin, and Pearl's husband, Herbert, both joined the family business too. Herbert, who had learned to sew parachutes while in the service, was there only briefly, but Irwin, who handled much of the business end of things, besides doing most of the rhinestone-studding in the 1950s, stayed for thirty years. The shop was decorated with signed photographs of Turk's celebrity clientele, and primarily it sold Turk garments, with Lee jeans, Stetson hats, and Justin boots filling out the merchandise. Turk conjured up his designs in a back room: "I remember watching him draw out patterns," Jean recalls. "He had a big table in that little room. He would take chalk and measure and draw this or that and then cut—just like magic."

For a while, Turk employed a leather worker to make hand-tooled belts; that employee eventually left to work for renowned silversmith and saddlemaker Edward Bohlin. Another employee, pantmaker Johnny La Pekis, later joined Hollywood custom designer Marge Riley, eventually going out on his own in Nevada and Arizona. Also working for Turk were a coatmaker and two women who helped Bessie with the finishing. Eventually, Irwin assisted with some of the cutting and fitting, though Turk continued to do the lion's share and always made the shirts. Occasionally traveling to such cities as San Francisco, Las Vegas, and Dallas for

Marion has very fond memories of Turk. "He was a beautiful man with a lot of class," he says. "He was always wearing a custom shirt and trousers of the finest material, very classy, stately."

trunk shows, Turk sold his apparel through high-end stores such as Neiman-Marcus and Rex Bell's, a clothing shop opened by ex-Western actor Rex Bell, who briefly had his own Western wear label, Walking Box.

A September 1950 *Movie Thrills* magazine article on musician Jimmy Wakely found him "driving toward home out in North Hollywood," when "Jimmy drops in at Turk's Western and English Apparel shop just to look around. Mr. Turk, however, proves himself to be a super salesman and convinces James he should be fitted for a new suit." The next year, in an October movie rag, the star of the television series *Annie Oakley* is featured shopping at Turk's: "Although she's been Gene Autry's leading lady in six of his films, Gail Davis has never had an offscreen Western outfit. So she decided now is the time to get one . . . so she buys [a Western shirt] from owner Mr. Turk." John Wayne was also a regular customer, outfitting his family in Turk's custom designs.

With Western wear reaching a zenith in national popularity in postwar America, Turk toyed with expanding from "individually styled" garments to a manufactured line of shirts, jackets, suits, and pants. "He opened up a small factory in Hollywood," Jean says, "hoping to get into a little bit more manufacturing, but it never worked out because he wasn't satisfied

with the quality unless everything was done individually." Sister Pearl recalls, "The idea was to cut ten outfits at a time, instead of one, and to maybe stock some stores, but it never panned out. Daddy had this idea that he wanted to start a wonderful business for his family, his sons-in-law, and that everybody should have a wonderful income from his business. That was really his motivation. Because of quality control, he could never do it, though."

His daughters say that family was a priority to Nathan Turk, who enjoyed taking them to Western movies, parades, and classical concerts at the Hollywood Bowl. But he stayed out of the spotlight, spending most of his time dreaming up designs rather than promoting his business. Turk never printed a mail-order catalogue as did Rodeo Ben and some other custom tailors; instead, he placed small ads in Western magazines and sent regular customers the occasional letter (accompanied with fabric swatches) encouraging them to come in and select a new outfit. During the 1950s, Turk set up a booth at the El Monte Legion Hall where *Ranch Party* and *Town Hall Party* dances were televised, according to regular Hank Thompson, to get orders from such stars as Tex Ritter, Johnny Bond, and Carrot Top Anderson who appeared on the show.

Into the 1960s, country and western (C&W) artists, particularly Ernest Tubb and Buck Owens, continued to frequent Turk. Favoring short bolero jackets embroidered with metallic filigree designs sparkling with rhinestones, Owens recalls that Turk would "give you a quick turnaround. The band and I would go in there and in half an hour he'd measure everybody and ten days later we'd go back for a fitting and two or four days later, you would have them— a two-week turnaround." Depicted on the 1959 album cover of *Under Your Spell Again*, Owens' first Turk suit was of black wool gabardine, with silver embroidery, rhinestones, and small kick pleats in the pants leg.

Resistol hat salesman and Western enthusiast Mel Marion recalls being introduced to Turk by Roy Rogers in the 1960s. "The first shirt I had made by Mr. Turk was $35," Marion remembers. "It was a beige worsted wool with contrast piping in turquoise, with worsted gabardine wool pants for $65. The last suit Mr. Turk made for me was in 1974 or '75 and was a $325 brown silk suit with arrow pockets and arrow darts in the front and back—three on each side in the front and three on each side in the back—just awesome." Marion has fond memories of Turk. "He was a beautiful man with a lot of class," he says. "He was always wearing a custom shirt and trousers of the finest material, very classy, stately. He spoke softly and very kindly. You were the center of his attention as he showed you swatches or whatever. He never mentioned anything about himself, the competition, the market or anything. His whole thinking was the fabrication that he was working on and what he would do with it."

Indeed, Turk was a true artist and his clothing, with its fine detail and careful construction, still holds up as the *crème de la crème* of Western wear. Though Turk's business slowed down in the 1960s, his reputation as a perfectionist never dimmed. He resisted the move to cheaper synthetic fabrics. "He only worked with gabardines and wools, never polyester," says Pearl. "That was not his thing—he never tried shortcuts." By the mid-1970s, highly decorative cowboy clothes had become passé, and cheap mass-market Western apparel predominated. As business decreased, some Turk garments became available at a few high-end retailers, including Nashville's Tony Alamo. Finally, in 1977, suffering from a serious liver ailment, Nathan Turk closed his shop. Recovering a bit, he turned to painting as a hobby—and he always crafted imaginative ensembles for his grandchildren at Halloween. At age ninety three, Nathan Turk died of pneumonia on October 21, 1988.

Just four years earlier, the other great pioneering Western-wear tailor, Rodeo Ben, had passed away at age ninety one in Philadelphia. Bernard Lichtenstein was born April 10, 1893, in the village of Stashowe, Poland. A third-generation tailor, he immigrated to America and settled in Philadelphia. In 1928, Lichtenstein was a successful woolen-goods salesman, when a customer in Willow Grove, Pennsylvania, sent out an SOS. "My father sold fabric to tailors all over the Eastern seaboard," said Gerson "Rodeo Ben Jr." Lichtenstein, who was ten years old in 1928. "And this menswear tailor in Willow Grove says he needs fabric in fuchsia, aqua, purple, and pink. My father said, 'What do you need those colors for?' He said, 'There's a cir-

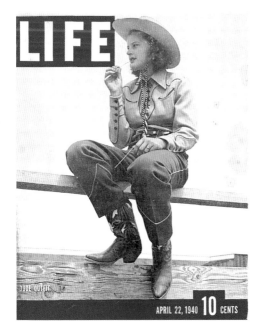



Below: Every **detail of a Rodeo Ben product** said quality. Autry Museum of Western Heritage, Los Angeles. Donated by Mr. and Mrs. Gene Autry

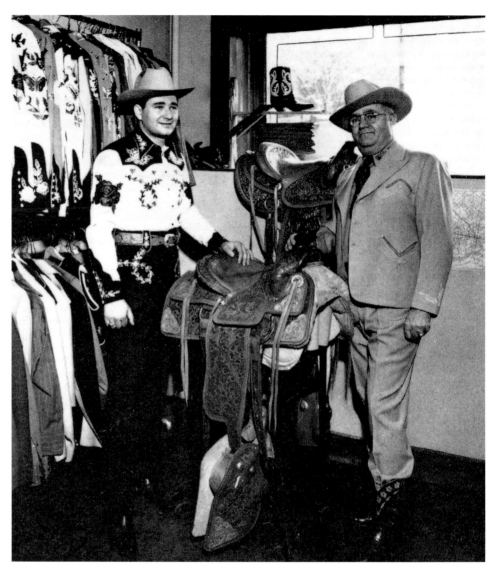

cus and rodeo at the fairgrounds and a lot of these people were in asking for this fabric—why don't you just go there and take care of them directly?' So he went to the fairgrounds with the fabric and they jumped all over him."

Mamie Francis, a trick-shot artist, cornered Lichtenstein. "She said, 'I wanna make a cape and pants and a jacket and bolero,'" recalled Rodeo Ben Jr., "and my father said, 'Well, you need two yards for this and three-quarter yards for that,' and she said, 'How do you know?' and he said, 'That's my trade—I'm a tailor,' and she said, 'If that's your trade, why don't you make it for us—we don't have any time to make it, and we've never found anybody who could make it.' As a consequence, my father took her measurements and went back and fashioned things for her, and word really got out about this guy in Philadelphia who makes beautiful clothes—and that was the beginning."

According to a May 1958 feature in *Western Horseman* magazine, when Rodeo Ben first met Francis, "he was horrified and his tailor's conscience touched by Mamie's attire. She was decked out in drab English-style riding breeches—baggy in the stern and totally unflattering. Ben not only sold her some livelier material, he made up the garments himself. What he brought back set a new style in rodeo wear—the tight-fitting suit had a short coat with fancy-stitched lapels, room in the armpits for easy action, and cuffless trousers cut low on the hips and snug in the rear. Mamie was so pleased she had Ben make a suit for [her husband] California Frank, and she began bragging up Ben's skills wherever she went. So many orders came pouring in from all over that Ben had to give up his fabric peddling and settle down to filling the requests."

In 1930, at 3209 West Columbia Avenue, in Philadelphia, the Rodeo Ben shop opened for business. "The first couple years my father made the clothes out of his home," Ben Jr. says. "Then when he got the store, he had room to spread out, with cutting tables, fabric racks, and all kinds of things." Also known as Ben the Rodeo Tailor, the former Bernard Lichtenstein became the first celebrity Western designer.

Before long, word had spread from Ben's rodeo customers to such early celluloid cowboys as Ken Maynard and Tim McCoy, as well as the movies' snappiest-dressing buckaroo at the time. "Tom Mix's secretary had sent us a jacket of his to use for measurements," says Rodeo Ben Jr., who joined the business when he graduated high school in 1936. "We were in the process of making him some things when he died prematurely [in 1940]." As they gained more customers by traveling to rodeos and Western events all over the country, the jovial father-and-son team developed a number of groundbreaking Western wear innovations. The feature perhaps most synonymous with cowboy shirts—snap closures—was developed by Rodeo Ben.

"In my mind, the whole idea came from leather gloves," says Rodeo Ben Jr. "I remember seeing one with a snap on it and saying, 'This would be a perfect application for a shirt—in case a cowboy got hung up on the steer horn, the shirt could break way.' I went to a manufacturer and presented the idea to him, and he started to make them for me. And the cowboys grabbed it up in a hurry! The snaps started getting fancier and fancier—we started using mother-of-pearl that came from the Orient, though [during World War II] we had a lot of trouble getting it."

In the mid-1930s, with most of their customers based far from Philadelphia, Rodeo Ben created the first of a series of mail-order catalogues. Beneath a photograph depicting a fortyish, dark-haired Ben wearing a bowtie and traditional man's suit was a letter:

For the convenience of the many boys and girls who demand the best in Rodeo, Sports and Show clothes, I am illustrating in the following pages a number of suggested designs. It would be impossible to completely show the various cloths, cuts, colors, and finishes of all the suits which I have made, and these designs indicated are but a few. Many of my customers write from all parts of the United States and Canada, giving me their ideas for clothes, or leaving a great deal of the detail to my own judgment for something dressy, neat and conservative, or flashy, according to the purpose of the garment. The matter of making a particular suit, shirt, or jacket is not a ready-to-wear business with me. You must remember that each garment is made completely to your measurements and is not duplicated. I have for many years made repeat orders for topnotch boys and girls, always using their own particular design. When you order a garment from "Ben" you are ordering something which is completely individual.

Photographs in the catalogue show a portly, slightly older Ben modeling "some of his own famous creations," and performer Dixie Starr wearing a large-brimmed cowboy hat and fancy bib-front shirt with scalloped trim, and her husband, Jack Hoxie, a "stellar performer and rancher of movie fame," attired in a simple Western shirt and slacks.

Illustrated mostly with simple line drawings, the debut brochure features outfits like that made for Mamie Francis, with short cape, split skirt, bolero vest, and flared, decorated pants, as well as men's shirts, jackets, and trousers. For shirts, a choice could be made between five different back yoke styles, seven sleeve designs with either button or snap fasteners, and thirteen types of pocket, including sawtooth and other shaped flaps and a half-dozen kinds of smile pockets. Pants embellished with lace, cord, or braid were available for ladies, and men could choose between trouser pocket styles for front and back, as well as eleven different types of belt loops. Prices ranged from $9 for serge, gabardine, or whipcord shirts to $12 for extra-heavy silk satin shirts; from $11 for serge, gabardine, or whipcord pants to $18 for heavy cavalry twill or bedford cord pants; $10 for jackets made of "any type of

A **Rodeo Ben suit with stripes, a Stetson hat, and a gold and silver Bohlin buckle** would have made a winning rodeo performer look great in the 1930s or 1940s. It would have made a second-place cowboy look like a winner as well. Autry Museum of Western Heritage, Los Angeles

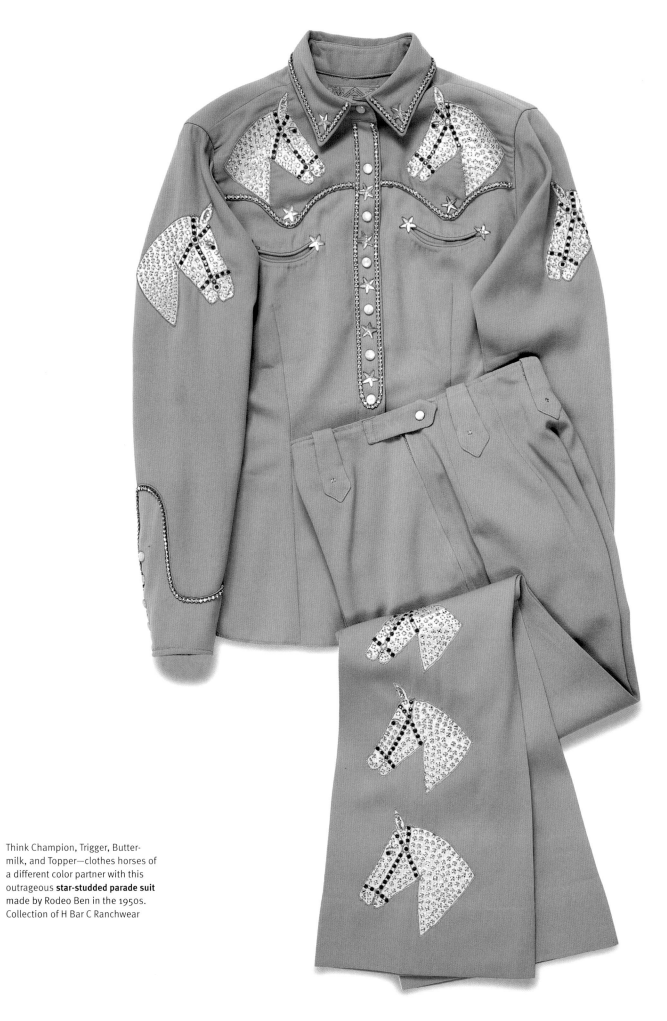

Think Champion, Trigger, Butter-milk, and Topper—clothes horses of a different color partner with this outrageous **star-studded parade suit** made by Rodeo Ben in the 1950s. Collection of H Bar C Ranchwear

worsted suit material." Special suits could be had from any of these fabrics, with the cost ranging from $22 to $30. For women, a "suit requiring embroidery" cost $15, while for men and women pearl snaps could be had "for no extra cost."

Rodeo Ben was renowned for selecting fine fabrics, favoring a wool gabardine, Forstmann, originally imported from Germany, then eventually manufactured in America. "Since my dad sold the fabrics before he got into tailoring, he knew the mills and the makers of the best," says Ben Jr. "Forstmann produced some of the finest fabric ever woven. It was used for several reasons—it was svelte, attractive, had a good feel, and it was long wearing and pleasant to the touch."

"Autry was the one that liked the thunderbirds," Ben Jr. recalls. "We used that on a lot of his designs. Roy liked fancy floral work, embroidered flowers with different colors. One thing we had problems with was that because we were making clothes for two stellar people, we had to keep them different."

When Gene Autry became a customer in the early 1930s, the creative collaboration between him and the Lichtensteins was extraordinary, resulting in all kinds of shirt embellishments. "Gene Autry came up with the idea to work out something with eyelets and lacing," says Ben Jr. "We worked it out on the sleeve, on the front and across the yoke in the back, and he was thrilled." From the beginning, Autry loved the pointed yokes and bib fronts. "He made suggestions, and we carried them out," said Ben Jr. "Everything we brought to him he loved. He was greatly instrumental in the success of our business."

Before long, Autry, followed by Roy Rogers, began ordering elaborately embroidered shirts. "Autry was the one that liked the thunderbirds," Ben Jr. recalls. "We used that on a lot of his designs. Roy liked fancy floral work, embroidered flowers with different colors. One thing we had problems with was that because we were making clothes for two stellar people, we had to keep them different—different colors, different styles, different embroidery work. We were always careful to keep a record of everything we made for them so that we never repeated it. We certainly didn't want them to see each other in the same outfit. The thunderbird became a specialty of ours, as well as a lot of floral effects, a lot of cactus, and a lot of Western themes." Other special touches included candy-striped whipcord piping and snaps spaced in batches of two or three down the shirt-front placket.

As Autry and Rogers began donning their fancy duds in rodeos, movies, and at public appearances, apparently others, such as the upstart Globe Western Tailors in Philadelphia, tried to copy their costumes, judging from a note in Rodeo Ben's catalogue from the late 1930s: "The styles and designs that are used in my work are frequently imitated, but under no circumstances have they ever been duplicated. Cheaper and inferior imitations are bound to spring up when a fine product is born. My unparalleled tailoring has often been called 'The Expression of Perfection' in tailored Western Clothing. Remember it is not a true 'Ben Product' unless it has Ben's bright label in it signifying that it has been styled, fashioned, and tailored by Ben."

That label changed over the years, from an early one that simply stated in block letters "Ben the Rodeo Tailor," to one with Ben's picture within a triangle-shaped brand, to a later version with the name spelled out in rope surrounding a bucking bronco. Design innovations began turning up in the catalogue pages, such as eyelet-laced decorative elements above the smile pockets on shirts; and Ben Jr. started making public appearances, debuting in a shot taken with his dad behind the cutting table. Before long, Ben Jr. began contributing design ideas and doing the cutting. Depending on business, between ten and thirty tailors worked in the studio in the back of the shop.

"We had tailors that were good in all areas," Ben Jr. recalls. "I was the one who decided who would make what. The embroidery was done on a lease-out business. Two of the finest embroiderers on the Eastern Seaboard worked for us for many years. They were artists. They

made samples and we decided what we wanted, or I would make sketches and they would do it on tracing paper and transfer it to the fabric. We sent them the parts of the outfit—the yokes and bibs—and they did the embroidery, then brought it back to us and we put it together." Ben Jr.'s wife, Hannah Lichtenstein, who helped out in the store, has a fond memory of one master embroiderer: "The best embroiderer of all had the most lovely name—Mr. Flowers." Ben Jr. agrees: "He worked for us for twenty, twenty-five years, beginning in about 1940. He was a gentle soul. He had a loft and did our work there. He came around one day and said, 'Do you have any need for some artistic floral work?' He used a Shiffli chainstitch machine and a Bonaz [embroidery] machine."

"Rodeo Ben had the reputation of being the very best rodeo tailor," says champion bronco buster Jim Shoulders. . . . "Even in the 1940s, Ben got $250 and up for a good suit. And it was a prestige thing if you got a Rodeo Ben suit in the rodeo business—well, it showed you had a little money or a little credit!"

Though more and more entertainers became Rodeo Ben's customers, he continued to specialize in making clothes for the sport from which he got his name. "Rodeo Ben had the reputation of being the very best rodeo tailor," says champion bronco buster Jim Shoulders in 1999, fifty-two years after first meeting the Philadelphian. "You couldn't go to a Western store in those days and buy a good Western suit that was designed with a lower rise in the cut of the pants. To have a Rodeo Ben suit that was tailor-made to fit you—and he did fit you right—and have that special cut on his britches that made it more comfortable and Ben put a little bit of bell from the knee to the bottom so you could lift the pants right over your boots, that was the in thing. Even in the 1940s, Ben got $250 and up for a good suit. And it was a prestige thing if you got a Rodeo Ben suit in the rodeo business—well, it showed you had a little money or a little credit!"

Shoulders, like many rodeo cowboys, put in his order when Rodeo Ben (and/or Ben Jr.) showed up at various events, like the big Madison Square Garden Rodeo. "Ben always came and stayed across the street from the Garden at the old Belvedere Hotel," Shoulders recalls. "And you could go there and he'd measure you and show you samples of the material that he had available for your suit, your pants, or whatever. He also used to come to Houston quite often and some of those major spring rodeos. He'd get a room somewhere and just put up a sign at the rodeo office that he was there. It was the top cowboys who wore Rodeo Ben suits: Roy Rogers, the Garden rodeo producer Everett Tobin, and the elite of the Hollywood cowboys. Rogers and Autry and them guys had the fringed shirts and real fancy stuff. But the rodeo cowboy just wanted a nice suit with a yoke—not the fancy pockets and all the chrome that the movie stars wanted."

Shoulders can still remember his first Rodeo Ben suit: "It was blue—my wife's color was blue and she picked out the material. It had a yoke with a pointy deal in back and was single breasted. He made the belt loops wide enough to fit a two-inch-wide belt with the trophy buckle. He kept your measurements and if you'd call or write him, he'd send you samples and you could order by mail or phone."

In 1947, to capitalize on Rodeo Ben's reputation as the cowboys' preferred tailor, Blue Bell, the Greensboro, North Carolina, manufacturer of denim work clothes, contracted Rodeo Ben to design a pair of special buckaroo-friendly Wrangler jeans. As he had with his custom pants designs, Ben constructed the jeans' rise to give more ease in the saddle. The tag had Rodeo Ben's picture on it, and according to Ben Jr., "We got a royalty [from] them for ten years." Shoulders, who began endorsing Wranglers in the 1940s and wears them to this day, says, "Wrangler was smart enough to get him to design the jeans and they haven't changed from the first ones they had. Over the years, there have been a lot of people that claimed they designed them, but you can bust me if they can prove that Rodeo Ben didn't do it."

In the late 1940s, after a fire in the store, Rodeo Ben moved to a new, larger location in Philadelphia, at 6240 North Broad Street, its fancy facade proclaiming it "The East's Most Western Store." The shop remained there until it closed in 1983. Along with the custom wear, Wranglers, hats, boots, and accessories, it "sold everything for a horse," says Hannah Lichtenstein, "saddles, tack, everything but the horseshoes—except the lucky ones." The catalogues also became more elaborate, as did the garments displayed inside. One shirt back featured a large embroidered Indian chief's head, with real feathers inserted into the stitched war bonnet. Photographs of celebrity clients like Autry and Rogers, as well as family members such as Ben Jr.'s daughter Elise, graced the pages. By 1958, Rodeo Ben had "10,000 people's dimensions on file, of which [rodeo] arena contestants make up only a fourth," according to *Western Horseman*. "Ben is his own best ad. East or West he dresses his part with some sixty suits and seventy-five shirts of his own making. 'As long as I make the right stuff in the East,' says Ben, 'they'll buy it in the West.'"

Four years later, another article in *Western Horseman* (in which Rodeo Ben frequently advertised) quoted the tailor: "We use the traditional Old West for our model when we're designing new clothes. The new look for '62 designs will still include the symbols we all know and love, like the chuck wagon, the steer head, the branding iron, the rope, and the birds of the West—all representing the wide open spaces and the rugged spirit of the range. But we are featuring fabulous new fabrics now—non-tarnishable metallic yarns (gold and silver) woven into wool. We use only the best imported rhinestones and other jewels in our designs."

As times changed, and newcomers aggressively wooed customers from Turk and Rodeo Ben, the two tailors stuck to their ideals, painstakingly creating the styles that they'd innovated decades earlier. Fame continued to visit both from time to time: Rockers Flo and Eddie of the Turtles and Dennis Wilson of the Beach Boys discovered Turk, who was still occasionally making costumes for films, including *The Misfits* and *Giant*. Charles Kuralt featured Rodeo Ben on his *On the Road* television program, becoming a regular customer in the process. Rodeo Ben Jr. kept his family's shop going after his father retired, even riding the wave of the urban cowboy bonanza in the early 1980s. When Ben Jr. fell ill in 1983, though, Philadelphia lost its one and only celebrity Western shop.

The designs of both Turk and Rodeo Ben live on, however, thanks to films preserved on video, as well as to collectors and museums that treasure them. Like the promise once made by a certain Philadelphia tailor— "a Rodeo Ben outfit is made to hold up in the toughest show or rodeo performance"— garments with the Turk and Rodeo Ben label endure as examples of the finest American Western attire ever created.

Rodeo Ben's customers could have their choice in the styling of belt loops, pockets, snap buttons, piping, and pictorial embroidery via his catalogue. **These examples date from the 1930s.** Autry Museum of Western Heritage, Los Angeles. Donated by Mr. and Mrs. Gene Autry

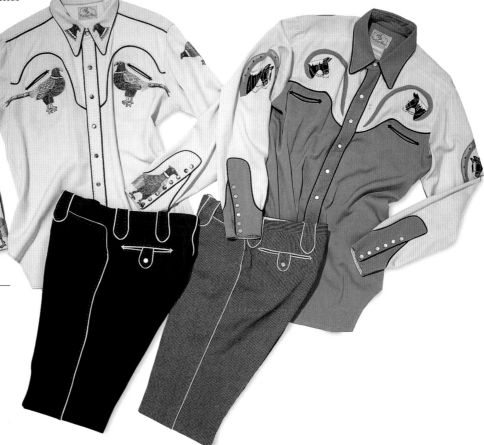

Clothes Horses:
THE SINGING-COWBOY STYLE OF GENE AUTRY AND ROY ROGERS

Seated behind a massive oak desk in his roomy, memorabilia-filled office in Studio City, California, Gene Autry, eighty-nine, is thumbing through *Western Classics*, a 1947 volume of his recordings. Its cover is emblazoned with a picture of Autry in his signature white Stetson and a plaid cowboy shirt with fancy piping. On this March 1997 afternoon, Autry is dressed in a sophisticated Western business suit, his cowboy hat hanging nearby. Decorating the walls are numerous images of Autry, from vintage movie posters and photographs to original oil paintings, all showing him in eye-catching cowboy clothes. As Autry makes his way around the office, he stops to compliment a visitor on her Western ensemble. "I'll tell you the truth, you did real good putting that outfit together," he declares. "Those are pretty nice boots you got there." Wearing perfectly buffed red-and-black cowboy boots topped with a harlequin pattern and steer heads, Autry also dispenses some advice. "Boots are bound to get a little scuffed up," he says, "so you must work on them and keep them clean."

Articles in fan magazines and feature stories often made much of the size and variety of **Gene Autry's wardrobe**. One February 1942 article, "Million Dollar Cowboy," reported, "A goodly share of his fabulous $75,000 wardrobe is tied up in red and blue tooled leather boots at $40 a throw. Pays $50 for his ten-gallon hats." Another piece on Mrs. Gene Autry, Ina Mae, claimed she spent her time "watch[ing] over Gene's mammoth wardrobe, keeping his more than 300 shirts and trousers in repair, seeing that his pure white Stetsons are clean." Autry Museum of Western Heritage, Los Angeles

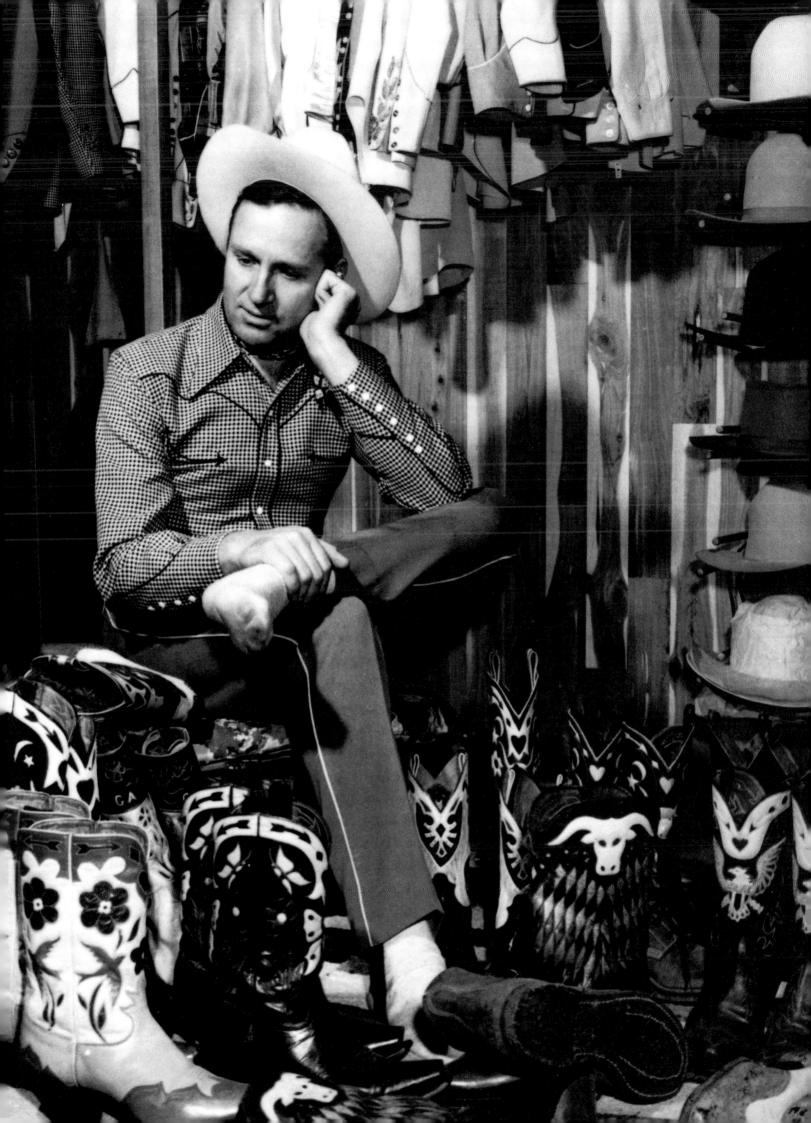

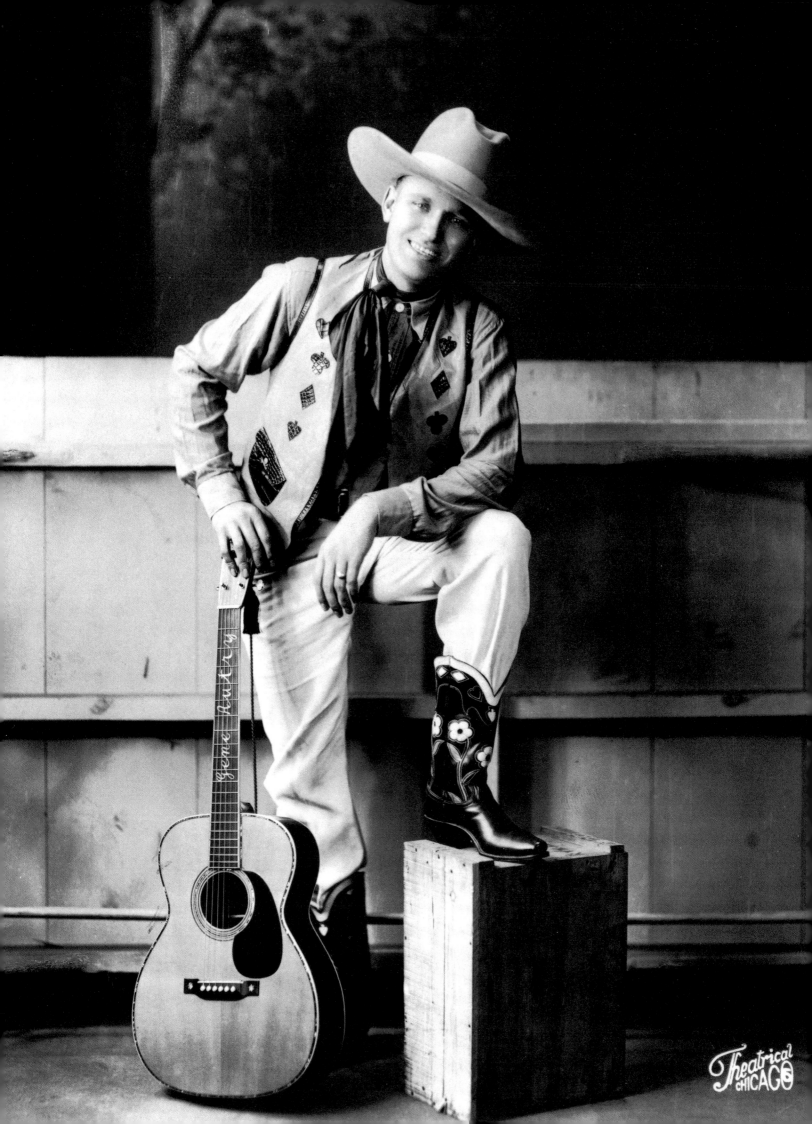

Indeed, the late Gene Autry was quite the expert when it came to Western wear. In the musical Westerns he pioneered, his ornate wardrobe popularized a new style among celluloid cowboys, as well as country and western recording artists who followed in his footsteps: Tex Ritter, Jimmy Wakely, the three Mesquiteers, Monte Hale, Rex Allen, and, most of all, Roy Rogers. Moving away from working cowboy clothing, the luxe look became *the* signature style for Western entertainers during the 1930s and 1940s in musical Westerns, as well as at rodeos, fiestas, and for personal appearances. By the late 1940s, not only were the stars wearing decorative Western fashion, but many of their fans were too.

When Gene Autry (born September 29, 1907, in Tioga, Texas) started his career in the late 1920s as Oklahoma's Yodelin' Cowboy on a Tulsa radio station, he set aside regular men's suits in favor of Western-style garb. Initially, of course, his Western style was fairly homespun, similar to that of other Texas and Oklahoma ranch hands: a simple work shirt, neckerchief, and frontier pants worn with a cowboy hat and boots. By the early 1930s, relocated to Chicago radio station WLS and with a smash hit under his hand-tooled belt, Autry gradually began to dress more elaborately. His likeness on a 1932 songbook, *Gene Autry's Sensational Collection of Famous Original Cowboy Songs and Mountain Ballads*, depicts the young Autry in a high-crowned hat, two-tone boots with the pants tucked into them, and flowing kerchief, all of which give him a dashing look. Notes from WLS announcer Anne Williams describe Autry's look at the time: "A tall, slender chap, guitar slung over his shoulder, standing close to the microphone yodeling a song of the range. A gray sombrero tipped slightly back, almost but not quite, hiding his blond hair. A gaily colored scarf knotted loosely round his neck"

A publicity photograph of the period (see opposite page) shows Autry decked out in a cowboy vest with leather-appliquéd spades, diamonds, clubs, and hearts spilling down the front. After Autry's earnings increased from the first-ever gold record, 1931's "That Silver-Haired Daddy of Mine," he found his way to Rodeo Ben. "Gene was trying to emulate Tom Mix," according to Alex Gordon, vice-president of Flying A Pictures, who worked as Autry's advance man during his tours in the 1950s. "He used to see Tom Mix movies as a teenager in Oklahoma. That influenced Gene when he started in show business—even before the movies—to wear fancy-looking cowboy outfits. Between his radio programs, he was making personal appearances at anything from Kiwanis Clubs to private clubs to parties, and he wore those kinds of outfits." Soon after his first starring role in a Republic picture, 1935's *Tumbling Tumbleweeds*, Autry took to wearing lavish cowboy shirts. "In *Tumbling Tumbleweeds* it was not quite as pronounced as the ones that followed," says Gordon. "But though his dress was not that spectacular, at one point he did wear an embroidered white outfit. He loved those outfits with the arrows. He began wearing one of those in almost every picture."

By the time of 1939's *Blue Montana Skies*, Autry had established his signature look, depicted on that film's promotional poster: a dark, pinstriped shirt festooned with railroad-tie-style lacing on the front placket and up the cuffs, with collar, yoke, and cuffs outlined in white piping. Also around this time, Autry was photographed wearing sophisticated white drape-cut, double-breasted Western suits, undoubtedly the work of Rodeo Ben or Nathan Turk. In fact, Autry was frequently featured in Rodeo Ben's catalogue, modeling the tailor's "famous exclusive designs," including shirts embroidered with butterflies, Indian heads, and flowers, and fancy-yoked numbers with zigzag piping. Under one picture, Ben commented, "It is not too difficult to design clothes for Gene. He has a wonderful flair for wearing clothes. Looks extremely well in them and has a very fine color perception."

In 1997, Autry repaid the compliment: "I thought Rodeo Ben did a very good job of making Western clothes. I got along with him very well, though once in a while I'd have to change something." At age eighty-nine, Autry still expressed pride in being a fashion plate: "I wore a lot of fancy clothes—I think I started that trend really. A lot of the cowboys in the early days wore dungarees, and I think I might have been the first one to wear the very fancy clothes. I really liked the beautiful embroidery. When I first started out at Republic, I wore fancy clothes; then later on I switched, depending on what the story was." That March day, as Autry

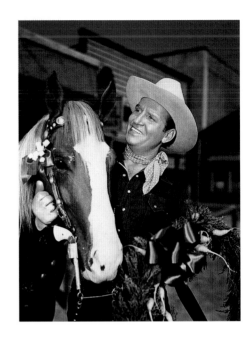

Fred Martin, a member of Gene Autry's backing band, the Cass County Boys, recalls that when the group "started in 1936 in Dallas, it was catch as catch can to get Western clothes." The trio tried to dress alike but "just bought whatever we could find in the few stores that handled riding clothes. We had no choice of getting anything alike. They were just khaki pants with as narrow legs as possible and no pleats to tuck into our cowboy boots. Now and then, we could find some colorful plaid cotton shirts, but it was a scramble to get cowboy clothes unless you wanted to just go for the denim shirt and the blue jeans. By the time we moved to California [after World War II], you could buy Western clothes at just about any big store." **Autry is seen here as he dressed for movies and television in the late 1940s and 1950s.** Autry Museum of Western Heritage, Los Angeles

Opposite page: Gene Autry first found fame in radio and recording. **In about 1934, he posed for this picture, looking as he might at a state fair or on radio station WLS.** The vest and boots with the symbols of playing cards are harbingers of how fancy his dress would become. Autry Museum of Western Heritage, Los Angeles

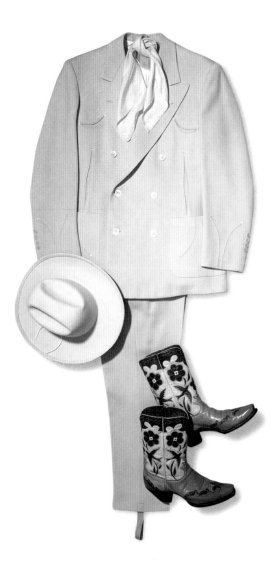

Gene Autry was frequently named Hollywood's best-dressed Western star. Autry wore this **elegant double-breasted business suit by Rodeo Ben** with his signature white Stetson and bluebird boots custom made by Olsen-Stelzer in the 1940s. Autry Museum of Western Heritage, Los Angeles. Donated by Mr. and Mrs. Gene Autry

described his wardrobe, he flipped through a book of his old movie stills, stopping to admire certain garments, exclaiming at one point, "See that pretty shirt I have there!"

To go with the fancy embroidered shirts, Autry usually wore tight-fitting, double-seated pants, often trimmed in piping, tucked into colorful boots with various designs and pictures inset in the leather. In some of his early movies, including *The Big Show* and *The Old Corral* (both of 1936), Autry played a Western entertainer, giving him license to dress the part. The fantasy presented by Autry's clothes made just as much impact on young movie-goers as the films' message of good's triumph over evil, as a letter printed in a 1941 issue of *Cowboy Movie Thrillers Magazine* illustrates:

> *Hello Gene:*
> *How are you? As for me, I am an infantile paralysis case; a boy of 15. Gene, you dress nicer than any of the cowboys I know of, and I think you are the best. I go to see all your pictures that are shown at our local theatre in Charlotte. Wish I had a cowboy suit like one of yours . . .*

Even more resplendent than Autry's movie costumes were his rodeo and personal appearance outfits. Elaborate embroidered butterflies, thunderbirds, flowers, and other designs covered these garments. Though Autry primarily worked with Rodeo Ben and Turk, he also obtained fancy shirts from Hollywood's Marge Riley, Rex Bell, embroidery maven Viola Grae, Minnesota's Elise Wiggin, and Buffalo, New York's S. A. Sam Formann. One of Autry's show programs, in fact, ran shots of the star and his famous closets. The Autrys' home reportedly contained 1,000 square feet of closet space with towers of hat boxes, tiers of shelving filled with boots, and racks crammed full of fancy shirts. The accompanying "Gene's Wardrobe" pointed out that Autry, "named one of America's 'Ten Best-Dressed Men' . . . does not own a conventional suit." His business suits were carefully tailored from, "fine gabardines, whipcords, flannels, and twills," the article reported, "in such colors as pearl gray, cinnamon, beige, royal blue, and a dozen other shades of blue, his favorite color, ranging from powder through navy." It went on to explain:

> *For special dress-up occasions there's a midnight blue tuxedo and several all-white suits. All are tailored Western style. This means tight-fitting trousers with tapered legs and a well-fitting, double-breasted jacket cut somewhat longer than the standard suit and detailed with contrasting inserts, hand-stitching or similar trim. With these suits Autry wears a relatively soft shirt in subdued color and either a kerchief-style tie or a hand-painted four-in-hand tied with a large double bow.*
>
> *For onstage appearances he usually wears tight, tapered white pants and a multi-colored shirt, elaborately decorated. The shirt may be made of gabardine, flannel or high-lustre satin. It may be embroidered with sequins and beads, or hand-painted, or appliquéd with contrasting floral design. . . . One shirt has the national emblem embroidered across the chest. In all, there are some 150 of these shirts, and are produced by a Philadelphia maker who specializes in rodeo duds. . . . Gene wears high-heeled, hand-tooled Texas-made leather boots. He has 50 pairs in various colors and designs. . . . On the street he always wears his trousers on the outside of his boots, for he is real cow country and knows that only range hands tuck their trousers inside their boots. He always wears a big ten-gallon white hat, and keeps 50 to 75 on hand at all times and orders them by the dozen from Stetson. So individually is his crown denting that it is now known as the "Gene Autry Crush." This is his own variation of the Oklahoma Foreman's Crush.*

For his Madison Square Garden performances, Autry devised the idea of satin shirts "trimmed with specially treated fabric that glows in the dark," enabling him to gleam under the spotlight in the dim arena during the grand finale of "Ghost Riders in the Sky." In a 1953 article for *Who's Who in Western Stars*, Autry wrote that "taking care of a wardrobe that con-

sists of about 50 shirts and pants to match and 20 pairs of boots is quite a chore on the road. I like to polish my own boots whenever I get the chance."

Singer-songwriter-actor Johnny Western, who became Autry's protégé after performing with him in 1956–57, remembers being awestruck by his boss's fashion sense. "Gene's wardrobe was just immaculate. He had hundreds of pairs of boots and suits and coordinating shirts and pants. He had a walk-in wardrobe closet as big as most people's houses. I've stood there in Gene's house and looked at those things with three hundred pairs of boots staring me in the face. Lucchese and several other custom boot companies made his boots out of every kind of exotic leather you ever dreamed of. And it was always the white hat and the fantastic clothes. His shirts and pants were totally coordinated and made of every type of material from the heavy satins to the gabardines, and the embroidery was just beyond belief and the workmanship was tremendous. If it was not tremendous, Gene wouldn't put it on."

After Autry served three years as a pilot in World War II (1942–45), his movie wardrobe became much more subdued; when he switched from Republic to Columbia in the late 1940s, he frequently wore blue jeans and a plain Western shirt with his hat and boots. "At Columbia, Gene didn't have the flamboyant clothing anymore," Alex Gordon says. "He had working cowboy duds, or if he was a sheriff or something like that he would have that kind of outfit on. There were no more fancy things unless it was a rodeo appearance or a show in the movie where it would be logical to wear it. Otherwise he was a regular working cowboy. He had been much more serious than he was before—this was an effect of the war."

Excluding his golf shoes (and he did have boots with golf cleats), Autry never owned any footwear but boots: "His feet were so attuned to boots he couldn't wear regular shoes," says Gordon. One 1942 magazine depicted Autry supposedly having "his boots pulled off for the last time until victory." During the war, however, Autry got special dispensation to wear cowboy boots with his Army Air Corps uniform.

Autry's low-key, realistic look continued on his television show in the 1950s, and, as he began spending more time pursuing his corporate ventures, he frequently wore elegant business suits with subtle Western accents. These were primarily made by a custom tailor, Tartaglia, who had been in business since 1907 with shops on Hollywood Boulevard near the Roosevelt Hotel and on Santa Monica Boulevard in Beverly Hills. Tartaglia primarily designed traditional men's suits for his celebrity clientele, but for Autry he used a Western cut accented with slash pockets and arrowhead stitching. "Gene had two lives, you know," says Johnny Western. "He had the movie-star image and then he had this Mr. Businessman image—and he loved those Tartaglia business suits for that." Autry also addressed this dichotomy: "I tried to have two types of wardrobe," he said in 1979. "If I was on the stage in the arena or a parade or something, I wore a loud wardrobe with colorful embroidery. But I could never figure going to church or doing business wearing loud clothes, so for those occasions I had . . . suits that were a little more subdued. I wore the cowboy cut always and still do. I also always wear boots and if I wear a hat, it's a white Stetson."

During Autry's military service, Republic Pictures pushed another of its singing cowboys with a penchant for fancy duds into the spotlight, eventually naming him the new "King of the Cowboys." Roy Rogers (born Leonard Slye in Cincinnati, Ohio, on November 5, 1911) first put together a Western look in about 1930 while performing in the singing group the Sons of the Pioneers, previously named the O-Bar-O Cowboys. Before leaving Ohio for California, Rogers had worked in a boot factory and learned his

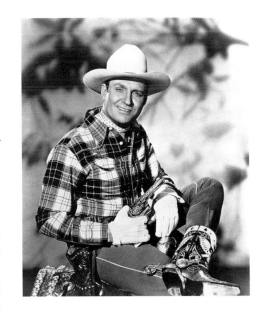

Above: Gene Autry's saddle, holster, and spurs came from **Ed Gilmore**, and his boots came from a number of the best Texas makers including Lucchese and Olsen-Stelzer. Autry Museum of Western Heritage, Los Angeles

Below: As did his wardrobe role model Tom Mix, Autry liked blanket coats. These three examples from the 1950s were **made from Pendleton blankets** by Nudie the Rodeo Tailor. Autry Museum of Western Heritage, Los Angeles. Donated by Mr. and Mrs. Gene Autry

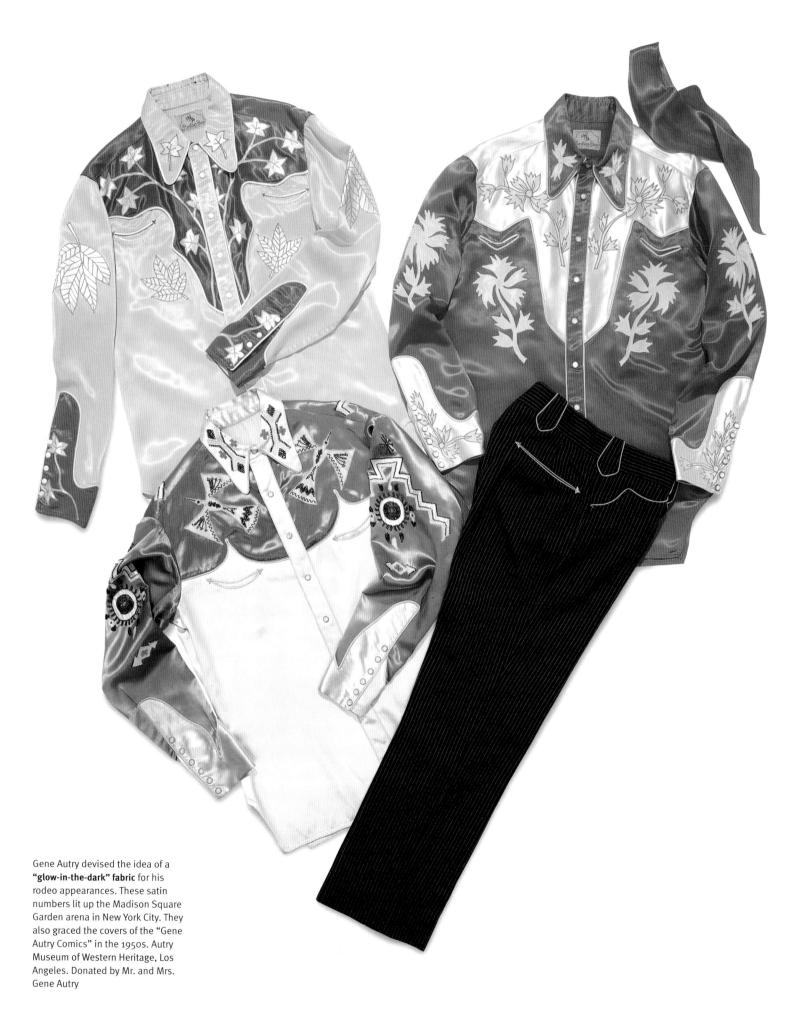

Gene Autry devised the idea of a **"glow-in-the-dark" fabric** for his rodeo appearances. These satin numbers lit up the Madison Square Garden arena in New York City. They also graced the covers of the "Gene Autry Comics" in the 1950s. Autry Museum of Western Heritage, Los Angeles. Donated by Mr. and Mrs. Gene Autry

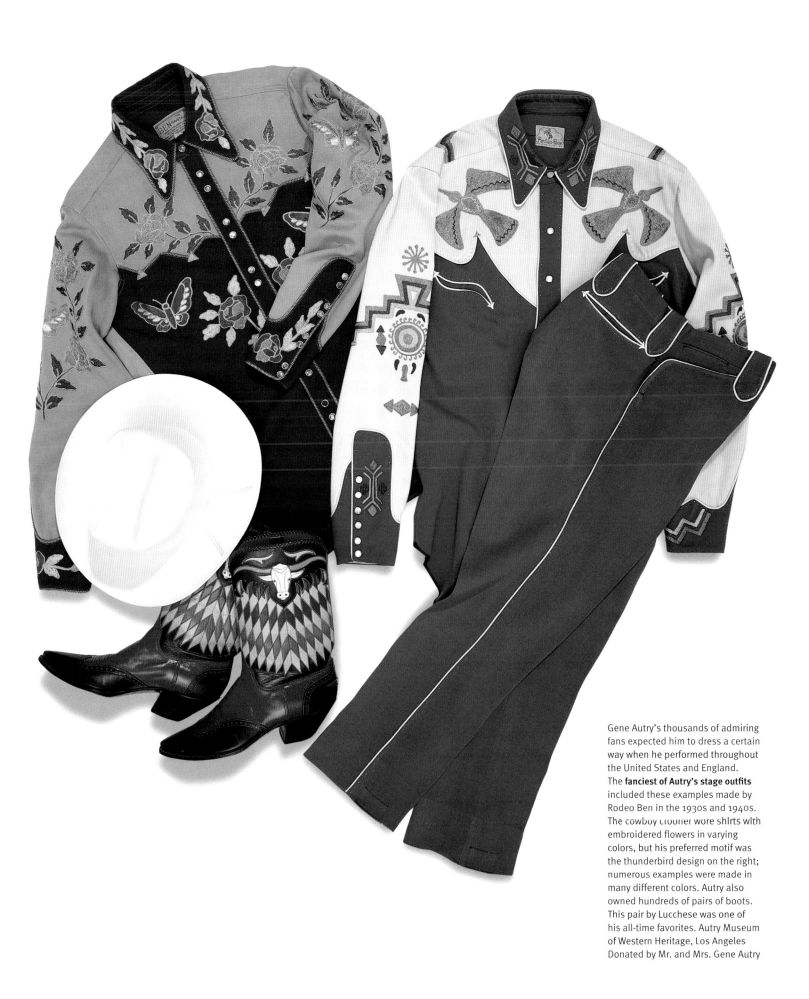

Gene Autry's thousands of admiring fans expected him to dress a certain way when he performed throughout the United States and England. **The fanciest of Autry's stage outfits** included these examples made by Rodeo Ben in the 1930s and 1940s. The cowboy crooner wore shirts with embroidered flowers in varying colors, but his preferred motif was the thunderbird design on the right; numerous examples were made in many different colors. Autry also owned hundreds of pairs of boots. This pair by Lucchese was one of his all-time favorites. Autry Museum of Western Heritage, Los Angeles Donated by Mr. and Mrs. Gene Autry

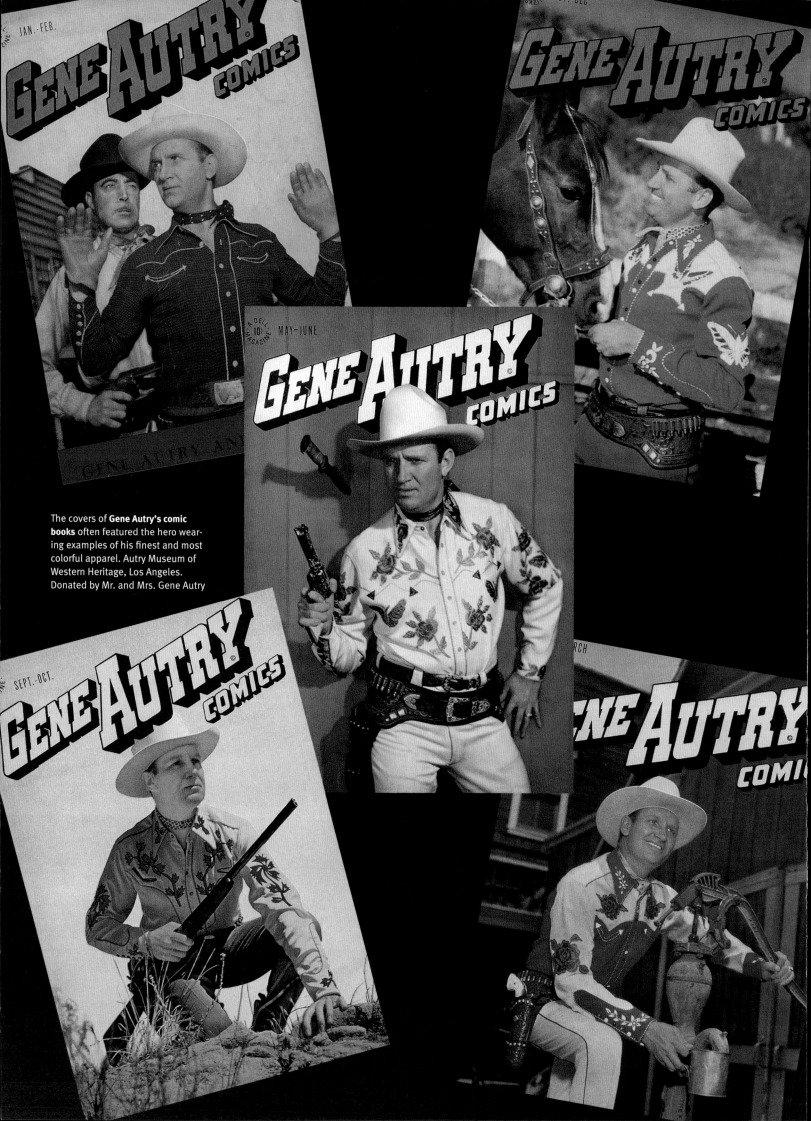

The covers of **Gene Autry's comic books** often featured the hero wearing examples of his finest and most colorful apparel. Autry Museum of Western Heritage, Los Angeles. Donated by Mr. and Mrs. Gene Autry

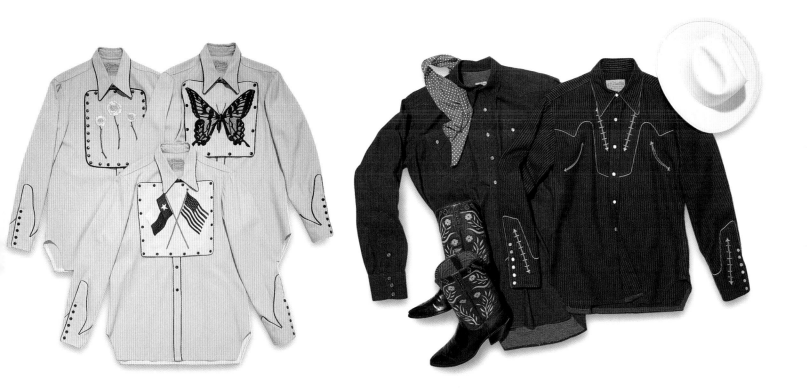

way around leather, a skill that paid off when he made his group matching hand-stitched vests. "Even in the early days of the Sons of the Pioneers, Roy recalls adding silver conchas and fringe to their stage outfits to give them a more resplendent Western look," wrote Jane and Michael Stern in *Happy Trails: Our Life Story*, a memoir coauthored with Rogers and Dale Evans. "I had always liked to wear stage clothes that set us apart," Rogers wrote in *Happy Trails*. " . . . I used to make leather vests for us to wear with fringe along the sleeves and a 'Sons of the Pioneers' brand on the back."

Beginning in 1935, the group was cast in B-Westerns and outfitted in basic Western-style clothes—simple Western shirt, denim pants, cowboy boots, and hat. When Roy Rogers, after shedding his original stage name of Dick Weston, replaced Autry (who was having a dispute with Republic at the time) in the 1938 picture *Under Western Skies*, he finally began acquiring the wardrobe he had doubtless been coveting. "Well before Roy Rogers acted in this first movie, the public's image of the cowboy had become more show business," the Sterns point out. "By the early 1930s, deluxe ranch wear was in vogue. . . ." As soon as he could afford custom-tailored Western suits, shirts, and pants, Rogers headed to Turk's and Rodeo Ben's shops. Before long, as Rogers's star rose, he, too, made the pages of Rodeo Ben's mail-order catalogue. According to a 1958 article on Rodeo Ben, "Roy Rogers's private thunderbird design runs him $150 per [shirt]."

In his movies, Rogers began wearing fancier attire, with simple piped and plaid Western-cut shirts of the late 1930s giving way in the 1940s to elaborate two-tone affairs, embellished with embroidery and layers of fringe. Around his neck, Rogers usually wore a long flowing silk or cotton scarf, jauntily knotted on the side. His tight gambler-striped pants were always tucked into a sharp pair of boots, frequently embellished with heroic looking eagles on the tops. A 1941 movie magazine

Above left: Beginning in the mid-1930s, Gene Autry favored **bib-front shirts**, especially for personal appearances. These three examples made by Nudie the Rodeo Tailor in the 1950s postdate similar examples made by Rodeo Ben in the 1930s and 1940s. The center example is like the shirt worn by Autry at the Texas Centennial in 1936. Autry Museum of Western Heritage, Los Angeles. Donated by Mr. and Mrs. Gene Autry

Above right: After his service with the Army Air Corps in World War II, Gene Autry returned to radio, recording, movies, and live performing. His movie wardrobe took a decided turn toward the **plain and functional after 1945**. These examples, a denim shirt by Hubbard and a striped gambler's shirt by Nudie, along with Stetson hat, polka-dot scarf, and Texas boots, are typical of the 1940s and early 1950s. Autry Museum of Western Heritage, Los Angeles. Donated by Mr. and Mrs. Gene Autry

Left: A young Roy Rogers fashioned this leather vest for himself and other members of the **Sons of the Pioneers**. The group's subtle Western look of the 1930s grew decidedly fancier in the following years. Courtesy of the Roy Rogers and Dale Evans Museum, Victorville, California

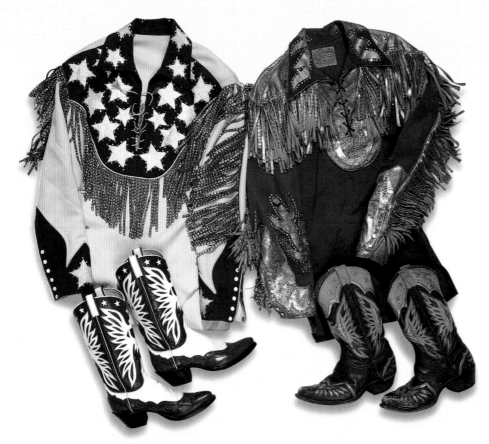

Left: Rogers wore the **Nudie shirt with gold leather trim on the right** for appearances in the 1960s. He wore the **red, white, and blue number on the left** to celebrate the Bicentennial in 1976 and for a cable television appearance in the 1980s. Courtesy of the Roy Rogers and Dale Evans Museum, Victorville, California

Above: Here Trigger is dressed in fine **Bohlin-made silver-mounted gear**. Roy Rogers is equally well turned out in a Western-cut drape suit, probably by Rodeo Ben or Turk. Autry Museum of Western Heritage, Los Angeles

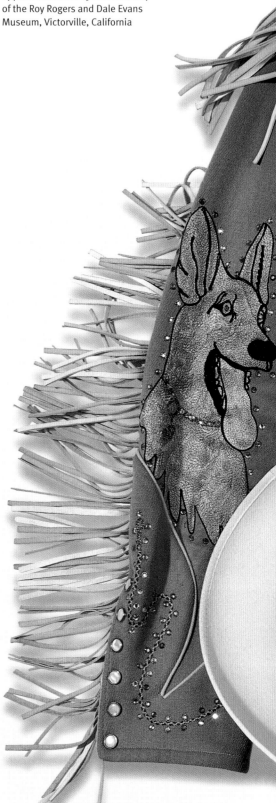

Right: Roy Rogers was strongly attached to his **German shepherd, Bullet,** and Nudie was happy to create a unique shirt featuring the dog. Bullet's leash embellishes the cuffs and collar. Courtesy of the Roy Rogers and Dale Evans Museum, Victorville, California

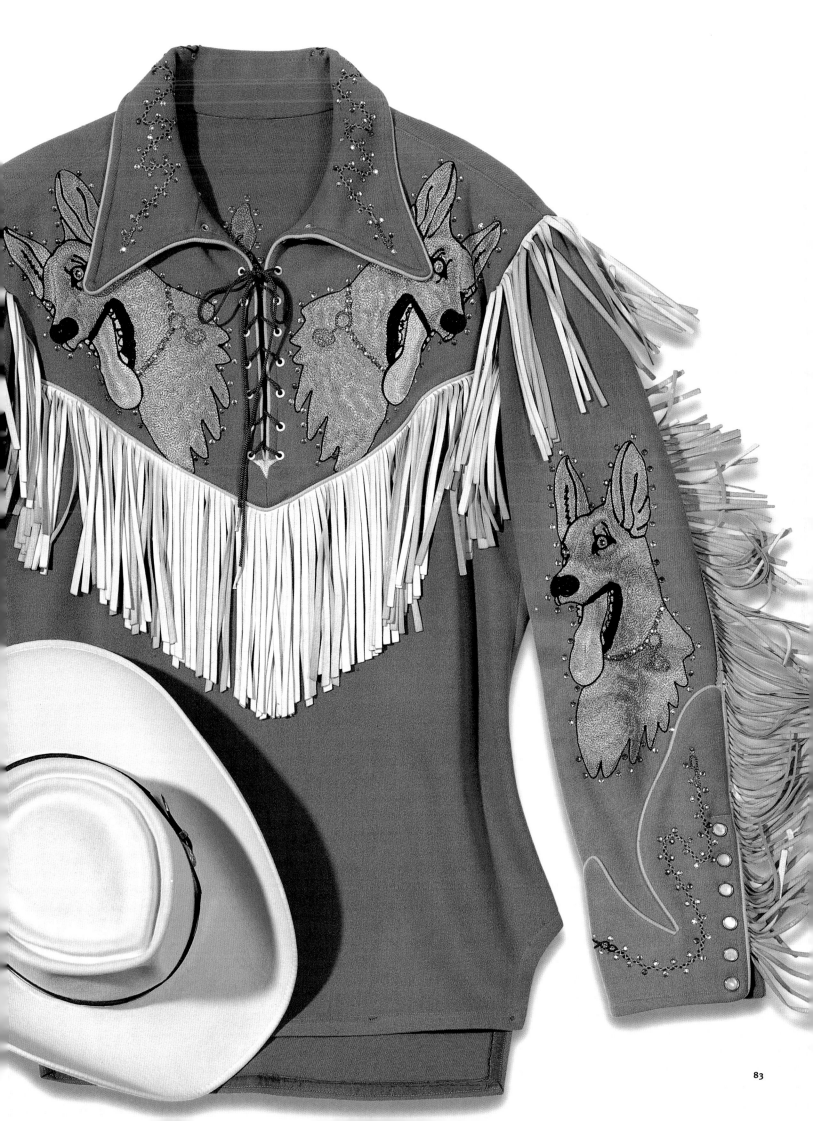

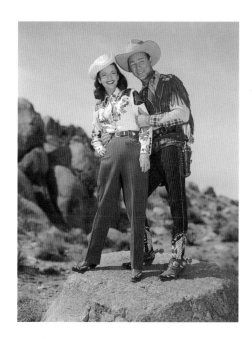

For their long-lived television program, **Roy Rogers and Dale Evans dressed up for their fans**—in layers of fringe for him, embroidery for her. Courtesy of the Roy Rogers and Dale Evans Museum, Victorville, California

article, "From Hillbilly to Hero," noted: "Except that his all-cowboy wardrobe is a little snappier than most, he's the type of unspoiled, unaffected, happy-go-lucky young Westerner you might meet on any colorful ranch."

By the early 1940s, Turk was making custom shirts and pants for Rogers's movies, as well as impeccably styled, sophisticated drape suits in beautiful color combinations—frequently gray and pale blue—with exquisite Western details like hand-stitched arrowheads and top-stitching on the jacket backs and fronts. Rogers became very close to the Turks, whose daughters recall their parents comforting the brokenhearted cowboy star when his first wife, Arlene, died in 1946. Rogers's frequent costar and future wife, Dale Evans, also wore Turk's gorgeous fringed cowgirl ensembles with split skirts and bolero vests, appliquéd and embroidered with stars, flowers, and butterflies.

Still lovely in a bright purple cowgirl outfit with white fringe and sparkling rhinestones, Dale Evans, eighty-six, reminisced in 1999 about Turk and her favorite early costumes: "The kelly green felt outfit Turk made me had the Texas star and longhorns on it embroidered in white, to commemorate that I was from Texas. The studio sent me to him. He was very good—an impeccable tailor."

In *Happy Trails*, Evans recalled that after he saw *Oklahoma* on Broadway, Republic Pictures president Herbert Yates insisted on the Rogers/Evans movies becoming more like the musical. Rogers, too, once told Western film historian Jon Tuska the same story, as Douglas B. Green (also known as Ranger Doug of Riders in the Sky) points out in his authoritative essay, "The Singing Cowboy: An American Dream": " . . . The heavy indulgence in costumes and production numbers in [Rogers's] wartime movies was a result of a directive from Yates himself." According to Green, the "unbearable gaudiness of [Rogers's] clothing, what [film historian] Don Miller calls the 'era of the shrieking Rogers costumery,' stretching the willing suspension of disbelief to the breaking point," caused Rogers's films to fare less well than Autry's. The fancy shirts had other drawbacks as well, as Rogers himself acknowledged: "Those dang woolen cowboy shirts I used to wear . . . were hot as an oven and liked to itch me to death, but they didn't get wrinkled and always looked nice."

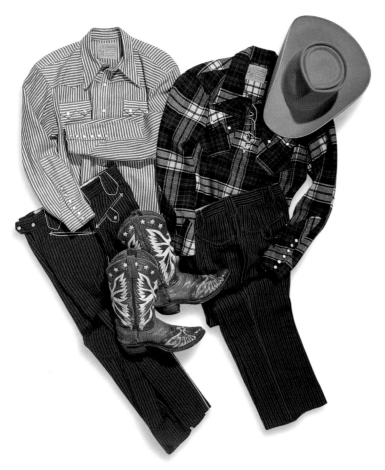

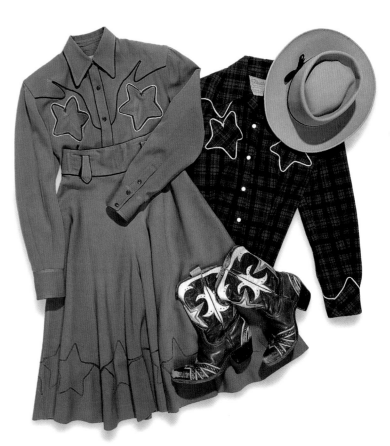

After Rogers and Evans married in 1947, they began wearing matching outfits, many of which Dale designed. They also became associated with certain symbols frequently embroidered on their garments or decorating their boots. Rogers's was an eagle with wide-spread wings, and Evans's was a butterfly. Their son, Roy "Dusty" Rogers Jr., explains their significance: "The eagle seemed to set the tone for what Dad was doing—it's a majestic bird. The butterfly fit Mom and the way she believed in rebirth. The butterfly starts out as a worm and it basically dies, then goes into a cocoon and suspends animation, and when it comes out, it's this beautiful butterfly. Mom equates this with the way you are reborn again into a new Christian life."

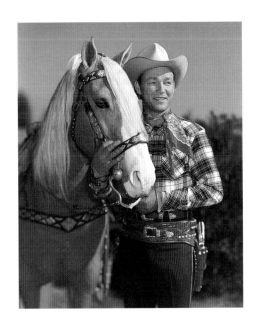

Above: Heroes for a generation: **Roy Rogers and Trigger in the early 1960s,** outfitted by Nudie the Rodeo tailor. Courtesy of the Roy Rogers and Dale Evans Museum, Victorville, California

During public appearances, Rogers wore snug shirts that frequently laced up the front and zipped on the side. Dusty has vivid memories of helping his father with wardrobe changes during his parents' tours in the late 1950s. "I remember Dad would be wringing wet when he'd get off stage because his shirts were gabardine wool. They wore like iron, but they were hotter than blazes in the summertime. We'd have to get behind him, and [brother] Sandy and I would grab a hold of the tail end and pull it. Getting them off was really a challenge because they were soaked and stuck to him. They were tapered down and tailored to fit tight. We'd have to get hold of the collar and pull with enough pressure to where he could back out of the shirt. Sometimes he'd be wandering around with his two arms up and the shirt stuck."

Rogers was also known for the way he creased his white Stetson hat (before switching to Resistol hats in later years). In 1999, Dale Evans fondly reminisced about her husband's creasing technique: "Roy shaped it with his own hands. He would go to the bathroom and get in the shower with the hat on and shape it when it was wet. Then he would tie it with a scarf. . . .put it in the bedroom out of the sun to prevent it from shrinking, and let it dry. I started to shape mine the same way—in the shower." Evans confided that "rodeo cowboys" ridiculed the way she wore her hat tilted on the back of her head, "keeping it from hiding her eyes," with the brim framing her face like a halo.

At home, according to Dusty, Rogers enjoyed wearing simple off-the-rack Western shirts, like those made by H Bar C Ranchwear, which he also wore to entertain troops in Vietnam in the 1960s. There, he favored a nylon number that dried quickly in the humid jungles. "Dad was always casual at home," said Dusty, "in jeans and a Western snap-front shirt and work boots."

In public, though, Rogers made a point of dressing Western to the hilt. Both he and Autry went down in B-Western history as the genre's biggest stars *and* snappiest dressers, inspiring a generation of singing cowboys, country artists, and Western actors to go for the glitz. The friendly rivalry that ensued between Autry and Rogers extended to their wardrobes, and may have endured until their final years, judging from an anecdote Alex Gordon tells. In 1986, Autry and Rogers each hosted a Nashville Network television show featuring their old movies. "Roy was going to appear as a guest on one of Gene's shows," Gordon says, "and when Roy walked in, he was wearing the most spectacular shirt you've ever seen in your life! I mean it was just like a fireworks display—silver spangles and things. It was absolutely glowing. Gene was wearing just a regular cowboy suit, nothing spectacular, like the kind he wore in his later pictures when he dressed down and played more working type cowboys. Mrs. [Jackie] Autry said, 'Wait a minute, if we put you on with Roy, nobody is going to look at you—everybody's eyes will be on Roy all the time!' So she went through all Gene's shirts she'd brought from Hollywood to find the most spectacular one to match this thing. Finally she pulled out a shirt that Gene wore in 1942, in his last movie before going into the Air Corps—*The Bells of Capistrano.* It had an American flag embroidered on it and a few other things. So there they were—Roy in his, and Gene in his. What a pair."

Certainly, in the 1940s and 1950s, each man's keen aesthetic sense—and desire to impress his fans—resulted in some of the most dazzling entertainment wardrobes ever known. No doubt, some future stars were watching.

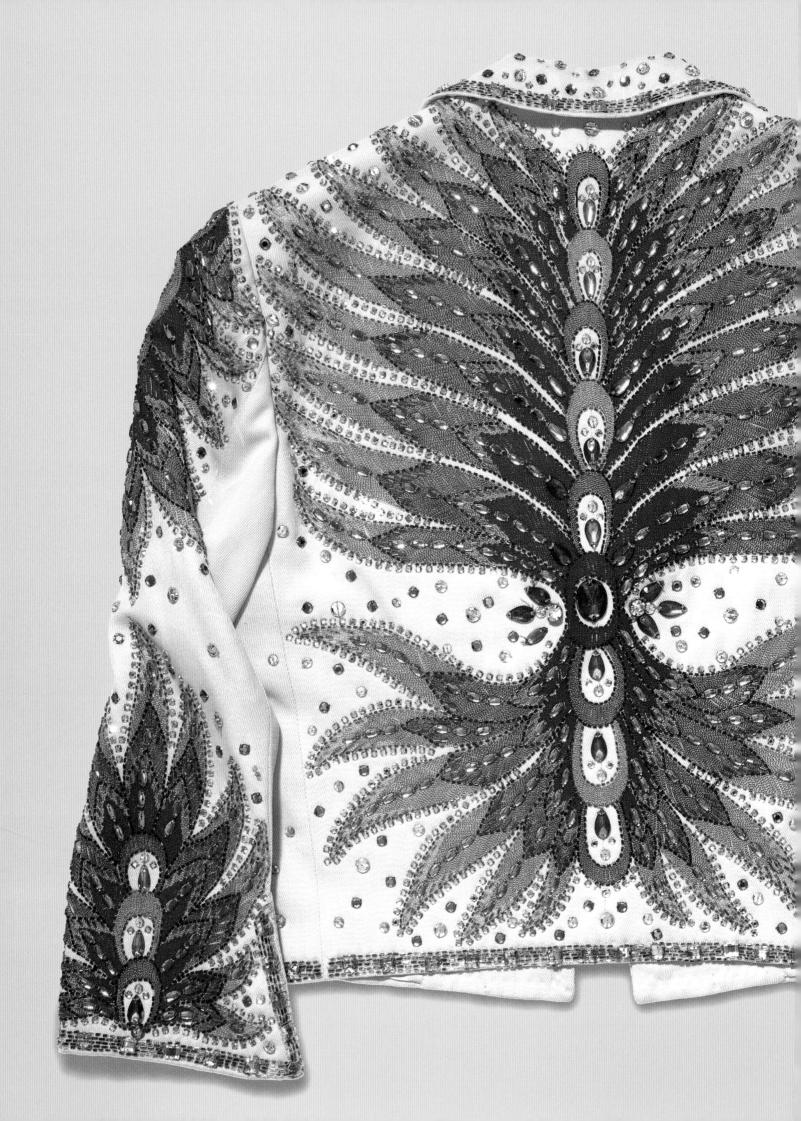

CREATOR OF THE RHINESTONE COWBOY

It's a hot July day as petite eighty-five-year-old Bobbie Nudie (Cohn) leads two visitors into the storage building behind her modest Arleta, California, home. She passes through a Western-motif-landscaped yard flanked by a concrete wall decorated with a comical cowboy mural. Just outside the door, a once-festive cocktail bar sits forlorn, surrounded by scores of wrought-iron chairs obviously not sat upon for a long time. Inside, the room is chockablock with memorabilia, all Western-themed, including tooled-leather portraits; framed, auto-graphed pictures of well-known music and film personalities; tarnished trophies; massive mounted longhorns; and a dusty glass cabinet crowded with signed photographs of such celebri-ties as Hank Williams, Elvis Presley, Audie Murphy, and Andy Devine, labeled with the legend THEIR LAST CURTAIN CALL. Bobbie's husband, the proprietor of this roomful of cowboy ephemera, took his final bow on May 9, 1984, and the landmark North Hollywood store it adorned closed eleven years later. Its founder's legacy lives on, however, not only here but as a sort of brand name that has come to stand for the fanciest, most embellished Western wear: the "Nudie suit."

Above: **Nudie (center) with some of his customers** (left to right): Tex Williams, Gene Autry, Roy Rogers, and Rex Allen. Autry Museum of Western Heritage, Los Angeles

Previous pages: **Nudie's personal outfit.** "I take a plane to Frisco and look around and everybody is wearing blue serge suits and black shoes and carrying a briefcase. They'd rather be dressed like me, but they haven't got the guts," Nudie told the *Los Angeles Times* in 1979. Autry Museum of Western Heritage, Los Angeles. Donated by Bobbie Nudie

Dubbed King of the Cowboy Couturiers and Dior of the Sagebrush in countless newspaper and magazine puff pieces, Nudie Cohn brought mass-media attention, flash, and sparkle to the fancy Western-wear ensembles that became synonymous with celluloid cowboy and country music stardom during the late 1940s, 1950s, and 1960s. As imaginative a self-promoter as he was a designer, Nudie lived a rags-to-riches life that seemed the stuff of the movies he loved so well. Like his predecessors, Turk and Rodeo Ben, he emigrated from Eastern Europe and was versed in the tailoring and embroidery techniques originating in that region. He then took the decorative styles Turk and Rodeo Ben had pioneered to the extreme, creating imaginative Western clothing that was more costume than anything a working cowboy could have ever dreamed of wearing.

He was born Nutya Kotlyrenko on December 15, 1902, in Kiev, Russia, to a Jewish bootmaker and his wife. One of five children, Nutya became a tailor's apprentice at the age of eight; when he was eleven, his parents arranged for him and his older brother, Julius, to join their eldest son, Sam, in America. At Ellis Island, young Nutya gave authorities the surname Cohn, the name being used by relatives living in Brownsville, Brooklyn, where the boys intended to stay; his first name was misunderstood as "Nudie" when the youngster couldn't write or spell "Nutya." In a 1979 unpublished autobiography written with Trina Mitchum, Nudie said of the immigration officer who mangled his moniker, "I guess that man never knew what a favor he did by giving me that name, but it's been my trademark for years. People are always impressed by an unusual name, and Nudie has suited me just fine." It also set the pattern for decades of mystery and intrigue about Nudie's past and illustrated his knack for reinventing himself.

Nudie briefly lived with, and delivered tuxedos for, family friends in the garment business but soon found other ways to make a living. He ran errands for vaudeville star Eddie Cantor; bought discount sateen, turning it into ladies' skirts and selling the garments to Macy's; tried to break into show business as a mandolinist; and boxed as a 106-pound welterweight, all before he turned sixteen, when he traveled with a troupe of pugilists to California for the first time, getting work as a negative cutter for a movie studio. An avid fan of Westerns, Nudie wanted to be a cowboy actor, but his job in the editing room quickly dissolved. He then began roaming the country, eventually winding up in Cleveland, Ohio, where he was arrested in 1918 for unwittingly transporting cocaine. Released from Leavenworth Penitentiary in 1920, he found work as a tailor in Youngstown, Ohio, doing alterations and dry cleaning. At twenty, he returned to Hollywood to work as an extra and stand-in, but in 1923 opened his first tailoring shop on Beverly Boulevard. Becoming restless, he gave it up, and for the next nine years zigzagged back and forth between New York and Los Angeles, working for cleaners and tailors or in his brother's brassiere business. Along the line, he realized that "I still hadn't shaken my desire to be somehow involved in show business. . . . It wouldn't be enough, I thought, to simply have entertainers as my customers. There's no glory for the guy who shortens the pants of a big star. Who cares about the cleaner who gets the lipstick stains off a sex symbol's shirt? . . . I kept dreaming until I could see myself as a famous costume designer. My creations would be worn by great stars the world over and they'd really stand out so that my clothes would be as famous as the people in them."

Hitchhiking back to the East in 1932, he landed at a Mankato, Minnesota, boarding house, where, at age twenty-nine, he was smitten with the owners' eighteen-year-old blond daughter, Helen Barbara Kruger, whom he nicknamed Bobbie. The pair married on September 4, 1933, and spent the next few years alternating between New York and Minnesota. "Nudie was a roamer, you know," Bobbie says. "He just had to go here and there—he could not settle down." She recalls that once when the pair had been hitchhiking in Minnesota, none other than Tom Mix whizzed past them in his fancy car.

In 1934, after operating a short-lived dressmaking business, the Cohns opened Nudie's for the Ladies on the second floor of a building at 49th Street and Broadway, near New York's Times Square. There, burlesque queens working such clubs as Sidewalks of New York and Leon & Eddie's could purchase G-strings and skimpy stage costumes; the two-year enterprise led to the common misperception that Nudie got his nickname from this line of work. According to his memoir, it did lead to his future creative pursuits: "I used lots of shiny spangles and rhinestones and feathers and fringe to create fantastic costumes a little different than anything else that had been done along those lines. I really liked the rhinestones and it was an idea I got in the back of my mind then to someday design a cowboy suit with rhinestones." He and Bobbie also schmoozed their clientele, another trademark of his future business dealings. "That's one of the main secrets to a successful career in show business," Nudie wrote. "You've got to keep in touch with the people. . . . People will be impressed with quality workmanship, but you've got to be able to sell it to them, and good public relations are essential to salesmanship." For the garrulous, diminutive cowboy wannabe, this was perhaps his greatest strength.

Tiring of New York, the Cohns returned to Minnesota. Then in 1940, after operating a successful tailoring shop/dry-cleaners there, the Cohns, with their two-and-a-half-year-old daughter, Barbara, decided to give Los Angeles a try. Says Bobbie of her hometown, "Nudie was too ambitious for that town. They didn't like an outsider to come in and do things that weren't their way—and Nudie didn't ever adhere to other people's ways."

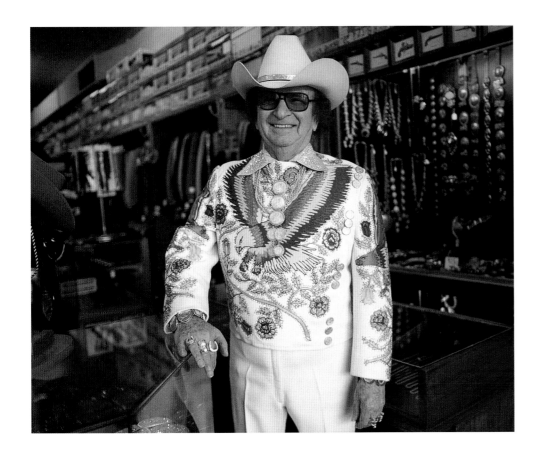

Rolling Stone chief photographer Baron Wolman shot **Nudie in 1969** for the cover of the June 28, 1969, issue.

In Los Angeles, Nudie did alterations, then set up a tailoring shop in the living room of their bungalow across from Hollywood High. He began making custom women's pants, finding young female customers at the local drugstore and charming them into placing orders: "Every time I'd see a gal that I thought was nice looking, shaped nice and who had a nice smile, I'd start talking to her and she'd end up going over to my shop with me and buying at least one pair of slacks." The business boomed, and eventually the Cohns moved to a bigger house on LaBrea Avenue, where they added a dry-cleaning operation and hired a couple of

On weekends, Nudie hung out at San Fernando Valley clubs featuring Western swing and early honky-tonk, and "got to thinking maybe I should try to get into designing costumes for the kinds of bands that we were seeing . . ."

sewing-machine operators. "The popular fashion rage at the time," Nudie wrote, "was two-toned loafer jackets and I began making them in gabardine and tweed. They sold like hotcakes." He entered a partnership to market the designs but was cheated out of the business by his partner, so the Cohns had to start over once again. They moved to a smaller North Hollywood home, and Nudie began designing and manufacturing Western shirts in a Hollywood Boulevard loft for a wholesaler. "[I] hired a staff of cutters and sewers and at long last began designing Western wear," he recalled. "I was proud of my shirts. They had a certain kind of yoke that had never been done before and the style was so successful that my partners and I were given a very big contract by a major shirt company."

On weekends, Nudie hung out at San Fernando Valley clubs featuring Western swing and early honky-tonk, and "got to thinking maybe I should try to get into designing costumes for the kinds of bands that we were seeing, but I was too busy with my shirt business to move on the idea." The Cohns relocated to a Valley home with a garage that they converted into a tailoring space. In early 1947, Nudie underwent emergency surgery for a hernia, and with no medical insurance, the Cohn finances were wiped out again. To make ends meet, Nudie sold his share of the shirt business and, while recuperating, decided to finally go for his big dream. Bobbie recalls, "He said, 'That's it—I'm not going back to manufacturing.'"

Vocalist Tex Williams was also starting over. Recently ousted from the Spade Cooley band, he was playing Valley roadhouses backed by his Western Caravan. Said Nudie, "I was crazy about Tex's music and I figured that since he was starting with a new band that he and his musicians could use some snazzy new outfits. I also figured that maybe he'd give me a fat advance and with that I could go out and buy a machine and materials and be back in business." Next stop, Tex's home, where Nudie found him cutting the grass. The fledgling bandleader didn't have the cash for costumes but was impressed enough by Nudie's chutzpah that he decided to auction off a horse and saddle and bankroll the tailor's business. With $135 from the sale, Nudie bought a sewing machine and purchased fabric on credit, then made an appointment to take measurements for Tex and his eight-member band.

Disaster struck again: "When we all got together, though, we got to drinking," Nudie recalled. "I had a friend with me to help take the measurements, but he was half drunk and so was I. Between us, we made one whole drunk, and boy was he a drunk! The band was pretty juiced too and nobody would stand still properly for the measurements. It was a mess, but we sure had a great time. I got home and started cutting out the suits."

Needless to say, none of the clothes fit, but Tex didn't give up on Nudie, and the indefatigable tailor hustled another supply of fabric on credit, correctly measured Tex's band, and made garments that fit perfectly. At the popular Riverside Rancho nightclub, the combo debuted their spiffy white Western shirts with contrasting piping and hand-stitching and matching frontier pants, with Tex out front in a dashing drape suit accented with elaborate piping; all the outfits had fancy Ws gracing the front pockets. Rather than the usual three hundred patrons, twenty-five hundred people happened to show up, and the band did so well they paid Nudie the entire $850 they owed for the costumes. His business was off and running.

Opposite page: Eddie Dean gained fame on radio station WLS and finally tried his hand at making low-budget Western movies in Hollywood. Beginning in the 1950s, most of his **stage outfits were made by Nudie**. This one had matching belt, gun belt, and other accessories. Autry Museum of Western Heritage, Los Angeles. Donated by Eddie Dean

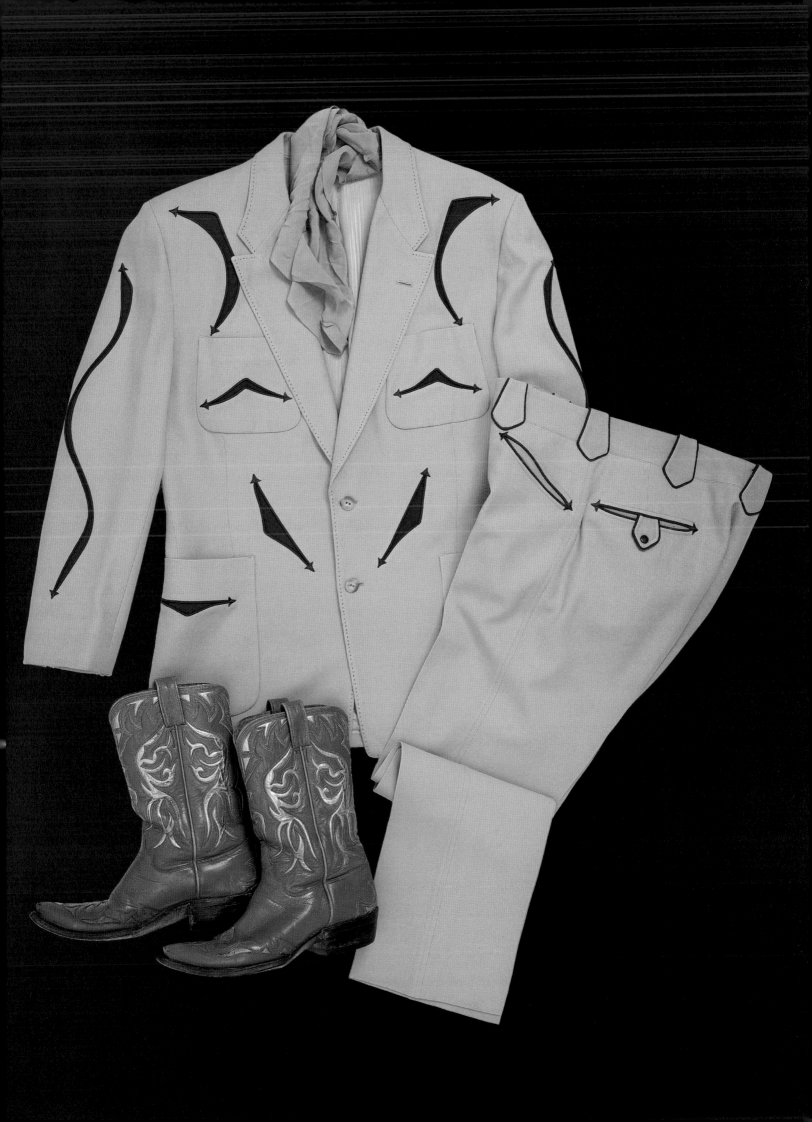

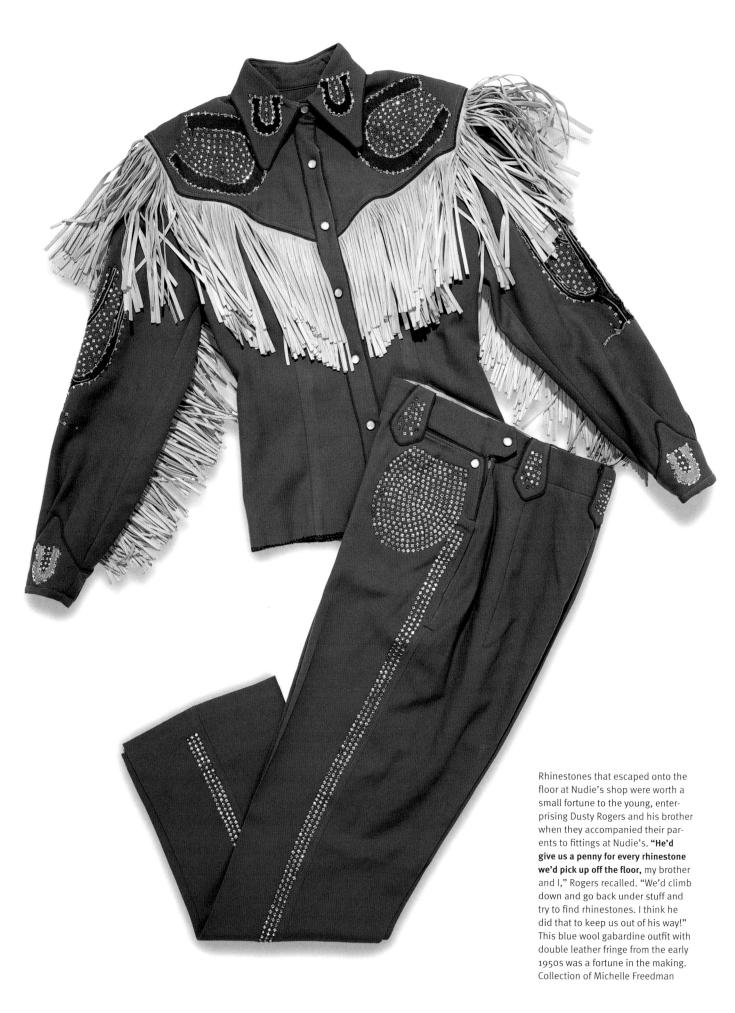

Rhinestones that escaped onto the floor at Nudie's shop were worth a small fortune to the young, enterprising Dusty Rogers and his brother when they accompanied their parents to fittings at Nudie's. **"He'd give us a penny for every rhinestone we'd pick up off the floor,** my brother and I," Rogers recalled. "We'd climb down and go back under stuff and try to find rhinestones. I think he did that to keep us out of his way!" This blue wool gabardine outfit with double leather fringe from the early 1950s was a fortune in the making. Collection of Michelle Freedman

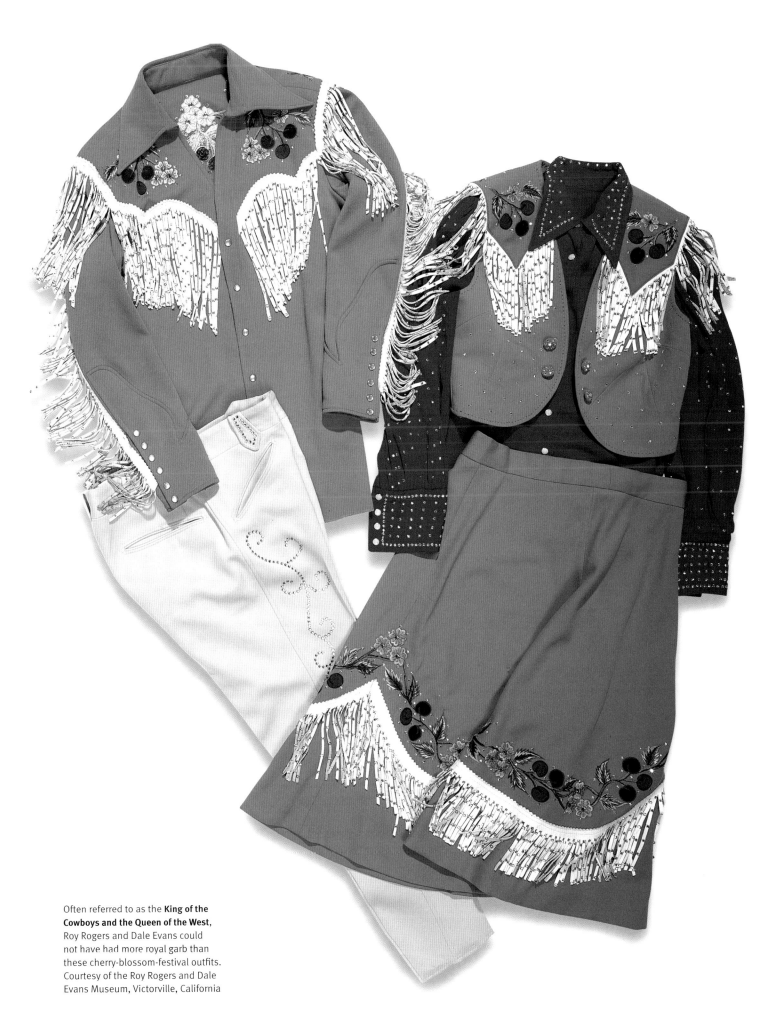

Often referred to as the **King of the Cowboys and the Queen of the West**, Roy Rogers and Dale Evans could not have had more royal garb than these cherry-blossom-festival outfits. Courtesy of the Roy Rogers and Dale Evans Museum, Victorville, California

The club owner also let Nudie display his designs, which according to Bobbie, "was a big boost. He had beautiful wool gabardine things on display. We were making shirts and pants at that time for $19 each." In addition, Tex broadcast live radio shows and raved about Nudie's designs on air, even giving the tailor's home address. "With all the free publicity I was getting, people were starting to come in from all over the place to buy Western clothes from me," said Nudie. "Of course, I still had to hustle more than ever. I'd hang around the cowboys at the saddle clubs on Riverside Drive and try to drum up a little business and I'd go out at night and make friends with the local entertainers. I kept at it and soon I was able to buy another sewing machine and a snap machine. I had the whole setup on an old Ping Pong table that we never used. I really had the garage all fixed up nice, with pictures of different celebrities on the wall. Some of the people I had made costumes for, but most of them were of people that I wished I could make costumes for."

Bobbie fondly recalls those early days: "All these characters started to come out to our place on Sunday with their instruments. We had a great big flagstone patio out there with a fireplace and Nudie would be making hamburgers—it became a hangout. They're coming, they're playing, they're pickin' and having a good time. So one's telling the other, and they like him because he's fun." Regulars included Cliffie Stone, Spade Cooley, Hank Thompson, and Merle Travis, and soon, it became de rigeur for country and western stars to perform in a Nudie suit. Another lift was a $28,000 order from a Texas oil millionaire introduced to Nudie by singer Eddy Arnold and his manager, Colonel Tom Parker, who would later commission Nudie's most famous suit.

In 1950, with business thriving, Nudie moved his operation into a storefront at 11000 Victory Boulevard on the corner of Vineland in North Hollywood. Over the door hung the sign, NUDIE'S RODEO TAILORS. "At that time we had two boot makers, one alteration man, maybe three tailors, a leather man, and Nudie was doing his own cutting," Bobbie recalls. "There was a lady in town, Viola Grae, doing all the embroidery, but soon after we put in our own lady. Her name was Ruth. We set up a place for her with all the threads and machines. Nudie let the movie studios know what he was doing. We began making mostly period clothes for the studios, cavalry outfits and this and that." Before long, they were outfitting Tex Williams in film shorts for Universal as well.

Next, Nudie sought the clients he'd been lusting after: the King and Queen of the West. "Nudie never wanted to approach Roy and Dale while we were in the garage," Bobbie recalls. The two couples hit it off, and Rogers and Evans became some of Nudie's best customers. Said Rogers, "I liked the kind of clothes [Nudie] was making so much I helped bankroll the tailor shop. [Dale] sketched ideas for a lot of the clothes we wore and gave her pictures to Nudie, who went wild with them." "Nudie was a little more daring than Turk," Evans recalled. "I've always liked free-hand drawing, and I'd say to Nudie, 'I'd like this' and 'I'd like what you'd suggest in colors' and 'this is what I had in mind.' We would get our heads together and do it."

Before long, Rogers's and Evans's most flamboyant urges were being fulfilled by a needle and thread—and eventually rhinestones. According to Nudie, he first won Rogers's loyalty by devising a special cut for his suits: "Before I came into his life," said Nudie, "Roy had been wearing tight-fitting suits with rope shoulders. I believe that I was the first tailor to design a drape model Western suit with wider shoulders, and it sure looked terrific on Mr. Roy Rogers." Nudie also claimed that the first-ever Western tuxedo was the one he created for Rogers. Eventually, Evans and Rogers gave Nudie so

Opposite page: **Rex Allen looks every inch the hero,** but is he defending the lady or reacting to comments about his outfit? Autry Museum of Western Heritage, Los Angeles

Below: Rex Allen thrilled young audiences when he performed onstage. The glitter of this **gold lamé Nudie suit** may have added to the drama, but it did not do much to endear Allen to the working cowboy. Autry Museum of Western Heritage, Los Angeles. Donated by Rex Allen

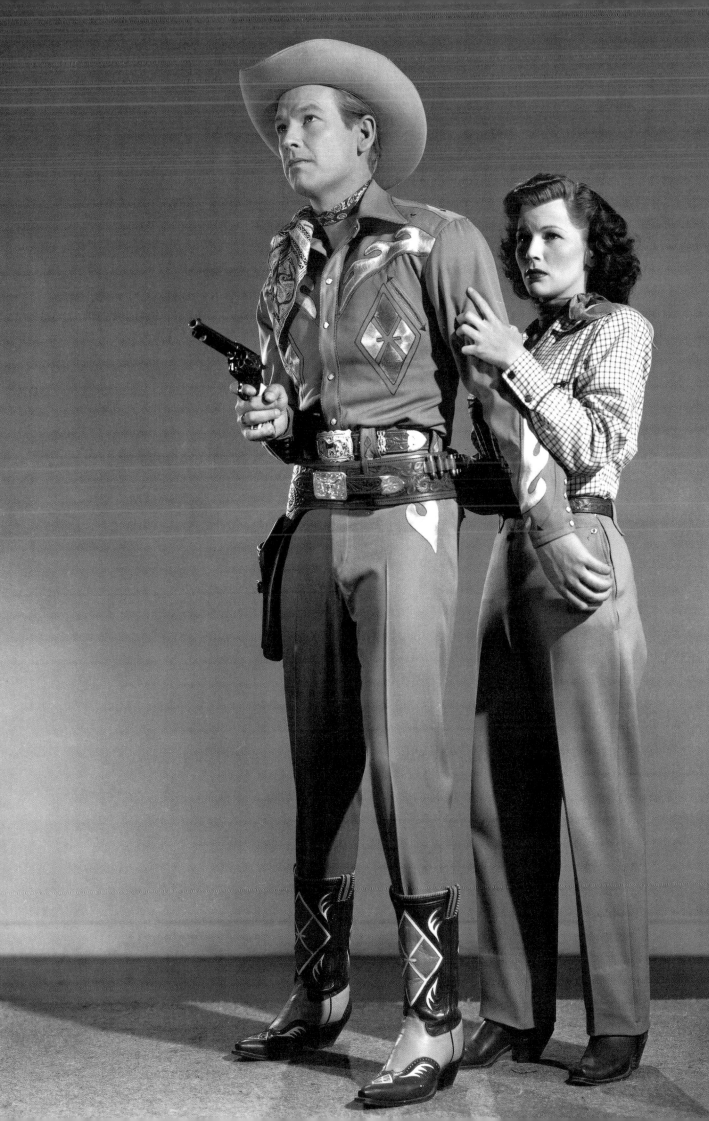

1800-59

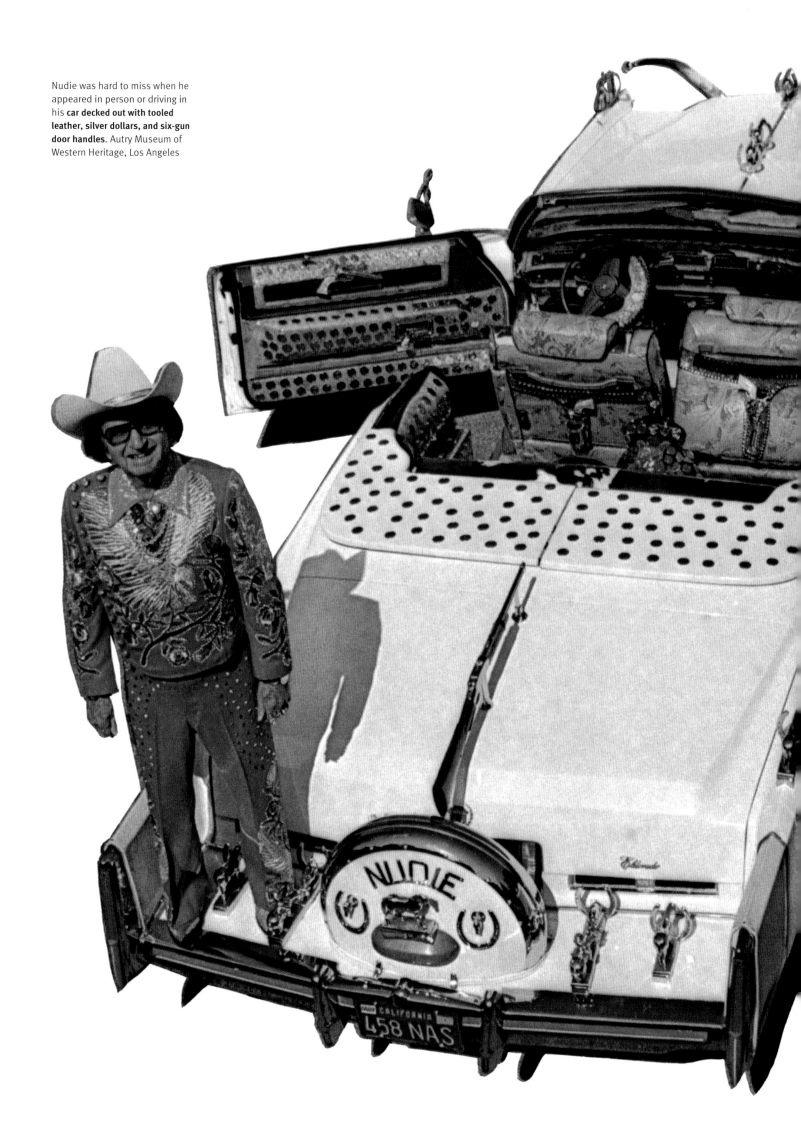

Nudie was hard to miss when he appeared in person or driving in his **car decked out with tooled leather, silver dollars, and six-gun door handles**. Autry Museum of Western Heritage, Los Angeles

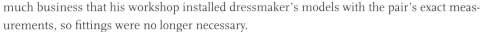

much business that his workshop installed dressmaker's models with the pair's exact measurements, so fittings were no longer necessary.

Fringe became Roy Rogers's trademark, distinguishing his costumes from Gene Autry's, whose business Nudie had also secured. Wrote Nudie, "I had to be extra careful to make sure that their outfits never looked alike, but since they each had distinctly different tastes, this was never too much of a problem. Gene preferred a more conservative look than Roy, but he loved fine detailing. He liked lots of piping and beautiful embroidery. He also favored the bib-front shirt and liked to wear neckerchiefs. He always looked sharp. Roy favored fancier duds; the rhinestones became a great favorite of his and he always liked lots of fringe. One of the best ideas ever was one he came up with, which was putting rhinestones on the fringe."

"Roy was at Madison Square Garden a lot," Evans explained, "and with the rhinestone fringe, people could still see you even when we were far away. The lights would catch the fringe." Usually worn at rodeo shows and parades, the pair's sparkling costumes were magnificent, with everything imaginable embroidered and rhinestoned on them: Roy's RR brand; their animals Trigger, Buttermilk, and Bullet; and even their jeep, Nellybelle.

"Dale has always said I was the original rhinestone cowboy," Rogers wrote in *Happy Trails.* "Those loud outfits were designed more for personal appearances than for movies. When we rode into the arena, we looked like glittering flags, which made it easy for kids in the last row of the balcony to see the show." He stuck to the glittery look, explaining in 1979, "I still wear the Nudie suits . . . when we make appearances at state fairs and so on. I know the kids like to see the costumes. It's showmanship, that's what it is when it gets right down to it. When those spotlights hit you, you just come alive."

Such showmanship became standard procedure among singing cowboys, after the example set by Rogers and Autry. Monte Hale wore fancy bib-front shirts with numerous buttons or snaps, and Rex Allen, who replaced Rogers as Republic's final singing cowboy, probably took the look to its pinnacle. "I always had the fear that people would look at me and say, 'Gee, you're copying Roy Rogers or Gene Autry,'" Allen said in 1979. "So Nudie and I tried to do something different. We would sit down and design some things which were completely away from what anyone else had. It was sort of a fetish with me and Nudie to go to a lot of trouble to make my stuff look different."

The result? "At one time, Rex's inventory of Nudie outfits consisted of 385 shirts, 160 pairs of frontier pants, 60 Western business suits, 68 pairs of custom made boots, 100 hats and two Western style tuxedos," Nudie wrote. "When you stop to consider that some of those sets cost as much as $3,500 apiece, you begin to get the idea." "Nudie was the greatest salesman in the world," claims Monte Hale, who still surrounds himself with all things Western,

Fringe became Roy Rogers's trademark, distinguishing his costumes from Gene Autry's, whose business Nudie had also secured. Wrote Nudie, "I had to be extra careful to make sure that their outfits never looked alike, but since they each had distinctly different tastes, this was never too much of a problem."

including massive steer horns courtesy of Nudie, in his Studio City condominium. "This guy could sell anything—I'll bet you he could have sold rhinestone icepicks to the Eskimos. We all just loved him—he was a wonderful guy to be with. His store used to be our first pit stop in the morning. Rex, Jimmy Wakely, Eddie Dean, and I would go in. A lot of us guys lived local. I'd play the guitar while he played the mandolin. Sometimes Gene Autry would come in, sometimes John Wayne would have a fitting."

"Every five or ten minutes somebody like Audie Murphy or Guy Madison or somebody was coming through the door," regular Johnny Western recalled in 1999. "Nudie made all

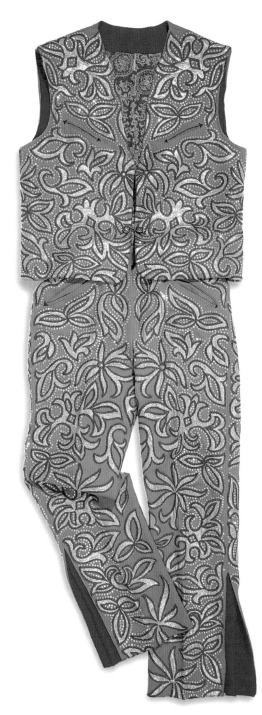

Webb Pierce's customer file from Nudie's is thick with orders, measurements, and specifications. This outfit is one of many that helped him stand out on any stage where he appeared. Autry Museum of Western Heritage, Los Angeles

those buckskin fringed outfits for Guy Madison when he was doing *Wild Bill Hickok,* for Jock Mahoney when he was doing *The Range Rider,* and for Dick Jones when he was doing *Buffalo Bill Junior* and when he was Jocko's costar in *The Range Riders.* So he made everything from buckskins to you-name-it. Nudie could just do everything. You'd give him an idea or a picture and he did it."

Garments weren't the only items to get Westernized in Nudie's world: "I was naturally always looking for ways to promote my business," Nudie wrote. "One day I got a great idea, one that has really paid off over the years. I told Cactus [his brother Julius, who was briefly his business partner] and Bobbie, 'Wouldn't it be a hell of a good thing if we took our car and put some steer horns on it? You know, dress it up a bit Western style.' That way whenever we drive anywhere we'd be advertising our business. . . . So we stuck a pair of steer horns on our 1950 Hudson and a tradition was born." The extraordinary vehicle became the talk of the town and Nudie went even further the next year customizing a new Pontiac. *Life* magazine ran a story on it, and the manufacturer offered Nudie a free Pontiac every year. Each became fancier than the last, and Nudie would sell his extras to C&W artists like Webb Pierce and Buck Owens. When Pontiac discontinued the promotion in 1971, Nudie switched to a Cadillac Eldorado convertible, which he adorned with hundreds of silver dollars embedded in the dashboard and door panels, a hand-tooled leather interior, pistol-shaped door handles, and an enormous pair of steer horns mounted on the front. An eight-track tape player loudly projected sounds of horses whinnying and cows mooing. Wrote Nudie, "Kids love it and even a grumpy old person has to smile when they hear that racket coming out of my car."

A photograph of the car with the little tailor posed upon its bumper adorned the cover of several editions of Nudie's mail-order catalogue, *Nudie's Rodeo Tailors Western Style Roundup.* Each one opened with the note: "Nudie is the man who has overcome the drab discomfort of the tight-fitting old-time cowboy clothes. Here at last is Western apparel that combines the quality and comfort of regular clothes with dashing and colorful Western style." In addition, a friendly letter went on to say: "Dear Friends, I am Nudie, the tailor, and my custom is fine clothing for countless Western stars, Sunday riders, dudes, and honest-to-goodness wranglers, cowpokes, and rodeo folks." The garment descriptions were brief, but the outfits were loud enough to be heard over a stampede: bold embroidered orange alligators slithering down the front of a royal-blue tuxedo, bald eagles, headdresses, and totem poles splashing across another. The catalogue also displayed equally ornate, coordinated fancy boots and rhinestone-studded hats. Additionally, the catalogue included several styles of Chimayo and Hudson's Bay blanket jackets, posse shirts, parade suits, charro- and gaucho-style suits and hats, custom-tooled leather saddles, holsters, suitcases, and guitar cases and straps. Of course, all catalogue items were prominently displayed in Nudie's North Hollywood store as well.

By the late 1950s, the store and its tailor had become well known thanks to the celebrity clientele, Nudie's promotional activities, and the resulting media coverage. Around this time, the extremely talented tailor and designer, Manuel Cuevas, joined Nudie's, and began handling much of the custom work. One 1954 newspaper reported that Nudie "gets $1,500 for some of his gabardine Western suits with blue sequin stars or diamond-studded horseshoes. . . . He now has fourteen employees and a bootery catering to Western stars." According to a 1959 press account, the tailor outfitted seventeen Western television series as well as "authentic wardrobes for Western epics," and the typical Nudie suit sold for $750. The store's walls were adorned with hundreds of autographed photographs of celebrities, and from the ceiling hung steer horns, cowboy hats dangling from each point. A 1961 *Western Horseman* article reported that Nudie had "enlarged his showroom and workshop until he now has one of the finest shops in the land. Dignitaries and the general public alike enjoy the atmosphere at Nudie's. The place is always jammed with the finest in Western clothes and accessories, as well as saddles and riding goods."

In 1963, Nudie's Rodeo Tailors moved into the store that became a landmark at 5015 Lankershim Boulevard in North Hollywood. With a large horse statue out front and buckaroos rearing up across the roof, the eye-catching establishment maintained its place as head-

quarters for cowboy actors, country stars, and the like, and the staff increased to seventeen. That year *Western Horseman* ran an article on Judy Lynn, a United Artist entertainer who mainly performed in Las Vegas, and Nudie's biggest female customer next to Dale Evans: "Judy's personal wardrobe consists of a wide array of glittering, hand-embroidered outfits, all with matching boots and hats, designed and tailored exclusively for her by Nudie of Hollywood. Her costumes are insured for $75,000." In the 1970s, Lynn told *People* magazine she had spent $300,000 at Nudie's.

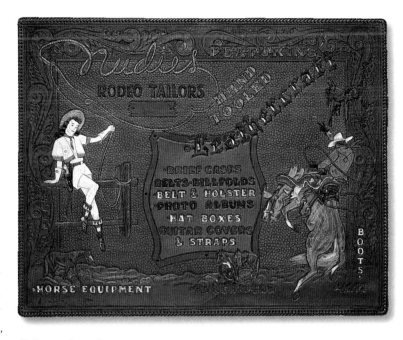

This leather carving was part of **Nudie's shop decorations,** but it doesn't give a lot of clues about the brilliant nature of the designer's products. Autry Museum of Western Heritage, Los Angeles

"The first suit I did for Nudie was for Judy Lynn," recalls Rose Clements, an English-born master embroiderer who had studied the craft in art school and worked in the British garment industry before moving to Los Angeles in 1963. She was a sales clerk at Bullocks Department Store when, in the mid-1960s, she saw Nudie and his suits featured on television. "I thought, 'My God, I could do that.' So, I called, and as it happens, they had an elderly man working there who wanted to retire, but they couldn't let him go because there was nobody to replace him, so I became the replacement." Now in her seventies, Clements still does selected custom embroidery out of her Valley Village, California, home.

Clements did the embroidery for many of Nudie's own extravagant ensembles, which complemented his outgoing personality. He began to favor rhinestone-laden jackets decorated with cobras, peacocks, eagles, and Indian designs, all in bright colors. After being appointed honorary sheriff of North Hollywood, Nudie decorated his bib-front shirts with shiny gold buttons engraved with the Sheriff's Department insignia. Wearing a ten-gallon Stetson and dark glasses, he strutted about in mismatched cowboy boots, telling the curious that he had another pair just like them at home. In his memoir, he described being a barefooted street urchin until a Brooklyn schoolteacher took pity on him and gave him a mismatched pair of boots, to which his odd footwear style was a tribute.

Perhaps his own impoverished childhood also fostered Nudie's generosity. Many clients who later went through hard times have recounted how Nudie offered a helping hand. As honorary sheriff, he raised funds and organized benefits for retired or sick entertainers and for local schoolchildren. He also gave discounts to some musicians just starting out. (He was very proud of his own recording, *Nudie and His Mandolin*, which he financed and released himself, and he loved to strum along with his musical customers.) Nudie went on to befriend yet another generation of musicians—rock & rollers—beginning in the 1960s. In a 1976 *People* magazine profile, he claimed, "If Tom Mix got out of his grave and saw my clothes, he'd get back in again." Not long after, he began work with Trina Mitchum on his autobiography, and got a small part in the 1978 Albert Brooks comedy *Real Life*. By the late 1970s, though, things were slowing at Nudie's, as entertainers began to favor a more casual, denim look. Battling ill health, Nudie retired in the early 1980s, and in 1984 he died of kidney failure at age eighty-one. His decked-out Eldorado followed the hearse to Forest Lawn cemetery, where Dale Evans delivered the eulogy at his star-studded funeral. Bobbie, with granddaughter Jamie, continued to run the shop until 1995, when she retired and closed it down. In 1999, Jamie opened Nudie's Java Joint, a Valley coffeehouse decorated with memorabilia from her grandfather's store.

Today, Nudie suits are valuable collector's items, worth thousands of dollars. Those who knew him, though, stress that Nudie's unique personality and loyal friendship had greater value than even his most extravagant designs. "Nudie did more for people than anybody will ever know," says Resistol/Stetson hat salesman Mel Marion, a friend and customer for two decades. "He was rough and tough and wanted things his way, but if somebody needed help, he helped them. He had a big heart, because Nudie had been down on his luck a lot of times and people had helped him out. And he in turn helped others. Oh, boy, he was something."

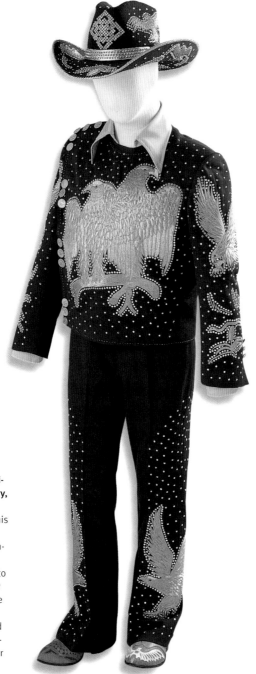

Right: For festive events in the early 1970s, **Nudie wore this dress suit radiating with rhinestones and embroidery, along with his famous mismatched boots** and matching Stetson, while his wife Bobbie wore a matching dress. Nudie wrote in an unpublished memoir, "As far as I'm concerned, one of the greatest feelings in the world is to walk into a place with my lovely lady on my arm, both of us dressed to the nines, and to see everybody in the room turn and stare. . . . I don't mind saying that on more than a few occasions we have stolen the show in our beautiful costumes." Autry Museum of Western Heritage, Los Angeles

Opposite: Though Nudie's name became synonymous with **fringed shirts** like this one, he never wore them himself. Collection of Michelle Freedman

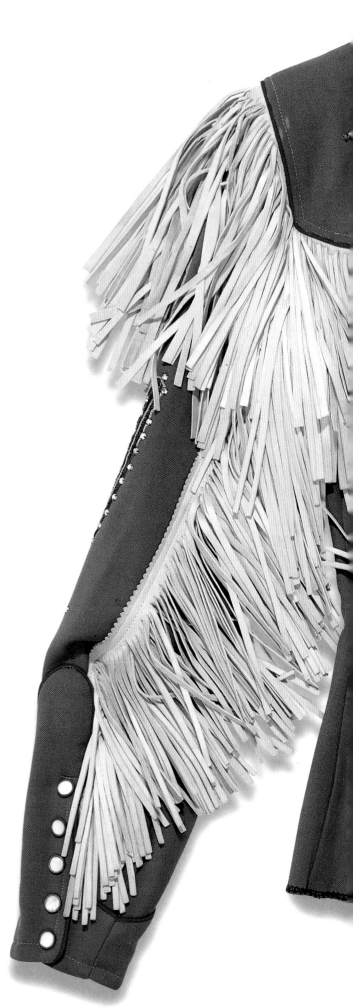

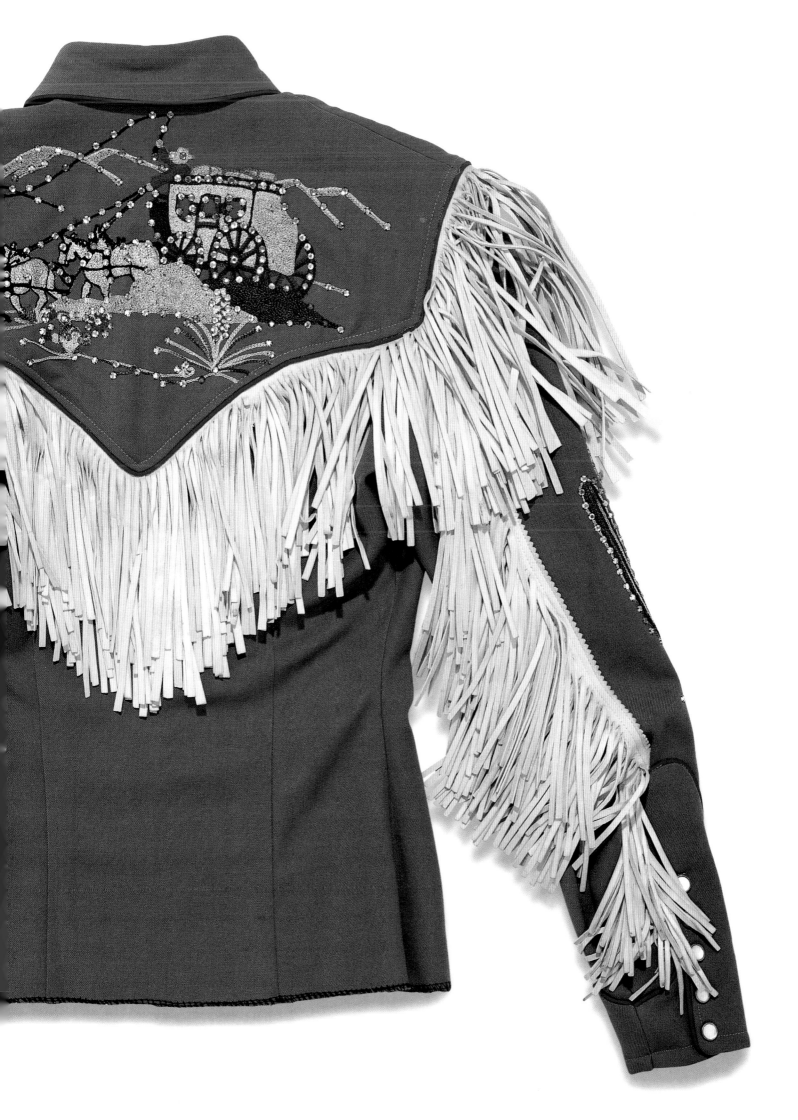

From Vaudeville to Nashville:

COUNTRY & WESTERN COSTUMING

Backstage at the Grand Ole Opry on a Saturday night is always a bee-hive of activity, and it's no exception this evening in September 1998. Chatting in the hallway with fans is "Little" Jimmy Dickens, a fifty-year Opry veteran resplendent in a bright blue suit embroidered with a deck of cards, tumbling red and blue dice, and dollar signs, all sparkling with rhinestones. Cajun-country singer Jimmy C. Newman strolls by, a snappy sight in a white Stetson and cropped ebony jacket sprayed with silver and cobalt stones. In dressing room number 14 is a shrine to the Nudie suit. Here, Porter Wagoner holds court surrounded by hundreds of photographs of himself—perhaps the most extravagantly attired member of the Opry—with friends and colleagues, including Nudie and his wife, Bobbie. Tonight, the tall, lanky Wagoner wears a stunning purple suit with a cutaway jacket, showcasing his ornate belt buckle; stars and wagon wheels spill down the pant legs and jacket sleeves, and a magnificent Conestoga wagon and setting sun outlined in rhinestones decorate the jacket back. His closets bulge with bespan-gled suits in nearly every color of the rainbow. "The fans deserve you dressing up for them," he says of his world-renowned costumes. "I wouldn't pay $10,000 to $12,000 for a suit if I didn't feel like it was worth it to the fans. The suits were a big part of my success in this business."

There has never been a combo as creatively attired as the **Maddox Brothers and Rose.** Nathan Turk transformed the C&W group into "the most colorful hillbilly band in the world." Autry Museum of Western Heritage, Los Angeles

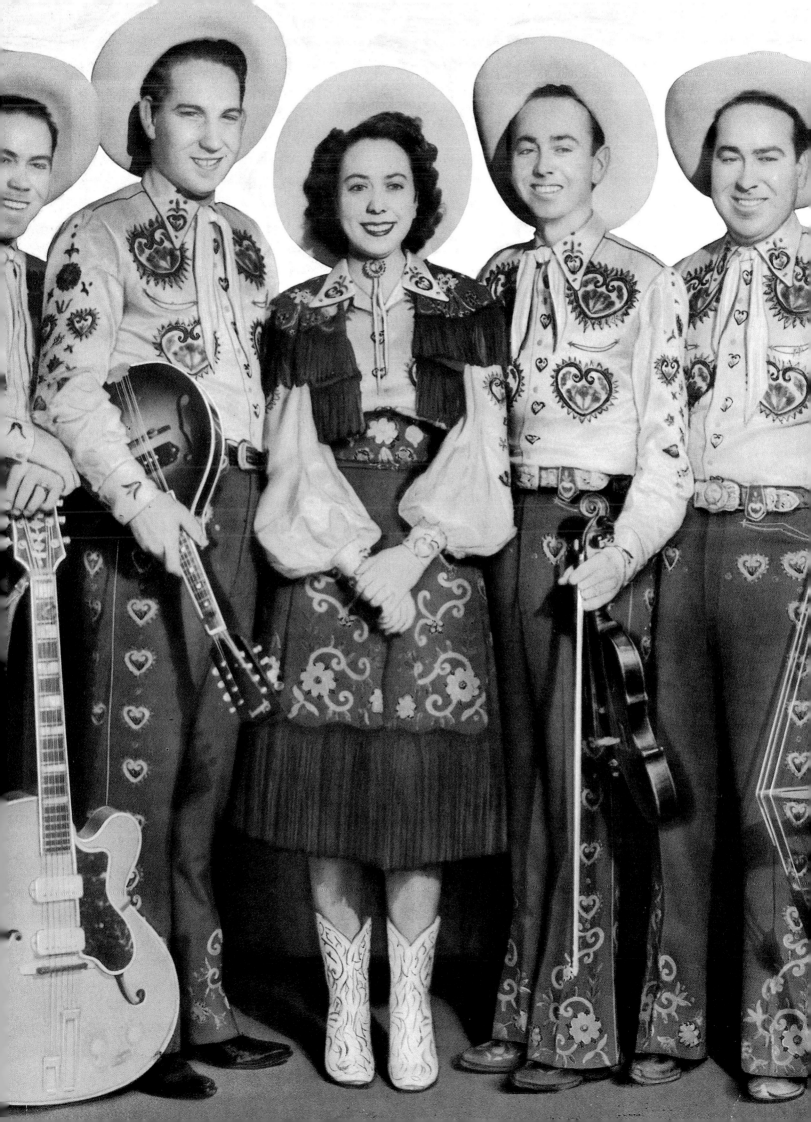

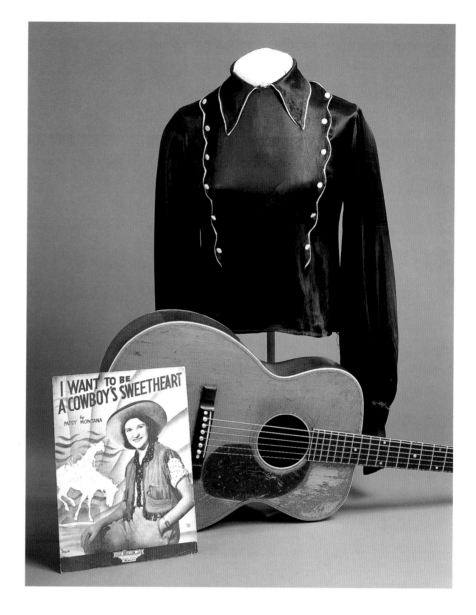

Right: When Patsy Montana appeared in the Gene Autry feature film *Colorado Sunset* in 1939, she had already gained fame for her million-selling hit, "I Want to Be a Cowboy's Sweetheart." The **black satin blouse** was one of several costumes worn in the film and was kept by Patsy for public appearances. Autry Museum of Western Heritage, Los Angeles. Blouse donated by Patsy Montana

Below: Ray Whitley was best known for the music he wrote and the performers he worked with, including his famous collaboration with Gene Autry, "Back in the Saddle Again." Whitley was often recognized by his **pure white Stetson, Chimayo wool jacket, and pink and blue Nudie cowboy boots.** Autry Museum of Western Heritage, Los Angeles. Hat donated by Forrest White; jacket and boots donated by Kay Whitley

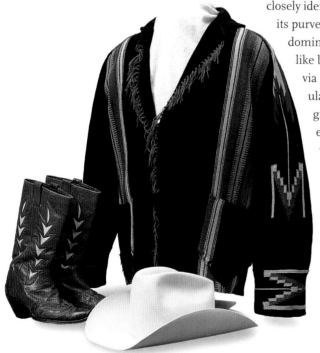

Perhaps more than any other form of American music, country & western has been closely identified with the look of the cowboy (and cowgirl), and clothing has helped to define its purveyors to the public. Though the first decade or so of commercial country music was dominated by Southeastern artists wearing Sunday-go-to-meeting attire or work clothes like bib overalls, by the 1930s, with the greater dissemination of American pop culture via movies, radio, and recordings, the heroic look of the West—inaugurated and popularized by Gene Autry, Tom Mix, and other B-Western and singing cowboy idols— gradually was embraced by C&W entertainers. And, of course, as the popular artists embraced Western style, so too did amateur and wannabe entertainers, as well as their fans.

The idea of musical groups dressing to a Western theme did not begin in the twentieth century. The Dodge City Cowboy Band, for example, was formed in 1880 or 1881 with professional cow-town musicians. Led by conductor Jack Sinclair, the group played the stirring marches of the day, decked out in leather fringed chaps, cowboy hats, gun belts and revolvers, leather cuffs, and cowboy-style pullover shirts. Sinclair donned an exaggerated leather shirt collar with tooled steer heads and sported matching spurs, revolver, and baton crafted from silver and gold inlaid with semiprecious stones and decorated with pictures of cowboys roping cattle. The Dodge City Cowboy Band performed throughout the West as late as 1916.

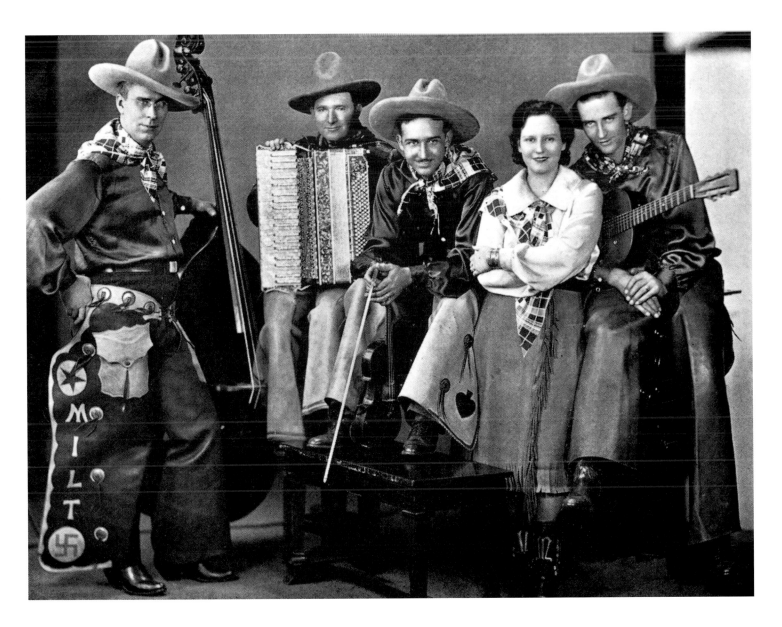

Other musical groups also dressed Western and entertained the public. Buffalo Bill's Wild West Show included a cowboy band that traveled the world over from 1883 to about 1916. Even the Frisco Railroad, as early as 1910, had a cowboy band whose members dressed out of C. P. Shipley's Kansas City supply company catalogue with leather chaps and bib-front shirts embroidered with the words FRISCO SYSTEM. But the dress of these early Western bands only hinted at the flamboyance to come.

The cowboy image was present from the very first commercial country music recording in 1922, in the costume worn by Texas-born fiddler Alexander "Eck" Robertson. The next year, Oklahoman Otto Gray put together a group, dressed them in Western getups, and called them the Oklahoma Cowboys. They claimed to be "riding, roping, shooting, bronco-busting cowboys, and musicians as well." In the late 1920s, the very first hugely successful country artist, Jimmie Rodgers, abandoned his usual attire for a special publicity shot in which he dressed like a cowboy, down to his woolly chaps, neckerchief, and Stetson, a signpost of the future.

Most early country artists, starring on Chicago's WLS National Barn Dance, Nashville's Grand Ole Opry, and other regional barn-dance programs, still looked as if they were right off the farm. In the mid-1930s, though, things began to change when the National Barn Dance's Western-wear-clad stars Gene Autry and Patsy Montana began scoring hits with buckaroo-themed material like Autry's "Back in the Saddle Again" and Montana's "I Want to Be a Cowboy's Sweetheart."

In a photograph from the 1934 *WLS Family Album*, **Louise Massey poses with the rest of the Westerners**. Milt Mabie is to the left, and Louise's brothers, Curtis and Allen, flank her. True to their roots, the group looked more authentic than their pseudo-cowpoke colleagues: Louise wore a buckskin-fringed skirt, like those sported by women in rodeos and Wild West shows, with a large-collared blouse and fairly decorative boots. Under cowboy hats with wide brims and medium-sized crowns, the fellows' puffed-sleeve, yokeless shirts were paired with fancy chaps. Mabie's name was spelled out down the side of his chaps, next to fringed conchas and Navajo symbols. All wore matching plaid scarves knotted in front with the fabric draped around their shoulders. Autry Museum of Western Heritage, Los Angeles

Opposite page: Although her moth-
er, Hilda Hensly, had to make **Patsy
Cline's first outfits**, including this
one, Cline's rapid rise to stardom
soon allowed her to afford the best.
Cline had mailed a letter and specifi-
cations for a new outfit to Nudie
shortly before her death in an air-
plane crash on March 5, 1963.
Collection of Marty Stuart

Below: Fans knew the voice of Tex
Owens because of his appearances
on radio broadcasts; he gained fame
with his composition "Cattle Call."
When he appeared onstage In this
outfit, some of which he ordered
from C. P. Shipley in Kansas City,
Owens fit the part of the singing
trail-drive cowboy. The **custom satin
shirt, studded batwing chaps, and
ivory-handled Colts** were familiar to
fans of Pittsburg, Kansas, radio sta-
tion KOAM, where he was known as
the "Original Texas Ranger." Autry
Museum of Western Heritage, Los
Angeles

Patsy Montana didn't let the fact that she was born Ruby Blevins in Hope, Arkansas, stop her from dressing like a cowgirl. In 1931, after winning a talent show, the eighteen-year-old Blevins moved to California and, under the moniker "the Yodeling Cowgirl from San Antone," started singing on a Los Angeles radio station. Soon after, she teamed with two other aspiring singers billed as the Montana Cowgirls to accompany cowboy entertainer Montie Montana, and took the name Patsy Montana. By 1933, she had made her way to the WLS Barn Dance, where she joined another group, the Prairie Ramblers. There, she found fame with her 1934 million-selling "Cowboy's Sweetheart" and began inspiring other women artists with her white cowboy hat (worn cocked on the back of her head), appliquéd bolero vest or jacket, neck scarf (looped under her Western blouse's collar or knotted around her neck), fancy-beaded belt, and fringed split skirt. Her look—which she sported on stage until her death in 1997—was widely influential.

Also joining Chicago's Barn Dance in 1933, Illinois' Girls of the Golden West—sisters Mildred and Dorothy Goad—wore fancy cowgirl outfits sewn by their mother. Louise Massey was the only authentic Westerner of the 1930s cowgirl singers. The daughter of a New Mexi-co rancher and fiddler, Massey formed The Westerners with her brothers Allen and Curtis and husband Milt Mabie. They began playing at chautauquas and lyceums before getting into radio. Their Western outfits were purchased by mail along the way. The Westerners joined the Chicago Barn Dance in 1933 and became one of its most popular acts, soon releasing hit songs and gaining a national audience.

Gradually more performers started going Western, including Kansas-born singer-song-writer Carson Robison, who put together a group called the Buckaroos, which toured England in 1933. By the late 1930s, the "WLS Family Album" depicted such Western artists as "Curly," decked out in a fancy Western shirt with contrasting piping and exaggerated outlined yoke and smile pockets. In the same program the Prairie Ramblers wore their pants tucked into ornate, butterfly-festooned boots.

Thus the Chicago Barn Dance was instrumental in bringing the Western look to C&W music. In the beginning, most performers in buckaroo garb actually played cowboy songs or "Western" music, making their costumes appropriate, even if the performers had never been on a cattle drive or straddled a horse. But how did the look cross over to Southeastern "hillbilly" singers? It all started with "the Dixie Yodeler," Alabama-born Zeke Clements. After playing the WLS Barn Dance in 1929, Clements took cowboy clothes for the first time to the Grand Ole Opry stage in 1930. That same year, Ken Hackley's Oklahoma Cowboys wore Western on the WSM program. Clements later teamed with Hackley's group, and the resulting Bronco Busters brought the cowboy look to the Opry again.

In the mid-1930s, the first cowgirls on the Opry stage were Texas Ruby Owens, who wore a white hat and tailored Western outfit, and the Lakeland Sis-ters, attired in cowboy hats, fringed frocks, and buckskin vests. This style was never really encouraged for Opry gals, however. Over the next few decades, conservative, ladylike garb such as flouncy calicoes and the occasional "squaw" dress or the comical hillbilly gal "sack" were preferred. Even for the guys, the Western look was initially frowned upon. Pee Wee King's Golden West Cowboys were the first buckaroo-costumed group with an extended Opry stay, beginning in 1937, and that ruffled the feathers of Opry boss George D. Hay, also called the Solemn Old Judge. In his autobiography, *Hell-Bent for Music*, the Wisconsin-born King countered, "If you look at photo-graphs of the Opry cast or the WLS Barn Dance performers in the 1930s you'll see that most of the men dressed in denim trousers and flannel shirts or in overalls and the women wore gingham dresses. To me, they didn't look classy or professional. . . . I bought the best costumes for myself, and I required that the rest of the band do the same. . . . When I came south and formed the Golden West Cowboys, I decided that we should wear cowboy

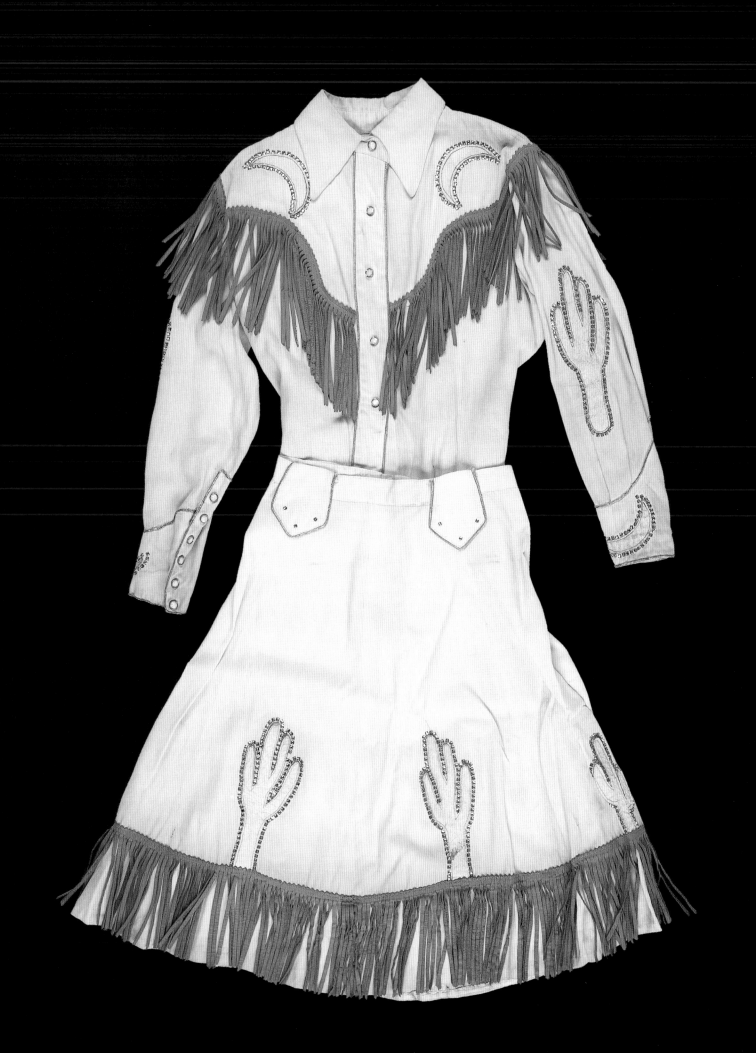

costumes more in keeping with our music and our name. Our first costumes were fairly simple outfits that looked like the trim-fitting costumes used in cowboy movies." Who wouldn't prefer looking like a dashing buckaroo rather than a backwoods clodhopper?

Up in Halifax, Canada, in 1937, a struggling wannabe singing cowboy named Hank Snow cobbled together a homemade Western outfit for a theater engagement. In his memoir *The Hank Snow Story*, he recalled that "[a]ll I had to wear were my neckerchief, dungarees, and the shirt Mother had made. When I went into the dressing room, [the MC] saw me in my Western outfit and said, 'You can't go on the stage wearing that!'" Undaunted in his desire to go Western, Snow purchased his first pair of cowboy boots secondhand for $26 from a circus cowboy.

Western swing also nurtured the cowboy look. According to Hank Thompson, who grew up in Texas seeing such 1930s Western swing outfits as the Lightcrust Doughboys and Bob Wills and His Texas Playboys: "After Gene Autry, the other singers who came along kind of identified with being Western. Bob Wills, back in his early days, didn't dress Western. Then Bob did a Western movie with Tex Ritter called *Take Me Back to Tulsa*, where the band dressed in cowboy clothes, and from that point forward, they all dressed Western." Their attire began to include cowboy hats, boots, and tailored Western suits or matching shirts with frontier pants, with women singers like Carolina Cotton fronting the band in coordinating cowgirl garb. After touring Texas, Oklahoma, and California dance halls, Bob Wills and company made it to the Opry in 1940. Minnie Pearl, in her self-titled autobiography, remembered the impression Wills made: "His men got off the bus dressed in an all-white Western wardrobe . . . just exquisitely tailored gabardine, cut in the Western style. . . . It's the sexiest thing in the world to me."

Before long, Turk and Rodeo Ben began catering to C&W artists, and consequently costumes got fancier and fancier. In California, the Western look became the status quo long before it was accepted in Nashville. "Everybody on the West Coast would wear the colorful outfits," recalls Hank Thompson, who started performing in California in the 1940s. "I don't remember hardly anybody that didn't dress Western out there." Bandleader Spade Cooley, extremely popular in the Los Angeles area beginning in 1942, commissioned Turk to make for him wide-lapeled, piping-festooned drape suits, while his band got coordinated, matching costumes. Jimmy Wakely, Stuart Hamlin (Cowboy Joe), Tex Ritter, and the Sons of the Pioneers also wore Turk's Western clothes. Bands frequently dressed in matching bib-front shirts in coordinating colors with frontier pants attached to stirrups for tucking pant legs into ornate boots. Jerry Scoggins, a member of the Cass County Boys, which backed Gene Autry in the 1940s and 1950s, remembered in 1998 how the group would coordinate their outfits, custom made by Turk (and eventually Nudie). "We went in as a trio to select what we wanted," Scoggins said, "and we'd pick out the material. We all decided together. It wasn't too hard to agree on the things because we pretty much thought alike. We never had any argument about what color, as long as it looked classy. Then it would take them two or three weeks to make them. We had about four or five complete outfits that were alike. And we called them A, B, and C. We'd get on the phone and say, 'We've got a job Thursday night,' and we'd decide we'd wear 'B' and we'd all know what that was."

Not every performer bought custom Western clothing from Rodeo Ben or Nudie. Some of the **suede outfits worn by Carolina Cotton,** who sang with Bob Wills, Spade Cooley, and other big Western swing bands, were homemade. Her boots, now dyed brown, were tan when Nudie first crafted them with the cutouts she specified. Because she could only afford one pair, she would wear colored socks with the boots to match or highlight different outfits. Autry Museum of Western Heritage, Los Angeles. Donated by Carolina Cotton

"Everybody on the West Coast would wear the colorful outfits," recalls Hank Thompson, who started performing in California in the 1940s. "I don't remember hardly anybody that didn't dress Western out there."

Far and above, the biggest singing clotheshorses in California were Rose Maddox and the Maddox Brothers. The Alabama-born family moved west and formed a hillbilly band in the late 1930s. Starting out, the brothers wore simple cuffed denim jeans and matching satin shirts with neckerchiefs, while younger sister Rose chose a fringed buckskin cowgirl skirt,

blouse, neckerchief, inlaid cowboy boots, and hat. By 1945, they had paid enough dues to dress themselves in custom Turk. Rose told her biographer, Jonny Whiteside, "We heard about Turk, that he was the tailor who made all the costumes for the Western stars, so we went down there and had some made. He designed them himself, and they were absolutely fantastic. The boys didn't like straight-legged pants. They wanted bell bottoms like sailors had, and they looked great. Nobody else but the Navy had 'em! We had the short jackets like Eisenhower wore (a style which became known as the Eisenhower jacket); that's where we came up with the idea. We had some made with the longer jackets, but most of 'em were short. The shirts was all embroidered satin, to match the suits, so that in hot weather you could take the jacket off and still have the shirt with matching embroidery and rhinestones, everything to match the trousers. The suits were all made of wool gabardine, a heavy material that stayed looking good, and the shirts were all heavy satin, not this flimsy stuff, and the inside was lined."

Soon, the group's new moniker was "The Most Colorful Hillbilly Band in America." Their spectacular suits of gabardine wool accompanied by satin shirts dazzled audiences with an array of rich hues and eye-catching flowers, hearts, Slavic embroidery designs, and even coyotes howling at the moon. Rose's colorful ensembles and dresses often featured the flower for which she was named. Some of her split, fringed skirts were constructed of buttery soft suede, including a purple one with a wide embroidered waistband embellished with the kind of hearts, vines, and flowers pattern often found on Eastern European clothing and linens. A matching bolero vest with double fringe across the shoulders and edges was worn over a yellow satin blouse with hearts embroidered on the front placket, shoulders, under the piped smile pockets, and on the collars. She also wore fantastically embroidered, body-hugging dresses. Her outrageous wardrobe eventually got her kicked off the conservative Grand Ole Opry, where she started performing as a solo artist in the 1950s. Rose remained loyal to Turk as long as he was in business, telling writer Barbara Hirshberg-Lituchy, "He was the first and the best and was a very nice man."

Turk also found a client in Hank Snow, who purchased his first custom clothes in 1944 from the Philadelphia-based Globe Western Tailors, then from Rodeo Ben. On a trip to California in 1946, Snow later recalled being told that "'out here Nathan Turk does all the Western wardrobes for people in country music and for most of the actors in movie studios.' I went to see Mr. Turk, who took my measurements and I ordered two suits from him. Since he had my measurements, any time I needed a new suit he could send me samples of fabrics and he'd make the suits from the fabrics I'd chosen and forward them to me." One of his first Turk outfits was comprised of an "embroidered quilted shirt and riding britches," with "wide elastic bands across the bottoms of [his] feet [that] held [his] britches in place on the inside of [his] boots." At the time, Snow performed with his young son, Jimmie, whom he "dressed in a little outfit to match mine, along with a cowboy hat and a pair of cowboy boots." By 1948, Hank wrote that his Western "wardrobe was in excellent shape."

In the 1940s, Texas C&W star Ernest Tubb joined the ranks of Turk clients, sporting an elegant custom wardrobe. His trademark became impeccably tailored Western-cut suits with embroidered, contrasting-color designs inset on the jacket fronts, the sleeves, and sometimes the pant legs. Tubb also outfitted his Texas Troubadours in dashing, matching ensembles designed by Turk. Tubb, who helped get Snow on the Opry, made quite an impression on the Canadian yodeler when they first met: "I remember Ernest was wearing a Western-style topcoat and of course his customary big white Stetson hat." Snow was no slouch his first night

Spade Cooley's orchestra filled California dance halls with the swinging sound of his band. Active through the 1940s and 1950s, **Cooley and the band dressed Western with clothes from Nathan Turk and other makers.** Cooley's biggest hit, **"Shame on You,"** seemed to reflect the part of his life that led him to murder his wife and spend the rest of his life in prison. Autry Museum of Western Heritage, Los Angeles

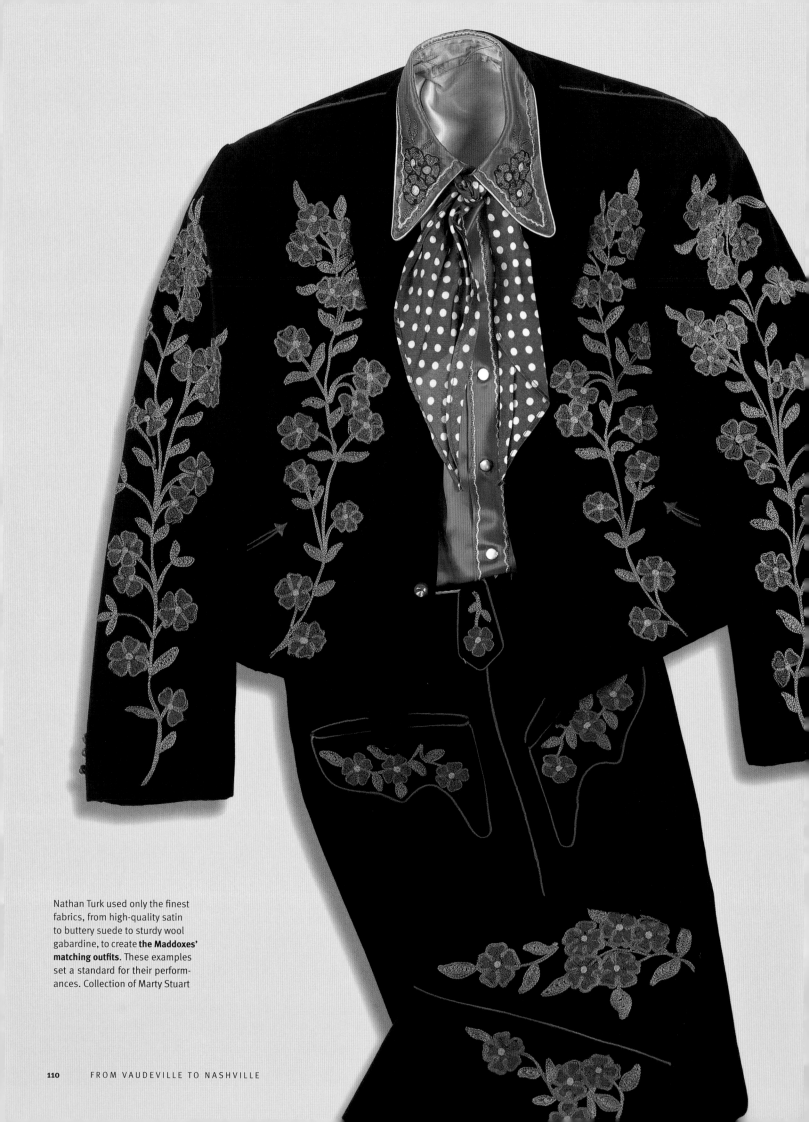

Nathan Turk used only the finest fabrics, from high-quality satin to buttery suede to sturdy wool gabardine, to create **the Maddoxes' matching outfits**. These examples set a standard for their performances. Collection of Marty Stuart

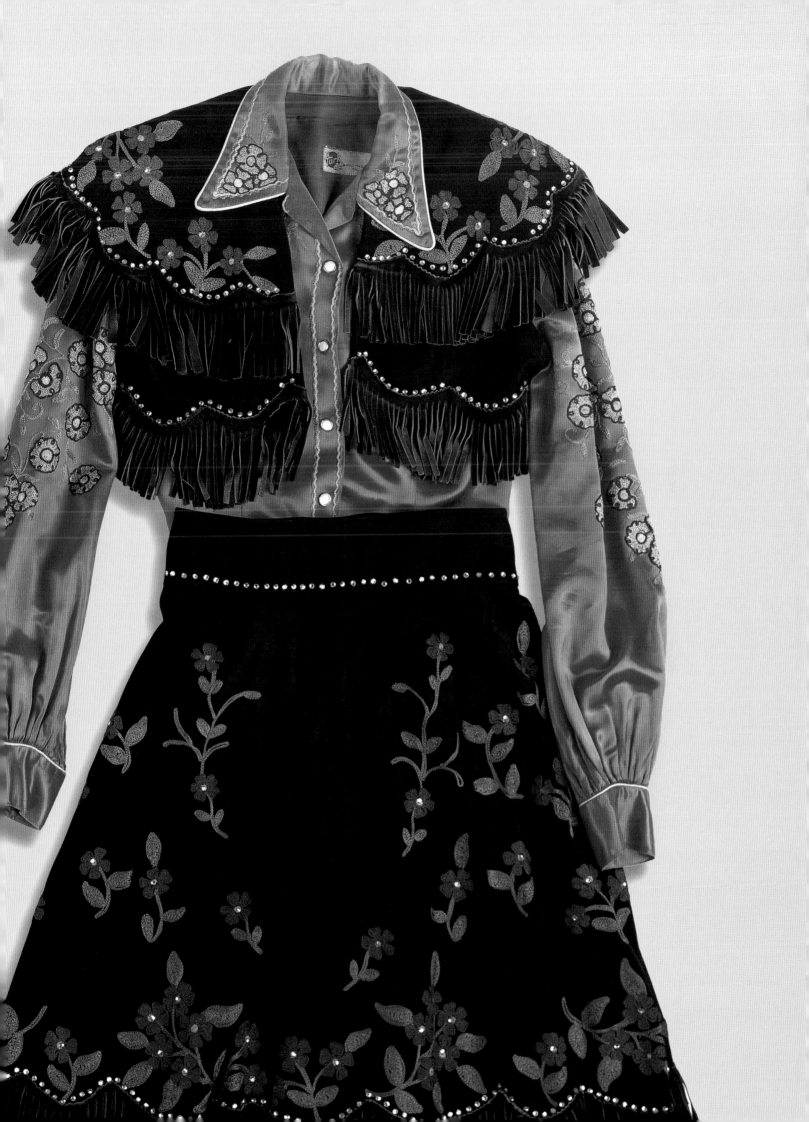

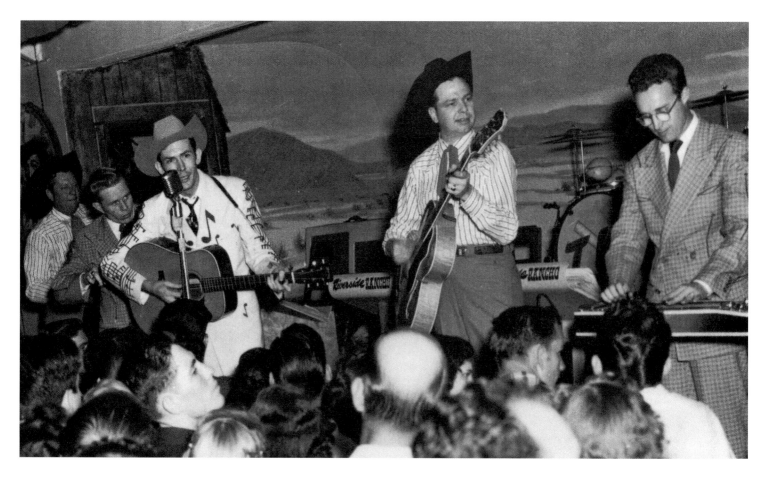

Hank Williams (left), wearing his most famous Nudie suit, backed by his Western-suited Drifting Cowboys. Collection of Holly George-Warren

on the Opry, by the way, wearing his "beautiful custom-made gold suit." That evening, apparently inspired by Tubb, Snow "did something that I have done very few times since. I wore my big white Stetson hat. Back then hats were not so important to country singers. Most artists on the Opry didn't wear them." Once Tubb moved to Nashville, he helped to spread the Western word in fashion, with Snow as his number one proselytizer.

One of the few Southern country artists of the time who had always dressed Western was up-and-coming Hank Williams. It was during World War II, while on tour with Pee Wee King, that Minnie Pearl first met the Alabama-born Williams, who "was wearing a tan suit, boots and a cowboy hat that was slightly soiled." Around the same time, for a tour of troops stationed in Panama, according to Minnie, Pee Wee "had a new wardrobe made for his boys that consisted of white wool cowboy pants and a change of shirts—heavy blue satin and heavy pink satin." Poor Hank, though, could only afford, in those days, to buy a used Western suit from another performer, Floyd Tillman, who happened to be several inches shorter and quite a few pounds heavier. "Mrs. Maxie Goldberg, who had a tailoring place across from KWKH [the Louisiana Hayride, in Shreveport], tailored it to fit Hank, but the britches never did fit," Tillman told Williams's biographer, Colin Escott. "I sold it to him for sixty dollars, but he never did pay me." Hank was not alone; struggling artists wore homemade show clothes, bought them from local, cheaper custom tailors, or purchased them secondhand from other performers.

Enter Nudie: In the late 1940s, he began wooing away many of Turk's C&W customers and winning new ones by giving them their first set of clothes for free. To gain even more customers, the peripatetic Nudie quenched his road thirst by delivering custom stagewear to touring performers, and by attending out-of-town music jamborees. In 1948, he journeyed to the Louisiana Hayride in Shreveport and met new member Hank Williams, whose star quality Nudie immediately sensed. "Hank had been so humble when I visited with him backstage

in Shreveport and that had impressed me too," Nudie recalled. "I knew he wanted one of my suits real bad, but he was too proud to ask me to make him a deal. I liked that. So I decided that I would make him a real special suit and send it to him as a gift and that's just what I did. Hank was thrilled to pieces when he received that suit in the mail. Of course, once Hank hit the big time he wouldn't wear anything but Nudie suits. He and his wife Audrey often wore matching outfits and when their son Hank Jr. was born, they dressed him in Nudie suits as soon as he could stand up."

Nudie had been attending to country stars' needs since his 1947 breakthrough with Tex Williams and his notoriety at West Coast clubs, like the Riverside Rancho. Hank Thompson recalls Tex turning him on to Nudie in 1948, when Thompson played a six-week residency at the Riverside Rancho. "Nudie came along, and he was so much more reasonably priced [than Turk] that I was the second one that Nudie ever made clothes for. I saw Tex and his band and these outfits they had on and I knew they weren't Turk's, so I said, 'Where did you get those outfits?' and he said 'Well, there's a little Jewish fellow and his wife out in the valley that do these.' And I asked him how much he paid for them, and he said 'Well, $40,' and I said, '$40 for a shirt?' and he said 'Yeah, he and his wife work out in their garage.' So I went out there and visited with him and got acquainted and so he made some things for me. The first one was red and white with a black yoke. And he made my wife a matching outfit. Oh, they were really stunning."

The first Grand Ole Opry star to become a Nudie regular was Little Jimmy Dickens, who remembers being introduced to Nudie in late 1949 or early 1950 by his Columbia Records A&R man, Art Satherley. "My first [Nudie] suits were not rhinestoned," says Dickens. "They were just the plain Western suits more or less in different colors. My first one was yellow with a button-on bib front with a large JD embroidered on it. It cost maybe $150." Dickens, in fact, holds the distinction of being the first artist to wear a Nudie suit on the Opry. "When I would go to California, I'd always go to Nudie's," says Dickens. "He would say, 'How's your wardrobe holding up?' I said, 'All I can afford. . . . 'And he'd say, 'Well, let's make you some clothes!' Never sent me a bill. No. I'd have to ask what the suit cost and then pay him as I wanted to pay him. He kept me looking like a million dollars on the stage all the time when there were times that I couldn't afford it."

Before long, Nudie came up with the idea of extraordinary theme-embroidery costumes for special customers like Thompson and Dickens who, in turn, helped spread the popularity at the Opry of ornate Western wear. The song title of Thompson's first huge hit, 1948's "Humpty Dumpty Heart," inspired a bib-front shirt featuring a lavishly embroidered Humpty Dumpty with a heart face, complete with matching footwear. "Nudie was not making boots at that time but he had somebody do that though," Thompson recalls. "There was a girl who was doing some boot work. I think he was farming it out and the tops were done by a lady named Viola Grae who did embroidery work. Actually she did some more embroidery work for me over some things. She did the Humpty Dumpty stuff for Nudie and I'd say she did it for me but she did it for Nudie for me, you know. Nudie helped her do the stuff. Boy, she was really good at it, she was really an artist."

Thompson had several additional pictorial suits made by Nudie to commemorate his hobbies and favorite venues. "Later on, Nudie did some other theme things for me. Because I was a pilot he did something with an airplane and a runway on it, and then of course, I was a hunter, so he made some with ducks and geese and deer and outdoor scenes with trees. A mallard is a very colorful bird and he did some beautiful work with those ducks on there. It was a really neat suit. I was playing the Golden Nugget [in Las Vegas], and so he made me two suits with that theme. One was with a pot of gold and these golden nuggets. It was black with the gold stuff in gold and outlined in rhinestones. And it was a

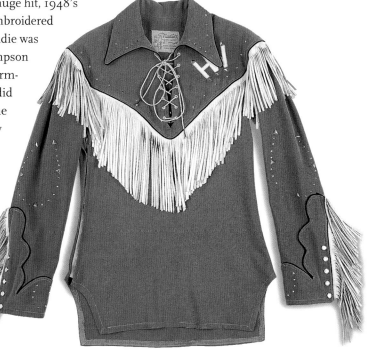

Although **Hank Williams's career** was brief, his contributions to American music are still reflected in the work of the many younger stars who were inspired by him. Collection of Marty Stuart

beautiful suit. The only thing was it was awfully heavy, made of some type of a metallic leather. And then the other one he made me was the Silver Dollar suit. At that time, at The Golden Nugget in the late 1950s to early 1960s, they were using the silver dollars [for gambling]. So Nudie made me silver appliqués of the coins on the jacket and the pants. It was beautiful."

Before there were music videos, there were Nudie suits! Jimmy Dickens's often humorous songs particularly lent themselves to immortality on Nudie's embroidered garments: 1949's "Take an Old Cold 'Tator and Wait" (spuds galore), 1965's "May the Bird of Paradise Fly Up Your Nose" (beautiful multicolored flocks), and 1966's "Who Licked the Red Off Your Candy" (roosters perched on candy canes). "Nudie could do the designs so well," says Dickens. "When I had a song come out that was very popular, he would make a suit. Like I had a [1950] song called 'A-Sleepin' at the Foot of the Bed' that was about a bed full of little kids and the adults at the head of the bed and the children at the bottom. He made a suit like that for me with the bed on the back of the jacket with the adults at the head of the bed and all of the little children at the bottom."

Another fashion plate who eventually became a Nudie regular was Lefty Frizzell. The Texan had been dressing Western since the early 1940s, following in the footsteps of Gene Autry, according to Frizzell's biographer, Daniel Cooper: "Becoming a bit of a dandy himself, [Frizzell] was as entranced by Autry's Hollywood Western fashion as by the music. Lefty loved to wear bright bandannas around his neck—both to hide his birthmark and to better affect

Little Jimmy Dickens's **outfits, decorated with elements from his hit songs,** came in many colors and designs. These reflect his well-known hit, **"May the Bird of Paradise Fly Up Your Nose."** Collection of Little Jimmy Dickens, courtesy of the Grand Ole Opry Museum at Opryland USA

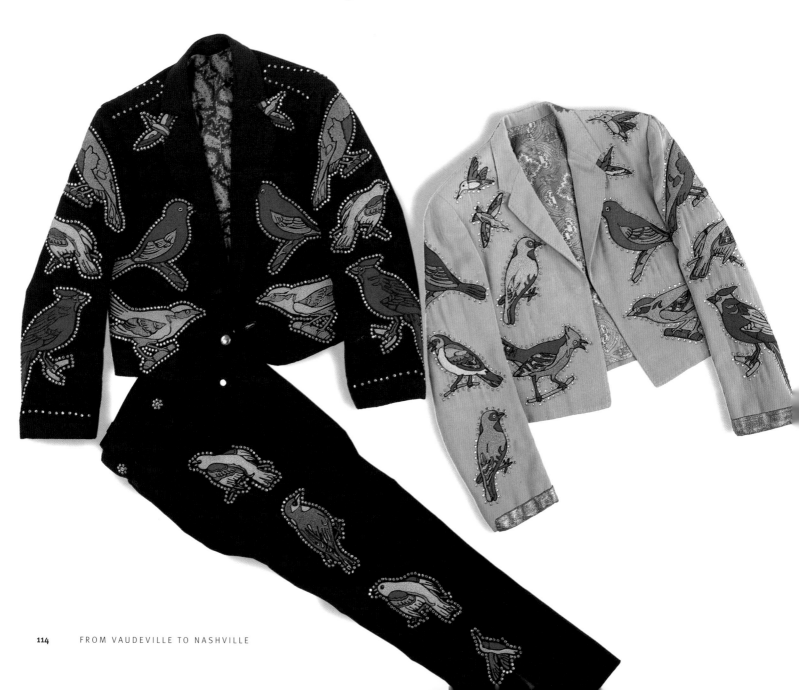

the cowboy style. He'd have his mother sew flashy buttons onto his shirts and sometimes ask her to dye them." According to Cooper, the day Lefty met his future wife, he "was wearing his usual bandanna and one of his fake cowboy shirts. He had moccasins on . . . and his thick curls were plastered flat with an ocean of Brilliantine. The girl took one look at him and wrote him off. 'I thought he was kind of sissy-lookin', she said." Once Lefty made it big in the late 1940s, he began "designing his own western outfits—heavy on the leather fringe angle. . . . Detachable fringe was not the least of Lefty's concepts." Nudie, of course, was his perfect match, and their meeting resulted in what became the tailor's signature design innovation.

The two met in 1951, when the Riverside Rancho's owner brought Frizzell to Nudie's store. "Lefty Frizzell was such a hot number when he hit Los Angeles," Bobbie remembers. Nudie also wrote of this momentous occasion in his memoir: "Lefty was a real handsome guy, and I got to thinking Lefty would sure look terrific wearing rhinestones. He had ordered some stage clothes from me and I decided to surprise him by making him up a shirt with some sparklers. I figured that I'd better not get too wild for starters or else he'd never wear it. So I made him up his regular style suit and sewed his initials on either sides of the lapels in rhinestones. Now, my rhinestones are the best that money can buy. They're made in Austria and they're almost as brilliant as diamonds. When the spotlights hit them, they really shine. . . . I kept it simple knowing that there'd be enough sparkle in those initials to captivate everybody in Lefty's audience. Of course, I'd started to wear rhinestones myself, and by my standards Lefty's suit was downright conservative. But when I showed the suit to Lefty, you would have thought I was asking him to go onstage in a G-string. . . . He said that he was afraid to look like a sissy."

The white Western shirt, with long contrasting fringe (a Lefty trademark) hanging from the yoke, had matching frontier pants, with fringe dangling from the front pockets. The L and F outlined in blue rhinestones took up much of the yoke. Sure enough, the shirt was a huge hit when Frizzell wore it onstage. "After that," wrote Nudie, "Lefty kept coming back to me for more. Every time he'd order a suit, he'd say, 'Put on a few more rhinestones, Nudie. Put on those rhinestones!'"

Bobbie Cohn smiles at the memory: "It was like setting a fire. Lefty said, 'You can make 'em as loud as you like!' Nudie started making fringe and putting rhinestones just at the bottom of the fringe. But as time went on, we'd rhinestone each fringe. It took hours, it was a slow process. You set one stone at a time. That's the way it grew, you know. Everybody saw that rhinestone fringe." Frizzell's outfits got more and more ornate, with huge embroidered, rhinestone-encrusted guitars on lace-up shirt fronts, with lengthy glittering fringe dangling from sleeves and yoke. A white gabardine suit with detachable gold metallic leather fringe studded with rhinestones was one of Frizzell's most famous outfits.

In the meantime, by 1951, Nashville-based entertainers were clamoring to meet this Nudie fellow. Dickens, along with Cowboy Copas, another Opry star who played California, "came to see us, and they said, 'Nudie, you've got to get to Nashville. They've got to see your stuff,'" Bobbie recalls. Shortly thereafter, she and Nudie filled their car with costumes and headed east for the first of many Music City trunk shows. Opry and Louisiana Hayride stars began ordering their own signature designs with imaginative embroidered motifs symbolic of their name or repertoire: thus, wagon wheels for Porter Wagoner, husky dogs for Ferlin Husky, spider webs for Webb Pierce. Some would come up with innovations in the clothing's design, based on their needs. Wagoner commissioned Nudie to make him cutaway jackets, for example, to show off the fancy belt buckle the tailor had given him as a gift. Country star Carl Smith, who frequently rode in rodeos, had Nudie cut out a rectangular slice of fabric from the back of his pant-leg bottom so his silver spurs could poke through unhindered.

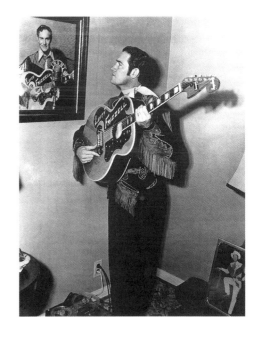

Above: With Nudie's encouragement, **Lefty Frizzell adapted nicely to Western fringe.** He appears to admire the look himself. Collection of Michael Ochs Archives, Venice, California

Below: Flash and fringe, **musical notes and embroidered guitars by Nudie** helped to light up Lefty Frizzell onstage. Collection of the Country Music Hall of Fame, Nashville

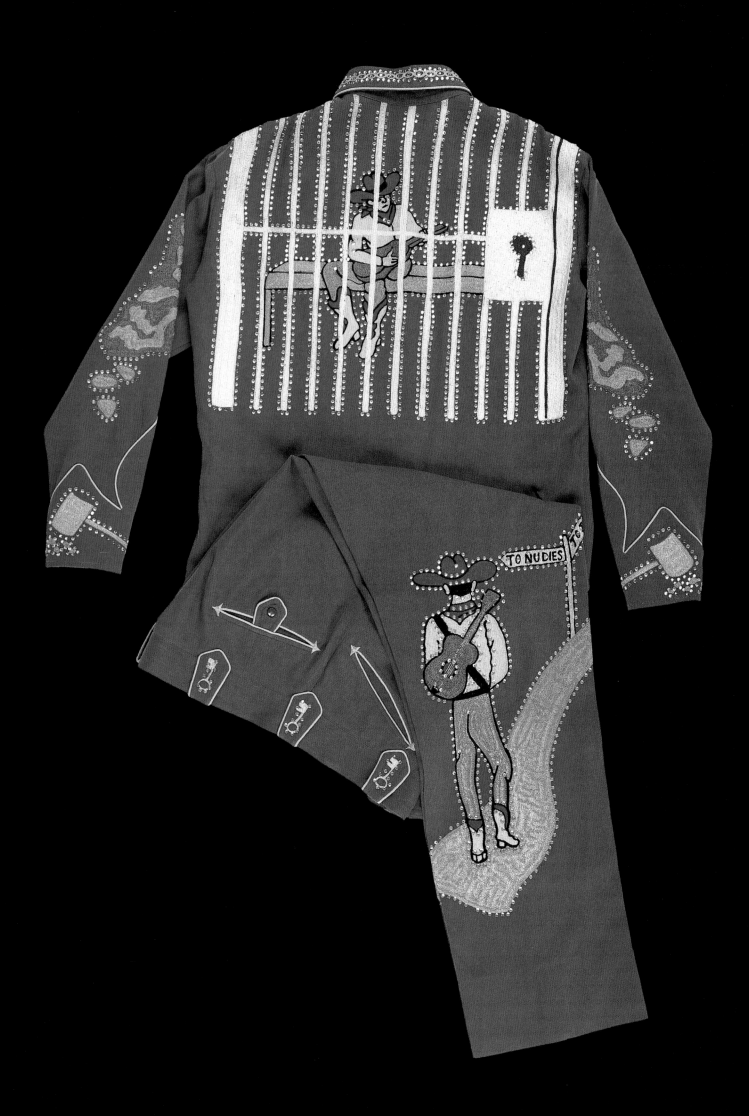

Once he became a star, Hank Williams was also a regular Nudie costumer; his most famous ensemble was a white drape suit covered in black musical notes. (In 1953, at age twenty-nine, Hank was buried in it; years later, son Hank Williams Jr. commissioned an identical one.) Wife Audrey ordered fringed cowgirl suits that coordinated with her husband's outfits. In 1951, the couple opened their own Western-wear shop, Hank & Audrey's Corral, in Nashville. After Hank's death, Audrey continued to order clothes for herself and Hank Jr.; in a 1965 letter to Nudie, she demanded, "Hank Jr.'s suit will be all gold sequins. You should use gold Italian silk material for this. Hope that this will give you a clear picture of what I wanted. SWEETHEART, I needed this yesterday."

Also among Nudie's regular Nashville clients was Pee Wee King, who wrote in his autobiography, "I wanted my own outfit to stand out. It had to be not just bright and shiny, but flashy, with gold and red and green embroidery. Even in the 1950s my shirts would cost as much as $65 each." Nudie made him fancy shirts and jackets embellished with dazzling crowns and fantastic castles to commemorate King's name.

One of the few country queens to wear Nudie's fringed and rhinestoned dresses on the Opry stage was Goldie Hill, who began performing there in 1953. A Texan, she had grown up wearing cowgirl outfits and boots, and as a singer starting out with her brothers, she dressed up in lovely embroidered Western-cut blouses with matching skirts and boots that she bought off the rack in San Antonio. "In Texas, there were a lot of Western stores around," says the blue-eyed Hill, who today lives with her husband Carl Smith on a Tennessee horse farm. "Even people who weren't singing wore those kind of Western outfits with fringe and leather inlay. My brothers wore the pearl button shirts with jeans. They didn't wear the rhinestones and I didn't either—until Nudie, that was the rhinestones. After I was in Nashville a while I didn't wear Western dresses all the time. The Opry frowned on that, they didn't like it!"

Carl Smith was also a big Nudie customer; he wore handsome suits with inset gold or silver trapezoids, decorated with rhinestones, as well as the occasional fringed ensemble. Spectacular ones include a fringed red outfit decorated with large guitars and musical notes appliquéd and studded with rhinestones; and a pair of white suits, one with silver leather appliqués and studded fringe, the other gold. Smith recalls that the suits weighed thirty-five pounds each.

Besides Hill, the only major East Coast cowgirl of the 1950s was Patsy Cline, who began her career wearing fringed tops and split skirts designed and sewn by her mother, Hilda Hensley. Patsy's sometimes skimpy, skintight costumes became renowned in small-town Virginia and Washington, D.C. She "incorporate[d] a Nudie's of Hollywood meets Frederick's of Hollywood costume in her act," according to Margaret Jones in *Patsy*. "'The Outfit' consisted of a pair of fringed short shorts that emphasized Patsy's bodacious fanny, a fringed décolleté top that bared her midriff, broad wrist cuffs, a dashing white scarf tied flush around her neck, and the usual white cowboy boots. It was cowgirl show glitter to the max, and it is still remembered for its sheer audacity." (As a matter of fact, Frederick's was making sex-bomb cowgirl ensembles at the time, which could have inspired Patsy's style.) Cline's more modest split-skirted fringed outfits in an array of colors often sported appliquéd moons and cacti created by her mother's loving hands. She eventually gave up her cowgirl outfits for glamorous cocktail dresses.

On the West Coast, the cowgirl look predominated among women performers, such as the stars of its 1951 television program *Town Hall Party* and its 1958 nationally syndicated spinoff, *L. A. Ranch Party*, hosted by Tex Ritter. Television helped to spread a variety of Western looks among C&W artists and viewers: Levis with trim cowboy shirts; Davy Crockett–style fringed buckskin jackets or "shirt-jacks"; fringed, embroidered, or appliquéd split skirts with tops; and dresses with Western details, like piping along the yoke and smile pockets. All could be found on *Ranch Party*, where women

Opposite page: Webb Pierce told mournful stories in his songs, and Nudie illustrated them on Pierce's suits. This one is for **"I'm In the Jailhouse Now,"** originally recorded by Jimmie Rodgers. Collection of the Country Music Hall of Fame, Nashville

Below: Until his death in 2000, accordion player Pee Wee King was considered Nashville royalty. After playing with Gene Autry, King moved to Nashville in the late 1930s. With his band, The Golden West Cowboys, he gained his greatest fame with "The Tennessee Waltz." This is **one of his Nudie outfits, complete with castles and crowns, from the early 1960s.** Autry Museum of Western Heritage, Los Angeles

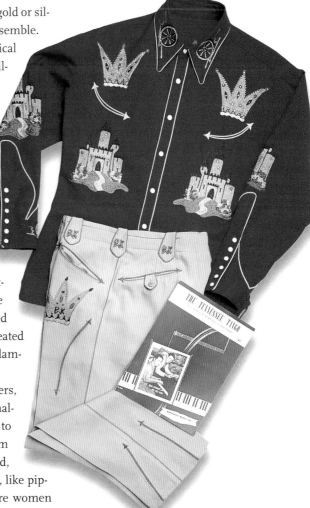

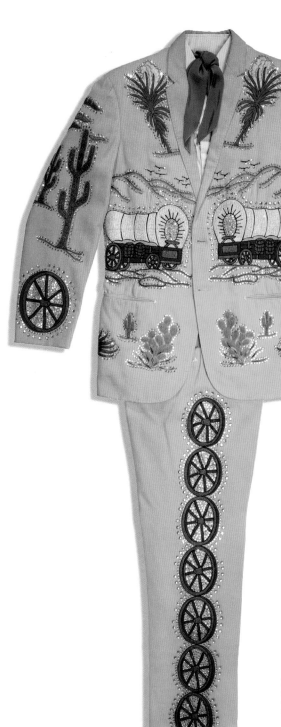

From the Grand Ole Opry to his long-syndicated television program, Porter Wagoner has been a fixture in Nashville and anywhere country music is popular. His **signature Nudie suits with covered wagons, wagon wheels, and cacti** took on many colors and many forms. Autry Museum of Western Heritage, Los Angeles

played much bigger roles than on East Coast television shows. Rose Lee Maphis, Lorrie Collins, and Fiddlin' Kate were among the regulars on the show, which also boasted several female backup singers and a woman pedal-steel-guitar player. (Outfitted by Turk, one male regular, Carrot Top Anderson, wore a wardrobe of various colors, each outfit with pistol-packing anthropomorphic carrots embroidered on the bib-front shirt.) Nudie also outfitted a lot of the performers on *L.A. Ranch Party* and other shows, including those of Cliffie Stone and, on the East Coast, Jimmy Dean, who had previously been a Rodeo Ben customer.

Also based in California, Buck Owens, architect of the Bakersfield Sound, began wearing his own distinctive suits featuring short bolero jackets studded with luminous rhinestones and twinkling metallic embroidery. Owens and his Buckaroos frequented Turk before switching to Nudie. "Turk was about half as cheap [as Nudie] and gave you a lot," Owens explained in 1999, while showing off his costumes on display at his Crystal Palace museum and roadhouse in Bakersfield. "He gave a quicker turnaround too." Turk made Owens dashing black, charro-inspired suits, with silver embroidery, before Buck migrated to Nudie's for extravagant rhinestone-studded suits. One gold suit, covered in approximately ten thousand stones, was so heavy Owens only wore it once.

Jimmy Dickens, who, like Owens, favors short jackets, remembers that "you chose the material, then Nudie would do all the measurements. Mr. Nudie cut every piece of cloth." Dickens estimates he got about three Nudie suits a year for decades. "My wife says that she's married to one man, and when he puts on a Nudie suit he's a different person," Dickens explained in 1998. "I think that wardrobe in this business is a great percentage of your acceptance. It means so much. I feel good in it, you know. There's a change when you take off your blue jeans and put on a suit like this."

Longtime country star Bill Anderson agrees: After donning a costume with its sparkling rhinestones, "it's like when Clark Kent goes in the phone booth—he comes out and he's Superman!" Waiting to perform on the Opry in 1998, decked out in a sharp Eisenhower-cut black jacket sprinkled with jet stones, Anderson explains, "It just always gave me a feeling of confidence—like I knew that curtain wasn't going to go up and I would see somebody out there wearing the same thing I was." In 1960 and 1961, before Anderson could afford Nudie suits, he ordered costumes via mail from a Buffalo, New York–based tailor, S. A. (Sam) Formann. One of Anderson's favorites was purple with white snowflakes. When he scored a string of number-one records in 1962, he began outfitting himself and his band, the Po Boys, in custom Nudie ensembles: "If I had a nickel for every outfit I bought from Nudie, I could have retired a long time ago!" Anderson says with a laugh. "I always believed in dressing my band, though. I wanted them to look sharp. The curtain would go up and there they would be in those bright-colored suits and I would always have a contrasting suit."

Hank Snow, a Nudie customer for decades, also became one of his dearest friends. Snow took an active role in designing his outfits, sending the tailor long letters describing in minute detail the look he wanted, with embroidery ideas, color choices, and sizing information, sometimes accompanied by drawings: "Hi there Ole Buddy. . . . I will attempt to try to describe four suits that I would like you to make at your earliest possible convenience . . . and along with the information I am about to give you I am sending a very rough sketch of the suits, but these were made or drawn while I was in bed sick with the flu so they are horrible. . . . I would like a color something between an amber and a cream . . . and on the front of this coat, I would like a train on each side, preferably the old-time steam engine type instead of the diesels I have drawn. Train could be most any color that would contrast good with the suit, the smoke should be brown or black. On the two breast pockets should be a brakeman's lanterns and which should be red or black . . . no pockets on the sides unless you can put them there without interfering with the trains, which is the whole idea of the suit—'Movin'

On,' remember?" Snow also specified that shirt pockets be deep enough to hold his favorite brand of "extra long" cigarettes.

Bullfrogs, lily pads, turtles, Indian chiefs, and dancing braves made their way onto Snow's suits. As Versace would be to Madonna and Elton John, Nudie was to Snow, Webb Pierce, Faron Young, Ray Price, Cowboy Copas, Hank Thompson, Merle Travis, and other C&W stars. Among their unforgettable suits are Webb Pierce's "You're in the Jailhouse Now" outfit, decorated with an imprisoned cowboy on the back and on the front a signpost with the legend TO NUDIE'S and TO JAIL, leading down a curvy road; George Jones's "White Lightnin'" suit, covered in moonshine stills and xxx-marked jugs; Merle Travis's suit featuring giant guitars, with his name emblazoned on the neck; and Cajun country artist Jimmy C. Newman's gator-covered suits. And for Porter Wagoner, of course, it was Conestoga wagons and wagon wheels.

Wagoner's relationship with Nudie began way back, but his present-day account is as vivid as if it were only yesterday. "My wearing rhinestones was entirely Mr. Nudie's idea," says Wagoner.

I was working in Springfield, Missouri, in 1953, on a television show called the Ozark Jubilee. *Mr. Nudie showed up there one day at the rehearsal. He came backstage and introduced himself. At that time I was wearing just regular Western-cut clothes, like stockman suits—none of the fancy things. Nudie said, "I wanna talk to you a few minutes about your wardrobe." He said, "I make clothes for movie stars in California. What you've got on looks great on you, but anything would look great on you because you're like a mannequin—you're about 6'2", slender built, and so forth." He said, "You'd really look great in clothes that was made tailored to fit." He talked on a few minutes and he said, "I wanna make you something that is really different—something like you've never seen." And I had no earthly idea what he was talking about. He said, "I wanna make you a suit that when you walk out on the stage, people will just go ahhhh." So I said, I probably wouldn't be able to afford something like that, and he said, "I'll make the first one for you for free. Because then if it works," he said, "I know I'll be making a lot of them for you throughout your career." I never really thought a lot more about it, and about six weeks passed, I guess. I got this box in the mail one day, and in it was the most beautiful peach-colored suit I'd ever seen in my life, and a pair of boots that matched it, and a shirt. The jacket had rhinestones all over it and a covered wagon on the back outlined in rhinestones. It was just unbelievable—you can imagine, a country boy seeing something like that! Hell, I just went nuts! My sister said I tried it on eleven times that day—she counted. I'd put it on, go and look at it in the mirror, then I'd take it off and in about an hour I'd go and do it again. The first time I wore it on the* Ozark Jubilee *I walked on the stage and people just went 'Wow!' It was that powerful!"*

Fifty-three suits later, all of which he can still wear, Wagoner estimates he has spent hundreds of thousands of dollars on his wardrobe. The first Nudie suit he paid for was $1,500; the most expensive was $14,000. His favorite is a lavender beauty with roses and unicorns on the front and a giant unicorn embroidered and studded with sparklers on the back. Though that fabled animal is "extinct," it lives on in legend. And thanks to Porter Wagoner, Jimmy Dickens, and a few others, the golden era of the Nudie suit—the mythological cowboy look taken to the extreme—lives on every Friday and Saturday night at the Grand Ole Opry.

Above: Nudie's original files document **explicit customer instructions, measurements, even sample embroidery,** in this case related to one of Porter Wagoner's multitude of wagon-wheel outfits. Autry Museum of Western Heritage. Donated by Bobbie Nudie (Cohn)

Overleaf: Hank Snow and His Rainbow Ranch Boys toured the country with their leader in a never-ending variety of Nudie suits. This **outfit with bullfrogs and turtles** was created at about the same time Snow first released the hit song "I've Been Everywhere," in 1962. Snow took an active role in dreaming up the the embroidery that Nudie brought to life. Collection of Marty Stuart

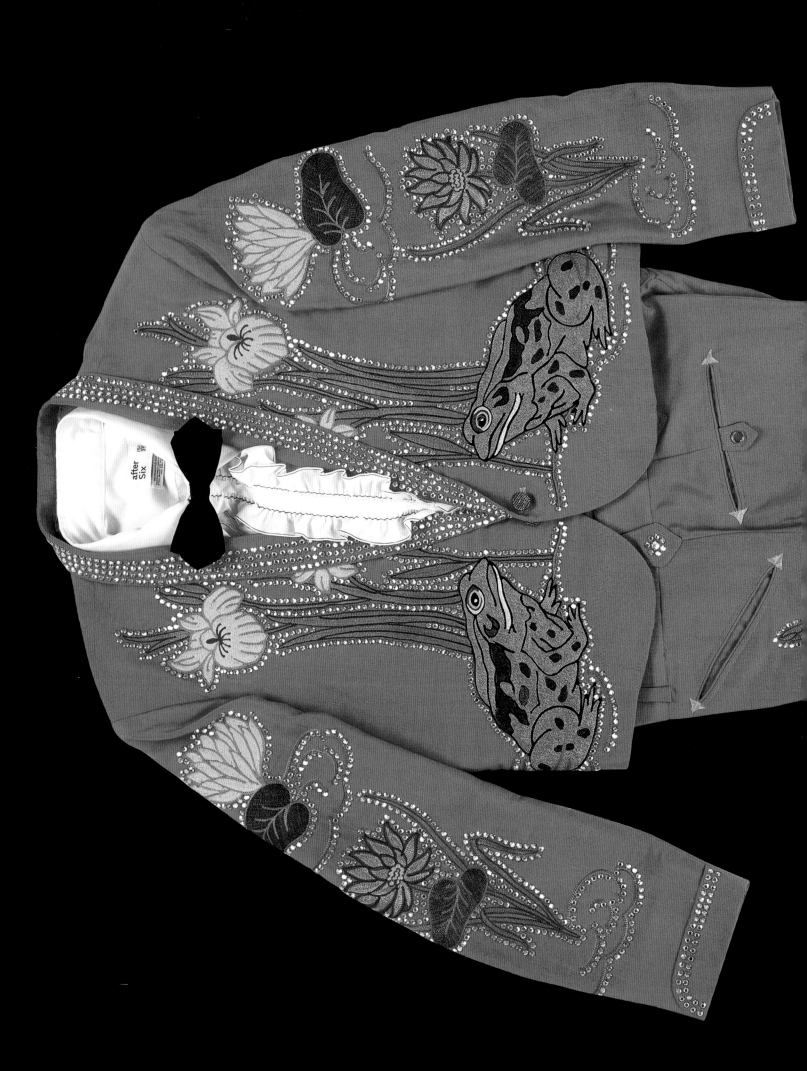

Western Wear Beyond the West:

Rodeo Attire, Dude-Ranch Duds, and Fiesta Dress

A low drawl hums through the halls of the Denver Merchandise Mart as members of the Western English Sales Association (WESA), dressed to the nines in smart Western suits, fancy cowboy boots, and stylish felt hats, fill orders for the latest in Western garb. Every January since 1922, merchants and manufacturers have descended on the Mile High City to trade their wares. Friendly but competitive, the folks milling about the show booths at the 1992 International Western/English Apparel and Equipment Market make up a virtual *Who's Who* of the Western-apparel industry. Members of old family businesses delight in recounting the stories behind their colorful Western fashions. An annual event is a cocktail party thrown by Rockmount Ranch Wear, a third-generation family-run manufacturer that has been selling Western wear to retailers and mail-order catalogues since 1946.

Dude-ranch brochure. Autry
Museum of Western Heritage,
Los Angeles

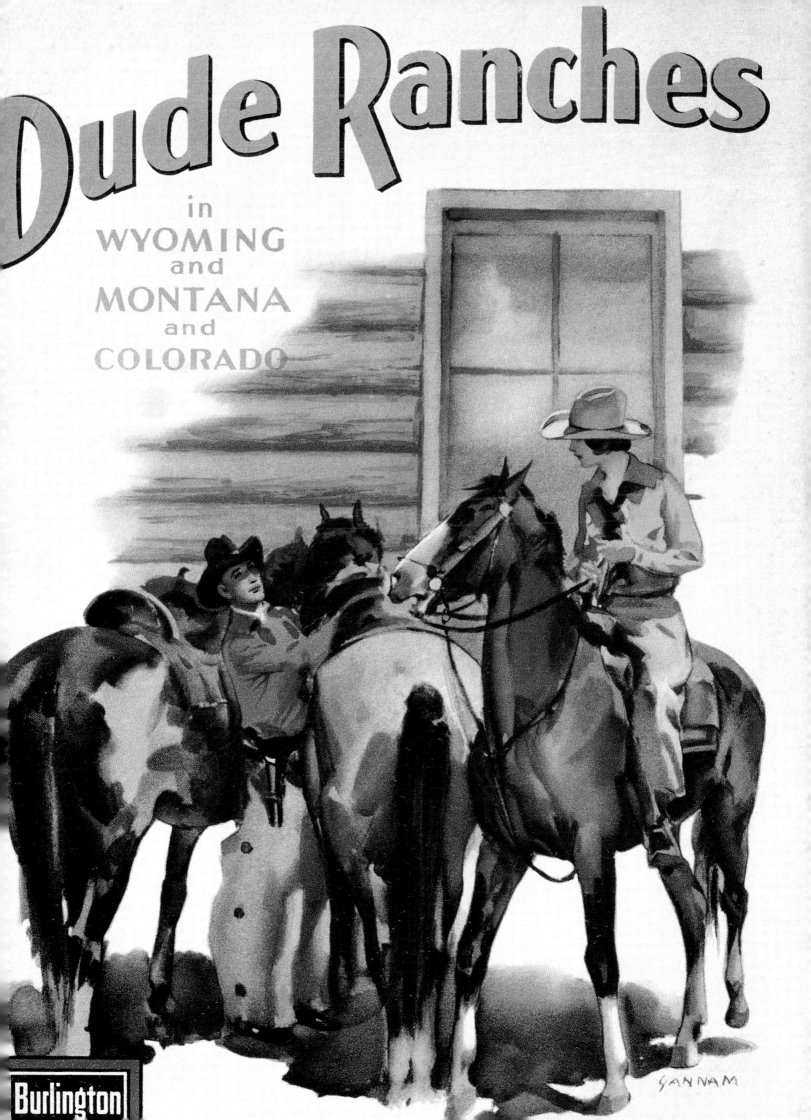

Above: **Three generations of the Weil family** have contributed their talents to the success of Rockmount. Clockwise from upper right: Jack A. Weil, who founded the company in 1946; Steve Weil; and Jack B. Weil. Courtesy of Rockmount Ranch Wear Mfg. Co., Denver, Colorado

Right: Manufactured in about 1946, this purple and black Rockmount shirt with snap buttons and embroidery, created by Rockmount founder Jack A. Weil, is one of the earliest mass-produced women's **Western shirts**. Weil's son, Jack B., in turn created the woman's sleeveless yellow shirt in about 1954. The man's plaid shirt dates from about 1949. The classic Rockmount sawtooth pockets and diamond snaps are characteristic of the period. Collection of Rockmount Ranch Wear Mfg. Co., Denver, Colorado

Opposite page: Actor Alan Ladd wore an **H Bar C shirt** just like this one. Little did he know that the horse heads and the cowboy on the bucking horse on the back had been copied directly out of a Gene Autry coloring book. Autry Museum of Western Heritage. Donated by Margaret Meile

Jack A. Weil, born in 1901, is the founder and president of Rockmount Ranch Wear. Wearing his signature silver bolo tie, he hangs salesman's samples on a metal grid wall. On this day, in a meeting with the Frontierland gift-shop buyers from Tokyo Disneyland, the veteran salesman, his son, Jack B Weil, and grandson Steve Weil talk up their latest cowboy collection. Steve shows off one of the company's best-sellers, a denim bib-front cavalry shirt sporting buttons reminiscent of Indian-head nickels, and then gives his Far Eastern clients a sneak preview of a fitted vest with contrasting saddle stitching and diamond-shaped snaps that is not yet in the line. "They have ordered things from us that we never thought were salable because they broke the price barrier," Steve explains. "We've been able to experiment with special fabrics and treatments for the contemporary Japanese market as a result of their commitment to new and different design."

One of the latest trends in Western shirt designs is embellished yokes inspired by retro looks. Steve holds up a shirt modeled on one of his grandfather's original 1940s designs. It sports floral embroidery, piped cuffs, pearl snaps, and set-in smile pockets reinforced with the eldest Weil's signature three-point stitched star. He then proudly points out that Rockmount has a shirt in its line that is thought to have been in production in the industry longer than any other: a solid broadcloth shirt with sawtooth pockets and diamond-shaped pearl snaps, the prototype of which resides in the Smithsonian Institution's permanent collection.

The business of bringing Western apparel into the homes and lives of working cowboys and cowgirls, as well as those folks far removed from the real West, developed as it became apparent to retailers and manufacturers that there was a market for it. What had originated as practical, utilitarian clothing for stockmen, cowboys, and ranchers gradually became embellished by details of Western costuming made popular by entertainers and rodeo stars.

By the 1930s, Western apparel makers had begun to diversify to appeal to unique regional preferences. Although fancy rodeo styles were still considered show attire by both the manufacturers and the ranching community, brightly colored, fancy piped "rodeo shirts" and sturdy wool "rider" pants and jackets, along with boots, belts, mufflers, chaps, and hats, filled numerous pages of mail-order catalogues and graced eye-catching displays in stores. In the 1940s, embroidery began to proliferate on both men's and women's Western shirts.

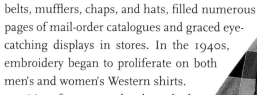

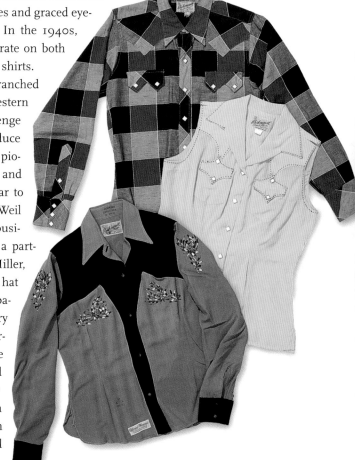

Manufacturers who branched out into the decorative Western shirt market faced the challenge of devising ways to produce these styles in factories. A pioneer in bringing distinctive and unconventional Western wear to the mass market, Jack A. Weil began his first stint in the business when he entered into a partnership in 1935 with Philip Miller, of Denver's well-established hat distributor, Miller and Company. Although Weil's primary expertise was in manufacturing and sales, when he turned to design, he spruced up the company's line by adding colorful Western shirts decorated with set-in arrow pockets, whimsical

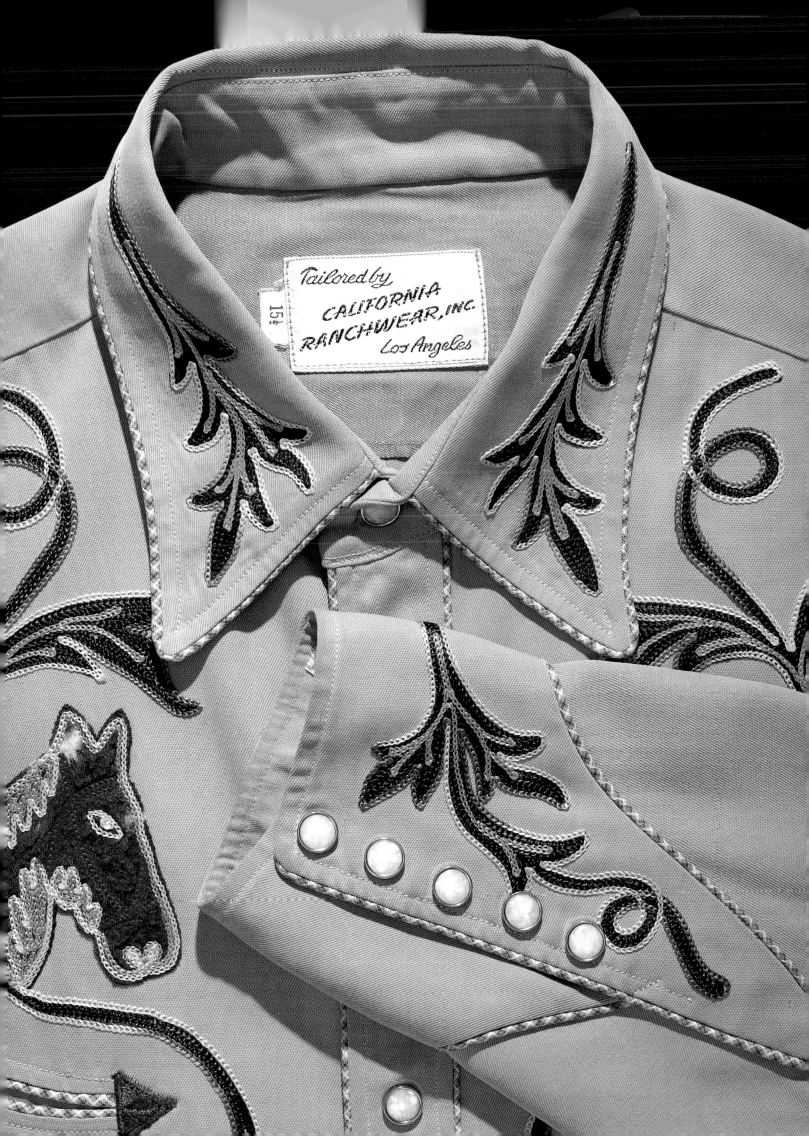

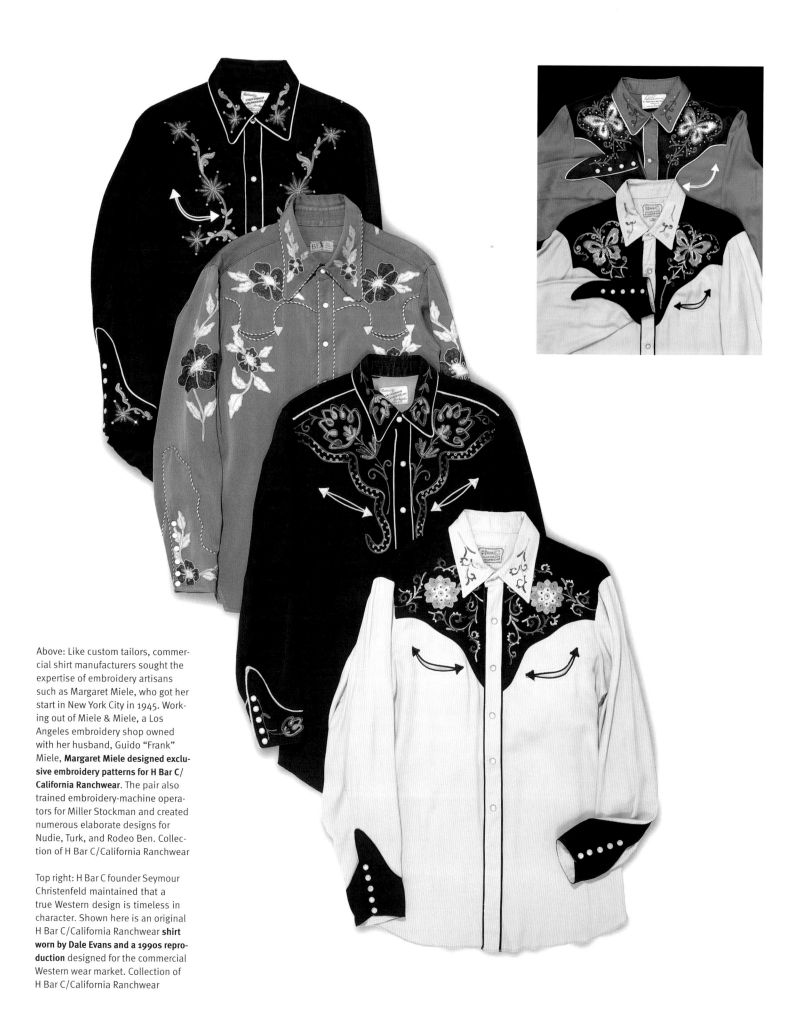

Above: Like custom tailors, commercial shirt manufacturers sought the expertise of embroidery artisans such as Margaret Miele, who got her start in New York City in 1945. Working out of Miele & Miele, a Los Angeles embroidery shop owned with her husband, Guido "Frank" Miele, **Margaret Miele designed exclusive embroidery patterns for H Bar C/ California Ranchwear**. The pair also trained embroidery-machine operators for Miller Stockman and created numerous elaborate designs for Nudie, Turk, and Rodeo Ben. Collection of H Bar C/California Ranchwear

Top right: H Bar C founder Seymour Christenfeld maintained that a true Western design is timeless in character. Shown here is an original H Bar C/California Ranchwear **shirt worn by Dale Evans and a 1990s reproduction** designed for the commercial Western wear market. Collection of H Bar C/California Ranchwear

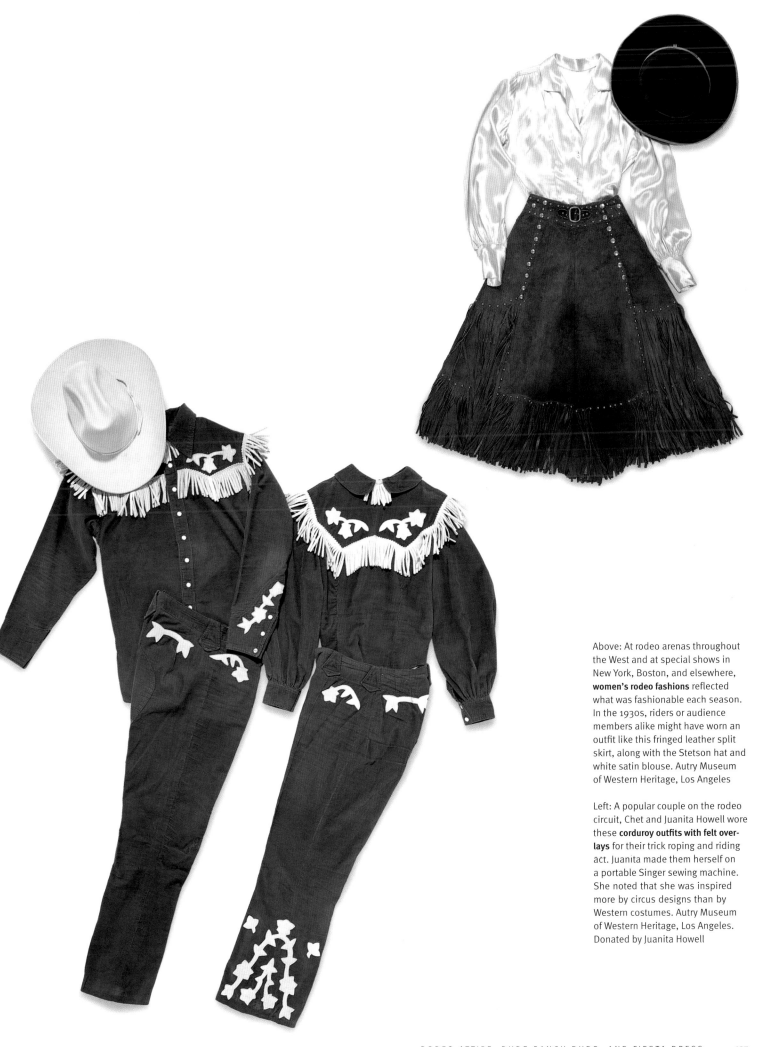

Above: At rodeo arenas throughout the West and at special shows in New York, Boston, and elsewhere, **women's rodeo fashions** reflected what was fashionable each season. In the 1930s, riders or audience members alike might have worn an outfit like this fringed leather split skirt, along with the Stetson hat and white satin blouse. Autry Museum of Western Heritage, Los Angeles

Left: A popular couple on the rodeo circuit, Chet and Juanita Howell wore these **corduroy outfits with felt overlays** for their trick roping and riding act. Juanita made them herself on a portable Singer sewing machine. She noted that she was inspired more by circus designs than by Western costumes. Autry Museum of Western Heritage, Los Angeles. Donated by Juanita Howell

Above: In 1915, Yakima Canutt proudly posed with his Pendleton, Oregon, 2nd-place **champion cowboy chaps**. His checkered pants, *Police Gazette* champion buckle, cotton shirt with cravat and sleeve garters make up the perfect outfit of the pre–World War I rodeo star, not to mention both working and Hollywood cowboys. Autry Museum of Western Heritage, Los Angeles

Right: **Blue Bell Wrangler jeans** have long been the first choice among cowboys and rodeo riders. One 1954 Wrangler ad claimed that "Five out of six rodeo champs wear trim-fitting Blue Bell Wranglers," including all-around champions Todd Whatley, 1947; Gerald Roberts, 1948; Jim Shoulders, 1949; Harry Tompkins, 1952; and Bill Linderman, 1950 and 1953; all were paid to endorse the 11MWZ and 13MWZ jeans. Wrangler's distinctive pocket and label have been constant since the jeans were first developed. Autry Museum of Western Heritage, Los Angeles

Western-theme embroidery, and fancy contrast piping. Like many of his peers, Weil was inspired to create his designs by watching cowboy movies.

"My greatest asset when I got into this business was that I knew that I didn't know anything about it," Weil reminisced in 1992. "I used to sit in the picture shows and watch Tom Mix, whose shirts were tailor-made, and I'm sitting there trying to see how I can do that commercially."

One of the most significant changes in mass-market Western fashions occurred when pearl snaps replaced buttons on the cuffs and front plackets of cowboy shirts. Though many commercial manufacturers have claimed to be the first to use snaps, Weil's recollections are very clear. "I thought a snap on a shirt was a breakaway item; if you hung on a pommel of the saddle it would pop open and not hang you there like buttons would," he recalled. Prior to World War II, Weil sought out, from Connecticut's Scovill Manufacturing Company, metal open-end gripper-snap fasteners like those used on infants' clothing and undergarments. Unbelievably, Scovill salesmen resisted selling Weil the snaps, arguing that it would be a misapplication of their product; needless to say, Weil persisted and won them over. "The day the war was over [and metal rationing had ceased], I was back in [their showroom in the] Chrysler Building," he remembered. "I said, 'You damn fools! All I want to do is make money for you!' I finally talked loud enough that one of the big-shots of the company heard the conversation and came in and said, 'I want to meet this man!'" Weil left Miller and Company in 1946 to start his own successful enterprise, Rockmount Ranch Wear, and years later adopted the befitting slogan for that company, "We put the snap in Western wear."

Concurrently with Weil's groundbreaking successes in the Western shirt business, the Christenfelds of H Bar C Ranchwear in New York City, were fashioning a small fortune in frontier pants, Western shirts, and English riding breeches. Operating under the auspices of Halpern and Christenfeld, Inc., H Bar C produced some of the industry's finest embroidered and appliquéd gabardine Western shirts and Western-styled stockman pants and suits. One of the five sons born into the business, Paul Christenfeld recalled in 1992 that "H Bar C was started in 1920 by a partnership with Abraham Halpern and my father, Samuel H. Christenfeld. Halpern had been in the men's pants business, and Christenfeld had been a factory manager making breeches for the U.S. Army during the Great War [World War I]. Making army breeches led to work breeches after the war, which in turn, led to English riding breeches and jodhpurs, then to Western double-seat frontier pants and Western shirts—tapered, double yoked, and with snaps." In 1936, Seymour Christenfeld, Paul's younger brother, headed west to open a Pacific Coast branch in Los Angeles. H Bar C merchandise was

stocked and distributed in their Los Angeles offices. In the 1940s, the company moved to larger quarters, installed a garment factory on the premises, and began to manufacture beautifully embellished Western shirts and apparel under the name of California Ranchwear.

The postwar popularity of all things Western had a domino effect, and the burgeoning Western-wear market attracted many savvy entrepreneurs. In the late 1940s, following in Jack Weil's footsteps, other ex-Miller employees founded such Denver-based companies as Karman Western Wear and Prior. Western-state-based brands such as Texas Togs, Ranch Man, and Ranch Maid of Denver, Panhandle Slim, Tem Tex, and Gross of Denver began affecting the apparel scene as well. Charles Kauffman, great-great-grandson of Herman Kauffman, founder of the New York City Kauffman's, a saddle shop and Western-wear emporium that opened in 1875, enjoys pointing out that in those days "West of the Mississippi, Western wear *was* the entire apparel business."

Special events and occasions associated with cowboys and Westerners—rodeos, dude ranches, and Western fiestas—helped popularize Western clothing styles across the nation. For those who headed West to attend such events, part of the fun was dressing up. Those who wore the clothing every day defined the styles associated with these festive affairs: the rodeo cowboy's flashy shirts and chaps, the dude rancher's blue jeans, plaid shirts, and buckskin jackets, and the decorative ribbon-trimmed patio dresses worn for fiesta days in the Southwest. These styles became synonymous with the look of the West and with the places where they were worn.

The rodeo especially proved to be a breeding ground for Western styles. Details spurred by rodeo attire, such as the snap closures on Western shirts and specially cut jeans, are what ultimately sets Western wear apart from other genres. Throughout the years, rodeo style developed from a melting pot of clothing types: practical Western work wear, Native American costume, Mexican folk dress, theatrical Western costumes, and, of course, the rider's preference for and interpretation of these styles. Rodeo riders created unique "looks" so that fans and judges could recognize them in the arena. Gene Autry and Roy Rogers took this style to extremes in the 1940s and 1950s, lighting up rodeo arenas for their personal appearances with their rhinestoned and fringed—even fluorescent—Western glamour look. With coveted championships and lofty purses at stake, rodeo riders sought to distinguish themselves by their outfits, as well as by their roping and riding performances.

As cowboy clothes became more popular with Western consumers, specialty catalogues that primarily sold riding equipment such as saddles and harnesses began featuring Western-style garments. Renowned saddle makers Hamley and Company of Pendleton, Oregon, established in South Dakota in 1883 and relocated to Oregon in 1905, started adding ready-made clothes to its catalogue pages prior to World War I, along with local tailors' custom apparel for rodeos and roundups. Hamley's 1942 *Cowboy Catalog* offered an assortment of merchandise from other West Coast apparel manufacturers, including White Stag, Pendleton Woolen Mills, and Levi Strauss. as well as custom-tailored "made for a Queen" rodeo show leathers. The catalogue also offered 150 pages of anything a Westerner would need to fulfill his wildest rodeo and parade-riding fantasies: handcrafted saddles, including the official regulation "Bucking Saddle" for major rodeos, sterling-silver bits, spurs, mounts, champion buckles, boots, and hats. Companies such as Hamley's, and Prosser Martin of Del Rio, Texas, often sponsored major

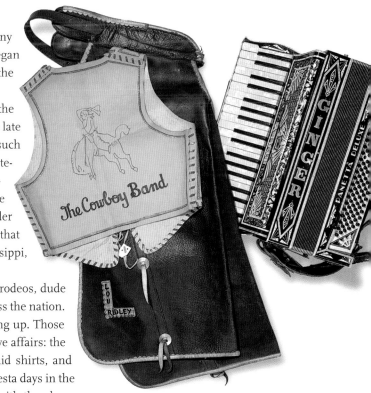

Above: There is no reason to believe that Lou Ridley ever sat on a horse even though he **performed at Madison Square Garden in the Cowboy Band**. Each member of the band had an identical outfit. The chaps and vest were probably ordered from a New York maker. Autry Museum of Western Heritage, Los Angeles

Below: For many years, the firm of White and Davis outfitted Colorado cowboys, whether in person or by mail. This cartoon displayed in the shop perfectly summarizes **some attitudes toward both dudes and fancy Western wear**. Autry Museum of Western Heritage, Los Angeles

Above: **Fay Ward,** cowboy, historian, and designer of Western wear. Courtesy of Mrs. Fay Ward

Below: The **Sundowners in one of their matching Fay Ward outfits,** featuring embroidered longhorns, cacti, and tooled belts with matching buckles. Courtesy of Bob Boyd

rodeo events, set up merchandise booths on the rodeo grounds, advertised in the programs, and paid the champions to endorse their products.

Jeans were standard garb for rodeo riders, and as the demand for Western styles expanded from regional to national and competition grew, jeans manufacturers began using the popularity of the Western mystique in marketing to the rest of the country. In 1947, Blue Bell Manufacturing of Greensboro, North Carolina, introduced its Wrangler label after enlisting the talents of Rodeo Ben to create the definitive Western jean. A year later, the Wrangler IIMWZ (men's with zipper) was launched with "Qualitag" booklets, attached to the belt loops, which featured comic-book-style illustrations of Rodeo Ben and world-champion cowboys Jim Shoulders and Casey Tibbs, both of whom contributed to the final design, and stories of "Great Moments in Rodeo." The same year, Levi Strauss dropped the wholesaling division of its business to concentrate solely on manufacturing. Later, Casey Tibbs would endorse Lee Riders; he was quoted in a 1954 ad as saying, "Rodeo is tough on clothes. That's why I always wear Lee Riders—best cowboy pants made."

In saddle-bronc riding, cowboys could experiment with fashion and flaunt their personal styles. The 1954 Madison Square Garden Rodeo program described this event as "one of the more colorful features in that the competing cowboys usually adorn themselves with their fanciest shirts, chaps, boots and ten-gallon hats." Rodeo Ben was the best known East Coast tailor who catered to rodeo champions, but others were scattered about the country. The Globe Tailoring Company in Denver, for example, made custom suits for the likes of famed rodeo announcer Cy Taillon. In the early 1940s, ranch hand, author, illustrator, and happenstance Western-wear designer Fay Edward Ward set up shop at 306 West 48th Street in New York, designing Western ensembles for the competitors and tourists who flocked to the annual rodeos and Wild West shows there.

Ward's life story is as colorful as the Western clothing bearing his label. According to his widow, Mrs. Martha Ward, Fay E. Ward was born on October 8, 1888, in Adelaide, Iowa, to parents who performed in Wild West shows. His father, a Roman chariot racer, met another woman and left his mother, a trick rider who was dying of cancer. Eight-year-old Fay was placed in a foster home in South Dakota with a family who raised Morgan horses. Grateful but unhappy with his situation, he ran off to work on a ranch, spent several years living on a Sioux Indian reservation, and eventually found a job on another ranch doing chores and learning to break horses. From 1909 to 1922, he participated in rodeos. Later in the decade, he did some land-sitting on isolated property, where he began writing and illustrating a book *The Cowboy at Work.*

During the Depression, Ward found himself in New York City in search of a publisher for his book. Though he did not immediately find a publisher (the book was eventually published in 1958), the artistic Ward stumbled upon a new avocation while hanging around Madison Square Garden during the annual rodeo. Meeting a fellow cowboy who had a small tailoring business, Ward was hired to illustrate a catalogue featuring his own Western-wear designs. Ward's design ideas, based on his experiences, led to him to start his own business, "which wasn't much more than a hole in the wall," Martha Ward recalls. "He rented a cheap little one-room place . . . and took a bedroll down there and that's where he slept. He paid whatever he could afford. But soon the cowboys were coming to him with their orders to sew things. That was how Fay got started in the clothing business." Ward hired seamstresses (eventually number-

ing six) and learned how to choose piece goods for his embroidered shirts, piped jackets, and ranch pants. He found another ex-ranch hand, Bill Dickey (known as Nevada Dick), who had become a tailor, and hired him as store manager and chief cutter. Producing small mail-order leaflets, Fay Ward eventually made custom shirts for such stars as Ken Maynard and Tim McCoy, as well as for small time entertainers like Chicago's Sundowners, who ordered more than one hundred garments through the mail in the 1940s and 1950s. Fay Ward frequently advertised in rodeo programs and magazines like *Hoof and Horn*. Tiring of city life, Ward sold his business to his partner, who carried on production in New York while Ward headed west to Arizona, where he met and married Martha in 1959. There, they began work on a second book about the history of the rodeo, which was never published. Fay turned to sculpting, which he pursued until his death in 1979. Until she became an invalid, Mrs. Ward sewed cowboy shirts for friends using Fay's old patterns.

Buck Bernie was another custom tailor who sought rodeo champs as clients. His plain stockman shirts, fancy suits, and cowgirl outfits were available through his mail-order catalogue and at his shop on South Main Street in Los Angeles. Beginning in the 1940s, he billed himself "the Cowboy's Tailor" and ran ads in magazines like *Western Horseman*.

One of the best known artisans who catered to fashionable broncobusters was Edward H. Bohlin of Hollywood and Palm Springs, who, from the 1920s to the 1980s, dressed both horse and rider in elaborate silver-studded leather riding show-ring and parade outfits, many of which are still being used. A patron of the rodeo as well as outfitter, Bohlin commonly donated to their purses valuable championship buckles and bridles, many with detailed images engraved in silver of Western-attired rodeo riders competing. Along with his heavily ornamented leather creations, he offered custom-tailored gabardine riding apparel, using silver for trim accents, such as sterling snap fasteners fashioned after California mariposa lilies on shirt-front plackets and sleeve cuffs. Bohlin also created deluxe leather cowgirl outfits laden with silver, and a bevy of flamboyant Western accessories including silver collar points, scarf slides, hat bands, heel caps, gauntlets, and ornate buckle sets. His customers often appeared to be dressed in shining Western cowboy and cowgirl armor.

From the early days of rodeo, its queens wore some of the most resplendent outfits in the arena. When young Miss Bertha Anger won the Pendleton Round-up ticket-selling competition in 1909, she also won the honor of being its first queen. She rode into the arena on a float wearing a fringed buckskin riding skirt with matching vest that her mother had made for her. Four years later, Gladys McDonald, dressed in a wine-colored fringed leather split skirt, cowboy boots, and a Western hat, rode in on horseback and set the precedent for future queens and their courts. White buckskin divided skirts, matching vests, and billowy satin shirts were the official attire for the Round-up's queen and court from 1922 to 1944.

Rodeo queens like Bertha Anger and Gladys McDonald represent the long line of cowgirls—dating back to Lucille Mulhall, "The Golden Haired Girl of the West"—who earned the respect of their fellow cowpunchers in the rodeo arena. Many of the cowgirls also performed trick and fancy riding in the rodeo, which required additional costumes, including ornately decorated boots with jodhpurs, satin bloomers, or split skirts made of corduroy or leather with matched bolero vests. It was common for cowgirls to fashion their own fancy duds, as many of them were as skilled on the sewing machine as on horseback. In the 1920s, famed trick rider Tad Lucas designed a new type of cowgirl

A rodeo fan, musician, or rider visiting Madison Square Garden often found Fay Ward's products appealing. This **wool outfit of the 1950s** is typical. Autry Museum of Western Heritage, Los Angeles

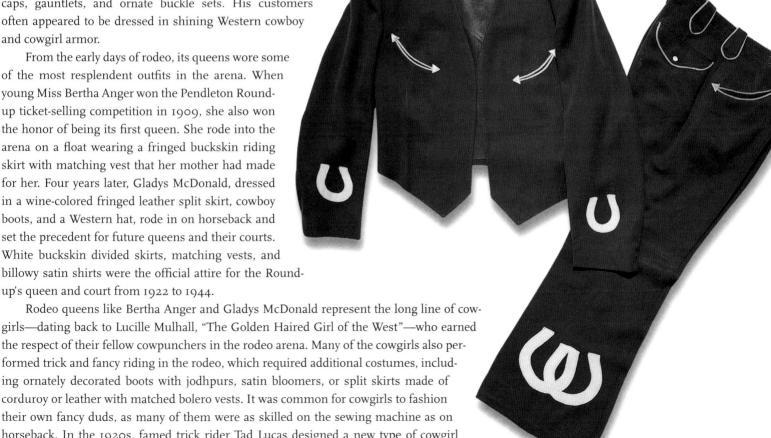

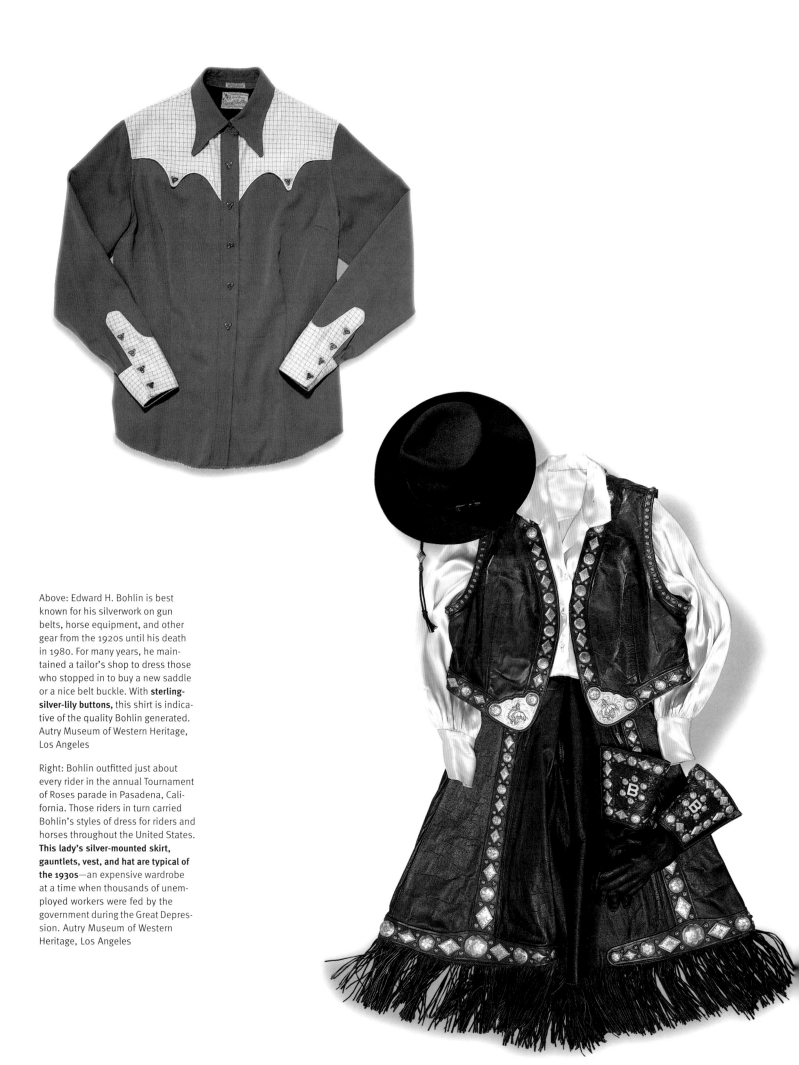

Above: Edward H. Bohlin is best known for his silverwork on gun belts, horse equipment, and other gear from the 1920s until his death in 1980. For many years, he maintained a tailor's shop to dress those who stopped in to buy a new saddle or a nice belt buckle. With **sterling-silver-lily buttons,** this shirt is indicative of the quality Bohlin generated. Autry Museum of Western Heritage, Los Angeles

Right: Bohlin outfitted just about every rider in the annual Tournament of Roses parade in Pasadena, California. Those riders in turn carried Bohlin's styles of dress for riders and horses throughout the United States. **This lady's silver-mounted skirt, gauntlets, vest, and hat are typical of the 1930s**—an expensive wardrobe at a time when thousands of unemployed workers were fed by the government during the Great Depression. Autry Museum of Western Heritage, Los Angeles

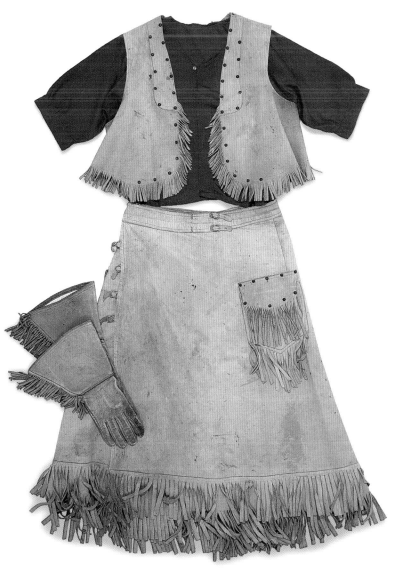

Left: From the 1910s until the 1950s, Caroline Lockhart was a liberated woman in quiet Cody, Wyoming. As an author, newspaper editor, rancher, and public figure, she was both worldly and common. This **fringed leather outfit** reflects Lockhart's growing girth in the 1930s and 1940s. It was likely worn at the Cody Stampede rodeos and other events. Autry Museum of Western Heritage, Los Angeles

Below: Bonnie Gray was one of the great cowgirls of the 1920s and 1930s. Her champion horse, King Tut, thrilled audiences by jumping over automobiles and performing other tricks. Bonnie was well known as a rider of broncos and a competitor in other rodeo events. Her **lace-up boots, jodhpurs, and silk sash were made Western with the addition of a huge Stetson hat.** Proudly wearing the number thirteen, Gray won many trophies. Autry Museum of Western Heritage, Los Angeles

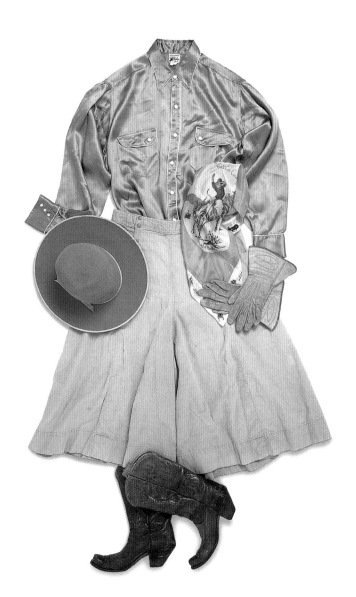

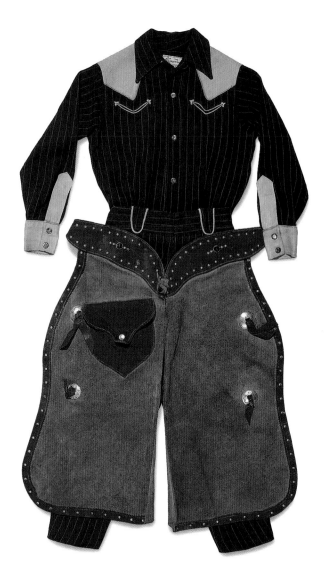

trousers to replace jodhpurs. She stitched fabric inserts into her flared pant legs, creating bell bottoms. Later, she took the flash up a notch, adding sequins and rhinestones to outline the flared leg.

Though male riders were undoubtedly competitive about their appearance, only the women were officially "judged" by their looks. According to "Meet the Ranch Girls," in an issue of *Rodeo Magazine,* rodeo queens "were selected from their communities as typical outdoor girls skilled in ranch duties and horsemanship. Other requirements were personality, photogenic qualities, intelligence, figure, beauty and oomph. . . . Just the same, they are real glamour girls of Western society and can slip into an evening gown and step out into a ballroom as rivals to their Eastern sisters." The duties of a court and queen necessitated elaborate and often costly Western wardrobes for multiple public appearances and social obligations.

Indeed, by the 1950s, women's high-styled Western wear was gaining immense popularity as contemporary cowgirls Dale Evans and Gail Davis, television's Annie Oakley, defined their own looks. Western manufacturers began expanding their women's line; rather than simply featuring suede split-skirt-and-bolero numbers reminiscent of rodeo-wranglin' lasses, or female versions of men's Western shirts, apparel companies offered the latest fitted fashions duded up with a Western twist. The 1950 Denver Dry Goods catalogue offered "exclusive Western wear for women—for every purpose." Besides an affordable assortment of Western wool gabardine and cavalry twill trousers, suede-fringed and blanket-style fitted jackets, and

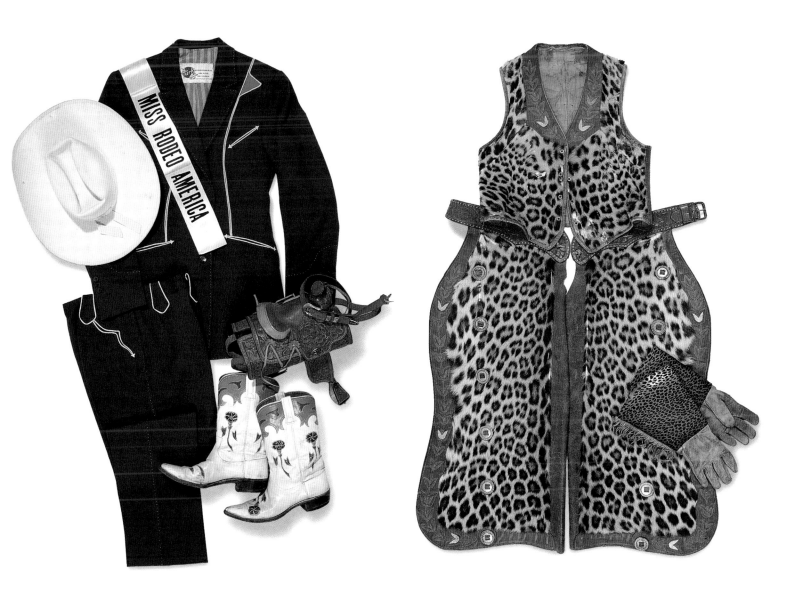

embroidered and appliquéd two-tone piped shirts, there were the Premier and the Ladies' Frontier—high-priced made-to-order Western wool suits. The catalogue included a separate section for "practical Western wear," featuring such denim apparel as Ladies Levi's, as well as cotton plaid long-sleeve snap-front tops.

Rodeo audiences had a perfect occasion to don their finest Western apparel too. Arthur Carhart wrote in *Hi Stranger*, his 1949 "handbook" on how to be an authentic Westerner, "If there is an excursion to a rodeo . . . you can cut loose in all the finery you can gather. This is the one place the range dwellers really give full rein to their love of color and fine fabrics. You'll not be out of step in the most colorful outfit you can put together." If a wannabe Westerner didn't already own Western shirts, cowboy boots, or ten-gallon hats, there was usually an assortment of merchandise available at the concession stands in the arena or in nearby Western stores. Fans could also have an outfit fashioned for them by local custom tailors and seamstresses, many of whom advertised in the classified sections of rodeo programs. Tyler Beard, vintage Western-wear dealer and author of *The Art of the Boot*, found that, in the 1940s and 1950s in rodeo towns, families such as the McClures of Fort Worth, Texas, "had a little place downtown or made outfits in their garage, or Mom and sister made them in the house. They could design [for their customers] right there on the spot." Mel Marion, who traveled to the big rodeos to build his Resistol accounts, remembers buying, as recently as the 1980s, from Williams Shirts, also out of Fort Worth. "They used to custom make me shirts," he recalled. "They were primarily cotton shirts, but you could design your own shirt right there,

Above left: In 1959, eighteen-year-old Susan (Cox) Stauffer was crowned Miss Rodeo America. Among the prizes she received was this **brilliant blue Nathan Turk suit and tooled-leather saddle-shaped purse**. Over the next year, Stauffer appeared at rodeos and other functions throughout the country. Her travel outfits included a suit of leather and a vibrant red one of wool. Autry Museum of Western Heritage, Los Angeles. Donated by Susan Stauffer

Above right: It would be difficult to imagine a more striking look than that conveyed by the individual wearing these **jaguar chaps and matching vest**. The gauntlets are calfskin with printed spots. Such fur garments were evident as early as the Civil War and occasionally made their way to Wild West shows and rodeos. The best guess would be that this example from the 1920s was worn by a showoff rodeo cowboy or a hopelessly misguided tourist. Autry Museum of Western Heritage, Los Angeles. Vest and gauntlets donated by High Noon Western Collectibles

put your fancy yokes on and everything. Or I'd get a letter from him with some new shirting material, and then you could sketch out the design you wanted or they had some sketches you could refer to and change."

Dressing up as a Westerner could be risky, though: "Cattlemen in eleven states are rounding up cowless cowhands—and making them pay for the fun of wearing boots and spurs!" read the headline from a New York newspaper during the sixteenth annual World Champion Rodeo at Madison Square Garden. The article went on to list Western-wear guidelines created by the "Sidewalk Cattleman's Association": "No one who does-n't own at least two head of cattle can wear those trim and ornate cowboy boots. It also holds that a man or woman must own at least three head of stock before he or she can stuff the right pant leg inside a boot. The right to stuff both pant legs . . . must be earned by the ownership of at least four head of cattle—and spurs must not be strapped onto boots without the possession of half a dozen head of cattle."

Perhaps the ultimate locations for the Easterner to dress Western without getting into trouble were popular dude ranches, primarily out West but also scattered throughout the Northeast. Dude ranch vacationing, which started in the late 1800s, became a booming tourist industry with the advent of automobile and train travel. Many ranches advertised in rodeo programs and Western lifestyle magazines, offering vacationers a guaranteed real West experience with authentic cowboys to guide them through all aspects of ranch life, including how to dress.

"I have to think hard to realize that I have not always been a Southwesterner," wrote twenty-year Arizona resident Stan Adler in the 1947 issue of *Arizona Highways.* Describing an Easterner's attempts to dress Western for a dude-ranch vacation, he wrote, "Irrespective of the measure of their talents in horsemanship, most guests get a secondary wallop out of their riding garbiture. When they start out from the corral along the trail for the morning's workout, they feel much more a part of the range setting when they are rigged out in broad-brimmed Stetsons, vibrant gabardine or satin shirts, blue jeans, cowboy boots—and even chaps. . . . It all helps to bring their conception of the West to life. . . . No guest ranch is a success until every guest feels that he or she is a shorenuff cowboy or cowgal."

"Ranchophiles," as Adler called dude-ranch guests, ranged "from experts in equitation to the terrified dude swinging into his first saddle." Many ranch brochures suggested what to pack for any ranch activity, which may have included cattle and horse roundups, trail rides, fishing and hunting excursions, swimming, outdoor sports, rodeos, and Western dances. One Southwestern Arizona ranch and resort's brochure from the 1940s even specified which brand to buy: "Better make Levi's blue jeans your daytime style . . . same for women unless they prefer a short, divided skirt or jodhpurs to jeans. . . . " Furthermore, "[i]f you forget something, there's specialty shops in the towns and cities nearby."

Western shops and trading posts were located close to most dude ranches. Dressing like a Westerner was expected at these resorts. A booklet titled *Montana: A Dude Ranch Vacation in Pictures,* from the late 1930s, shows a photograph of "The Wrangler Shop" with the caption: "If you haven't already brought along enough trappings to deck yourself out like a Brooklyn cowboy, 'Old Timer' will take you to the nearest cowboy store and suggest simple, practical Western clothes to enhance the pleasure of your vacation." A Colorado dude-ranch brochure from the 1950s coyly explained

Above: **Dude-ranch style circa the late 1940s:** According to a 1949 Valley and Ranches promotional brochure, "Old clothes and the ability to fit in are all that are necessary. . . . For ladies we suggest the Frontier riding trousers or blue jeans, or old breeches if you have them, old boots or the cowboy style, felt hat, cotton shirts, riding slicker or raincoat, war jacket, substantial oxfords, sweaters and skirts." Autry Museum of Western Heritage, Los Angeles

Right: Any dude-ranch patron could purchase his cowboy outfit by mail or at a local shop out west. In this case, the bib-front shirt came from Otto Ernst of Sheridan, Wyoming, and the Eddie Hulbert spurs were also purchased in Wyoming. The horsehair belt was made in a prison craft shop, and the hat was ordered by mail from Denver Dry Goods. At the end of July, **dudes and real cowboys alike dressed up for the great Cheyenne Frontier Days Rodeo.** Autry Museum of Western Heritage, Los Angeles

there was "no use carrying heavy baggage both ways—buy your Western clothes out here!"

The deep pockets and good taste of many dudes and dudeens contributed to the career of one budding Western-wear designer. In the early 1930s, Wyoming native Marge Riley began fashioning fringed suede jackets, brightly colored chaps, knee-length split skirts, and felt-appliquéd gabardine Western shirts first for herself, when she couldn't find what she liked in local stores, and then for neighboring ranch gals who admired her fancy Western ensembles. After opening her first shop in Los Angeles in 1936, she began getting orders from Dale Evans, Gene Autry, and Hank Thompson. By 1940, she had a second branch in Palm Springs and her designs were also showcased in Bullock's-Wilshire, I. Magnin, and Desmond's department stores. Riley's fashions were featured in the cover story of the April 22, 1940, issue of *Life* on the latest "fancy trend in ranch clothes." Riley's fringed-suede "ranch clothes," fit for the most fashionable rodeo queens, were shown styled with fancy inlaid boots and white wide-brimmed felt hats. One particularly creative outfit was a pair of skintight light-blue suede frontier pants with white lacing down the sides, worn with a wide corset-styled, lace-up belt, fringed bolero vest, and drapey satin blouse.

Besides riding gear, many dude ranches called for other garments for evening barn dances or square dancing. While men typically would dress in jeans, plaid-cotton Western snap-front shirts, and printed bandannas or string ties, women often danced in ankle-length, prairie-style gingham and calico dresses, petticoats, sunbonnets, and bloomers. By the 1950s, the flouncy tiered dresses worn with layers of ruffled crinolines underneath had become synonymous with square dancing. His-and-her matching styles were popular as well, and it was common to see couples and entire families in outfits created from the same festive fabrics.

While rodeos and dude ranches provided an occasion for tourists to wear Western garb, bona fide Westerners embraced the subtleties of regional styles, adapting elements into their daily dress. In addition to five-pocket blue jeans and embroidered Western pointed-yoke shirts, colorful styles inspired by traditional Native American and Mexican dress filtered into many Westerners' wardrobes. Tucson, Arizona, native Linda Ronstadt, the Grammy-award-winning recording artist known for her glamorous Mexican-inspired costumes, points out that "Western wear is Mexican. It is the regional costume of the Northern states Chihuahua and Sonora. That is really the way the people dress there—the bellbottom pants with the yoke cut in the back is what we call frontier pants in Tucson. The yoke cut in the jacket and the shirt is truly Mexican: the embroidery too." As a teenager in the 1950s, Ronstadt donned "squaw" dresses of rayon georgette with three tiers of skirt trimmed in rows of rickrack. "We wore them with a little concha belt to school. That stuff is all Spanish [influenced]. We had a rodeo parade every year, and everyone would dress up. That whole week you could wear your best rodeo clothes to school. We went for that in a big way when I was a kid."

New Mexico fiesta dresses and Arizona "squaw" dresses (also called patio dresses) gained tremendous popularity among Southwesterners in the 1950s. A 1953 *Western Horseman* article reported: "Right off the reservation comes a style known as the 'squaw' dress. These and fiesta dresses give the wearer a chance to run to lively colors, and the ideal opportunity to wear Indian jewelry. The full skirts are not ironed, but simply washed, squeezed

During the off-season, dude-ranch owners often traveled to the East in search of customers. **Brochures distributed in Boston, New York, Chicago, and elsewhere included advice on what visitors should wear,** and numerous Western retailers, particularly those near annual rodeos or dude ranches, offered mail-order catalogues for out-of-towners. In the early 1930s, Western Ranchman Outfitters (WRO) opened in Cheyenne, Wyoming, home to the celebrated Cheyenne Frontier Days rodeo. By 1935, it had a flourishing mail-order business catering to customers who only came to town once a year. "Order with assurance * the boss personally fills your order," asserted the inside cover copy of the 1940–41 catalogue. "We feature nationally known Western brands of high quality merchandise." John B. Stetson hats, Levi Strauss shirts and overalls, Pendleton shirts and pants, Crockett bits and spurs, Nocona boots, and Heiser saddles were all available from WRO through the mail. Autry Museum of Western Heritage, Los Angeles

As a teenager in the 1950s, Ronstadt donned "squaw" dresses of rayon georgette with three tiers of skirt trimmed in rows of rickrack. "We wore them with a little concha belt to school. That stuff is all Spanish [influenced]. We had a rodeo parade every year, and everyone would dress up."

together, and tied with a string or rubber bands while drying. Originally the squaw dress displayed the true Indian designs and colors in the full skirt, and the fiesta dress was much lacier and more decorated. Gradually the two have come very close together and are now known as Southwestern dress. The dress is gay and colorful and has several variations. . . . Soft leather squaw boots in bright colors are popular with these dresses. . . ."

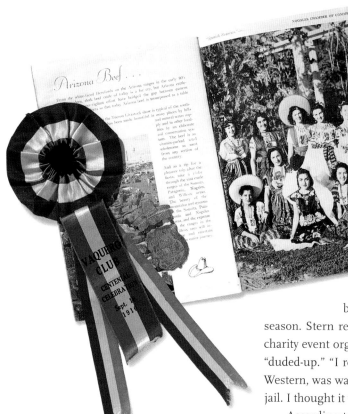

More elaborate "squaw" dresses could be commissioned from local seamstresses. Made of crinkled cotton, rayon, or occasionally corduroy or richly colored velvet (a convention of traditional Navajo dress), styles came in one-piece dress versions with a matching belt, or gathered three-tiered skirts with matching tops. The skirts and tops were often generously adorned with fancy ribbon trim and metallic rickrack; a deluxe outfit could have up to seventy-five rows—more than one hundred yards—on the skirt tiers. Matching blouses usually had cap or three-quarter-length sleeves, a side zipper, and a V-shaped or square neckline.

Jane Stern, Western-wear aficionado and coauthor with husband Michael Stern of *Way Out West*, remembers wearing matching mother-and-daughter "squaw" dresses in Tucson in the 1950s. Her father, Milton Grossman, a leather-goods salesman for New York–based leather firm Hermann Lowenstein, at one point successfully designed two-tone "squaw" boots, which he sold to New York City department stores during the resort season. Stern recalls walking around Tucson with her father on Boot and Hat Day, a local charity event organized by the Elks Club where the sheriff would "arrest" you if you weren't "duded-up." "I remember for some bizarre reason my father, who was totally into dressing Western, was walking around that day with me without a cowboy hat and we got thrown into jail. I thought it was real jail and became completely hysterical!"

According to Stern, fiesta dresses were originated by Santa Fe resident Allie McKenzie in the 1920s. Inspired by dresses brought back from neighboring Mexico, her own versions were made of red bandanna material and were first displayed in the windows at the Plaza shop where she worked. Her dresses gained national recognition at a fashion show she staged during Fiesta Week and by the mid-1930s were featured in national ads and eastern department stores. Two other notable New Mexican designers from the 1950s were Kathleen Lienan, who created Navajo-inspired velvet outfits, and Carolina McKee, whose clothing line "Carlotta" featured fanciful fiesta dresses. Off-the-rack versions, primarily marketed by Thunderbird Originals in Prescott and by Arizona Originals in Tucson, became widely available in the 1950s.

Fiestas held in Arizona, New Mexico, and California also helped popularize Mexican and Indian-inspired clothing. The 1942 program from Tucson's La Fiesta de los Vaqueros painted this colorful picture of its weeklong festivities: "When Tucson pulls on its high-heeled cowboy boots and ten-gallon hats, there's a show staged that can't be matched the width and breadth of the land. It's more than a show—it's a panorama view of the West when it was young. You'll see it represented during fiesta week . . . the Indians, the cowboys, the miners, wagon freighters, the gamblers, the merchants, the cattlemen, and the law. They all had a part in building the West. They, with the exception of the gambler, still have a part in La Fiesta de los Vaqueros."

Many styles that came to be associated with Western wear were made specifically for the tourist trade and were sold during fiesta days or at the rodeo. Imported Mexican felt jackets with embroidered and appliquéd motifs, sometimes called Rio Grande jackets, were available in an assortment of bright colors for women and girls. Also popular were hand-painted and sequined Mexican circle skirts, made of cotton or black velvet. Ronstadt remembers wearing the authentic version of the skirts known as *china poblano* skirts. Usually made of wool felt with red and green trim, embroidered, beaded, and sequined, with large Mexican eagles featured in the design, the skirt has as colorful a legend as its design. "A Chinese king's daughter was taken as a slave in Mexico," according to Ronstadt. "She would save little bits of things that were bright and shiny and she would work all year on these beautiful skirts to make sure people would know she wasn't just a common person." *China poblano* skirts are traditionally worn to dance Mexico's national folk dance, the *jarabe tapatio*. The male partners wear

Above: Traditions and dress of the Hispanic West were kept alive and romanticized at festivals, parades, and fiestas in many areas beginning in the 1890s. A badge and ribbon worn by a festival participant in 1896 and 1910, respectively, are reminders of such festive occasions. **Tourists and locals flocked to a colorful gathering in Arizona in 1940,** where local women wore traditional Mexican dress. Autry Museum of Western Heritage, Los Angeles

Opposite page: A **black Stetson hat, black velvet lace-up blouse, and suede split skirt with nickel spots** for decoration would have made the wearer of this outfit in the 1920s or 1930s stylish in many settings. Such fine outfits were favored by dudeens and locals alike. Autry Museum of Western Heritage, Los Angeles

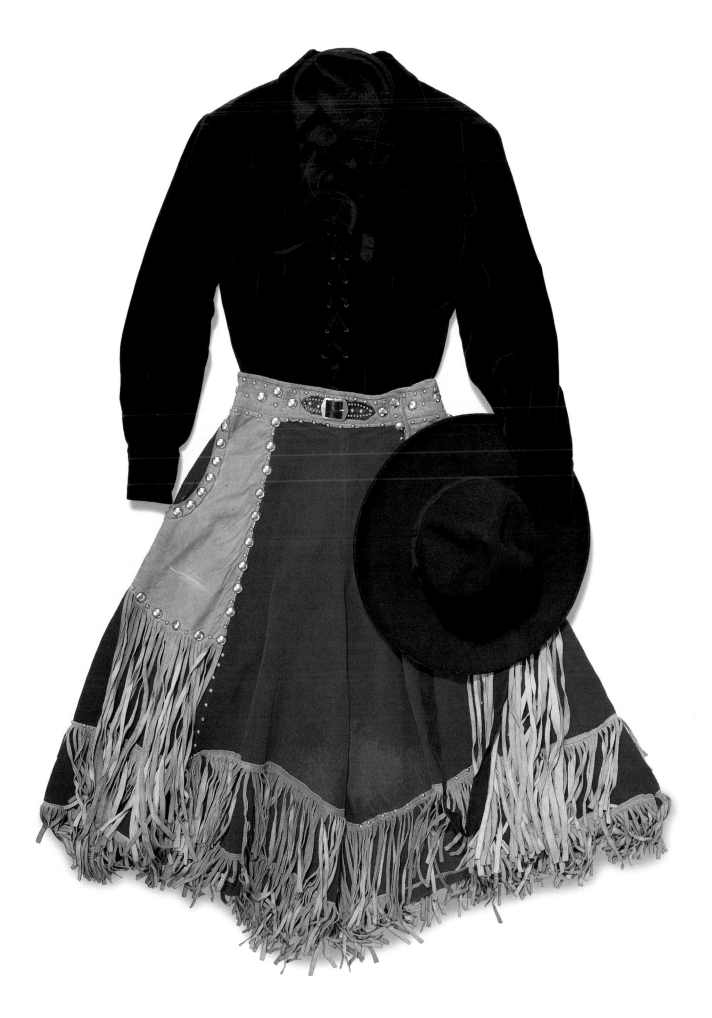

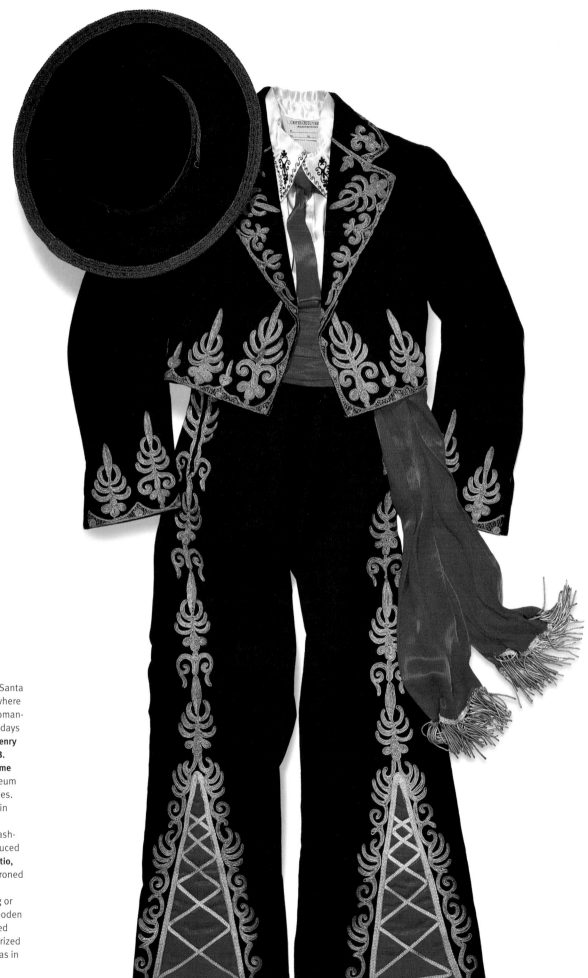

Right: Fiestas and parades in Santa Barbara, Pasadena, and elsewhere in California celebrated and romanticized ideas of early ranching days in the state. **By the 1920s, G. Henry Stetson, son of hat maker John B. Stetson, was wearing this costume** for such occasions. Autry Museum of Western Heritage, Los Angeles. Donated by Brooke Allen Rankin

Opposite page: Thunderbird Fashions of Prescott, Arizona, produced this **dazzling gauze fiesta, or patio, dress**. The full skirts were not ironed but simply washed, squeezed together, and tied with a string or rubber bands while drying. Wooden pocketbooks such as this Speed Demon by Madge were popularized by designer Enid Collins of Texas in the 1950s. Collection of Holly George-Warren

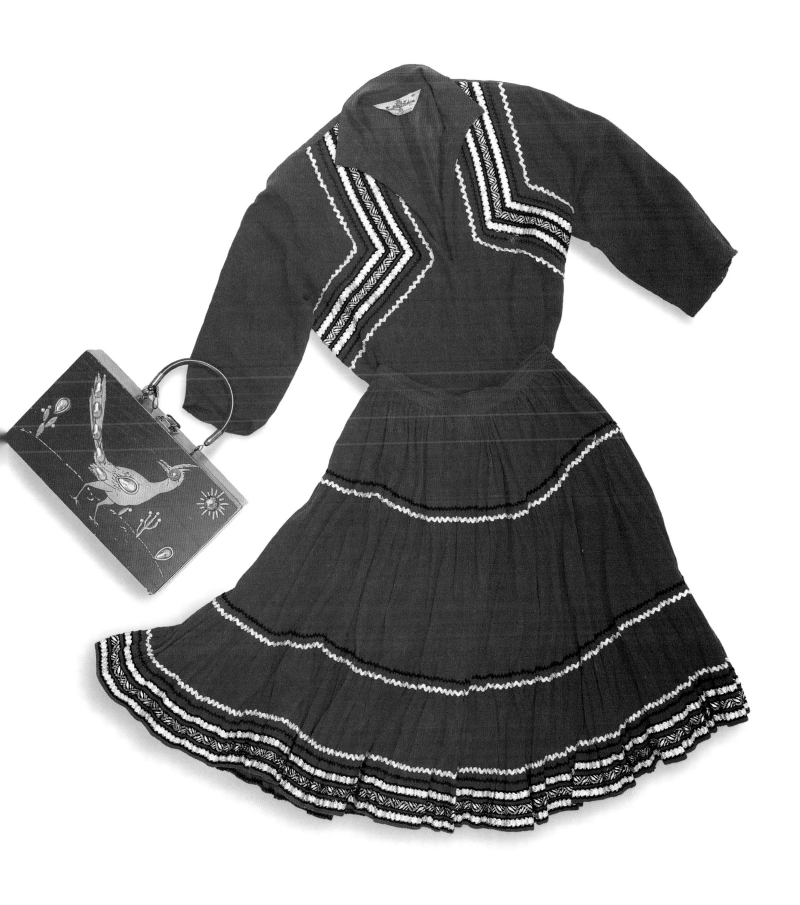

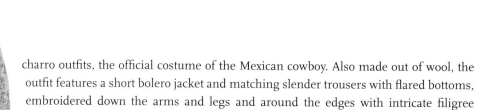

Right: Jewelry made by Navajo artisans and clothing made with **Navajo-influenced motifs** have become popular in the American Southwest. These examples date from the 1970s. Autry Museum of Western Heritage, Los Angeles

Below: This **H Bar C outfit** with Texas Rose blouse would have looked good at any dance, parade, rodeo, or C&W music function in the 1960s or early 1970s. Autry Museum of Western Heritage, Los Angeles. Donated by Margaret Miehle

charro outfits, the official costume of the Mexican cowboy. Also made out of wool, the outfit features a short bolero jacket and matching slender trousers with flared bottoms, embroidered down the arms and legs and around the edges with intricate filigree designs.

Another popular item came from the Chimayo Valley near Santa Fe, New Mexico. Chimayo jackets, made from Rio Grande weavings, were adopted from the traditional Spanish and Mexican styles into Southwestern fashion. The tradition of this craft was passed down through many generations: The Ortega and Trujillo families, for example, had been weaving clothing, blankets, and floor rugs as far back as the 1700s before adding Chimayo jackets to their line in the 1930s. Typical jackets have cream-colored backgrounds with blue, black, and red geometric diamond-shaped motifs or vertical ribbons of multicolored stripes, accented with hand-tooled silver buttons.

The traditional arts of American Indians, including gorgeous beadwork, silver and turquoise jewelry-making, and intricate weaving, have been featured in rodeos since the early days. One of the oldest is Pendleton Round-up's Happy Canyon American Indian festival. A promotional brochure from the twentieth annual Pendleton Round-up in 1929 described it as the "World's largest Indian gathering," where "entire families vie with one another in bedecking themselves in a more elaborate manner than their Indian neighbors. This rivalry is unique in that it [has] furnished an abundance of color and rich trappings which never make their appearance except at round-up time."

Clothing that originated from these and other types of Western gatherings has inspired fashion designers around the world with their colorful history and uniquely Western look. Collectors, too, covet the rare and unusual rodeo outfit and Native American handiwork that occasionally turns up for sale. And new adaptations of old looks continue to be developed, paying homage to the style-makers. Indeed, Western costume still comes alive via such traditions and celebrations, providing an occasion for rodeo queens, rodeo cowboys, square dancers, Mexican Americans, and American Indians to adorn themselves in full Western regalia.

By the 1920s, weavers in Chimayo, New Mexico, were producing commercial textiles for consumers. Purses and garments were among the products created by weavers like Niacin Ortega, and some fabrics were even used to cover exotic Western-themed furniture. These **two coats are typical of those created from Chimayo fabrics**. Autry Museum of Western Heritage, Los Angeles

POSTWAR AMERICA GOES WESTERN

In the 1940s and 1950s, **traveling photographers brought ponies and plenty of film** so that postwar parents could proudly pose their young cowpokes and, years later, baby boomers could remember their days on the range. The outfits could be purchased through mail-order catalogues which, as early as 1905, advertised miniature leather outfits, with fancy fringe and silver-studded "spots," for boys and girls sizes four to fourteen. Also available were three styles of youngsters' cowboy boots—the Butterfly, the Little Stockman, and the Jesse James, Jr.—along with hats, spurs, lariats, and belts. Lee's Boy's Rider overalls could be ordered with a child's name branded on the back left pocket's hide label, and, for an extra twenty-five cents, the pants came with a sportsman's knife in a leather sheath. Collection of Michele Freedman

Every evening when Clare Butler returns home from working as an editor in Atlanta, Georgia, she gets out her sewing. Her handiwork has ranged from embroidered ranch wear, to placemats crafted from cowboy-motif fabric, to quilts and pillows made of vintage Western-print bark cloth. A recent project is a miniature cowboy suit made as a present for Jackson, the one-year-old son of friends. Projects like this take Butler back to her own childhood in Memphis, Tennessee, in the 1950s and 1960s. Her mother taught her to sew when she was eight, but even before then she can remember loving all things Western: reruns of Gene Autry and Roy Rogers movies, C&W music, and cowboy television shows.

All these elements have inspired the unique outfit she created. The jacket and pants are decorated with hand-stitched cactus and cattle brands; the rickrack-trimmed bib-front top fastens with red snaps; the hand-embroidered centerpiece of a tiny buckaroo on horseback is encircled with rhinestones; the name "Jackson" is stitched beneath it. In late 1999, it would be impossible to find such an ensemble in a store, but 1950s style lives on, thanks to the nostalgia and expertise of forty-two-year-old Butler and others like her.

Below: Another role model for young girls in the 1950s was Gloria Winters, who played **Miss Penny in the *Sky King* television series**. She not only provided a model for how to dress, but she also wrote a book on good manners, which sold well at the time. Autry Museum of Western Heritage, Los Angeles. Donated by Gloria Winters

Baby boomers grew up during the golden age of cowboy culture. By the mid-1950s, nearly all American leisure activities were influenced by the West, from honky-tonk and Western swing music, to a proliferation of cowboys on television and the myriad products they endorsed (from children's pajamas to loaves of bread), to a resurgence of square dancing, dude ranches, and rodeos, and, beginning in the 1950s, theme parks. Most ubiquitous were the hugely popular Western television shows—approximately sixty per week by the early 1960s—ranging from kiddie fare like *Sky King* and *The Adventures of Rin Tin Tin* to long-running adult programs like *Gunsmoke, Bonanza, The Virginian,* and *Maverick.* In the grip of cowboy fever, suburbanites furnished their rec rooms with furniture accented with wagon wheels and horseshoes and whipped up curtains and tablecloths from Western-motif fabrics. Bedspreads and linens could be purchased with Gene Autry, Roger Rogers, or Hopalong Cassidy motifs and insignia. Since the 1940s, Western sewing patterns complete with embroidery and appliqué transfers have enabled home seamstresses to compete with pricey rodeo tailors. By the early 1960s, manufacturers were making wash-and-wear and "Sanforized" Western-style garments for the whole family.

Disney did its part, too, to make the West a favorite among families. Cowboys had been part of Disneyana since the earliest Mickey Mouse cartoons, as 1928's "Gallopin' Gaucho," 1930's "The Cactus Kid," and 1934's "Two-Gun Mickey" prove. Even Donald Duck got into the act with "The Three Caballeros." Opening in July 1955, Disneyland featured the Western-themed Frontierland; the Mouseketeers dressed in cowboy outfits during the popular *Talent Round-Up* segment of *Mickey Mouse Club*; and Fess Parker, starring in Disney's *Davy Crockett: King of the Wild Frontier* film and the *Daniel Boone* television show, made coonskin caps and buckskin hot commodities.

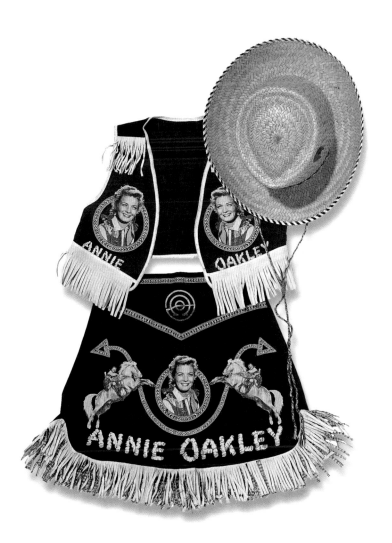

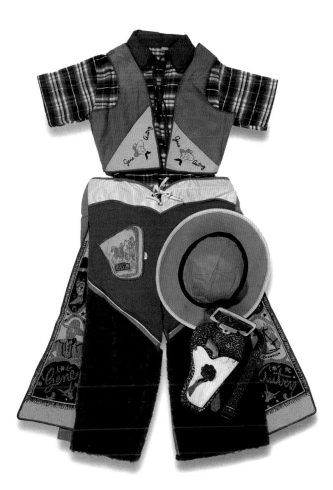

As early as 1947, large department stores like Chicago's Marshall Field and Company carried Western wear, as one full-page ad testified: "All your needs in leather are handmade, tooled, and stamped by our expert, a cow-country veteran who learned his craft from the old masters of days gone by." "Everyone can wear something from 'out west,' and for this reason, the interest in Western attire is sweeping the nation," proclaimed a 1954 issue of *Western Horseman* magazine. Sure enough, the Western-wear trend, more popular than ever, had spread from Portland, Oregon, to Portland, Maine. On its May 11, 1953, cover, *Life* pronounced that "Denim Gets Dressy," and featured inside models attired in denim finery posed around fancy parade saddles. "The only reason for saddles in the picture above is the almost bygone tradition that associates denim largely with a cowboy's faded blue jeans," read the text. "All the brilliantly hued clothes around the saddles are denim but hardly recognizable as such. . . . The new bright colored denims in stripes, plaids, and prints are lighter but still tough fabrics. It has taken a full century to move the useful cloth from Levi to the ultimate in denim, [a] sequin-trimmed floral print evening dress. . . ."

Denim was not the only fabric used to construct nationally popular Western attire. Besides gabardine, rayon, and wool, which had been around since the 1930s, such "exotics" as Celanese satin, seersucker, sharkskin, Madras, and moiré proliferated among shirt manufacturers. Fringed jackets made of leather, buckskin, and suede were increasingly popular, thanks to Davy Crockett mania. By the 1960s, synthetic materials took hold: polyester shirts and vinyl jackets were hailed for their easy-care attributes. For women, Southwest-inspired frocks and velveteen "Navajo" blouses became trendy back East, where they were worn at patio parties, with beaded moccasins or "squaw" boots. Even Frederick's of Hollywood offered sexy cowgirl outfits, ranchwear, and hand-painted Mexican skirts.

Boys and girls could dress like grownup cowpokes too, said *Western Horseman* in 1954:

Opposite page, left: Thanks to Disney's *Davy Crockett: King of the Wild Frontier,* played by Fess Parker, who also recorded a hit song with its theme, **1950s kids were crazy for coonskin**. Even protopunk artist Patti Smith has stated, "When I was a kid, I didn't gravitate toward dolls. I had a coonskin cap—I liked dressing like Davy Crockett." Autry Museum of Western Heritage, Los Angeles. Donated by Stephen Green

Opposite page, right: First appearing in Gene Autry films, then starring as Annie Oakley on her own television show, **Gail Davis popularized cowgirl suits in the 1950s**. Nudie made this particular two-piece gabardine riding outfit, accented with gold leather and rhinestones, around 1958, near the end of the program's run. Autry Museum of Western Heritage, Los Angeles. Donated by Terry Davis in memory of her mother

Above left: **Little girls could copy their heroine,** Gail Davis, with outfits readily found at local toy stores or ordered through catalogues. The design was appropriately reflective of Nudie and representative of the television program itself. Autry Museum of Western Heritage, Los Angeles

Above right: One of several different **Gene Autry cowboy outfits available for children,** this one includes a printed bolero vest with matching chaps. The set was made in the late 1940s. Autry Museum of Western Heritage, Los Angeles

Above: In the 1950s, **Roy Rogers and Dale Evans paper dolls,** marketed primarily for young girls, were available with many choices of Western dress. Autry Museum of Western Heritage, Los Angeles

Below: From the 1940s to the 1960s, **Roy Rogers and Dale Evans endorsed numerous outfits for boys and girls**. This pony-print girl's ensemble is decorated with faux conchas and fringe. The trick hat features a cap gun that pops out from under the brim when a hidden button is pushed. Autry Museum of Western Heritage, Los Angeles

"The young'uns can strut like peacocks same as everyone else, in . . . fancy togs," and television heroes—and heroines—helped to inspire them. In 1953, *Annie Oakley,* a popular syndicated television program, was the first to focus on a cowgirl. Produced by Gene Autry Productions, it starred Gail Davis, decked out in fringed split skirts and piped, appliquéd, and fringed Western blouses. Before long, little girls were dressing up in miniature cowgirl ensembles, some endorsed by Annie Oakley, some by Dale Evans. This was the latest chapter in a trend started in the 1930s by Tom Mix, who was the first to endorse children's toys and clothes.

Initially, the merchandise that bore Mix's name consisted mostly of code rings and small toys that could be ordered from the back of cereal boxes. By 1935, however, kids could send away their Ralston Purina box tops for a leather and cloth vest with matching chaps, each decorated with the Tom Mix brand, as well as leather wrist cuffs with Mix's Straight Shooters logo. After Mix's death in 1940, commemorative items such as Tom Mix neckerchiefs and ties were offered. By then, Gene Autry's singing-cowboy image was making its way into American homes via his endorsed guitars, songbooks, comics, books, wristwatches, toys, and children's clothing like cowboy suits, boots, galoshes, neckerchiefs, and pajamas.

Roy Rogers extended the range of products even further. Beginning in 1943, Roy's smiling face began gracing everything from boxes of Quaker Oats and Post Cereal to cap guns, bedspreads, and alarm clocks. Once he and Dale Evans became a team, her visage could be found on a cornucopia of wares too. Eventually, more than 450 products, including children's clothing, toys, books, furnishings, and items such as flashlights, binoculars, and lunch boxes, were licensed to use the Rogers and Evans name.

The children's cowboy clothes endorsed by Rogers and Evans were usually embroidered or silk-screened with Roy's or Dale's likeness, or decorated with butterflies and flowers. Yankiboy Play Clothes offered the first "Official Roy Rogers Cowboy Outfit" in the mid-1940s, which included chaps, vest, cowboy shirt, scarf, and spurs with bells.

In the large Rogers household, all those licensed goods came in handy, according to Roy's oldest son, Dusty Rogers, born in 1946. "I grew up in Roy everything," he recalls. "I had bedspreads and sheets and pillow shams and curtains and carpet—everything Roy. Most kids put R and L on their boots to tell the right from left and I had a double R on each boot. I didn't know which one was which for years. I had Roy Rogers pajamas to neckties to hats to boots to scarves—everything."

Probably just about every American youngster in the late 1940s and early 1950s had at least one product from the Roy Rogers line, which also included items emblazoned with the image of Trigger, Bullet the Wonder Dog, even Nellybelle the jeep from Roy and Dale's 1950s television show. By the mid-1950s, the Roy Rogers licensing brand was worth close to $50 million.

According to Dusty, Roy was very particular about what he put his name on. "He felt obligated that it had to be the best quality that could be put out simply for the fact that his name was going on it," says Dusty, "and the kids looked up to him a lot, especially because of his fashion. He was one of the better dressed cowboys on the screen. Kids wanted to emulate that, so consequently whatever came out with his name on it had to match what he wore. The gun belts matched, the hats, the shirt patterns, all matched. And a lot of the guys that made Dad's shirts, like H Bar C, also made children's clothes so they matched up real well there."

Today, vintage Roy and Dale goods are highly sought by collectors. Sometimes the boxes the items come in are worth more than the product, since original packaging is much less common. "You can get a pair of Roy Rogers slippers for $200 to $400," says Dusty, "But if you can get the box, it sells for $600 to $800."

Running neck and neck with, and then surpassing in popularity the Roy and Dale licensed goods, were those of Hopalong Cassidy. When William Boyd, who owned the rights to his sixty-six Hopalong Cassidy films from the 1930s and 1940s, syndicated

them on television beginning in 1950, Hoppy became more popular than ever, winning legions of young fans. "Something about William Boyd's Hopalong Cassidy image was perfect for the glowing little picture box," theorize Robert Heide and John Gilman, authors of *Box-Office Buckaroos*. "Perhaps it was the sharp black outfit against a white sky and gray terrain, or the man himself, who was old enough to be a father figure like Truman or Eisenhower. . . . By 1950, once the cowboy in black was an established hit on TV, the selling of Hopalong Cassidy merchandise took the country by storm."

Featured on the cover of the June 12, 1950, issue of *Life*, Hoppy was described as a "cowboy juggernaut [who] penetrates every dwelling which has young children. . . . American youth is more aware of Hoppy than earlier generations ever were of Buffalo Bill, Lindbergh, Babe Ruth or other idols of the past. . . . American children can well afford these days to pay $36 each for his black Western hats. Together with black shirt and pants, kerchief and steerhead clasp (called a 'concho'), boots and silver spurs, this constitutes the standard public Hoppy uniform." One inside photograph depicted eight youngsters decked out in Hoppy merchandise, with the caption, "Hoppy clothes from Lord & Taylor in New York, one of many stores with Hopalong Cassidy Hitching Posts, show a wide price range . . . leather jacket ($42.50); denim pants and shirt ($21.78); girls' frontier set ($27.80); paneled shirt set ($29.30); cheapest girls' Hoppy outfit ($4.95, with hat $1.95 extra); suit with leisure jacket ($42.75)." *Life* also reported that New York's Gimbel's Department Store had "placed an initial order for $22,500 worth of Hopalong Cassidy snow suits" and predicted that Boyd would rake in $800,000 from his share of the $70 million worth of merchandise sold in 1950.

Some pop-culture pundits theorize that Hoppy mania influenced future rock & rollers' permanent penchant for black. "Hopalong Cassidy was a great trendsetter for the baby boomers, all the way down to the Gen Xers—even though they, I'm sure, never even heard of Hoppy," says *Way Out West* coauthor Jane Stern. "Hoppy was so chic wearing his black outfits, which in fact were navy blue [for filming purposes]. I think on some subconscious level

Above: It has been said that, in 1950, there was a national shortage of black dye because of the huge number of Hopalong Cassidy products being made. This **girl's outfit** is typical of that time, although more expensive examples in leather could be bought by the indulgent parent. Autry Museum of Western Heritage, Los Angeles

Below left: **Whenever William Boyd made personal appearances, he dressed as Hopalong Cassidy**—as did many of his legions of fans. Autry Museum of Western Heritage, Los Angeles

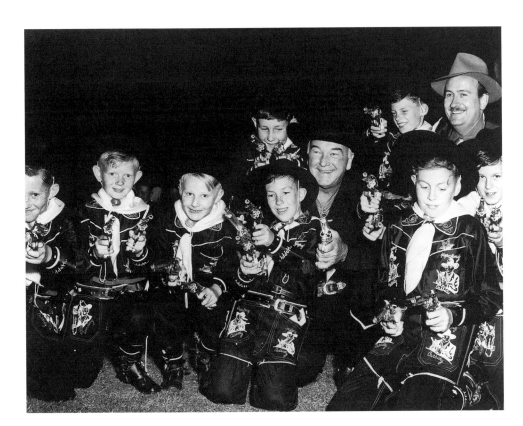

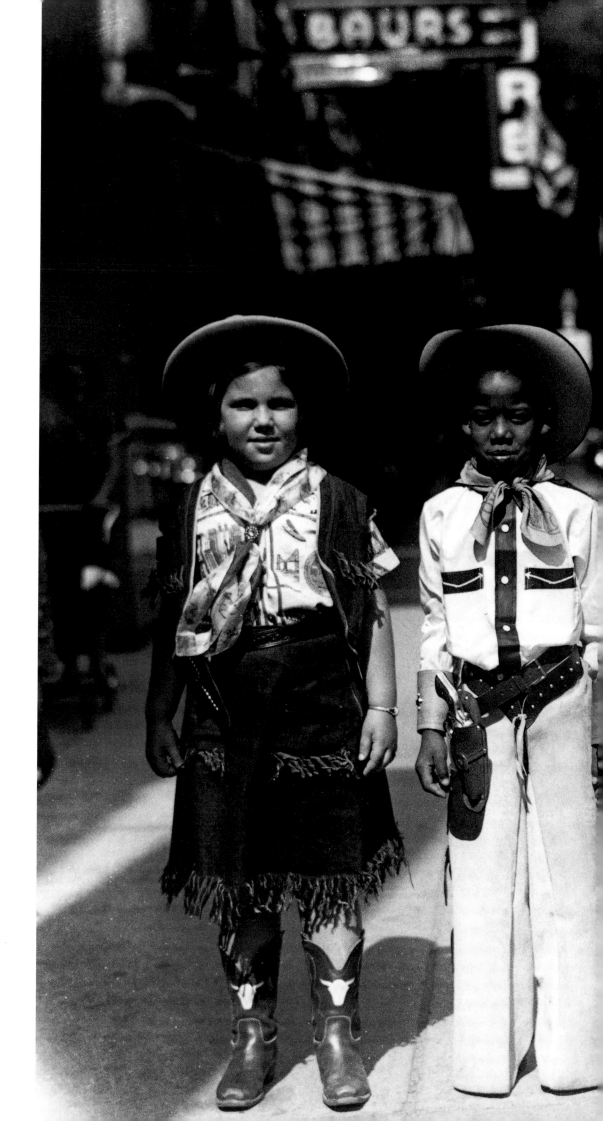

As early as 1939, Wyoming began attracting the attention of real ranchers, tourists, and young movie fans alike. This crew sports **a variety of store-bought and homemade outfits**. Surely, they are the real wild bunch. Wyoming State Archives, Museums and Historical Department

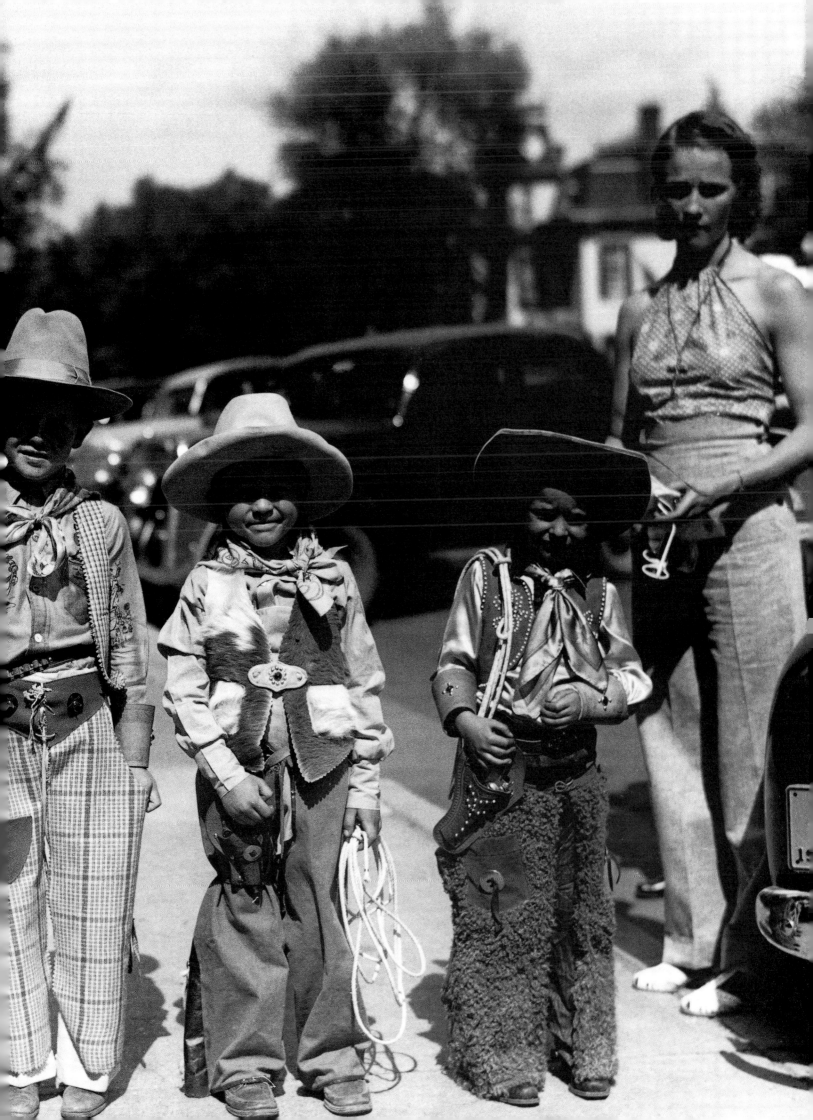

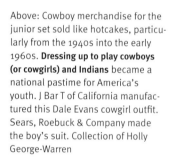

he influenced the rage for black over the last twenty years." Other *noir*-clothed heroes of the 1950s and 1960s include Zorro (in a popular Disney television series), Paladin of television's *Have Gun Will Travel*, and B-Western star Lash Larue, who toured in the 1950s with rockabilly acts, demonstrating his skill with a whip.

Hoppy (and Autry and Rogers) memorabilia collectors are fueling a thriving market, as evidenced by such books as *Hake's Guide to Cowboy Character Collectibles*. Its author, Ted Hake, a York, Pennsylvania, dealer, holds auctions of cowboy hero collectibles, publishes a catalogue, and has an internet site. "Never have there been more Hoppy collectors and never have the prices been higher," reports Hake, who saw the trend explode around 1993, when he sold a pair of vintage Hoppy boy's underpants for $173.

In addition to licensed children's clothes, in the 1950s, manufacturers produced every type of child's garment imaginable decorated with cowboys, steer heads, and other Western motifs. Brands like H Bar T, PlayMaster, Rocking K Ranch, Bar HN Ranch, K Bar Z, and Tex Son proliferated. As an article in the May 1958 issue of *Western Horseman* put it, "On every bypath and crossroad of the nation, youngsters are going Western from head to toe. And as Moms and Dads follow happy suit, they're discovering that colorful Western attire lends extra comfort to their leisure, extra gaiety to every fun-loving event, from square dance and hayride to picnic and outing."

Above: Cowboy merchandise for the junior set sold like hotcakes, particularly from the 1940s into the early 1960s. **Dressing up to play cowboys (or cowgirls) and Indians** became a national pastime for America's youth. J Bar T of California manufactured this Dale Evans cowgirl outfit. Sears, Roebuck & Company made the boy's suit. Collection of Holly George-Warren

Below: Colorful **Western-themed fabrics** existed in abundance for those inclined to create their own clothing, curtains, bedspreads, or other accessories. Collection of Michelle Freedman

But storebought Western wear wasn't the only way to go. By the 1950s, Western-themed fabric and sewing patterns were readily available. Fashionable women's bolero and ranch pants (complete with reinforced seat) with flower-embroidery transfers were introduced in 1947 by McCall. That year, *McCall's Needlework Magazine* advised that "Western shirts, launched at smart Western resorts, are now the active sports vogue. The gay embroidery is in rodeo tradition. Mannish tailoring, bright colors, and close fit are the new characteristics of these shirts. . . . Roy Rogers has done much to increase the popularity of the gay Western shirt as a sportswear vogue."

With a Roy lookalike illustration, McCall also featured in 1947 a man's Western shirt with tulip-embroidery transfer and interestingly shaped, Rodeo Ben–influenced yokes. In 1949, McCall presented a pattern for highly decorative, embroidered, yoked, and piped men's shirts. From McCall, boys' and girls' Western shirts could also be had, with embroidery and appliqué transfers included. The girls' pattern included a decorative skirt, bolero, cuffs, gaiters, belt with gun holster, and a leather trim tassel. The boy's version came complete with chaps, bolero, cuffs, belt with gun holster, and the same little attachable leather tassel.

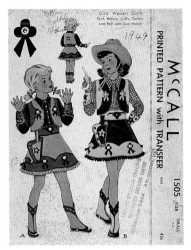
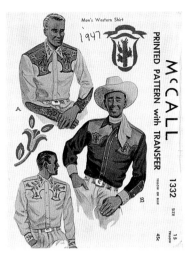

Simplicity also had plenty of Western pizzazz in its fashions. In 1947, it offered a streamlined pants and blouse ensemble with Western accents. For men in 1950, Simplicity featured a Western shirt with a transfer for an embroidered horse's head. Directions indicated that "contrasting piping outlines the front band, collar, yoke, shoulder seams and cuffs. The long sleeves, fastened with three buttons at the lower edge, have high shaped cuffs." An alternate style was "embroidered with a leaf and horse's head motif and overcasting with embroidery thread or crewel wool replac[ing] contrasting piping." Also in 1950, children's patterns from Simplicity included "Brother and Sister Fashions": Western shirts, pants, and chaps for boys, bolero and skirt outfits for girls, with floral-appliqué transfers.

Square dancing, which had been around for decades, became hugely popular in the late 1940s and 1950s. As the liner notes to a 1956 RCA album, *Square Dance*, explained, "Square dancing, extremely popular throughout rural areas of the country, has graduated to the metropolitan areas in the past several years as a successful form of entertainment. . . . Many country clubs have added the Square Dance Party as a regular feature Practically all TV shows of a hillbilly or country-western type include at least one good, lively square dance, especially impressive on color television, with the many-hued ginghams and calicoes, the flouncing crinoline skirts, and the ever-present blue dungarees."

So-called metropolitan types, as well as their rural counterparts, usually wore Western shirts with denim pants at square dances, much as they had in earlier decades, though overalls were also popular among square-dancing men in the early 1940s. Prewar women had dressed demurely in long gingham dresses with full-length, ruffly bloomers, in case an allemande left got out of hand. By the 1960s, however, shorter square-dance dresses, some inspired by the popular "squaw" dresses, had become the rage. Men almost always wore long-sleeved shirts, so their partners need not fear grabbing a sweaty arm.

Custom his-and-hers matching ensembles were embraced by square-dance clubs that sprang up across the country, inspired no doubt by the pros showcased on television. The Oregon Federation of Square Dance Clubs' March 1964 newsletter reported on the group's annual Winter Festival, at which participants danced "a square so that the[ir] outfits could be seen in action. . . . Rog and Pat Puhl, Daisy Chainers, appeared in a white dotted swiss with tiny red dots. A peek-a-boo of red ruffles on the skirt was topped with a red bow, and she wore a red cummerbund and pettipants trimmed with red ruffles and bows. His red vest covered a white cuff-linked Western shirt. Mona and Bob Waibel, Square-naders, wore club outfits and pins designed by Mona. Her dress was apple green Dacron and cotton trimmed with black linked squares and black musical notes. He wore a white Western shirt under his vest, black Western pants, tie and boots—and he grew a black mustache to match!"

Above: For those kids with ambitious mothers or grandmothers, a **fancy Western outfit was only as far away as a pattern, fabric, and sewing machine**. Western motifs even made their way into women's apron patterns. Collection of Michelle Freedman

Below: **Playsuits for youngsters who pretended to be Indians** were readily available throughout the twentieth century. This example, with dyed chicken feathers, is fancier than most. Autry Museum of Western Heritage, Los Angeles

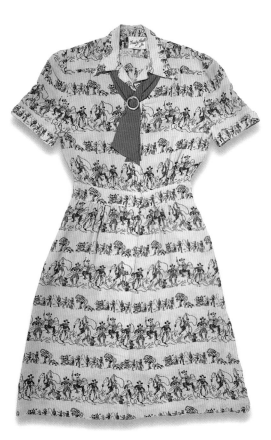

Above: Western-themed fabrics brightened up clothing, accessories, and furniture in the 1940s and 1950s. The whimsical rodeo print that decorates this **Trudy Hall rayon dress from the 1940s** creates a stripe using figures of cowboys doing tricks with their lariats. Collection of Michelle Freedman

Right: In the days just before the advent of rock & roll, **square dancing was a popular social activity among teens.** This group in the 1940s is clearly posed. Collection of Michele Freedman

For those not quite so ambitious, sewing patterns could also be purchased for basic "squaw" and square dance dresses. In addition, Simplicity featured a rickrack-trimmed "squaw" dress for little girls, and in 1952 McCall offered a two-piece "squaw"/square-dance hybrid, with a three-tiered flounced skirt. In 1959, from McCall, a pattern doubled for square dancing or centennial costume with matching sunbonnet. Manufacturers like Rockmount and H Bar C also produced lines of square dance apparel.

In the late 1940s and 1950s, festive Southwestern, Mexican, and Western figurative themes were featured in pebble cloth, birchbark, and bark cloth for accessorizing the home. Western-themed embroidery samplers were also available. Other do-it-yourself garments and accessories available in the late 1940s and 1950s included knitting patterns for "Wild West sweaters for young cowboys and cowgirls" (Regal) with a choice of designs such as a horsehead, thunderbird, galloping buckaroo, steer head, and cattle brands. Kits could be ordered for all kinds of Western leatherwork as well, ranging from "Kit Carson" buckskin pullover shirts to "hand-carved" pocketbooks and belts to hand-painted ties.

Today—as in the 1940s and 1950s—frugal Western wear enthusiasts still get out the needle and thread: "I started making a lot of Western costumes after I went to Tony Alamo's in Nashville and saw outfits I couldn't afford," says Clare Butler, who sang in several Atlanta-based groups in the 1980s. "And pictures of [singers] Patsy Cline and Wanda Jackson in their clothes really made a big impression on me, but of course you couldn't buy those anywhere. I thought, if I want Western outfits, I'll do it myself."

Another Western fan whose childhood was filled with cowboys is Robert Reynolds of the Mavericks. "As a little boy, I got my dad's cowboy toys and hand-me-down Western kids stuff—hat, boots, leather chaps, leather vest and guns and holsters," Reynolds recalls. "I was born in '62, so I think I'm from the last generation of 'cowboy and Indian children.' And ever since, I've almost always had some little dose of the Western wear and cowboy influence. It's there with me always."

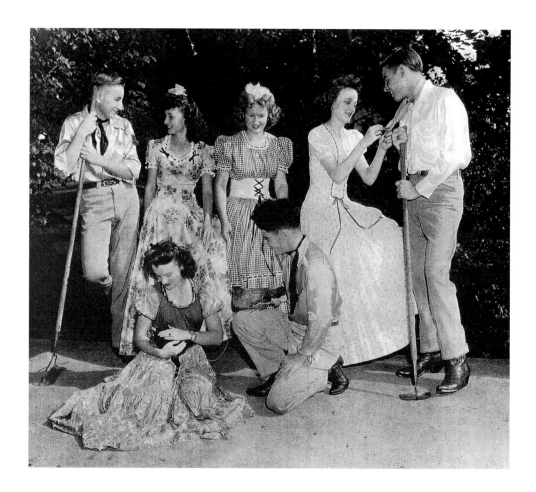

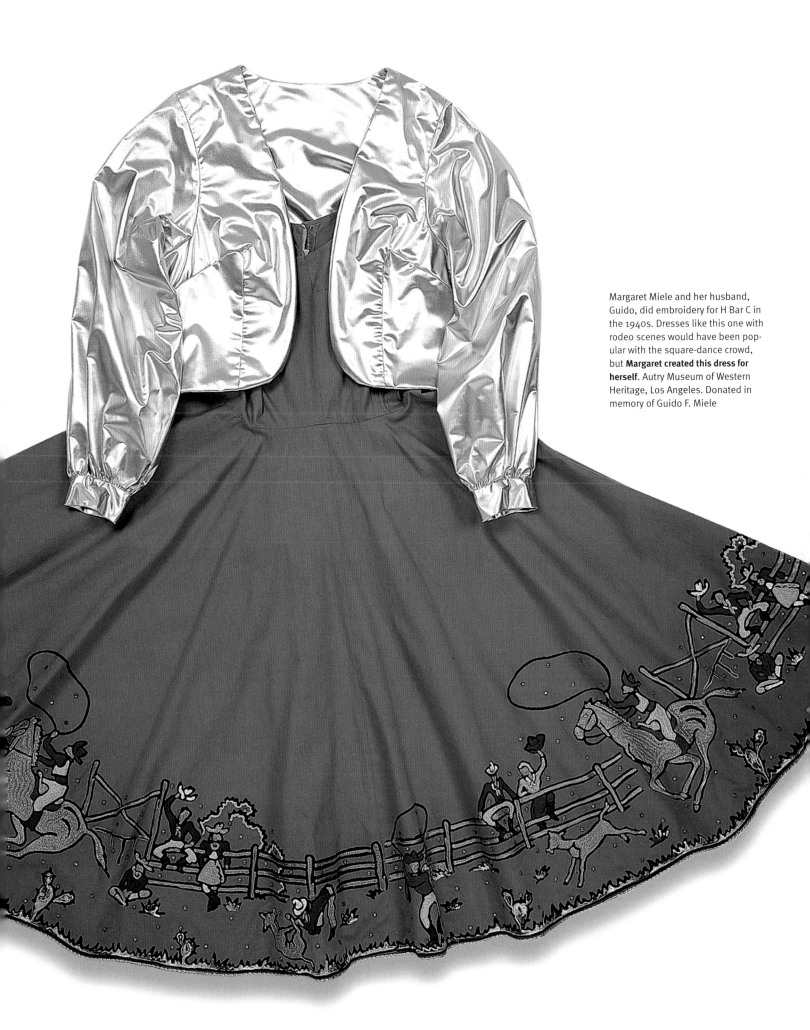

Margaret Miele and her husband, Guido, did embroidery for H Bar C in the 1940s. Dresses like this one with rodeo scenes would have been popular with the square-dance crowd, but **Margaret created this dress for herself**. Autry Museum of Western Heritage, Los Angeles. Donated in memory of Guido F. Miele

COWBOY CLOTHES MEET ROCK & ROLL AND
THE SPAGHETTI WESTERN

The Green Room at *The Tonight Show*, March 1997: Johnny Cash is about to go on as Jay Leno's guest, to perform his version of Soundgarden's "Rusty Cage," a track from his 1996 album, *Unchained*. In the forty years since his hit "I Walk the Line," Cash has veered from rockabilly to country, and back to rock again. Throughout most of that time, he has been known as "the Man in Black." Indeed, Cash's dark attire—notably his somber, Western-cut frock coats—have become as much his trademark as his deep rumbly voice. Tonight is no exception. As he heads toward the stage, he slips on over his tight-fitting black shirt and pants an elegantly cut long wool jacket, its onyx lapels and cuffs shimmering with jet rhinestones and intricate black embroidery—the work of his regular tailor, Manuel, Cash says. The jacket looks just right with Cash's black guitar, ornamented only with Gene Autry's signature in silver ink on its front.

Undoubtedly, Cash's unique take on the Western look has influenced countless rock & rollers, who were inspired by rockabilly's first wave in the 1950s. In the 1960s, a handful of rock rebels and flashy British showmen took the Nudie suit to the extreme, while other Western-influenced rockers looked to nineteenth-century desperados and twentieth-century buckaroos for fashion tips. By the 1970s, the down-and-dirty Westerns of Sergio Leone and Sam Peckinpah had introduced the scruffy cowboy look, which was soon taken up by "outlaw" musicians.

Dan Hicks was an original member of the Charlatans, one of the first rock bands to popularize the look of the Old West in their stage clothes. He left the group to start his own band, Dan Hicks and the Hot Licks, which also took up cowboy style.

A blue satin cape and a white ruffled shirt were the only non-black elements in this **outfit worn by Johnny Cash.** Created by Manuel, it was completed with knee-high alligator boots by Lucchese. Collection of Marty Stuart

Back in the 1950s, when Arkansas-born Cash followed Elvis Presley to Memphis's Sun Records, the nascent rock & roll sound was still in the sway of country & western music and its trappings. In fact, one of Presley's early career moves, on October 2, 1954, was performing on the Grand Ole Opry. And of course he wanted to look the part of country star: Decked out in embroidered cowboy shirt and contrasting ranch pants, Presley shone like the most handsome honky-tonker to hit Nashville yet. His band, Scotty Moore and Bill Black, also went for Western clothes. (They weren't asked back, and a brokenhearted Presley dumped his costume in a gas station bathroom on the ride home.) Gradually, Presley's style segued from decorative cowboy to flamboyant hillbilly cat, though throughout his career he revisited certain elements of Western style.

In March 1957, Presley's manager, Colonel Tom Parker, commissioned a suit that would be forever associated with him, and its maker, Nudie. Not particularly Western-styled, it was a gold lamé pseudo-tuxedo. Presley biographer Peter Guralnick has written that "the idea had come from the gold cutaway that Liberace wore in Las Vegas." Nudie said that Elvis's "real fourteen-carat gold lamé" outfit was "the most expensive suit I'd ever made at the time and one heck of a good publicity stunt for both of us." Reportedly costing $10,000, it was cut like a tuxedo, its jacket sporting a narrow shawl collar and French cuffs. The pocket plackets and stripes down each pants leg were made of metallic-gold, rhinestone-studded leather. A sparkly gold four-in-one tie, ruffled-front shirt made of gold "exotic" fabric with rhinestone-trimmed ruffle and collar, and gold lace-up bucks completed the ensemble. "Each one of those rhinestones had to be set by hand," recalls Nudie customer Johnny Western, who was on the premises while much of the work was being done, "and there were 10,000 rhinestones on it. That suit was Nudie's shining hour, as far as doing something other than for the cowboys." Interestingly, in 1970 folk singer Phil Ochs commissioned Nudie to make him a replica of the suit, which he wore on the cover of *Greatest Hits* and for concert performances. Nudie, according to Guralnick, measured Elvis for the suit on the set of his film *Love Me Tender*, but numerous regulars at the Victory and Vineland store, including Monte Hale, recall the young singer's visits there. Bobbie Nudie remembers Presley as "a darling boy, very polite," who bestowed a kiss upon teenaged daughter, Barbara, at a restaurant one night. Presley debuted the suit on March 28, 1957, at the Chicago International Amphitheatre. "What stood out most for the Colonel," said Guralnick, "was the first time Elvis fell to his knees like Al Jolson and left fifty dollars' worth of gold spangles on the floor. He went up to Elvis after the show and asked him not to do it again. Elvis wore the suit the following night at the Kiel Opera House, in St. Louis . . . but after that for the most part he stopped wearing the suit pants, substituting dark slacks [and a black shirt] to set off the jacket, sometimes wearing the gold slippers and bow tie, sometimes not. After a while he came to be embarrassed by it—it was as if he were advertising the suit rather than the other way around."

Presley and Nudie maintained a good relationship, and Nudie provided costumes for movies such as 1957's *Loving You* (red frontier pants and white satin shirt with embroidered red yoke) and 1967's *Clambake* (a white suit with black railroad stitch lacing, piping, and smile pockets). "Every time I came to deliver something to him on a movie set," Nudie recalled, "Elvis would stop what he was doing and come over and talk to me. He always called me Mr. Nudie, and that made me feel good. Elvis was so polite and charming in a real shy, Southern way that he just made you feel at ease with him." Presley wore working cowboy duds in films such as *Flaming Star, Tickle Me, Stay Away Joe,* and the period Western *Charro!* In performance, elements of Western style showed up on Elvis's 1968 comeback television special, in his Western-biker black leather pants and jacket and, for another segment, a pullover, black satin Western shirt with neckerchief.

At one point, in 1967, Presley became so smitten with the cowboy way that he bought a 160-acre ranch he named Circle G, and outfitted himself, fiancée Priscilla, and his Memphis mafia in Western wardrobe for their riding and ranching activities. Much of this wardrobe apparently came from Nudie's. Over the years, according to Nudie pal Buck Owens, the tailor "sold Elvis a hundred thousand dollars worth of clothes—worth four or five hundred thousand dollars today." Owens also remembers that Presley almost got himself a Nudie-mobile. "In 1972, Nudie made a [customized] car for Elvis 'cause Elvis thought, Well I've got to have that in my collection. But his manager would not let Nudie get close to Elvis [because he'd already spent so much money there on clothes]. Nudie wanted to present it to Elvis, but the manager'd say, 'I'll give it to Elvis.' Finally, in 1976, after Nudie'd had it for about three years, I happened to pull into the back of his space down there on Lankershim and he had two of them sitting there. I said to Nudie, 'What are you doing now? You driving one with one foot and the other with the other?' And he told me that story and said, 'I'm going to sell it to the first guy who comes in and wants to buy it,' and I said, 'How much would that be?' He said, 'Eleven thousand dollars,' so I pulled out eleven thousands." (The car now hangs over the bar in Owens's Crystal Palace roadhouse in Bakersfield.) Though Nudie's did not make Presley's latter-day white jumpsuits, the lavish embroidery, studs, and oversized belt, designed by Bill Belew, were certainly influenced by the rhinestone cowboy look.

When Presley was launching his career in the 1950s, other rockabilly artists were also taking up aspects of Western style, particularly fringe. Oklahoma's Wanda Jackson, who began as a country singer, was one of the first women to use fringe. Nellie Jackson, Wanda's mother, sewed most of her costumes. "I watched Wanda's stage actions and made her clothes to fit those actions," Nellie, a spry octogenarian, recalls. Wanda remembers, "My first stage outfit was by Nudie, and my mother looked at it and said, 'Well, I can make these costumes.' The first one had a full skirt with leather fringe and rhinestones, and that woman cut every one of those fringes and set every rhinestone by hand. She never used a pattern, she just molded them to me. I'd get an idea for one and sketch it and then she'd make it." Wanda continued to wear fringe on her stage wear long after she abandoned her rhinestone-accented cowgirl outfits and hats for shimmy-shimmy-shake cocktail dresses.

When Johnny Cash started his career, he had to make do. Beginning with his first-ever public performance at a North Memphis church, he chose a simple black shirt and blue jeans as the look for himself and his Tennessee Two. "We were a band, and we thought we ought to look like one," Cash explained in his 1998 autobiography, *Cash.* "Unfortunately none of us had any clothes a 'real' band would wear—I didn't own a suit, or even a tie—but each of us did have a black shirt and a pair of blue jeans. So that became our band outfit, and since the folks at the church seemed to like us and musicians are deeply superstitious, . . . I suggested we stick with the black."

As Cash and company's dates picked up, his mother also stepped in to help with stage attire. In fact, at an early performance televised on *Ranch Party,* Cash is sporting a shimmery white Western suit with appliqués and embroidery, probably the work of Mrs. Cash. "My mother hated [the black shirt and denim pants look]," Cash wrote, "so after my first couple of hit records, I gave in and started wearing the bright, flashy outfits she made for me—I remember one particularly festive white suit trimmed in glittering blue—but that didn't feel good at all, so I went back to black. . . . It just felt right." Cash's 1971 song "Man in Black," in fact, explained, "I'll try to carry off a little darkness on my back/Till things are brighter, I'm the Man in Black."

Like Presley, Cash has sported variations of Western style throughout his career: as a singer, as an actor in films and on his televised weekly variety show in the late 1960s, as a recording artist on concept albums such as *Ballads of the True West* and as a member of the Highwaymen, with Willie Nelson, Waylon Jennings, and Kris Kristofferson, and during his time off. "I'd put on my cowboy clothes—real ones, antiques—and go out to the desert or an

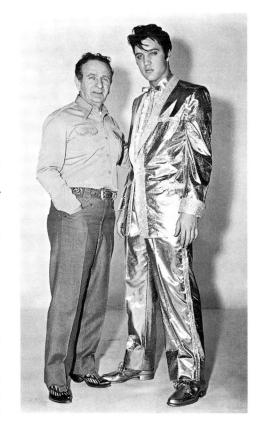

Above: **Elvis Presley in his famed gold-lamé Nudie suit,** with "proud papa," Nudie, in 1955. Autry Museum of Western Heritage, Los Angeles

Below: Beginning in the early 1970s, **Waylon Jennings (left) and Willie Nelson** popularized dressed-down denim and the "outlaw style."

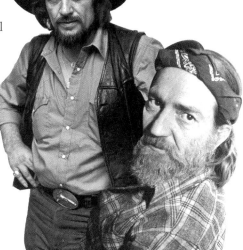

abandoned ranch somewhere, trying to feel how they felt back then, be how they were," he wrote in his 1975 memoir, *Man in Black*. "I wore authentic Western clothes on the road and in concert, too. I tried hard. . . . For *Ballads of the True West*, I just about became a nineteenth-century cowboy. I attached myself to people, like Tex Ritter, who'd spent their lives researching Western history."

He also spent time at Nudie's, having his custom Western-cut suits made. Johnny Western, who toured with Cash off and on for thirty-nine years, recalls, "Johnny had tons of wardrobe made by Nudie. When he switched to the black clothes, Nudie made all those things." Embroidery artist Rose Clements recalls, "I did all of Johnny Cash's embroidery for Nudie's and later for Manuel. It looked classy—always black on black, except doing something for a Christmas show that had a bit of green in it [such as lapels embroidered with holly], but mostly it was black." Future noir-clad rock & rollers were no doubt taking note.

By the mid-1960s, a new rock scene was emerging in the San Francisco Bay Area, an American answer to the British Invasion led by the Beatles. Bands like Big Brother and the Holding Company and the Charlatans were looking to Native American beadwork and feathers, frontiersman fringe, and nineteenth-century Western gambler duds as inspiration. While Big Brother, particularly guitarist James Gurley, went for the beads, feathers, fringe, and denim bib-front shirts, the Charlatans favored pinstriped, Western-cut waistcoats and black cowboy hats with silver concha hat bands. Founding member George Hunter explains, "With our look, we placed ourselves at the beginning of the twentieth century. . . . It was relatively easy to go out and find a lot of clothing from the turn of the century in thrift shops and antique stores. It was a fairly conscious effort we were making. The other part of it was not wanting to be associated with the British Invasion. Everybody and their brother was doing that. . . . Even the Byrds, when they started, were affecting that English look. . . . So we were looking for some strong American identity. That's what we were about."

The group really "went Western" when it established a residency at the Red Dog Saloon in nearby Virginia City, Nevada, an old mining town. According to *I Want to Take You Higher*, a history of psychedelia, "When the Red Dog Saloon finally opened to the public, on June 29, 1965, the sheriff came by to have a look. What he saw was enough to warm a man's heart. A lot of locals took the town's heritage lightly, but these mysterious young people were into it. . . . They had put in crystal chandeliers, an antique mirror-backed bar, thousands of dollars' worth of red-and-turquoise velvet drapes. They came up wearing city clothes but after a while began dressing as if they seriously believed they were living in the Old West The waitresses wore saloon-maid bodices and net stockings, and the bartender had on a striped shirt with sleeve garters. Quite a few customers were in period costumes. Maybe the entertainment, a rock band in cowboy clothes that had trouble telling one end of the instruments from the other, wasn't authentically Old West, and in the old days there probably hadn't been a Waso Indian bouncer in a Rainbow Girls sash or a box of flashing lights on the stage, but altogether the sheriff was moved to join the frontier fantasy. He walked up to the bartender and offered to leave his gun at the bar in accordance with the code of the West."

Down in Southern California, another rock & roller was cooking up his own fantasy of Western wear, based on the outrageous rhinestone suits Nudie had been making for C&W stars since the 1950s. Gram Parsons, a Florida-born, Georgia-bred singer-songwriter who suffused his traditional country sound with rock & roll attitude, first visited Nudie's in 1967 or 1968 when his International Submarine Band was playing the

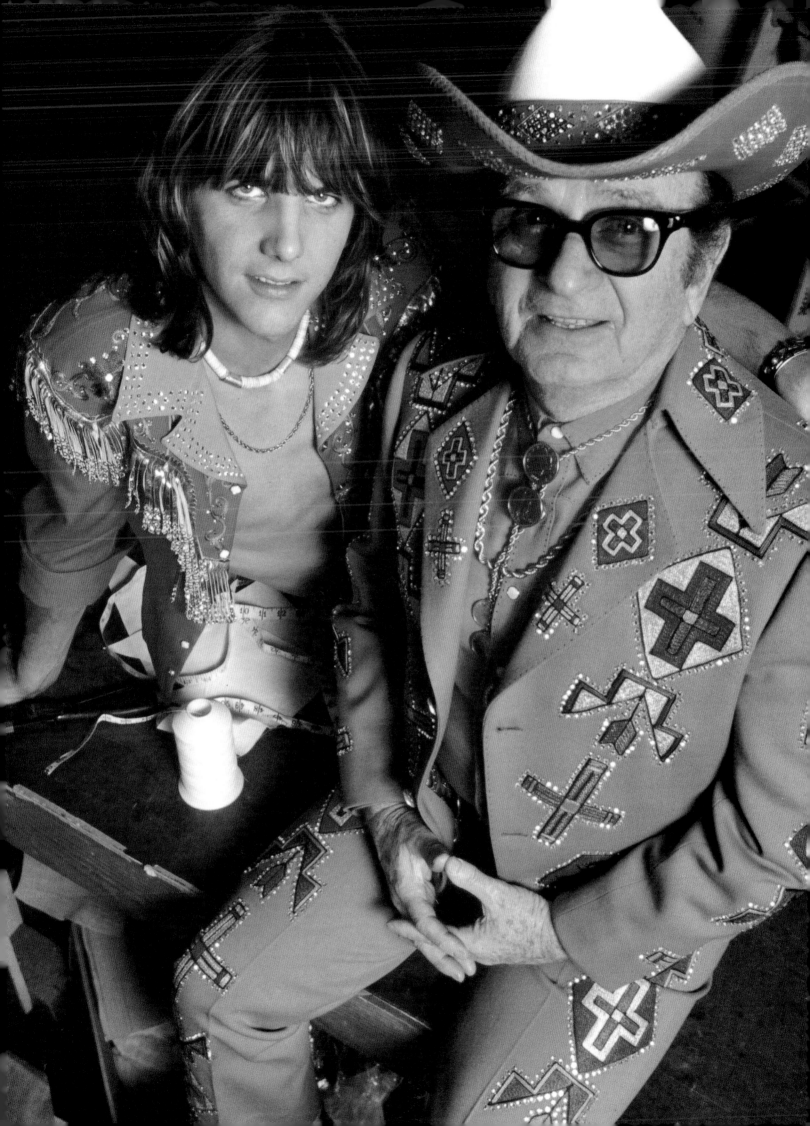

local honky-tonks. Though the members were depicted on the cover of its one album in Civil War–era costume, Parsons decided to use income from his trust fund to outfit his band in Nudie suits. Fellow Floridian Jon Corneal, who played drums with the group, got a red suit trimmed in Seminole Indian–inspired embroidery. Parsons's first outfit was embroidered with submarines.

By the time he had formed his next band, the Flying Burrito Brothers, Parsons's imagination had gone wild with possibilities for what would become his signature suit. He'd met a kindred spirit in Nudie: "I took a kind of special liking to [Gram Parsons]. Not only was he one hell of a good songwriter and musician, he was also real smart and a nice boy too. He was a real downhome kind of a guy and he liked to hang around my store and pick the guitar. Of course he would always call me and invite me to hear the Burrito Brothers whenever they were playing someplace in town and I always went. . . . Through the Burritos I got to be kind of well known to the rock & roll people, and I really appreciate what they did for me along those lines."

Former Byrd Chris Hillman, who cofounded the Burritos with Parsons in 1968, recalls that, by the late 1960s, "Nudie wasn't doing such great business when we first went down there because all the country guys were trying to be hip and they weren't all wearing [Nudie suits] anymore. A few of them were wearing them in the sixties but not like in the fifties. At first it was all tongue in cheek. Manuel, Nudie's son-in-law [who'd become the shop's head designer], did all the suits. Nudie was more a figurehead then. We were really having a great time in those outlandish suits."

On the cover of the band's first album, 1969's *The Gilded Palace of Sin*, all the members are dressed in their trademark attire: Hillman in a cobalt blue outfit with a giant embroidered sun on the jacket back, and peacocks adorning the front, their feathers reaching the sleeves; pedal steel player Sneeky Pete Kleinow in a black jumpsuit with a golden pterodactyl emblazoned across the front; and bassist Chris Ethridge in a white suit lavishly decorated with red and yellow roses. Parsons dreamed up the most spectacular suit of all: white hip huggers with poppies and flames engulfing the pant legs, which flared at the bottom via red "exotic" fabric insertions, matched with a short white gabardine motorcycle jacket, festooned with imagery personifying the Burritos song "Sin City." Original sketches and written instructions

for the suit from Nudie's customer file on Parsons offer these details: sketches of three kinds of pills—white cross (amphetamines), red capsules (barbiturates), and blue and green capsules (probably a little of both)—were to be embroidered "2 1/2 diameter" on the sleeves; the pill motif also would be stitched onto "3 inch belt loops—western." The jacket front was to be embellished with poppies and the lapels decorated with "girls (nude)." On the jacket back would be a "cross in red outlined with different color rhinestones—rays [surrounding the cross] to be different colors." Not written down but roughly sketched were marijuana leaves to be stitched on the jacket front. In 1999, a closeup of the jacket graced the cover of a critically acclaimed Parsons tribute album, *Return of the Grievous Angel*.

Nothing else Parsons ever wore topped this spectacular suit, but one 1969 order in his Nudie customer files called for "regular Western suits with buckles and buttons in silver; lapels braided with lining; 1 pink velvet [jacket] with black lining; 1 black satin [jacket] with pink exotic lining; pants also lined as coats; bellbottoms cut tight through upper legs." By this time, Parsons had become best friends with Rolling Stone Keith Richards, who also began frequenting Nudie's. Reportedly, Richards audaciously once ordered a suit adorned with phalluses, though Nudie claimed, "In all my years designing, I have only refused to make one suit. A fellow came into my shop one day and asked me to embroider some pornography on an outfit."

Mark Volman of the Turtles, and later of Flo and Eddie, recalls the impact on the local music scene made by the Burritos and their Nudie suits. "The Burrito Brothers came up with a unique situation—a show. They were really dressing that way purposefully, because of what they were doing musically. At the time, nobody had made that kind of commitment to go overboard with the look. It was the perfect way for them to draw some attention. I loved the stuff Nudie did with Gram and those guys. They were collectors and they knew what they wanted. They really went over the line—they wanted the traditional but they wanted it to be within the realm of the '60s. I remember Sneeky Pete was uncomfortable with that, but Gram could get into it because he saw the theater of it."

Rock archivist Michael Ochs, who was a Columbia Records publicist in 1970, remembers the rock & roll scene that began congregating at Nudie's. "Being a publicist, I'd take acts there that wanted to go check it out. In addition, Nudie's was just up the street from the Palomino club, so if I was leaving Columbia at 6:30 or 7:00 or 8:00, and the Palomino show didn't start until 9:00, what are you going to do? Basically you'd go hang out at Nudie's for a little while." Ochs bought himself a few sparkling garments that he found on the sale rack. "Because his prices were so high and back then we weren't making much, we'd only look at the sale stuff. Nudie had a rack that was either stuff that nobody picked up or stuff that he just wanted to get rid of." Nudie was friendly even to the bargain shoppers, Ochs recalls. "Nudie was always outgoing. He invited me to sit in one of the Nudie cars once. I think it had revolver handles. He talked incessantly, and he'd usually bring out the scrapbook. At least he did for me. I don't know if he did it on a regular basis. But he brought it out to show me all the pictures: 'There's me with Hank, there's me with Elvis.' He had a picture at the counter of him with Elvis. He also had a bunch of calendars with Elvis in the gold lamé suit that he gave away. I'd see Nudie at the Palomino, too, hanging out."

By the early 1970s, Western style was popping up among a number of rock & rollers. Volman explains the appeal of Western-cut garments: "I was the one guy in my group who was into the Western motif. It gave me a look in terms of the relationship of where I fit into the Turtles. I wasn't a country singer, but I was just looking for an image for myself and the Western thing was something I could do comfortably. It didn't matter if your size was big or small. The clothes made you look good—they were cut in such a way that they made you look thinner. That helped at that time for me." Janis Joplin, who had been lead singer of Big Brother, bought a few Nudie pieces, and had reportedly just ordered $15,000 worth of clothes when she died of an overdose in 1970. The Grateful Dead were also into Nudie's buckaroo look. The group had been doing such Western-themed songs as "El Paso" and "Mexicali Blues," inspired by, according to Dead lyricist John Perry Barlow, "a huge cowboy thing going on

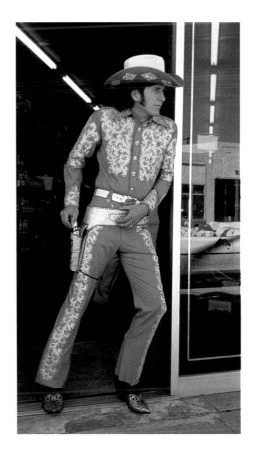

Rock & roll archivist **Michael Ochs hung out at Nudie's during the early 1970s** when he was a record-label publicist. He posed in full Nudie regalia—rhinestone-studded shirt, pants, hat, and gun belt—for a friend doing a magazine photograph spread at the North Lankershim shop in 1972. Collection of Michael Ochs Archives, Venice, California

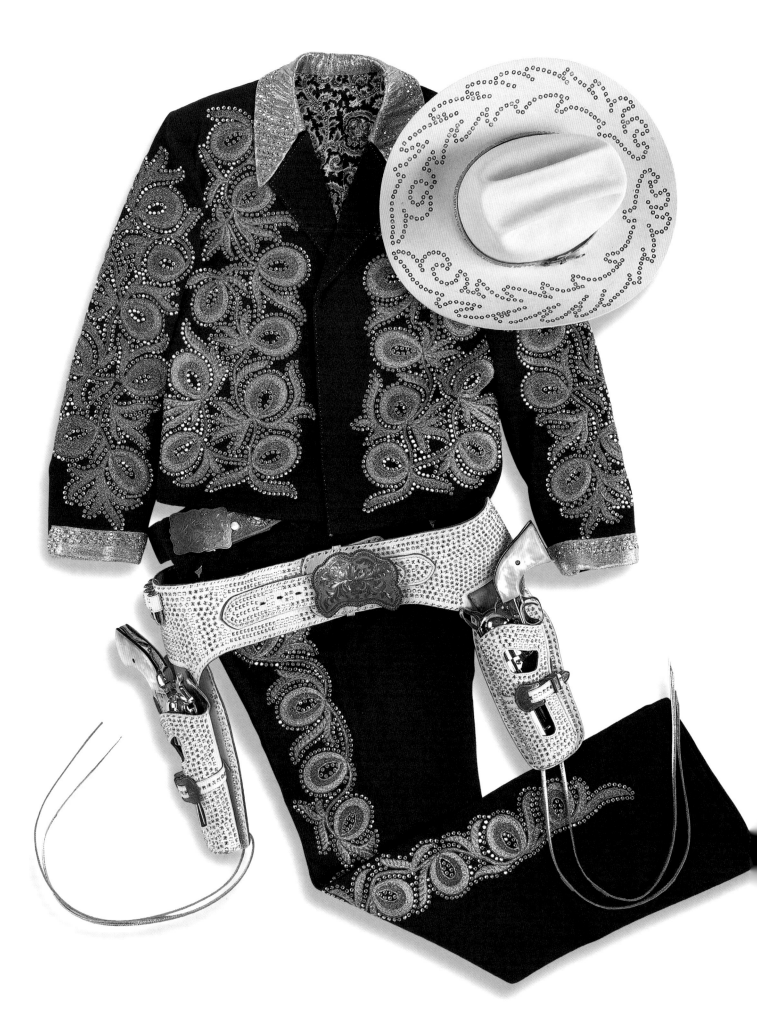

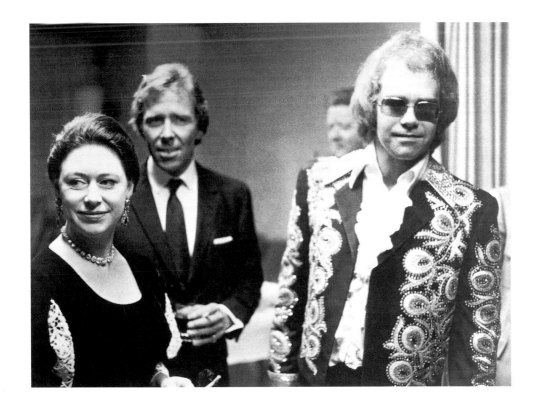

Left: **Nudie's shop was a stepping stone for Elton John on his way to flamboyant costume excess**. For a meeting with Princess Margaret and Lord Snowdon in 1972, he chose one of several custom Nudie suits he owned. Collection of Michael Ochs Archives, Venice, California

Opposite page: **Nudie originally created this outfit**—complete with rhinestone-decorated hat and double gun belt—for himself. Elton John later bought the outfit for himself and appeared in it, sans gun belt and hat, for his introduction to English royalty. Collection of Marty Stuart

inside the Grateful Dead culture, largely the result of a major cowboy influx in the road crew . . . all these guys from Pendleton." Guitarist/vocalist Bob Weir, in particular, Barlow has reported, "was in a cowboy phase . . . dressing up and thinking of himself as some kind of a cowboy. There was something that Weir found very appealing about the cowboy. His cowboy thing is about the mythical cowboy, not the real cowboy." One of guitarist/vocalist Jerry Garcia's side projects, New Riders of the Purple Sage, which later became a band on its own, took the desperado idea even further, dressing as nineteenth-century buckaroos and writing songs about the adventures of such characters as Panama Red.

In 1970 the Dead visited Nudie's and ordered a special embroidered design that became one of their trademark motifs: the skull and roses that decorated the cover of *American Beauty*. Rose Clements, who had only recently joined Nudie's, remembers embroidering the complicated design. "They only did chain stitch when I got to Nudie's," she recalls, "and after a while, I said, 'Why don't you get the other [French-made Bonaz] machine?' And Nudie didn't know what I was talking about, so he drove me downtown and we found the other machine. Then, just after that, I did a lot of work for the Grateful Dead. I did the skeleton and all this business. I could never have done that on the chainstitch machine. We could do that because we had the two machines, and that's when I started using both machines—because you get a better effect."

In 1970 the Dead visited Nudie's and ordered a special embroidered design that became one of their trademark motifs: the skull and roses that decorated the cover of American Beauty.

Other regular Nudie customers included Elton John, whose first rhinestone-encrusted suit set him back $3,500. Not quite so flamboyant but just as big a spender was Bob Dylan. In 1975, Nudie recalled, "Bob Dylan and the entire Rolling Thunder Revue waltzed into my store and cleaned out my racks. They bought almost every special suit I had made up. They couldn't wait for custom orders because they were playing a concert in Houston the next day and had decided on the spur of the moment that a show in Texas just wouldn't be right without Nudies. Luckily, they were able to find a suit for everyone in the band and walked out satisfied, leaving me $15,000 richer."

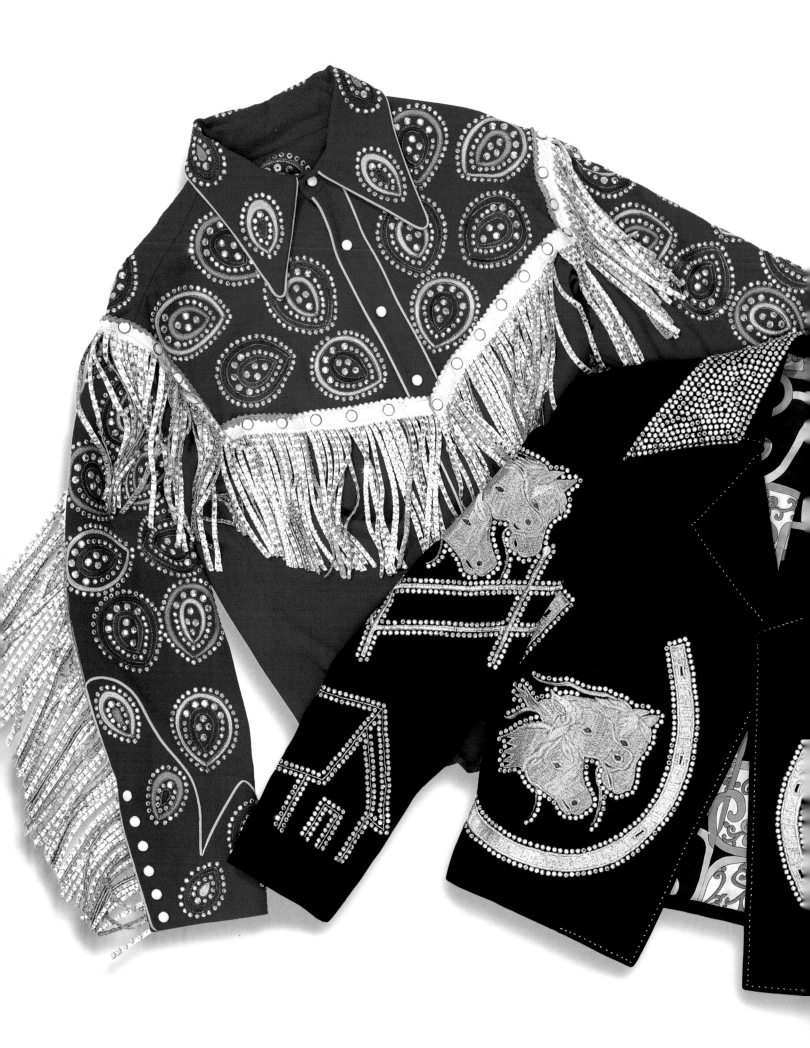

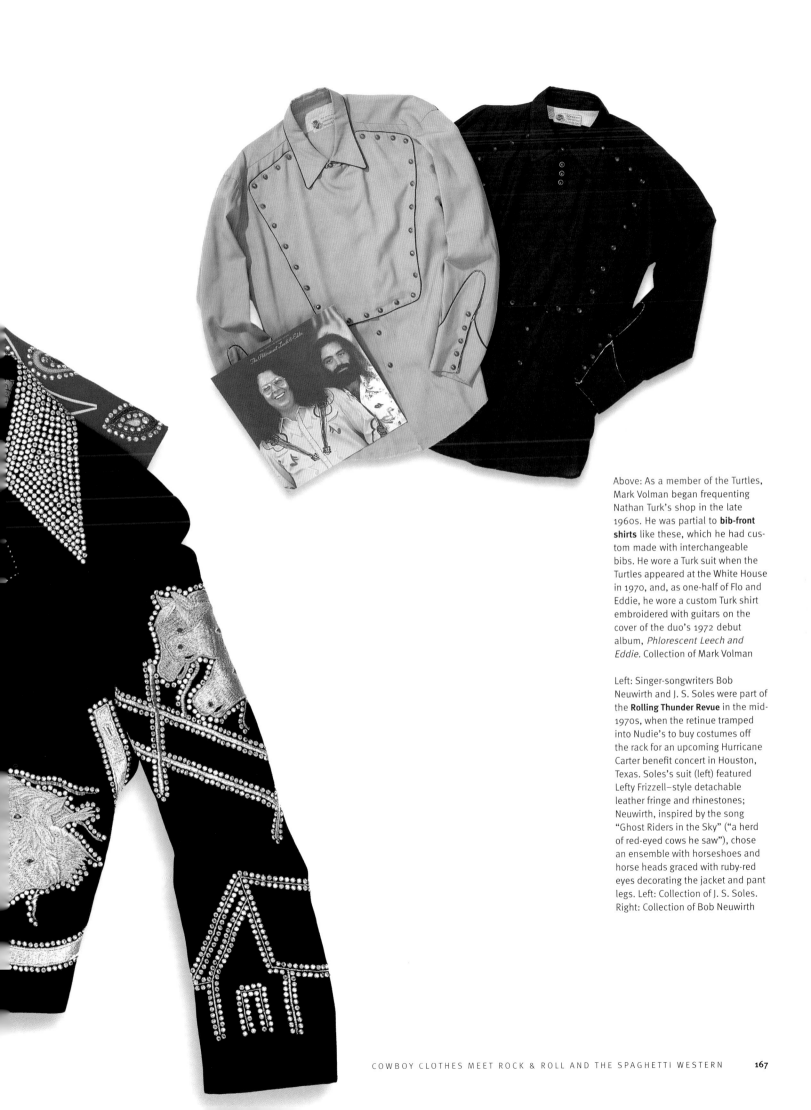

Above: As a member of the Turtles, Mark Volman began frequenting Nathan Turk's shop in the late 1960s. He was partial to **bib-front shirts** like these, which he had custom made with interchangeable bibs. He wore a Turk suit when the Turtles appeared at the White House in 1970, and, as one-half of Flo and Eddie, he wore a custom Turk shirt embroidered with guitars on the cover of the duo's 1972 debut album, *Phlorescent Leech and Eddie.* Collection of Mark Volman

Left: Singer-songwriters Bob Neuwirth and J. S. Soles were part of the **Rolling Thunder Revue** in the mid-1970s, when the retinue tramped into Nudie's to buy costumes off the rack for an upcoming Hurricane Carter benefit concert in Houston, Texas. Soles's suit (left) featured Lefty Frizzell–style detachable leather fringe and rhinestones; Neuwirth, inspired by the song "Ghost Riders in the Sky" ("a herd of red-eyed cows he saw"), chose an ensemble with horseshoes and horse heads graced with ruby-red eyes decorating the jacket and pant legs. Left: Collection of J. S. Soles. Right: Collection of Bob Neuwirth

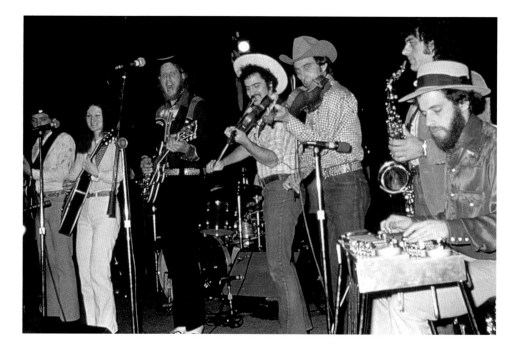

Left: **Asleep at the Wheel,** shown here in the early 1970s, was one of several bands that helped make cowboy clothes fashionable among hippie audiences. Collection of Michael Ochs Archives, Venice, California

Below: Asleep at the Wheel, whose members were aficionados of Western swing, acquired **custom Western wear** soon after the band's formation in 1970. The jacket pictured here belonged to bassist Gene Dobkins and was made by Gross; the shirt was custom-made by Williams of Fort Worth for bandleader Ray Benson in the early 1970s. Collection of Ray Benson

A huge number of rockers did find time to order custom clothing, including members of America, ZZ Topp, the J. Geils Band, the Beach Boys, New Riders of the Purple Sage, Mountain, and Poco, as well as Gregg Allman, Jackson Browne, George Harrison, Ringo Starr, Mick Jagger, Sly Stone, Jim Morrison, Roger McGuinn, Harry Nilsson, Mike Nesmith, Rick Nelson, the Osmond Brothers, Phil Ochs, Gene Parsons, Johnny Rivers, and Byrd Clarence White, who modeled suits in a Nudie catalogue. Volman, for one, enjoyed hanging out at Nudie's but preferred having his custom Western wear made by Turk. "I lived up in Laurel Canyon and drove by and noticed Turk's shop," Volman recalls. "I had been looking to do a bib-front shirt I had seen on an old Western on television. I went in and it was a very small shop, only one room—not like Nudie's, which was more like a museum. I noticed on the walls several photos of the early film and television cowboys and when I spoke to Mr. Turk I said I was interested in having a shirt like one of those on the wall. He said he'd made a lot of the shirts for the Western stars, so I knew I was in good hands. The nice thing about working with Turk was that he had a low-key approach to his work. His style didn't draw attention to the fact it was western, or that it was a cowboy piece—it was a nice piece of clothing you could wear in a lot of different situations. I like the bib front—they could be tucked in or worn out. They always looked nice, like you were conscious of your dress." Volman was also drawn to Turk's dedication to his tailoring. "Mr. Turk was real quiet, and he took a lot of pride in his work. He didn't really stand out—he just did great work. You could always count on it being done well. Turk wasn't a limelight chaser. He didn't have rock and rollers' pictures on his wall. He had the real cowboys. He wasn't chasing the rock scene. If you had a Nudie piece, it was like getting a piece of art—and you got charged for that. It was super expensive. Whereas Turk just charged you for the work." Carl Wilson, of the Beach Boys, became a fan too, and Volman recalls he commissioned numerous Turk garments.

Other, less well-heeled bands such as Asleep at the Wheel, put together cowboy outfits by scouring thrift shops, shopping at regular Western outfitters, and getting their girlfriends to sew them. Nudie customer Linda Ronstadt recalls, "Miss Pamela [des Barres] was requisitioned by all these guys: She made shirts for Chris Hillman, for Gram, she made them for everybody. She was just darling and so sweet. So that started it up—that was definitely the fad, and then for the rest of the guys that would

become the thing. You would get your 'old lady' to make you a shirt and get the little device that put rhinestones on stuff, and embroider it and your jeans."

As the cowboy look became trendy among the rock crowd, it made its way into the closets of rock fans, greatly increasing the numbers of a young Western-clad population, from those who could afford couture prices to those who shopped at Kmart. Rose Clements left Nudie's in the 1970s to open a boutique on trendy Melrose Avenue that sold denim garments decorated with her intricate embroidery, a very popular style that would return in the late 1990s. The 1972 movie, *Superfly*, featured this look, and Clements remembers that one of her best customers was an African American who was a successful pimp. The flashy "cowboy pimp" style also consisted of shiny, synthetic fabrics or fringed colorful suede, worn tight and decorated with studs and stones, accompanied by a large-brimmed cowboy hat and high-heeled boots. Artists who embraced this look include Sly Stone and Bootsy Collins, both of whom commissioned ensembles from Nudie. In the early 1970s, the Outlaw movement, led by artists Willie Nelson and Waylon Jennings, favored dressed-down scruffy jeans, Western-cut denim shirts, and red bandannas, tied around the head rather than the neck. Not coincidentally, Western movies had become populated with desperados following Clint Eastwood's spaghetti-Western style. Instead of shining heroes, cowboys were renegades, with long, tangled hair, dirty jeans, and dusty boots. Some country and rock artists even began starring in this new type of Western: Bob Dylan and Kris Kristofferson turned up in 1973's *Pat Garrett and Billy the Kid*; Willie Nelson played an outcast preacher in *Red-headed Stranger*, based on a Nelson song, in the mid-1970s. Jennings and Johnny Cash also played cowboys in Westerns.

By mid-decade, a Western shirt worn with blue jeans and cowboy boots (frequently made by Frye) had become practically a uniform for those attending rock concerts. Fancy, sparkling suits and rhinestone-studded T-shirts fell out of favor among those who had briefly followed the Burrito Brothers' example. Though a 1976 feature in *People* magazine claimed Nudie's still did "several million dollars in business each year," business was starting to fall off. As rock stars became infatuated with spandex and the synthesizer, the cowboy look began gradually to die down, only to return, riding a new pop-culture fad and reaching dizzying commercial heights by decade's end.

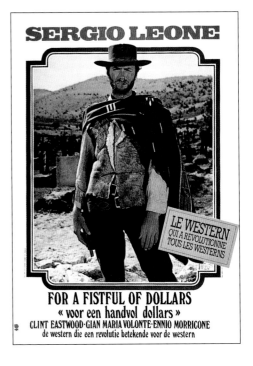

SERGIO LEONE

LE WESTERN
QUI A REVOLUTIONNE
TOUS LES WESTERNS

FOR A FISTFUL OF DOLLARS
« voor een handvol dollars »
CLINT EASTWOOD·GIAN MARIA VOLONTE·ENNIO MORRICONE
de western die een revolutie betekende voor de western

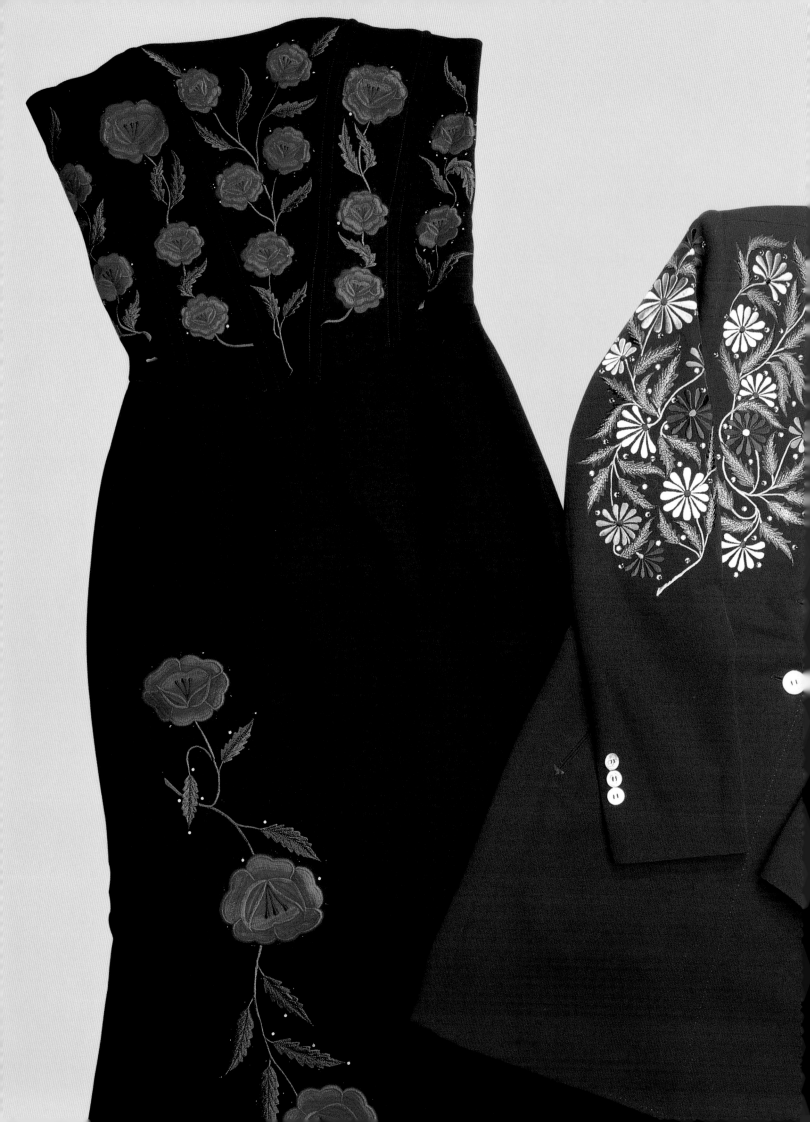

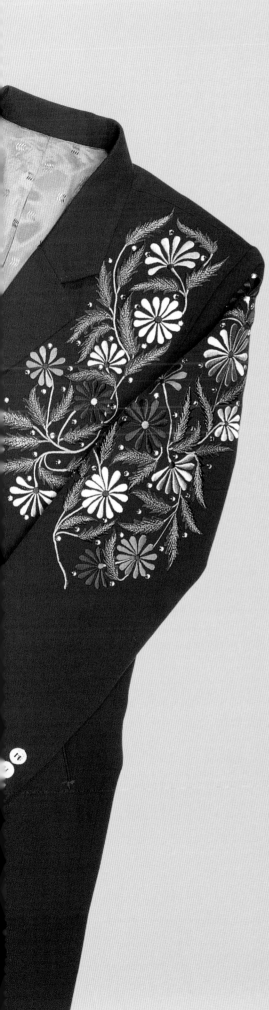

Manuel:
MODERN-DAY MASTER TAILOR

A stone's throw from Nashville's Music Row, a dark, three-story Victorian house became the mecca in the 1990s for entertainers in need of fancy threads for an awards show or upcoming tour. There's no marquee out in front of 1922 Broadway, but the tastefully appointed, Southwestern-style shop is clearly the headquarters for a master of Western wear. Proprietor Manuel Cuevas—usually just referred to by his first name—is the living link to the rodeo-tailor tradition pioneered in the 1930s and 1940s.

On this fall day in 1998, the handsome, white-haired designer, wearing an exquisite, Western-cut jacket ornamented only with his trademark embroidered arrowheads and topstitching, is showing off a special, ongoing project. He plans to complete a set of fifty jackets, one for each of the United States, stitched with imagery representative of each state's attributes. Also on display and available for purchase are Manuel's dazzling Western-style shirts, jackets, trousers, and dresses. Not for sale are a few vintage pieces prominently arranged around the high-ceilinged rooms: the flame-and-poppy-embellished white pants that had belonged to Gram Parsons in the 1960s and a small beige jacket festooned with stagecoaches and desert scenes worn by Little Jimmy Dickens in the 1950s. Of the Dickens garment, Manuel says, "Somebody sold it, and I rescued it back. I'm attached to my children—maybe it reminds me of all my mistakes, nothing was perfect. But it was what I could do at the time."

The floral-embroidered bustier with matching skirt on the left was designed for a formal occasion. At right is one of Manuel's more traditional lady's jackets. Both reflect **Manuel's long years of learning the business with Turk, Nudie, and other designers.** Courtesy of Manuel

171

If you wander into **Manuel's handsome brick shop** on Broadway in Nashville, you are likely to be greeted by the designer himself or his daughter, Morelia. Amid the elegant appointments of his shop, you can almost feel at home.

Upstairs hangs a 1920s portrait of a beautiful, stately woman dressed in traditional Mexican costume—Manuel's mother, who taught him to hand-embroider as a child. All these relics help paint a biographical picture of the man who immigrated from Mexico in the 1950s and became head designer for Nudie before establishing himself as the preeminent couturier of Western wear.

Nashville is a long way, both literally and figuratively, from the tiny village of Coalcomán, in Michoacán, a region of southwestern Mexico, where Manuél Arturo José Cuevas Martínez was born April 23, 1934, to a rancher and his wife. The fifth of eleven children, Manuel first learned to sew from his older brother, Adolpho, and became so enraptured with it that he started making all his own clothes when he was eight. Young Manuel was also drawn to the theater: "I belonged to a troupe for about eight years," he recalled over lunch at the cafe across the street from his shop. "That's when I began to envision costumes. But even before that, I was so flamboyant as a little child. I wore colors—green, royal blue, red—where most villagers dressed in white. I was fourteen years old and I had leopard cuffs."

The precocious youngster became an apprentice to a tailor (also named Manuel) when he was twelve and quickly mastered cutting and sewing coats. He also found time to go to the movies, walking to the next town to see his favorite serial, *The Lone Ranger*. While studying psychology at the University of Guadalajara, he continued to "sew shirts, dresses, pants, because I was dedicated." Realizing that "I was going to do what I love most in my life, designing clothes," Manuel recalls that his fellow students were appalled: "'Don't tell me you just want to be a stupid tailor.' 'No, not that, I want to be a designer.'"

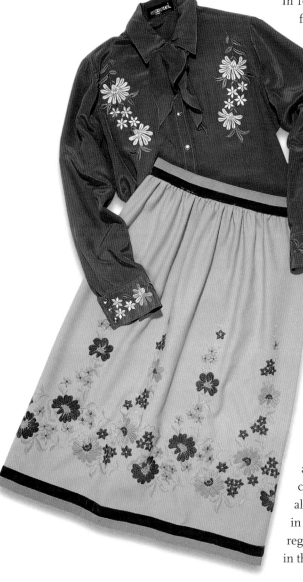

Former singing cowboy star Monte Hale introduced his wife, Joanne, to Western style in a big way. **In the early 1980s, Manuel created this outfit** for her to wear when she and her husband went out on the town with their friends, Jackie and Gene Autry. Autry Museum of Western Heritage, Los Angeles. Donated by Joanne D. Hale

In 1953 Manuel moved to Los Angeles, first finding employment at a brassiere manufacturer, working at a small tailoring shop making custom pants for $1 an hour, then moving to another outfit where he ran a "345-people shop for $8.65 an hour— what a jump!" His next job was with Sy Devore, "Hollywood tailor to the stars, Bob Hope, Frank Sinatra, Jonathan Winters, Robert Taylor—everybody." Hired to do fittings, Manuel was earning much more, but he grew bored with the work. After learning that it was Viola Grae's embroidery electrifying many of the costumes in Pasadena's Rose Bowl parade, he sought her out. "She was about sixty, blond, and very flamboyant," he remembers. "I knew hand-embroidery from my mother, but Viola taught me how to embroider on the machine."

He left Devore and began making shirts for Grae, who by then had started her own small custom-tailoring company in North Hollywood. Manuel recalls working on one exotic shirt commissioned by Salvador Dalí, which was "white with what I call 'Spanish gloves.'" He soon met Grae's colleague, Nathan Turk, and sold him a few of his "designs on paper—not patterns" for $10 to $50 each (though Turk's daughters don't remember this). "Turk was a quiet man, but he was the king! Once I went to his shop at night and cut some suits for him."

Before long, in the mid-1950s, Nudie learned about Manuel's talents and lured him away. "I just wanted to find my match," Manuel reminisced forty years later. "I thought Nudie was it—and he was! Here, people could wear the kind of things I wanted to make. Before, people thought my ideas were strange. I began to do a lot of great things—I was the guy with the prize."

Young and charismatic, Manuel bonded with the customers and was excellent at doing fittings, cutting the fabric, designing, embroidering, crafting leather, and sewing. As Nudie spent more and more time socializing with his celebrity clients and traveling to bring in business, Manuel took over the majority of the actual design and hands-on work. Having learned silversmithing and boot-making back in Mexico, he became Nudie's Renaissance man. Porter Wagoner was one of many regular customers Manuel handled. "Manuel made all of my suits," says Wagoner, who in the 1990s was still a client. "He's been a wonderful man throughout my career. He's

just absolutely brilliant with clothing. He's got such talent and imagination—he's just tremendous." Jimmy Dickens agrees: "Eventually, Manuel had a tremendous amount to do with the designing end."

Manuel also worked with Nudie's cowboy actor clientele, both on movie and television costumes, as well as their personal custom clothes. He also at long last got to meet his hero, the Lone Ranger, when actor Clayton Moore came in for his custom pullover dark blue shirts. "One day, while Clayton was in, Roy Rogers comes by," Manuel recalls. "Clayton says, 'You know, I've never met him,' so I had the glory of introducing the Lone Ranger to Roy Rogers. What a glorious day. That's my biggest claim to fame—all the rest can go to hell!"

Manuel eventually became a member of Nudie's family, in 1960, marrying Nudie's daughter, Barbara. Before long, Nudie entrusted his son-in-law to create his own outrageous, lavishly embroidered outfits. Manuel himself, however, continued to dress down; in a late 1960s Nudie's catalogue, Manuel modeled simple, Mexican-style embroidered shirts and an elegant frock coat. When the rock crowd began flocking to Nudie's, Manuel, like his boss, hit it off with them, frequently going out to hear the bands play. "I am one of those fools," jokes Manuel, still a club-goer today. "I listen to the music. I love what they do."

While at Nudie's, he became attuned to the artists and strove to create garments that could reflect their inner selves. Having worked with Gram Parsons on his Sin City suit, Manuel sees it, for example, as the doomed musician's foretelling of his tragic future. "We spent many hours together," Manuel recalls. "There was a lot of brotherhood going into that outfit—one of those things that happens once in a lifetime. But it wasn't until ten, fifteen years after making that outfit, that I discovered it was actually a map for him to follow to his death." On September 19, 1973, Parsons died of an overdose; a few days later his body was stolen by friends and cremated in the desert near the Joshua Tree motel where he had died.

Linda Ronstadt remembers meeting Manuel soon after seeing the Burritos dressed in their Nudie suits, which reminded her of "what I saw in the rodeo parade every year. Of course, I loved it. When I first started hanging out at the Troubadour, everyone sort of idolized the Rolling Stones and nobody was interested in country music. But all of a sudden the Burritos and those guys were really loving country music, and since I'd grown up in Arizona I'd heard it my whole life and loved it. In '71, I hung around with the Burritos a lot . . . we were all part of the same little tribe. We all trooped into Nudie's to see what we could get. I couldn't afford much. I remember I bought a really pretty rhinestone belt which I wore forever. My costume onstage was a pair of Lee Marshall shorts and then that rhinestone belt and a scarf wrapped around my top and that was it! Finally, Manuel made me a couple of blouses, a white one and an orangey-rusty-brown one. The white one had a Western cut, with some rhinestones on it and tied in front. The other one just looked like a slip, a very 1970s kind of Hollywood street urchin look."

Manuel also collaborated with the Grateful Dead on the skull-and-roses designs embroidered by Rose Clements. "[Jerry Garcia and I] talked at the Troubadour for hours when we first met," Manuel recalled in 1998, "and then I went to about two or three shows here and there. We spoke of ideas like, How could you be 'grateful' if you aren't covered in flowers—and making a garden out of the dead. I talked to him about how [in Mexico] people give presents [on the Day of the Dead] and how the happiest day is the celebration of the dead. 'Cause people die and you're supposed to sing, not to cry. He just fell in love with the idea. And that's when I came out with the roses all over the craniums."

Manuel's clothes are among the most **amazing examples of the tailor's and embroiderer's arts,** as well as reminders of the more traditional in Western styling. Courtesy of Manuel

In the early 1970s, Manuel met a teenage mandolin player who grew up to be one of his closest friends and best customers. "When I was fifteen, in 1974, I played in California for the first time, at a bluegrass festival in Orange County," Marty Stuart recalled sitting on the screened porch of his Tennessee home in September 1998. "Afterwards, I talked the band into going to a restaurant near Nudie's so I could tear down the street with the $200 I'd saved up. Guys on the Opry had told me all about Nudie's, and I wanted to buy me a Porter Wagoner suit. Of course, I would go straight to the loudest, brightest, and most expensive suit in the store. It was heavy gabardine, black, candy-cane red, and white, with rhinestones on the pants and coat. It was like a vision. I asked Nudie, 'How much is that suit?' and he said, '$2,500—if you've got cash, it's $2,250 total.' My heart just went right through the floor. Then over walked Manuel. He said, 'Hey, you come in here someday and you can buy every suit in the store. But today, we're giving away free shirts.' And Manuel gave a mc a little white, cheapo kid's shirt with some embroidery on it. It was a gesture of kindness from him. I was like, 'Wow!' And that's when I first met Manuel—and we've been going at it ever since."

In the mid-1970s, Manuel decided to leave Nudie's, after fourteen years, to branch out on his own. At the same time, his marriage to Barbara was ending. In 1975, Manuel opened his own by-appointment-only shop four blocks down North Lankershim. Not long after, he got a call from Nathan Turk, whose health was failing and who had decided to close his shop. Turk offered to sell Manuel his machinery and other goods. The last time he saw him, Manuel recalls, "He hugged me and said, 'You know, Manuel, I made a mistake many years ago. I should have hired you. I want you to know that I really thought I was taking advantage of you paying so little for your designs. Did you know that?' I said, 'Yes, sir, I did, but I was learning. It was very good for me to know that you appreciated what I was doing.' Then, one of the greatest things happened—something really touching. I bought sixteen or twenty of his machines, and he never cashed my check."

Many of Manuel's customers followed him from Nudie's to his own shop. "Manuel called me and told me he was leaving," recalls Wagoner, "and he said, 'I'm not going to ask you to go with me because I know you're a big customer of Nudie's, but this is where I'm gonna be.' 'Well,' I said, 'I'm gonna go wherever you're at, buddy,' so that's kinda how it turned out. I talked to Nudie and Bobbie about it because I wanted them to understand why I was going to Manuel. I told them, 'I love both of ya, but I'm just gonna go buy my clothes from him because he knows my size, he knows what I like, and he knows how to make clothes that fit me well.' I never had one that I had to have altered. Never. Same way with boots and stuff. They were happy with that." Rose Clements began doing embroidery work for Manuel after her Melrose boutique closed. (When she retired in the late 1980s, she passed along her embroidery patterns to Manuel.) Another tailor from Nudie's, Jaime, also joined Manuel.

Former Nudie's client Bill Anderson also switched to Manuel, who dreamed up an innovative design for his summer concert appearances. "The big suits are so hot, so he designed a real neat short-sleeve kind of a shirt-jacket for me that is very colorful and embroidered," says Anderson. "It's very functional. It's kind of a cross between a shirt and a jacket and that enables me to do the summertime things and still feel like I'm dressed for the occasion without just standing out there and burning up. You don't want the audience looking up there and seeing you wearing something like that and feeling sorry for you!"

Manuel continued to do costumes for movies (eighty-nine) and television shows (thirteen), as he had for Nudie's, and to discover up-and-coming artists. "We found Manuel in the early eighties and that opened up a whole new world," recalls Ranger Doug Green, leader of Riders in the Sky. "Nudie's by then was pretty much down to all polyester stuff. I went in there a couple of times and I saw nothing that was anything like Manuel's—it was pretty

Symbols of sin and evil abound on this jacket made by Manuel in 2000. The consequences of giving in to such sins is evident on the back of this jacket: an embroidered graveyard with headstones tells the story. This theme has been repeated on many of the garments Manuel has made for rock & roll musicians and C&W performers. Courtesy of Manuel

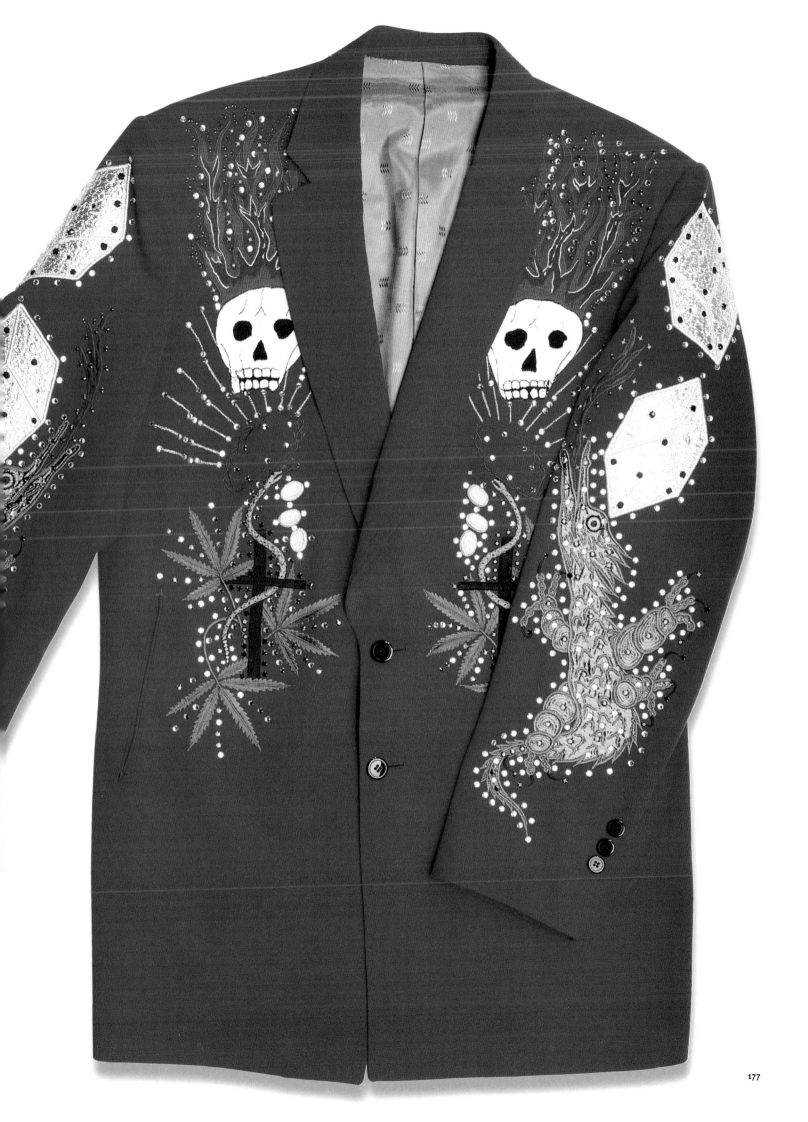

exciting in his store. We went in and thought we'd found paradise. There were pictures on the wall of Gene and Roy and Monte Hale all wearing Manuel's clothes. People like Pat Buttrum and Eddie Dean would just walk in. Manuel was always very gracious. He was very laissez-faire in those days about payment, just 'Pick out what you want, pay me when you can, it's ok.'"

Manuel prefers fine gabardine, silk, cotton, wool, suede, and leather for his garments, accenting them with intricate piping, unusual-shaped yokes, and exquisite embroidery. He specializes in beautifully sewn arrowheads, which, he says, are "very Mexican. Many, many years ago, in the early movies, clothes were made by Mexican workers in Los Angeles for the studios. They made those arrows for the cowboys. The piping is also Mexican." Another

"The American heritage, the settlers, the Army, real Indian costumes, the weavings and patterns—I have absorbed all this and put it on the clothing," Manuel explains.

Manuel trademark, long, graceful shirt cuffs, were inspired by the fancy gauntlet of classic suede, or leather cowboy gloves, he says. His fancy, "Frankenstein" stitch and eyelet designs have changed somewhat over the years. "I used to do round buttonholes with whipstitch by hand. I had an idea: Why don't I get leather lacing and crisscross it. I did those designs for so many different people. What is the next step? Eyelets put in with the machine, to avoid the ten or twenty minutes it takes to do it by hand."

Manuel's designs also frequently feature unique geometric-shape appliqués and embroidery, some inspired by his Mexican birthplace. A visit to his childhood home made him realize that numerous objects and imagery in his native land had subconsciously influenced him. "I discovered many signs that I put on my clothes," he said. "On furniture, I saw [carved] flowers that I've been making for forty or fifty years."

American Indian motifs also have inspired Manuel's designs. "The American heritage, the settlers, the Army, real Indian costumes, the weavings and patterns—I have absorbed all this and put it on the clothing," Manuel explains. "I try to follow the American tradition. My interest is in bringing it back, to nurture the individualism of the American tradition, which is why I'll travel to Indian reservations for hand-woven Chimayo blankets to make into jackets." Bob Dylan has been a fan of his Chimayo-blanket coats and bought one to the tune of $7,500.

Another tradition-minded artist who discovered Manuel in the 1980s was Dwight Yoakam. "Before he had a record deal he used to come into my store and roam around," Manuel told fashion writer Tanya Indiana in 1988. "I didn't know who he was; I blocked a hat for him. A few of my employees told me I should go to listen to this guy who was playing music in North Hollywood. I went to see him and really liked his music, the way he looked and the way he moved around, like a Cherokee Indian. One day Dwight came into the shop after he'd gotten the record deal. He said that he wanted to get a jacket. 'It's been my dream, my ambition, to do it right' were his words."

Yoakam wanted an appliquéd and embroidered bolero jacket similar to the ones Manuel had created at Nudie's for Buck Owens in the 1960s. "Together we came up with the Dwight look," according to Manuel, "everything from shaping his jeans to making the conchos that go up the seams. We got over three thousand calls from all over the world about Dwight's jacket." Yoakam wore the turquoise beauty on the cover of 1987's *Hillbilly Deluxe*, which caused a flurry of interest in retro Western wear, particularly bolero jackets. Obviously, many people agreed with Linda Ronstadt's assessment: "When Dwight Yoakam wore Manuel's stuff, God, nobody ever looked better. It was subtle, and that was it, man. He has a great body for those kind of clothes."

By the late 1980s, Marty Stuart had started a successful solo career, and, as Manuel had predicted in 1974, has become his best customer. Says Stuart of a Manuel garment, "The thing I get such pride out of is, you put this on and walk into any place on Rodeo Drive—

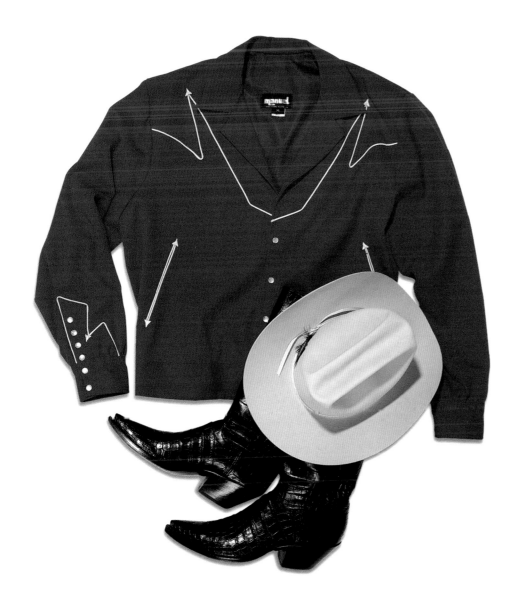

After collaborating on the blue gabardine jacket depicted on the cover of Dwight Yoakam's *Hillbilly Deluxe*, **Yoakam and designer Manuel embarked in 1990 on a partnership called DY Ranchwear.** "Because I don't like to repeat my designs," Manuel explained at the time, "I invented an extract of this thirty-year-old style [his California jacket]. The construction is not as serious as the original but it's still a tremendous bargain." Although the DY line was short lived, Manuel has since gone on to manufacture a full line of women's ready-to-wear garments. Collection of Robert Burke Warren. Boots and hat, Autry Museum of Western Heritage, Los Angeles

Armani, Ralph Lauren, you name it—and then go to Melrose and take your best shot at that, and everybody in all those stores just drops dead." Stuart has collaborated with Manuel on dazzling designs for his vast wardrobe, including over-the-top figurative pieces like one Manuel created as a surprise for Stuart. Called The Cowboy's Dream, it's covered with fetching cowgirls, musical notes, horseshoes, hearts, and guitars.

Subsequently, Stuart and Manuel have formed an almost father/son relationship. "At one point I was going through a recording career crash and a divorce—I was really messed up—and I went out to Manuel's," Stuart recalls. "I used to just lie on his cutting table and watch him work, because his hands are so pretty the way he works the fabric. He's a master. And when he gets on the machine, he sings—he starts singing his guts out. So I would just hang out and feed on him. Once he stayed up all night long working on this black leather suit with silver insets and silver studs. He was working so hard and I never asked him who it was for. I just thought it was a cool looking suit. When it was finished, he threw it at me and says, 'Try this on for me for a second,' and so I put it on, and I was just kidding—'cause I didn't have any money at that time—and said, 'It's a little big in the shoulders and in the chest,' and he said, 'Not if you throw your shoulders back and hold your chest out. It's yours.' He laid his heart out there for me, consoling me and being my brother."

Other high-profile artists who have benefited from the Manuel touch include Linda Ronstadt, Emmylou Harris, and Dolly Parton, who hired him to make the fringed, rhinestoned and embroidered cowgirl outfits they wore on the cover of their 1987 *Trio* album. "I just loved

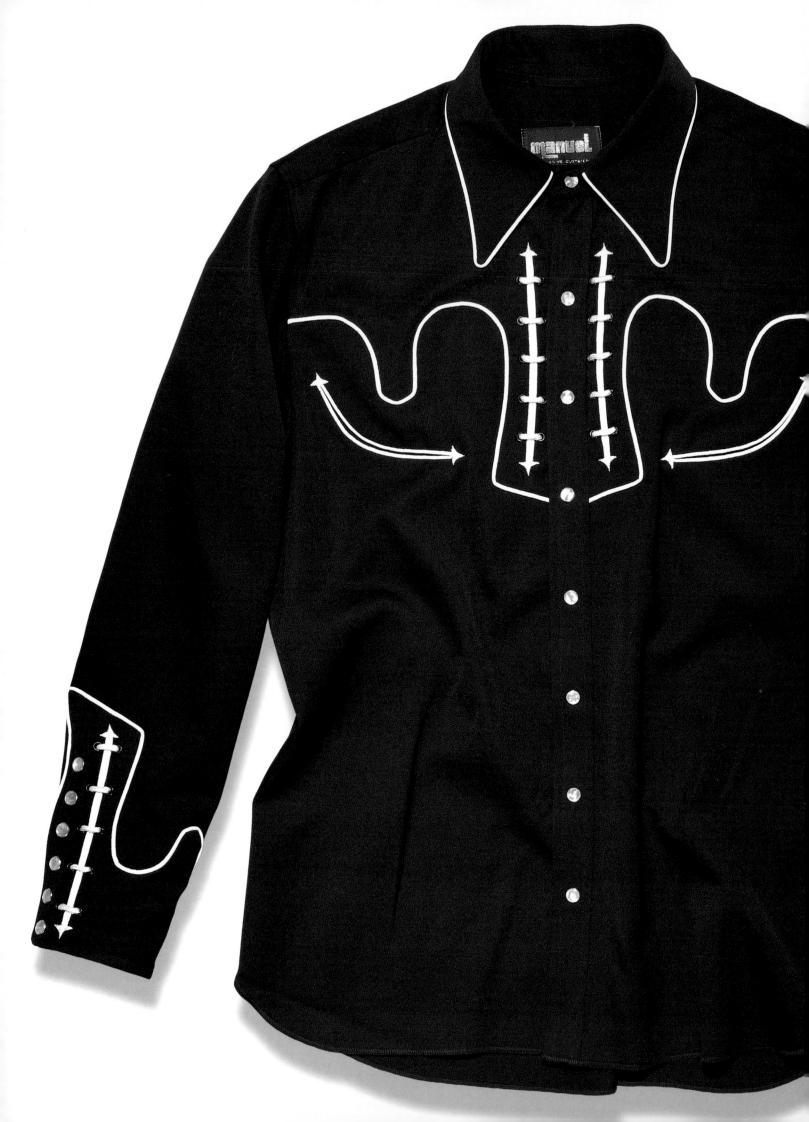

the Western cowgirl thing he made me," says Ronstadt, "with all the red embroidery on black, with black rhinestones on black fringe. It's really cool and fit like a dream and looked beautiful. He made me gorgeous black boots with red roses embroidered on the side, and the first day I put them on, I wore them the whole day."

Ronstadt has remained a loyal customer. "I love what Manuel does because he can make it as flashy as you want and he can make it as low-flash as you want. His machine embroidery is extraordinary—Manuel has certain techniques that he uses to twist the thread so that the thread gets more light when it's onstage or even when you're just looking at it. I love the black on black on black. You see all the different levels of workmanship on there in a low-flash way. Whatever you see, it's always an explosion on your senses even if it's the subtlest thing—like the suit he made for Ronald Reagan, which is a beautifully tailored suit. I always try to get him to do things for me that are on the subtler side—but he kinda does what he damn well pleases."

Ronstadt commissioned Manuel to make the Mexican costumes for her and her band's *Songs of My Father* (*Canciones de mi Padre*) tour of 1988–89. "I had three changes of his designs," says Ronstadt. "My favorite was black with white and silver flowers and an A-line, flared skirt and a hip-length jacket. It had the early California and Sonora feel to it. He made me this other thing that was spectacular—a black jacket and black skirt embroidered all over with rainbow flowers. I would never have gone for something like that in a million years. I'm a person who does not wear color, but I walked into his shop and there was this jacket up on the mannequin and I went, 'That is the most beautiful thing I've ever seen.' And he said, 'Well, put it on!' And it fit me perfectly—because he'd made it for me! It flares in a way that makes you look like you have an hourglass figure whether you do or not."

By 1990, the charismatic Manuel's elegant shop and sophisticated designs were garnering media coverage ranging from the *Los Angeles Times* to *People* to *Rolling Stone* to *Elle*. The *Times* described Manuel's showroom in an April 13, 1989, profile: "His open airy store, with its blond hardwood floors, provides more evidence of his sense of style. Manuel embroidered the pillows that are artfully tossed on the sand-colored couches. He also fringed and tooled Indian designs into the store's smattering of antique chairs and he painted a Western mural onto a partition near the back of the store. The walls are covered with gold records sent by singing celebrities and rows and rows of photographs."

Many of those singers were country artists based in Nashville, who clamored for Manuel to open a shop in their hometown. So by the beginning of the new decade, he'd closed his doors in North Hollywood and set up shop in Music City. The 1990s found both him and the artists of his new hometown reaching the pinnacle of success: Manuel received a prestigious Moda Award, in 1992, from haute couture Hispanic designers such as Oscar de la Renta, Adolfo, Carolina Herrera, and Paloma Picasso, in recognition of his exceptional career, while country music became the most lucrative genre in the business.

By the mid-1990s, the designer had embarked on a venture in which designs from The Manuel Collection were available at upscale shops in Santa Fe, Los Angeles, and New York. His line of dresses, shirts, and jackets is similar to his custom work, made of the same high-quality fabrics and featuring exquisite piping and embroidery. In the meantime, he continues creating new styles for yet another generation of entertainers. Manuel, who stresses he's always looking to the future, says the best is yet to come. Asked which of his famous designs is his favorite, he replies, as artists are wont to, "My next one."

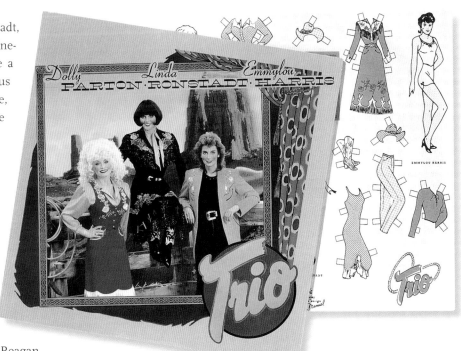

Above: **Dolly Parton, Linda Ronstadt, and Emmylou Harris** chose the cowgirl look when they commissioned custom tailor Manuel to design special outfits for their 1987 *Trio* album. The inner record liner was decorated with line drawings of the three as paper dolls with Western outfits. Collection of Mary Ellen Hennessey Nottage

Opposite page: Gene Autry commissioned **black shirts with contrasting white piping and lacing** from all of the great rodeo tailors. Manuel created this version with an unusual yoke detail for Autry's appearances on his *Melody Ranch* television show in the early 1990s. Autry Museum of Western Heritage, Los Angeles. Donated by Mr. and Mrs. Gene Autry

Enter the Urban Cowboy:

TEXAS LOW STYLE MEETS WESTERN HIGH FASHION

Now the Indians are dressing up like cowboys and the cowboys have leather and turquoise on . . . —"Cherokee Fiddle" by Johnny Lee, 1979

Marian Holsclaw, a regular at the Los Angeles country line-dancing nightspot Denim and Diamonds, goes by the nickname "Sissy" because she looks so much like Debra Winger's character from the movie *Urban Cowboy*. The thirty-year-old California native, who prefers Wranglers to Levi's, fancies herself a cowboy at heart. "Being a cowboy doesn't depend on living in the country," she told writer Aaron Latham in 1993. "It's a matter of what you feel inside."

And it matters what you *wear*. Holsclaw is particular about her clothes, right up to how she wears her hat. She prefers it "flat on your head, just above your ears," which, sans the pins, is how Sissy wore hers. Another local two-stepper, Sandie Salerno, a fifty-year-old, self-made business woman whom Latham describes as "more Rodeo Drive than rodeo, more diamonds than denim," dances at D & D five nights a week wearing handmade boots and expensive-looking cowboy hats. The scene, mechanical bulls and all, harkens back to the good old days in the late 1970s at Gilley's in Pasadena, Texas, minus the polyester fringed cowboy shirts, tight jeans, and scanty halter tops. It's as though history, with a little help from Latham, has repeated itself: These "attitude cowboys," as he's labeled them, are the urban cowboys of the 1990s.

Inspired by the film *Urban Cowboy*, tight-fitting Western shirts like these **H Bar C/California Ranchwear styles** were worn with blue jeans, fancy belts, and a black felt hat. This was "the look" for both men and women in the early 1980s. Autry Museum of Western Heritage, Los Angeles

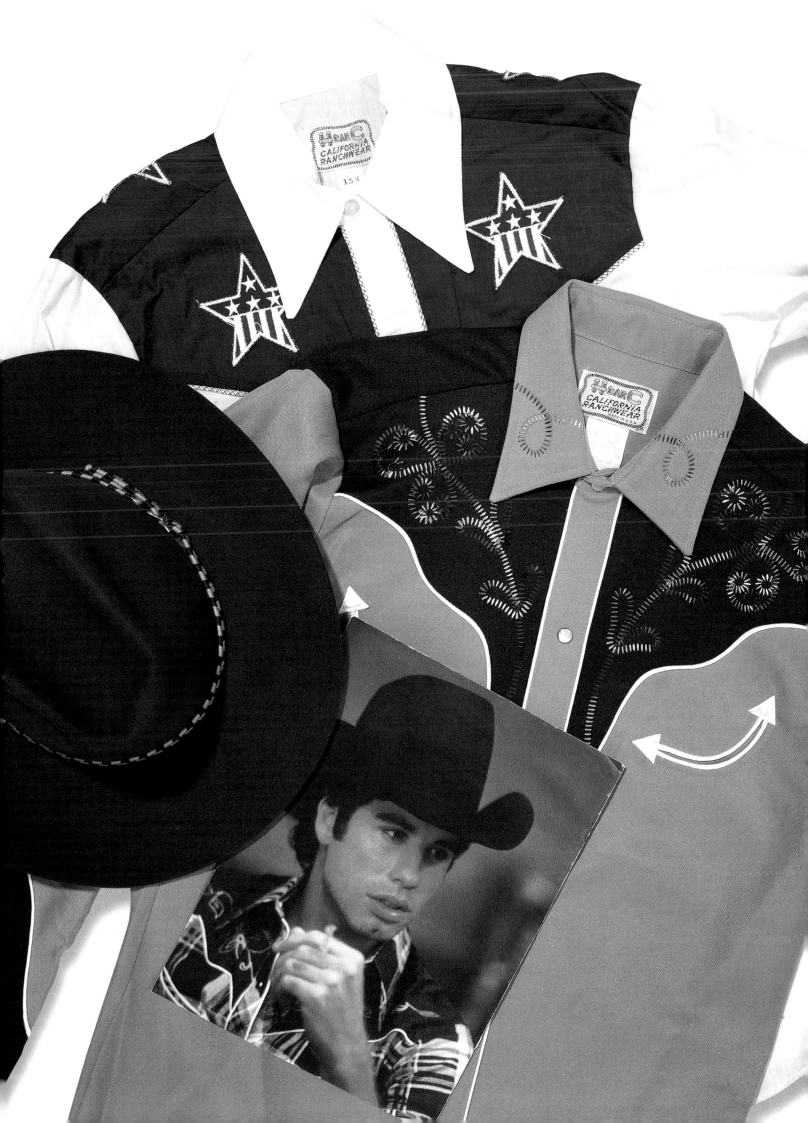

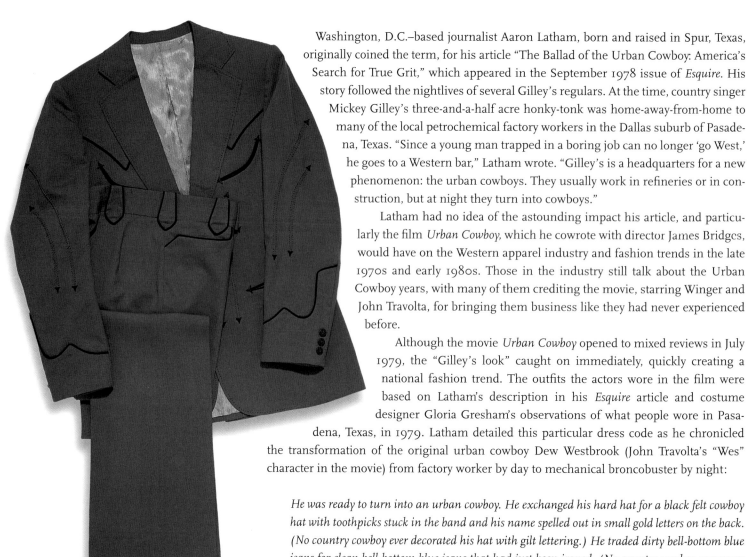

Washington, D.C.–based journalist Aaron Latham, born and raised in Spur, Texas, originally coined the term, for his article "The Ballad of the Urban Cowboy: America's Search for True Grit," which appeared in the September 1978 issue of *Esquire*. His story followed the nightlives of several Gilley's regulars. At the time, country singer Mickey Gilley's three-and-a-half acre honky-tonk was home-away-from-home to many of the local petrochemical factory workers in the Dallas suburb of Pasadena, Texas. "Since a young man trapped in a boring job can no longer 'go West,' he goes to a Western bar," Latham wrote. "Gilley's is a headquarters for a new phenomenon: the urban cowboys. They usually work in refineries or in construction, but at night they turn into cowboys."

Latham had no idea of the astounding impact his article, and particularly the film *Urban Cowboy*, which he cowrote with director James Bridges, would have on the Western apparel industry and fashion trends in the late 1970s and early 1980s. Those in the industry still talk about the Urban Cowboy years, with many of them crediting the movie, starring Winger and John Travolta, for bringing them business like they had never experienced before.

Although the movie *Urban Cowboy* opened to mixed reviews in July 1979, the "Gilley's look" caught on immediately, quickly creating a national fashion trend. The outfits the actors wore in the film were based on Latham's description in his *Esquire* article and costume designer Gloria Gresham's observations of what people wore in Pasadena, Texas, in 1979. Latham detailed this particular dress code as he chronicled the transformation of the original urban cowboy Dew Westbrook (John Travolta's "Wes" character in the movie) from factory worker by day to mechanical broncobuster by night:

John Travolta wore this slick Western suit in the film *Urban Cowboy*. "At one point, every shirt John wore, we owned at least six of," noted costume designer Gloria Gresham. "And for every shirt he wore, there were probably two that he didn't wear. That's how carefully they were chosen." Autry Museum of Western Heritage, Los Angeles

He was ready to turn into an urban cowboy. He exchanged his hard hat for a black felt cowboy hat with toothpicks stuck in the band and his name spelled out in small gold letters on the back. (No country cowboy ever decorated his hat with gilt lettering.) He traded dirty bell-bottom blue jeans for clean bell-bottom blue jeans that had just been ironed. (No country cowboy ever wore anything but unironed, straight-legged jeans.) Then he swapped his work sneakers for cowboy boots with a flat, rubber heel designed for a range made up mostly of asphalt, sidewalks, and linoleum. (No country cowboy ever wore anything but high, pointed, leather heels designed to let a cowboy dig in his heels if he roped something mean.) And his workingman's T-shirt was replaced by a cowboy shirt with mother-of-pearl snaps and short sleeves. (If a country cowboy wore short sleeves, his arms would be scratched off the first time he passed a mesquite tree.) Now the urban cowboy was ready to mount his pick-up truck and ride forth to Gilley's in search of adventure. He had his armor on. The cowboy has always been America's knight-errant. During the Middle Ages, dressing a knight in his armor was a solemnly important ritual. The dressing of the urban cowboy is no less so.

The women who hung out at Gilley's in the late 1970s wore clothing that exuded "out and out sex," says Gresham, "It was much more about T-shirts and tight jeans. Those women dressed like that. You went to Gilley's to have a good time, probably get drunk, and hopefully get laid at the end of the evening." Gresham went on a location survey with Bridges and the cinematographer, gathering inspiration for her costume designs. "It was important to keep the integrity of the setting that we were depicting," she noted. She purchased most of the clothes for the film from Houston, Dallas, and Los Angeles Western stores selling off-the-rack styles. "There were those upscale shops in Houston and certainly in Dallas where you'd see Ralph Lauren and a lot of other things that were not what those kids at Gilley's were wearing," Gresham said. "They couldn't afford that stuff, number one, and number two, even if they could afford it, it wasn't their taste. They wanted to put their blue jeans on and lie in the bathtub so that they could dry onto their body!"

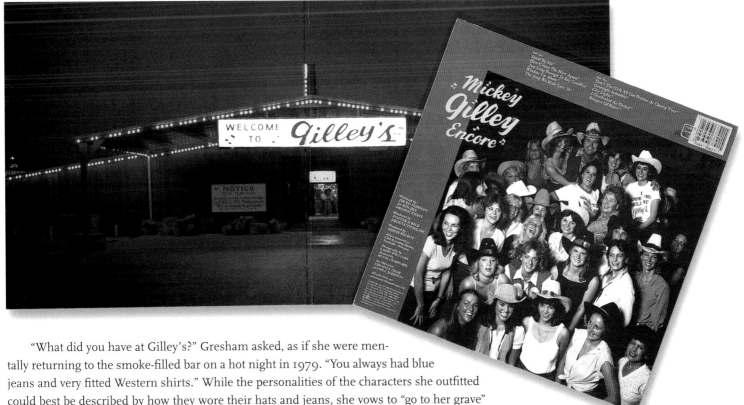

"What did you have at Gilley's?" Gresham asked, as if she were mentally returning to the smoke-filled bar on a hot night in 1979. "You always had blue jeans and very fitted Western shirts." While the personalities of the characters she outfitted could best be described by how they wore their hats and jeans, she vows to "go to her grave" not divulging which brand of jeans Travolta wore in the film. She will confess, however, that because of his dancer physique, the wardrobe department customized his jeans by taking apart store-bought pairs, down to the copper rivets and flat-felled seams, and putting them back together again. She credits Winger with devising the pin decoration on her brown felt cowboy hat. "We bought pins and bought pins and bought pins," she recalled. "But she totally and completely personalized it, so in the end she did it all. There were only two of them, one for her and one for her stunt double, and we never really got the second hat to match Debra's hat perfectly because some of the pins we could only get one of." Gresham added the black mesh T-shirt that Scott Glenn wore after she saw a local clad in a similar style coming out of Gilley's one night. The actors' outfits were authentic Gilley's garb down to the hand-tooled names on their leather belts.

Presciently following Latham's article in *Esquire* was a one-page story on New York City fashion designer Ralph Lauren (né Lifschitz), titled "Next, Urban-Cowboy Clothes." Although Lauren's work was completely different from what urban cowboys wore in Pasadena, Texas, both styles captured the cowboy Zeitgeist of the late 1970s. "If Bronx-born New York designer is on target again, urban dudes will be sporting cowboy duds in the city this fall," the article proclaimed. Lauren's fall 1978 women's wear collection featured ruffled prairie skirts, fringed leather jackets, and cotton plaid and denim Western shirts, inspired by the "classical romantic look" of Gary Cooper in *The Plainsman,* Lauren told reporters.

Back in 1974, Lauren's first Western-wear collection for women had been received with mixed reviews, and although *Women's Wear Daily* had advised him to "put his six shooters away," he continued to design Western-styled clothing. Four years later, Lauren seemed to tap into the collective unconscious with his Western-inspired collection. Bernadine Morris wrote in the *New York Times,* "Lots of new collections, but Lauren steals the show."

In his book *Ralph Lauren, The Man Behind the Mystique,* Jeffrey A. Trachtenberg described Lauren's star-studded women's fashion show in the fall of 1978. "The setting that year was the rooftop of the St. Regis Hotel. There, as such celebrities as Diane Keaton, Candice Bergen, and Angelo Donghia watched in wonder, the show opened to the sounds of 'Back in the Saddle Again.' Before anybody could blink, Ralph's models marched out wearing the wildest mix of Western looks east of the Rockies. They included suede fringed leather

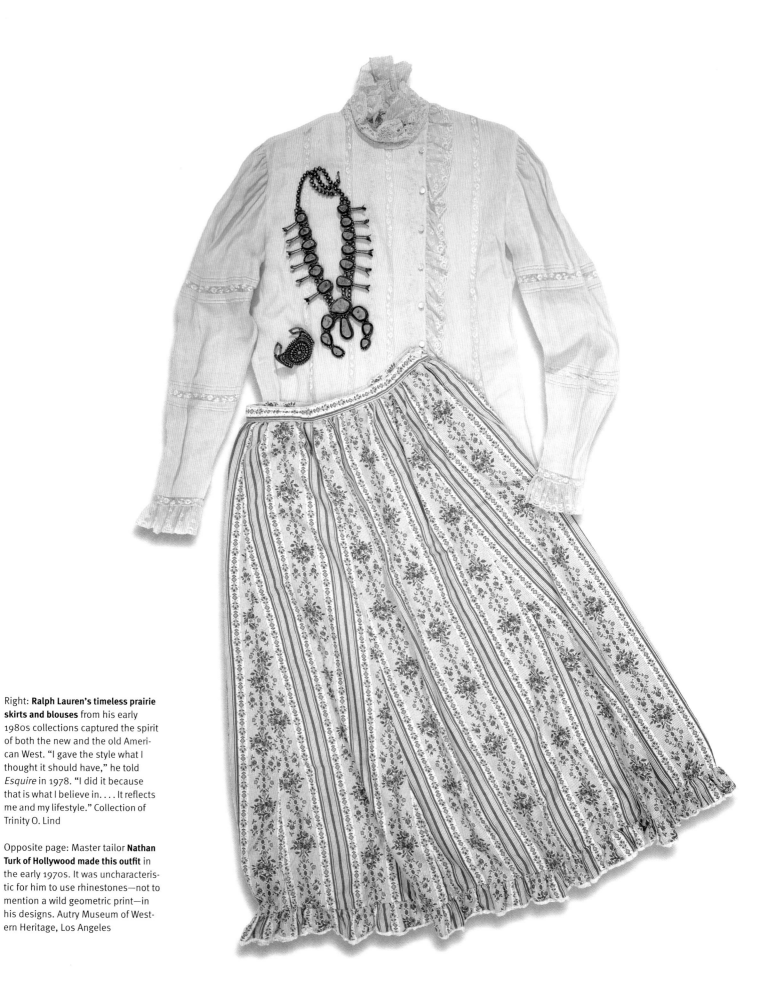

Right: **Ralph Lauren's timeless prairie skirts and blouses** from his early 1980s collections captured the spirit of both the new and the old American West. "I gave the style what I thought it should have," he told *Esquire* in 1978. "I did it because that is what I believe in. . . . It reflects me and my lifestyle." Collection of Trinity O. Lind

Opposite page: Master tailor **Nathan Turk of Hollywood made this outfit** in the early 1970s. It was uncharacteristic for him to use rhinestones—not to mention a wild geometric print—in his designs. Autry Museum of Western Heritage, Los Angeles

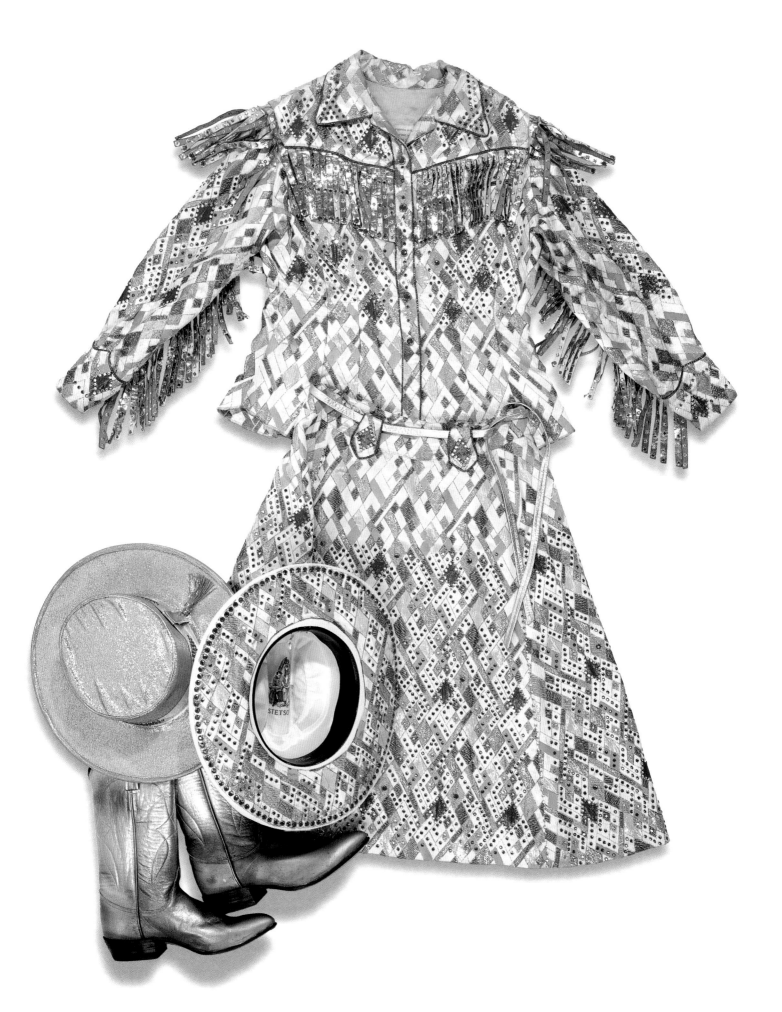

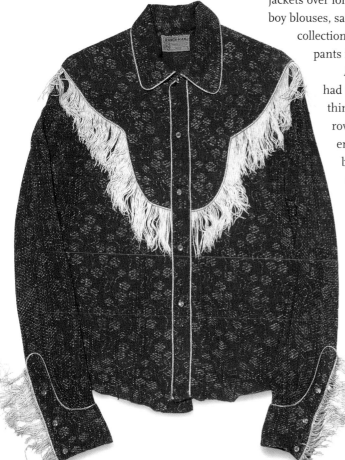

While it is difficult to imagine this shirt being worn in a Wyoming cowboy bar, it is not difficult to picture it as part of an outfit being worn at a club in other areas of the country during the **Urban Cowboy craze**. It was manufactured by Ranch-Man, in Denver, Colorado. Autry Museum of Western Heritage, Los Angeles

jackets over long flounced cotton prairie skirts, shearling coats, chamois blouses, satin cowboy blouses, satin suits, satin jackets, and brown lizard belts with silver cowboy buckles. The collection even featured velvet suits with silver buckles and satin cowboy shirts with pants for evening."

A few months later, the *Times*'s Bill Cunningham reported that such fashions had found their way to the streets of the Big Apple: "New York is becoming something of a cowboy town. Men whose ideas of a canyon is the space between two rows of skyscrapers take to the air in full regalia—ten-gallon hat, yoked shirt, embroidered denim jacket, hand-tooled belt, jeans, and boots. And the women beside them wreath their throats in bandannas, wear ankle-length skirts fit for a hoe-down and—faced with inclement weather—don hats and ponchos worthy of the crew of a cattle drive."

Lauren's contributions to the modern Western look certainly helped the style cross over into high fashion. Remembering Lauren and his wife coming into his family's one-hundred-year-old, New York City Western store, Kauffman's, to buy slickers, ponchos, and Western wear, Charles Kauffman recalls, "Ralph and Ricky were good customers. He was legitimate." Laughing, Kauffman adds, "He would buy whatever he knocked off, as opposed to a lot of other guys who didn't!" Although Lauren was periodically criticized by the apparel industry for reinventing expensive high-fashion versions of vintage Western wear, his designs have always been authentically and elegantly styled. "The look . . . of the American cowboy represent[s] a tradition . . . the way the ranch hands' dress never changes," he told *Harper's Bazaar* in 1982. Describing his collection as "anti-fashion" in the sense that his designs weren't intended to represent the "latest" looks, he explained that his designs instead reflected his personal style: "I like things that will age, that will look better next year."

Sandra Kauffman, author of *The Cowboy Catalog*, remembers her experiences at Kauffman's during the Urban Cowboy craze, when the store was besieged by hordes of new customers purchasing Western clothing and accessories. Most city slickers had never even seen a horse up close and were now traipsing around the city in their best cowboy duds. "Suddenly in the 1980's cowboy clothing became very hot and it was high style," she says. "What they didn't realize was that out West, this is *clothing* to people. It's not a *costume*, it's not something you put on to dress up, whereas here it is. And what happened is that when it became fashion, everybody just jumped on the bandwagon, all the boot companies, people who had never seen Western-wear, or had never produced it or anything like that. Suddenly everybody was making it. That led to an awful lot of junk around, and it led to things that weren't real being passed off as real. But I think there is always a core of people who have worn this type of clothing, whether they were out West or they weren't. And they were laughing. They said, 'Gee, we've always worn this!'"

Between Lauren's modern classic Western clothing, the pioneering Western-wear manufacturers who had been producing these styles for fifty-plus-years, and the custom cowboy tailors, consumers who wanted to dress in cowboy duds had plenty of choices. Rodeo Ben Jr., who ran the five-decade-old Rodeo Ben custom Western-wear store on Broad Street in Philadelphia, recalls the boom his business enjoyed: "Before that, we took care of Western people and movies and rodeo people, but when *Urban Cowboy* came out, everybody wanted to be a cowboy! All hell broke loose. We had hundreds of people lined up outside our store!" In addition to his custom-made creations, Rodeo Ben stocked off-the-rack goods by well-known Western apparel manufacturers. "After *Urban Cowboy* we had such a deluge in business, we ordered from every company," says Ben Jr. "Our name was known, of course, to everyone in Western goods and we had good credit, so they sold us everything under the sun. All the ready-made houses sent us everything we wanted—H Bar C, Rockmount. We had unlimited credit with them."

"What is an urban cowboy?" asked a caption from a photograph featuring a cowboy wearing Karman Western apparel on a mechanical bull in a 1980 issue of *Western Horseman*. "From nine to five he is a doctor, lawyer, banker, truck driver, or construction worker, but from five-thirty on he is a cowboy! Long and strong, he's a rough-ridin' son of a gun. He wears the new breed of Western clothes that are reminiscent of the old West, but have the urban styling of the new West, and Karman Western Wear makes them." Karman's Saturday Night Collection was a line of Western shirts in fitted plaid snap-front styles with sawtooth pockets, contrasting fabric-appliquéd yokes, and piping, and fancy cuffs. Karman also launched The Kenny Rogers Western Collection in 1981, a line of thirty different men's and women's Western shirts ranging from "classic to fancy country designs," and fourteen blue-jean styles endorsed by the country musician whose hit at the time was "The Gambler."

There was also an Old West meets the Urban Cowboy fad manifested in some of the Western apparel manufacturers' lines in the early 1980s. Karman-owned Tem Tex created a series of shirts commemorating the Old West with names such as the Wyatt Earp, a windowpane plaid snap-front shirt with a piped three-point yoke; the Belle Starr, a fitted plaid women's top with piped yokes and smile pockets; the Butch Cassidy, a floral-printed men's snap-front Western shirt; Sundance Kid, a border-printed shirt with flowers strategically placed on the yokes and cuffs; and the Wild Bill Hickok, a cavalry-style shirt with a button-on floral bib and matching cuffs.

Above: Although they never served their intended purpose, the **parade outfits designed by Levi Strauss for the 1980 Olympics** were featured in *Western Horseman*.

Left: According to founder Paul Christenfeld, H Bar C/California Ranchwear gave all their shirts Western names from the very beginning. Texas and Hollywood were **two of the original styles in their line,** which dates back to the 1940s. Collection of Michelle Freedman

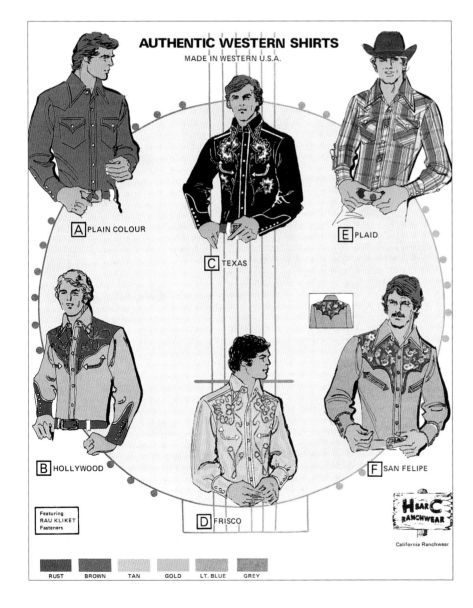

AUTHENTIC WESTERN SHIRTS
MADE IN WESTERN U.S.A.

A PLAIN COLOUR
C TEXAS
E PLAID
B HOLLYWOOD
D FRISCO
F SAN FELIPE

Featuring
RAU KLIKET
Fasteners

H BAR C
RANCHWEAR

California Ranchwear

RUST BROWN TAN GOLD LT. BLUE GREY

Perhaps the oddest Western "innovation" was the style blending the disco looks of the late 1970s and early 1980s with traditional Western apparel details. A 1981 H Bar C/California Ranchwear ad for Universe Shirts featured black, glittery, snap-front men's and women's matching shirts with bright white piping around the cuffs, collars, and curvy front and back yokes. The models, decked out in jeans, trophy buckles, and white hats with feathers over their "feathered" hair styles, were poised for "a night on the town or on the bull. . . . " Another ad featured the Cheyenne and Nevada sets, more traditionally styled matching pant and top ensembles with early 1980s twists. The Cheyenne had piped five-button pearl-snap cuffs, two-tone yokes with floral embroidery, and smile pockets; the Nevada was a solid powder-blue set with floral embroidery, pearl snaps, and matching extra-wide bell-bottom pants with permanent creases. The models posed in their "romantic Western" outfits that H Bar C had concocted for them to "ride off into the sunset in style."

"Levi Strauss provides all the basics for the urban cowboy," read an ad that ran at this time. "A plaid cotton flannel shirt, split cowhide vest, and a pair of Sta-Prest Nuvo jeans—plus his Resistol hat," was the uniform of the day. When Levi Strauss was chosen as the official outfitter to the 1980 U.S. Olympic teams, the company had originally planned to dress about a thousand athletes, coaches, officials, and managers in Western-style travel outfits, parade uniforms, and warm-up suits. Additionally, they expected to outfit twenty-three thousand Russian games attendants, ticket takers, and crowd controllers in Western garb. When President Carter chose to boycott those games, that part of the promotion was cancelled, but the team still received their Levi parade suits: bright red cotton-blend shirts with white piping and pearl snaps, Levi's Saddleman boot jeans for the men, five-pocket straight denim skirts for the women, Levi's for Feet cowboy boots, and white Stetson hats.

"Levi Strauss provides all the basics for the urban cowboy," read an ad that ran at this time. "A plaid cotton flannel shirt, split cowhide vest, and a pair of Sta-Prest Nuvo jeans—plus his Resistol hat," was the uniform of the day.

Texas style was specifically sought after and imitated due mainly to *Urban Cowboy*, but also to the popularity of primetime television soap *Dallas. Harper's Bazaar* ran a July 1981 spread on "Texas Spirit" that pictured the latest Lone Star fashions (including designs by Ralph Lauren) and featured Texas native Jerry Hall holding handfuls of hay and modeling suede jodhpurs. In addition to *Urban Cowboy*, other early 1980s films helped popularize these fashions, including *Electric Horseman, Coal Miner's Daughter, The Best Little Whore House in Texas, Honeysuckle Rose*, and *Smokey and the Bandit*.

Eventually, though, by the mid-1980s, the Urban Cowboy bubble had burst. After catapulting many businesses into the black, it also left a lot of merchandise on the shelves. "During Urban Cowboy everyone was into Western wear," says Lou Cohen, president and CEO of Shepler's Western Wear in the 1990s. "Retailers and manufacturers all believed it would last forever. Everyone built factories, expanded stores, increased inventory, and sold to everybody. And then we were all stuck with it." Mel Marion, longtime Resistol hat salesman, agrees that there were three really great years, 1979 to 1981, when they had to turn customers' orders away, before it all stopped. "I can remember the day I walked into Love's Western Wear in Orange, California, and I knew it was over just by the look on the owner's face. Fred Love looked at me and said 'Mel, I don't need any hats.' It was like a curtain had fallen."

Paul Christenfeld from H Bar C also recalls the Urban Cowboy aftermath: like the morning after a tequila-drenched night out at Gilley's, the companies "all had a hangover the next morning with merchandise." But though manufacturers and Western-wear shops may have been affected by the turn in fashion trends when urban cowboys were no longer "in," there was always the original customer to fall back on. "Periodically Western wear becomes fashion," Christenfeld rationalizes, "but there is that one type who was born wearing it in the womb and will die wearing it."

Opposite page: Malibu Clothes of Beverly Hills redesigned their **leisure suits to fit in with current fashion trends in the 1970s.** A laid-back cowboy could procure a Western polyester leisure suit in an array of pastel colors, or, if he preferred, he could have a denim version with leather trim. Autry Museum of Western Heritage, Los Angeles

Hillbilly Cats, Long Ryders, and the
Return of the Rhinestone Cowboy

CONTEMPORARY ARTISTS AND WESTERN WEAR

The drummer is decked out in a yellow suit embroidered with blue poppies across the front and down the pants legs, while the keyboardist wears a satin cowboy shirt with an embroidered yoke. Is it a 1950s honky-tonk? No, it's a 1999 Gram Parsons tribute performance being taped for a *Sessions on West 54th Street* PBS television program. Mistress of ceremonies Emmylou Harris has on a shiny red-and-black satin Western shirt over her indigo denims.

Singer/songwriter Jim Lauderdale looks elegant in a gorgeous black Manuel suit with oak leaves and acorns embroidered across the yoke, while singer/songwriter Gillian Welch sparkles in a vintage Nudie suit of white gabardine bespangled with dark orange appliqués trimmed in rhinestones, once the stage wear for a member of Bill Anderson's band. Sheryl Crow sports hip hugger, boot-cut brown suede pants accented with studs and rhinestones. And Mavericks bassist Robert Reynolds steps out in dazzling white trousers decorated with marijuana leaves, hearts, musical notes, and big red crosses. Tonight, the artists are clearly paying homage to Gram Parsons's wardrobe as well as his song craft.

When k.d. lang burst out of Canada in the mid-1980s, she was labeled a cowpunk, and she certainly did dress the part. This getup featured a vintage shirt worn with a bolo tie and Western belt. Adorning the skirt are little plastic cowboys and Indians that lang stitched to the fabric.

The singing cowboys of **Riders in the Sky** have been Western-wear aficionados since the group's formation. From left: Woody Paul goes for the fringe-and-rhinestone Roy Rogers look; Ranger Doug Green is partial to the railroad-stitched piping made famous by Gene Autry; and Too Slim concocts his own take on cowboy clothes, via his whimsical shirts, designed by his wife, Roberta, in collaboration with Manuel, and super-woolly chaps. Courtesy of Riders in the Sky

At the beginning of the twenty-first century, the look of contemporary recording artists has never been so varied. Ironically, many mainstream country artists have forsaken Western wear for a more rock and roll look, while a smattering of rockers—particularly alternative artists and roots rockers—have embraced cowboy style. Those wearing Western have been inspired by elements drawn from historical Western wear: from the working-cowboy look of Western artists Don Edwards and Michael Martin Murphey to a take on Urban Cowboy by hat acts like Garth Brooks, Brooks and Dunn, and George Strait, to the 1970s "cowboy pimp" wardrobe of Madonna and Kid Rock, to the singing-cowboy style of Riders in the Sky, to the retro Western attire of the Derailers and BR-549, to the custom cowboy glitz of country renegades Marty Stuart, Dwight Yoakam, and the Mavericks, as well as alternative rockers Mike Mills of R.E.M., the Edge of U2—and occasionally, the eclectic artist Beck.

Of course, C&W was always most associated with Western wear, that is until the late 1960s when rock and rollers started putting on cowboy shirts. Most hipsters had stashed away their Western threads, however, by the time every Tom, Dick, and Harriet was trying out the polyester Urban Cowboy Everyman look in the early 1980s. Curiously, around this time, the ornate, 1950s-style Western shirts, jackets, and suits, along with square-dance and "squaw" dresses, started turning up in dark rock and roll clubs, where retro, rockabilly, and cowpunk bands were playing. Just as Sun Records' early artists took fashion cues from their country cousins, so did the Stray Cats, Rockats, and other 1980s rockabilly acts and their fans draw on those elements of the yoked, embroidered, piped look. Contemporary Western wear designer Katy K recalls, "The rockabilly guys were wearing the tiger yokes—it was louder than traditional Western, a bit more of the punk thing—that edge. The girls would wear the Western [bolo] ties and Western shirts with miniskirts."

Meanwhile, early-1980s roots-rockers Rank + File, Lone Justice, the Blasters, the Screamin' Sirens (with Rosie Flores), Kristi Rose and the Midnight Walkers, and k.d. lang (with the Reclines) went the 1940s–1950s Western route with their retro attire. Customizing her vintage cowboy boots, k.d. lang cut off the tops, wearing them with "squaw" dresses and cowboy clothes found at the Salvation Army. Kristi Rose favored low-cut square-dance dresses à la Frederick's of Hollywood. According to founding Blaster Dave Alvin, he had to forgo his Western look after his vintage cowboy shirts kept getting stolen from nightclub dressing rooms.

Western style began garnering more attention in the mid-1980s when hillbilly rockers Marty Stuart and Dwight Yoakam started dressing like their 1950s role models. Robert Reynolds, then wearing cowboy shirts and boots and playing in a Florida roots-rock band, the Earthtones, remembers his own epiphany: "I saw Marty Stuart one night on *Austin City Limits*," Reynolds recalls. "I didn't know who he was, but I was like, 'Wow, that is the look.' I was wearing cowboy stuff, but I didn't know how to get the cool stuff—I didn't know where it came from."

Having been playing professionally since age twelve, Stuart was clued in earlier than most. "I used to watch Ernest Tubb's TV show when I was a kid," Stuart remembers. "His Texas Troubadours had real style. Everything was gabardine with colorful piping—they weren't into subtle. They were into bright colors, and they matched down to their belt buckles. The blocks on their [cowboy] hats made them look like tacos."

As a young member of Lester Flatt's group, Stuart toured on double bills with the Troubadours, whose look he began emulating. "Their Nudie pants had kick pleats, so I got me some satin and took my black pants to a lady at the mall and had her kick-pleat all my pants. Then I went and bought me some cowboy boots with pointy toes, then I started wearing my tie up around my neck [like a neckerchief], and blocking my hat like a taco. Lester did not like it at all because our group was more a Kentucky Gentlemen–looking band. He'd argue with me, saying, 'We're not cowboys.' It was a friendly round, but in the end I just wore what I wanted to."

By the mid-1980s, Stuart was ending a stint as guitarist with Johnny Cash's band, during which time his look had won him a nickname, "the Boy in Black." When he recorded a solo album for Columbia, he decided to go for the look he had long admired, beginning with his first music video. "I thought that country-music videos were really boring to look at," Stuart says. "[In planning a look for the video], I went back to those suits that I saw as a kid on TV—the Troubadours and Porter Wagoner and the Wagonmasters—they stood out even in black and white. I thought, 'Well, if I'm gonna do this, I'm gonna buy up some of those suits.' At the time, they were so far out of style you couldn't see anything—nobody was wearing them but Hank Snow, Jimmy Dickens, and Porter Wagoner."

Country-rocker Carlene Carter, Stuart's then-sister-in-law, whose stage look consisted of fancy cowboy boots and fringed Western-cut shirts or jackets with miniskirts, remembers Stuart borrowing a few Nudie things from her father, Carl Smith. "One day Marty pulled up in a jeep with his hair all messed up and a bandanna on, and said to my dad, 'Hi, I'm Carlene's brother-in-law. Maybe I could borrow some of your jackets for my band to do my video?' My dad practically had to repossess them, because Marty wouldn't give them up! He's definitely a fashion statement unto himself."

As soon as Stuart got the cash, he began spending it on the look he yearned for, including some of the Wagonmasters' suits. "At this point, I was really scouring every closet in Nashville," says Stuart. "There was a guy named Bobby Barnette in Oklahoma City, too, who was a treasure. He was a country singer in the 1960s, and he and Nudie were the same size and Nudie loved him, so he had gobs of Nudie stuff. And he gave me lots of stuff just to get started." Stuart also high-tailed it to Manuel's North Hollywood shop. "I walked in there and said, 'I want to do a black waist jacket, and Manuel said, 'No, no, those things are out of style,' and I said, 'Precisely! Let's do one, let's make it cool, let's put some attitude in it.' Then, Dwight came along, and Steve Earle wore a waist jacket on *Guitar Town*, then everybody started doing it."

Manuel and Stuart collaborated on what would become Marty's signature look: a short, bolero-style jacket with white piping, pronounced arrowheads, and railroad stitching, sometimes zigzagged or horseshoe-shaped. "Bobby Barnette had a dark suit that had some black lacing on it," Stuart explains about the inspiration behind his trademark style. "It was the coolest look. I knew Gene Autry had worn shirts with the lacing, and I thought it was absolutely the ultimate in cowboy style."

Over the years, Stuart's jackets gradually became more and more ornate, festooned with embroidery and sparkling with rhinestones. Stuart usually wears his jackets with skintight beat-up jeans tucked into fancy, multicolored custom boots made by Nashville's Bo Riddle or Oklahoma's Jay Griffith. Stuart also continuously has added to his vintage collection, buying numerous Turk pieces from Rose Maddox, as well as garments that belonged to the Maddox Brothers, Hank Williams, Johnny Cash, Patsy Cline, Ray Price, Lefty Frizzell, and many others. His commissions from Los Angeles's hand-custom tailor Jaime and Rose Clements include decorative items for his office and tour bus. Stuart has become so associated with Western wear that, in the mid-1990, Buck Owens, who first popularized the bolero jacket in the 1950s, asked him to design a coat for him.

Rock and roller Tom Petty is another artist who grew up loving cowboy style and has worn different variations of it throughout his career. Raised in Florida, he says, "I only wanted to wear cowboy boots, never conventional shoes. Then when I formed my first band, we wore Western clothes, and a lot of the hippies thought that was really stupid, but we dug it." Once he became successful in Los Angeles, he commissioned Western-cut stage wear. "I used to go to Manuel and get stuff, but it was so heavy and hot that you couldn't wear it," Petty recalls. "So I got [British tailor] Glen Palmer,

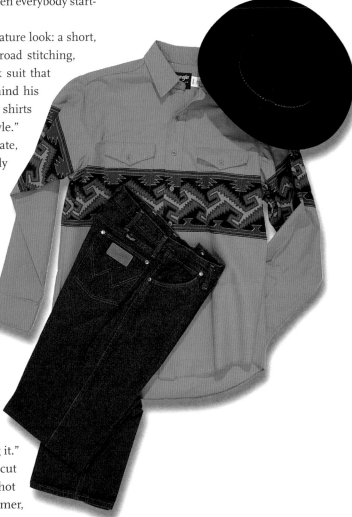

Thanks to the huge popularity of contemporary country and the accompanying line-dancing movement of the early 1990s, Western wear began yet another resurgence. **Couples on the dance floor frequently dressed in matching outfits and hats**. Autry Museum of Western Heritage, Los Angeles

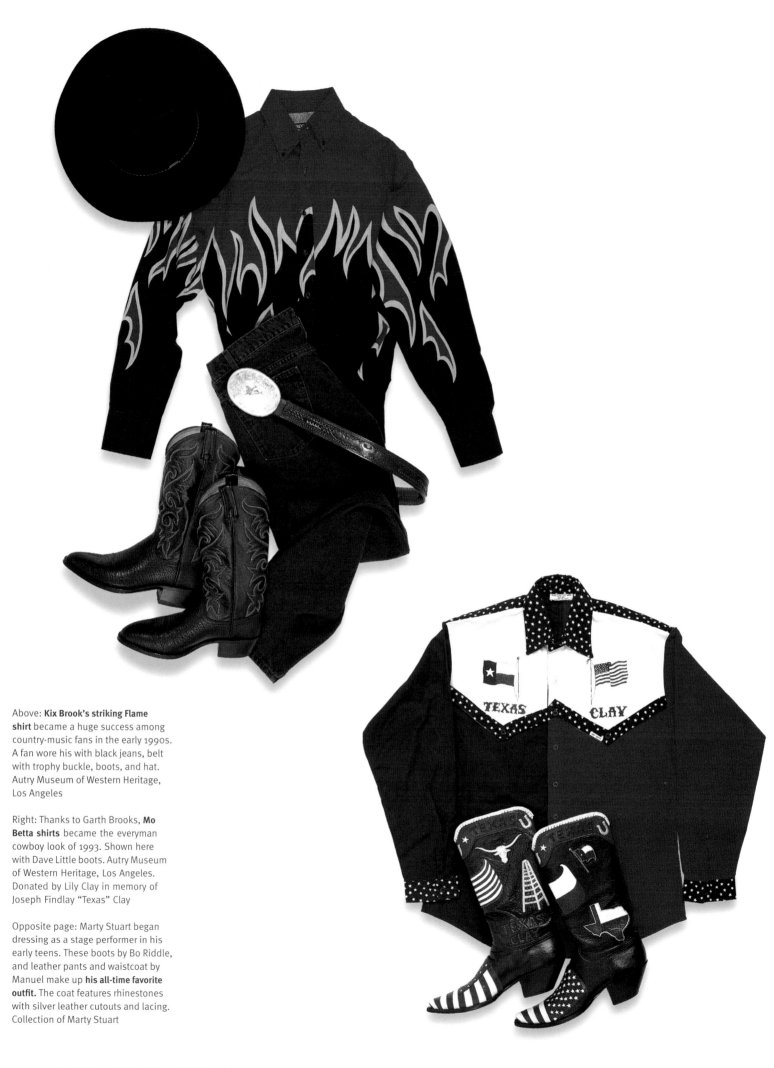

Above: **Kix Brook's striking Flame shirt** became a huge success among country-music fans in the early 1990s. A fan wore his with black jeans, belt with trophy buckle, boots, and hat. Autry Museum of Western Heritage, Los Angeles

Right: Thanks to Garth Brooks, **Mo Betta shirts** became the everyman cowboy look of 1993. Shown here with Dave Little boots. Autry Museum of Western Heritage, Los Angeles. Donated by Lily Clay in memory of Joseph Findlay "Texas" Clay

Opposite page: Marty Stuart began dressing as a stage performer in his early teens. These boots by Bo Riddle, and leather pants and waistcoat by Manuel make up **his all-time favorite outfit.** The coat features rhinestones with silver leather cutouts and lacing. Collection of Marty Stuart

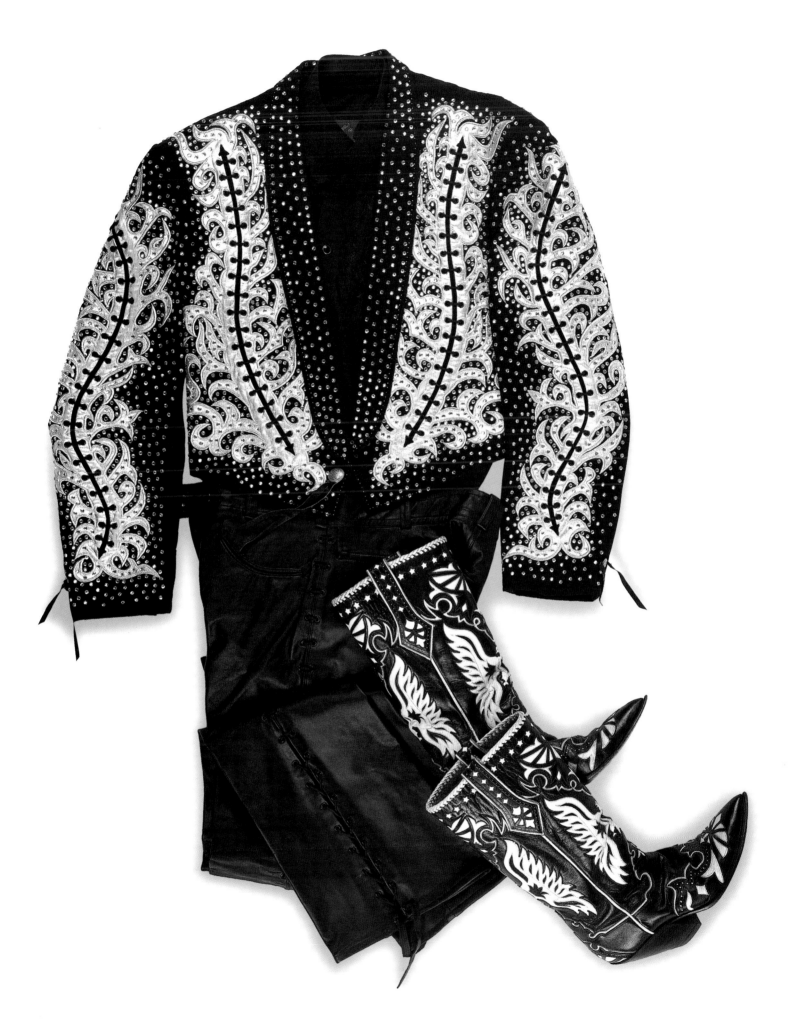

who'd had a store on the Sunset Strip, Granny Takes a Trip. He made me really light cotton versions of Nudie suits where you could go onstage and it wasn't a big deal—you weren't carrying ten pounds of clothes. Glen made me an outfit that had sputniks with Saturn on the jacket back and the pants legs had rockets taking off. And I had a burgundy suit with skulls with big red rhinestone eyes and crossbones. I had everything—jackets, shirts, pants, and boots."

Too Slim is renowned for his eye-catching woolly chaps and ten-plus-gallon hat: "My theory is that when the cowboys were really popular, they had big hats," says Slim, "and when the hats got smaller, everybody said, 'to hell with 'em.'"

Members of Riders in the Sky, "Ranger" Doug Green, Woody Paul, and Too Slim, have also stuck to the Western look. "We always liked the fancy shirts and wanted to look really sharp and classy onstage in a way that made us visually distinctive as well as musically distinctive," Green points out. In the late 1970s, when the band started, the guys scoured vintage shops or "got what H Bar C had to offer at the square dance stores," says Green. For a while, a friend, Susan Wright, custom made Green's first three or four costumes "in the style of Wild Bill Elliot."

Each member, in fact, has chosen his own special look: Green goes for bib-front shirts, embroidered with flowers (particularly roses), inspired by Elliot and Gene Autry. Paul prefers Roy Rogers's style, and orders his rhinestone-fringed pullover shirts embroidered with stars and horsehoes. Too Slim's wife, Roberta, collaborates with Manuel to design his colorful shirts, with unusual features like doughnut-style collars and whimsical embroidery. "I'll just say, 'I want black, I want varmints that nobody's seen before, I want it to say TOO SLIM FOREVER on the back,' and she sketches it out," he explains. Too Slim is renowned for his eye-catching woolly chaps and ten-plus-gallon hat: "My theory is that when the cowboys were really popular, they had big hats," says Slim, "and when the hats got smaller, everybody said, 'to hell with 'em.'"

Slim has also added to the Western-wear vocabulary with his unique cac-tie. "The first one was made of wood," Slim explains. "Our old guitar player Bill Collins made it. It was leather in the middle and took forever to make, plus we had to sell 'em for $75 [at their concerts' mercantile booth]. So Roberta started making them on her sewing machine. We went through a lot of different patterns and then we found a couple of good manufacturers. Now we sell a bunch. John Hartford named it when we were doing one of our TV shows, and he came on and said, 'Look, Too Slim's wearing a cac-tie.'"

Though decidedly more sedate in their style, Western music artists also have been bringing back traditional cowboy wardrobes. In the early 1990s, as traditional Western music, along with cowboy poetry, became increasingly popular, proliferating via festivals like West-Fest and the Elko Cowboy Poetry Gathering, the look spread among performers, many of whom had been "real" wranglers, as well as their audience. Referring more to the working buckaroo—or, at least a working cowboy on a night out—Don Edwards and Michael Martin Murphey, among others, wear cowboy boots and hats with jeans and vests over plain shirts. Murphey sometimes dresses a little more dramatically—cloaked in a duster, a bandanna encircling his neck, Old West–style. New Western movies, like Clint Eastwood's *Unforgiven* and the made-for-television miniseries, *Lonesome Dove*, added to the resurgence of Western style. The "Gus" cowboy hat, featured in *Lonesome Dove*, particularly took off.

Fans of mainstream country stars of the early 1990s took to dressing like their favorite artists too. The low-key Western style of George Strait had already primed country audiences to return to the hat corrals when he became popular in the late 1980s. Wearing a black Resistol Ranchman, which he eventually endorsed, Strait had a huge impact on hat sales, as his no-nonsense look influenced male style, according to Mel Marion. "The guy with the George

Strait type of hat wears his Wranglers out[side his boots]. You'll never see his jeans [tucked] in his boots. He'll wear the starched shirt like George Strait does, whether it's Polo or Wrangler or whatever—it's that look."

When Stetson-garbed Garth Brooks came along in the early 1990s, the cowboy hat and shirt business went through the roof. "We just came out this year [1999] with a Garth Brooks-look hat," Marion says. "We've never signed him [to an endorsement deal] but he wears our Stetson hat. Then he does his own thing to it [in shaping it a certain way]. So we came out with one that looks like [he shaped it]." Along with the Garth brim came the nationwide trend for Garth-style gaudy, print Western shirts, sometimes with a mini-duster flap on back, sometimes collarless, worn with snug blue jeans. After Brooks discovered the small Oklahoma shirtmaker Mo Betta, that company's business skyrocketed as 1990s-style urban cowboys began donning the affordable, brightly colored shirts. "I think Garth Brooks is a marketing genius because every guy in America can go and look like Garth Brooks for $300," Marty Stuart points out. "If you want to look like Dwight Yoakam or me—it's silly to spend that much money on clothes! It's nice that you have a choice. There's something for every level of the pocketbook."

When their fans started emulating their look on the dance floor, Brooks and Dunn began profiting from the sales of their own line of Panhandle Slim shirts. Ironically, their shirt business actually developed when the duo were still struggling musicians. "We honestly couldn't afford shirts for us and the band, too," Kix Brooks told *That's Country* magazine in 1993. "Early on, with two shows and three shows a night, I'd be wearing five shirts a day. Wardrobe is a real problem. Panhandle actually came to us just as we were talking about what to do and offered basically just to give us shirts. We said, great. . . Ronnie [Dunn] and I both have pretty distinct ideas as far as what we like and what we wear. So we got these shirts and would say, 'This is cool. If you would put square snaps here instead of round ones, and a yoke a little further down the back, and this and that, is it possible we could get something like that?' . . . So they just started custom-making the shirts that we were wanting to make. Finally, [Panhandle Slim president] Jeffrey Hochster said, 'Look, guys. You've got good ideas here. Why don't you just have your own line of shirts and do things your way . . . and we'll see what happens?'"

The duo receives a royalty for shirt sales, which exploded thanks to Brooks's Flame shirt, made from fabric printed with yellow-edged red flames shooting down a black field. "A shirt style will usually sell four or five thousand pieces," according to Hochster. "The Flame shirt sold 75,000 units." Needless to say, Brooks and Dunn set the house on fire at gigs: "To look out there [into the audience] and see a bunch of Flame shirts, it's pretty wild!" Ronnie Dunn exulted in 1994. "We can't believe it!" Brooks's follow-up brainstorm, the Lightning Bolt, featured "striking" bolts appliquéd onto the purple, red, black, and turquoise shirt. "We try to keep the price point under control," says Brooks. "Our shirts aren't that cheap, but we're real conscious of a working man and how many dollars he has to spend on his clothes. Your average line-dancin' workin' cowboy who buys our shirts is used to spending $30 to $40—and we don't want to lose that audience, 'cause that's us."

Dunn has his followers, too. He prefers solid black or gray gabardine or cotton shirts—one line came in silk—with button covers and interesting pocket treatments. "I personally prefer the vintage stuff, with the old square snaps and sawtooth pockets," says Dunn, who actually met Nudie and had him autograph the two shirts he purchased from his store in 1980. "I was shocked when [Nudie] walked in, because he had been hanging out with George Jones in a hotel room and had on a yellow cowboy boot and a turquoise one," Dunn recalls. "He was just hilarious! I walked out of there with two rhinestone shirts, which I never wore—but I paid a fortune for."

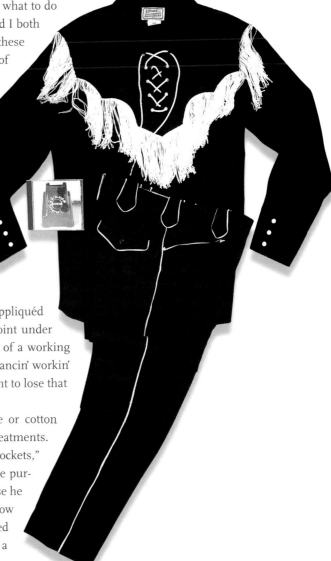

BR-549 vocalist-guitarist Chuck Mead loves the sound and look of vintage C&W. He frequently performs in this ensemble: **a contemporary H Bar C/California Ranchwear shirt and pants in the style of the company's earlier, 1950s designs.** Mead bought the outfit at the Nashville shop, Ranch Dressing, whose owner, Katy K, "customized" it by adding white piping to the pants. Collection of Chuck Mead

Ever since she began her career in 1972 at the age of thirteen, Tanya Tucker has been inspired by Western-tinged flash and sparkle as worn by her idol Elvis Presley. She donned **this bustier and cropped jacket, made by Chick Skins,** in the early 1990s. Autry Museum of Western Heritage, Los Angeles

Brooks and Dunn occasionally pair their shirts with black leather pants and have been seen sporting black leather dusters and jackets. "We tailor our Wranglers from the knee down and trim our jeans in," says Dunn. "I like the cuff tight around the bottom of the boot."

Current country musicians who dress Western seem to fall into two camps: those like Brooks and Dunn, Garth Brooks, and George Strait, who prefer the Everyman look their fans can easily duplicate, and those like Marty Stuart and Dwight Yoakam, whose custom threads enable them to stand out from the crowd. R.E.M.'s Mike Mills says that when he started wearing Manuel's lavishly appliquéd and rhinestoned suits onstage during his band's 1995 "Monster" tour, a few longtime followers reacted negatively. "Some fans are afraid of change and thought [my] going from wearing T-shirts and jeans to wearing Manuel suits represents some sort of fundamental change in R.E.M., whereas in reality, it is just me changing, not changing the band."

Developing his first taste for Nudie suits as a kid watching Porter Wagoner's television show (his Breeze commercials, where his suit matched the detergent box, really stuck in Mills' mind), Mills visited Nudie's right before it closed and bought a fancy green outfit off the rack, wearing it in the 1994 video "What's the Frequency, Kenneth?" He has since become a Manuel regular, ordering numerous custom suits in red, purple, blue, black, and pink, decorated with everything from flames to metallic appliqués to an embroidered desert landscape. Most recently, commissioning several more suits for R.E.M's 1999 tour, Mills says he likes the effect his fancy garb has on him. "To me, it makes the event of the show more special, it delineates it even further from your normal, daily life, and it makes it just more of an occasion, which it is hopefully for me and the audience as well," Mills points out. "When you put one of those suits on, you know you are wearing something that people are going to look at and you have to be prepared to deal with that. And you do have to, in a way, become a different person, but I tend to be that when I walk out onstage anyway."

Concurrently with Mills's embrace of fancy Western duds, U2's guitarist the Edge took to stadium stages adorned in a big black cowboy hat, spangly Western jacket, and cowboy boots. Since 1987's *Joshua Tree* album, U2 had been dabbling in cowboy garb but, with the 1997 "Pop" tour, the Edge seemed to be making a fashion statement with his look, much as Bono did in his hip-hop-style hooded sweatshirt jacket and baggy pants. Also in 1997, Beck began performing in a rented white and silver Nudie suit glistening with rhinestones. When asked about his switch from 1970s-style leisurewear and 1960s-era mod suits, he said, "I've always loved the Nudie suit. I've always thought of it as one of the greatest clothing styles in any kind of music. When I come out in a fringed Nudie rhinestone suit, I'm doing it as a tribute to the late-'50s George Jones or Webb Pierce."

Artists of a more twangy stripe also wear Western as an homage to their idols. The Derailers, from Austin, Texas, go for the mariachi-style bolero-jacketed suits, as did their heroes Buck Owens and the Buckaroos. BR-549, who have recaptured the golden age of honky-tonk with their sound, wear the string ties and piped and fringed Western suits and shirts that their predecessors wore. Robert Reynolds of the Mavericks combines his rock & roll and Western influences with his Manuel-designed custom suits, pants, jackets, and shirts.

"For the past few years, every time I [got something from Manuel] I went a little further than what I'd seen him doing," Reynolds says, the day after he wore an exquisite electric-blue velvet Manuel suit to the September 1999 CMA awards. "Marty and Dwight have beautiful things and I certainly love the stuff that they've worn over the years, but I needed something that was more me. I would want to use influences like [Jimi] Hendrix and stuff. I would go in and say to Manuel, 'Do what you do, but give it just a dose of psychedelia.' So I would end up with floral velvet suits that had Western stitching."

Reynolds, who dressed in a Manuel suit for his wedding to Trisha Yearwood, another of the designer's frequent customers, says he plans to continue wearing custom Western clothing, as well as cowboy boots, and tooled leather belts with unique buckles, even while some Nashville stars have forsaken Western wear. "I think one year I probably spent something foolish like twenty-plus-thousand dollars on clothes," Reynolds explains. "Money like that comes and goes in this business. I couldn't afford to do that all the time, but I'll always afford myself things like this because it's what I have fallen in love with and I believe in the stuff. I may not need as much of it one day. I may not need it to be as wild. I may find myself wearing Manuel suits that are just beautiful suits you could go to dinner in. The bottom line, though, is while the Mavericks are making records and shooting photos and doing videos and TV shows, I feel like it's part of my responsibility to carry forward the tradition of fashion and music. I'd be honored if in sixty years the Country Music Hall of Fame had a section on the '90s or a section on groups and we were represented and a piece of my clothing was there. That's why I'm doing it."

Though fashion trends do indeed come and go, the Western look will surely stay alive in the twenty-first century, thanks to prominent fashion plates like Reynolds and Stuart, just as their role models Gene Autry and Roy Rogers kept it going earlier in the twentieth century. As Stuart pointed out back in 1993, "Country music has not always been the most popular trend, nor has Western wear; but the one thing you can count on is that they're always here—they're timeless!"

R.E.M. bassist Mike Mills has been performing onstage in **custom-made Manuel suits** since the 1994 Monster tour. He wore one of his first, the jacket on the left, for the "What's the Frequency, Kenneth?" video. Collection of Mike Mills

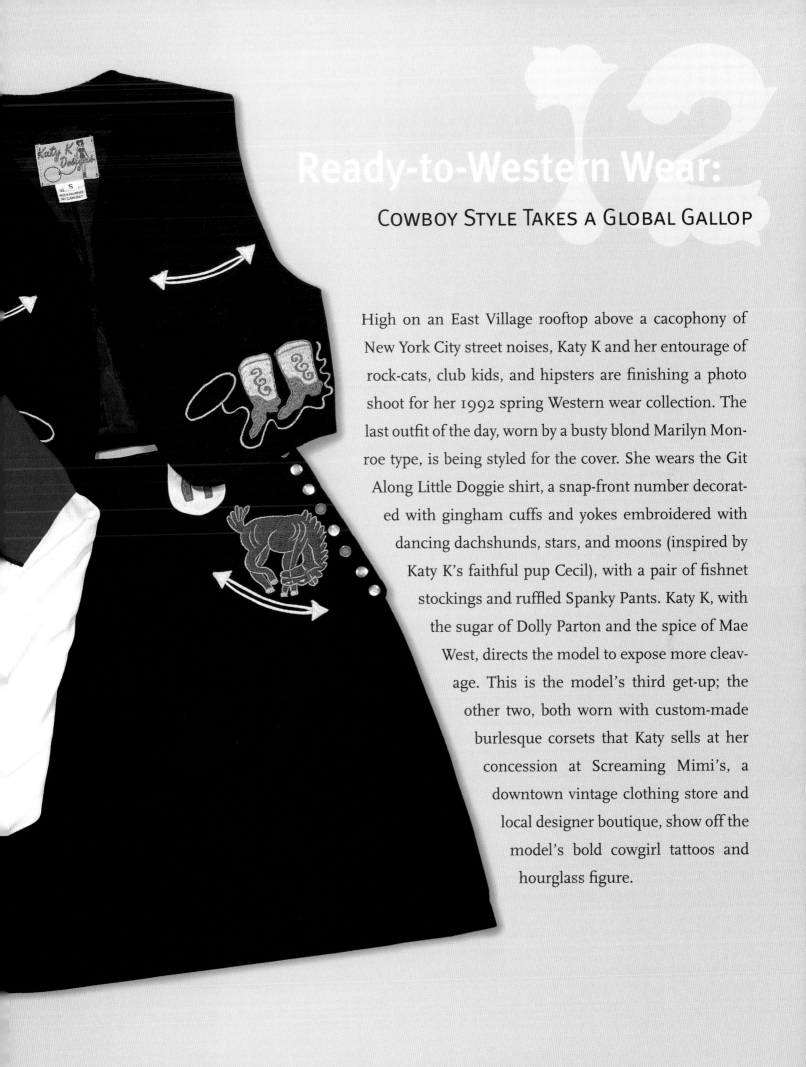

Ready-to-Western Wear:

COWBOY STYLE TAKES A GLOBAL GALLOP

High on an East Village rooftop above a cacophony of New York City street noises, Katy K and her entourage of rock-cats, club kids, and hipsters are finishing a photo shoot for her 1992 spring Western wear collection. The last outfit of the day, worn by a busty blond Marilyn Monroe type, is being styled for the cover. She wears the Git Along Little Doggie shirt, a snap-front number decorated with gingham cuffs and yokes embroidered with dancing dachshunds, stars, and moons (inspired by Katy K's faithful pup Cecil), with a pair of fishnet stockings and ruffled Spanky Pants. Katy K, with the sugar of Dolly Parton and the spice of Mae West, directs the model to expose more cleavage. This is the model's third get-up; the other two, both worn with custom-made burlesque corsets that Katy sells at her concession at Screaming Mimi's, a downtown vintage clothing store and local designer boutique, show off the model's bold cowgirl tattoos and hourglass figure.

Katy K

Above: Known as the **Gal of the Golden East, Katy K** turned many trendy New York kids onto the joys of dressing Western. She always surrounded herself with "scenesters" who frequently posed for her catalogues, modeled in her fashion shows, and performed wearing her creations. Collection of Holly George-Warren

Previous pages: With capital earned from her crinoline jackpot, **Katy K expanded her line to include pieces inspired by classic Western wear** from the 1940s and 1950s. She designed a half-dozen gabardine cowboy shirts with faux pony-fur insets, whimsically embroidered yokes, lace-up fronts, and striped piping. For the women, she created a two-piece embroidered bolero and A-line cowgirl skirt, along with Daisy Mae–style tops, petticoats, and bloomers. Shown left to right are her twill Music Note jacket, rayon gabardine Sexy Cowgirl shirt, and a two-piece embroidered cowgirl outfit. Collection of Holly George-Warren

Scattered on a card table behind the photographer's white paper backdrop are vintage cowboy boots and tooled leather belts with silver trophy buckles used earlier that day to accessorize some of the Western ensembles. Other pieces from her collection are haphazardly draped over a metal folding chair: a black-and-white charro outfit, a red ruffled miniskirt-length square-dance petticoat, a black Eisenhower jacket with stitched white music notes cascading down the sleeves, and the red and white embroidered Sexy Cowgirl Western shirt recently featured in *Harper's Bazaar*. Satisfied that this final setup conjures the image of a Vargas-calendar cowgirl, Katy gives the photographer the okay to shoot.

Katy K, California Wear's Amy Hoban, and Double D Ranchwear's Cheryl Matusek are among several young American fashion designers in the 1990s who sought to emulate and reinvent the golden age of Western wear. Others, such as Jaime, entered the business after working with established designers. At the same time, members of the American and European fashion establishment—designers like Donna Karan, Anna Sui, Todd Oldham, Isaac Mizrahi, Gianni Versace, Jean Paul Gaultier, Tommy Hilfiger, and Thierry Mugler—have added Western elements to their designs. Generally, throughout the latter quarter of the twentieth century, the Western look has cycled in and out of style approximately every seven years.

One of the first cohesive collections of Western wear by a European fashion house was maverick British designer Zandra Rhodes's mid-1970s work. In 1975, while traveling across the United States in a Volkswagen bus, Rhodes discovered country music, cacti, the lure of the West, and, particularly, Nudie. "I went back to my London studio armed with my cactus drawings and photographs, a few cowboy photographs, and the Nudie's catalogue," Rhodes wrote. "At first I used only the cacti, pinning them on the wall, side by side, the photographs supplementing the detailed sketches. So the prints were created. . . . But strange things were happening, little arrows had started to appear in the designs. Then the arrows took over . . . and [my] cowboy collection was conceived." The West, as Rhodes romanticized it, became the inspiration behind her imaginative 1976 spring collection, which included printed silk chiffon dresses, ultrasuede prairie skirts, gauchos, chaps, and skirts. She presented the line at London's Roundhouse, with models wearing fancy ostrich, lizard, and kangaroo cowboy boots custom made by Tony Lama.

America, of course, got caught up just four years later in Urban Cowboy fever and the resulting Americana everyman look of Western wear. Ralph Lauren, inspired by romantic images of the West from the 1930s and 1940s, was the principal United States fashion designer creating Western-wear collections, while mainstream apparel manufacturers prospered, keeping up with the fad. By 1983, the inevitable backlash had wreaked havoc on the industry, though, with the Western trend losing steam.

Just as cowboy mania was phasing out of the American limelight, French haute couture designer Christian Lacroix initiated its resurgence in Europe, showing ruffled petticoats and pony-print skirts in his breakthrough 1986 couture collection. In New York, upstart designer Katy K, who until then had catered primarily to her rockabilly musician friends, found herself inundated with orders from trendy specialty shops such as Fiorucci's for the crinoline petticoats she had been making for six years. "I had a little office on Fortieth Street in Manhattan," she recalls, "and we were working seven days a week just packing [the huge orders]!"

Primarily self-taught, Katy Kattelman has dressed many a Western enthusiast since she began cutting and sewing petticoats on the living room floor of her Manhattan apartment in the early 1980s. She had grown up in Philadelphia, inspired by Rodeo Ben and all things Western. Katy K credits comic-book character Katy Keene for instigating her original fascination with Western clothing: "In the late 1950s, early 1960s there was a comic book where

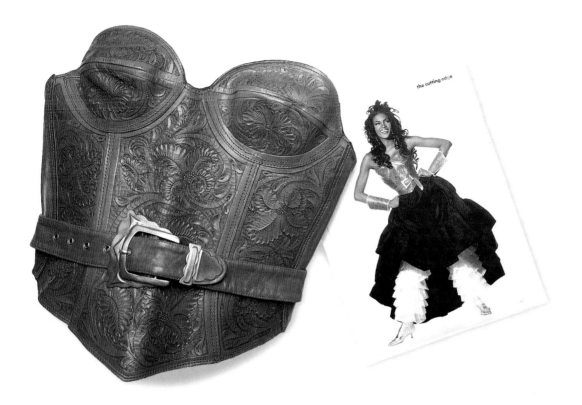

the cutting edge

Inspired by the decorative hand-tooling on Western saddles, **Isaac Mizrahi created this outrageous leather bustier** with a modern cowgirl in mind. For a *Vogue* magazine fashion layout, it was worn with matching tooled-leather cuffs, full-length prairie skirt, and yards of ruffled pettipants. Collection of Kathy Shepard

you'd send in designs—Katy Keene the Fashion Queen! She had different outfits and a lot of them were Western. She had a purple cowgirl outfit with gold fringe with purple and gold boots and a car to match."

After a brief stint in the late 1960s sewing fringed leather pocketbooks on a makeshift farm near Toronto, Katy headed to New York City, where she began taking night classes in fashion design at Parsons School of Design. Her illustration instructor, Harvey Boyd, encouraged Katy's budding cowgirl fixation by letting her draw models with "big hairdos and fringed cowgirl outfits." It was around this time that a small rockabilly scene began to surface in New York City clubs like Max's Kansas City and CBGB. "The guys wore Teddyboy jackets and cowboy shirts with the sleeves cut off," she says. "It was that strange kind of mixture that happened of Western and '50s. That made a big impression on me."

Katy hit the road again, this time to London, where she found herself as part of an underground rockabilly scene. "There were a lot of working class kids who just kind of missed the boat with the whole 1960s London scene: they went back a decade and made up a 1950s that never was. They had festivals where they would gather, that perpetuated this culture. There were two distinct groups, the Rockabillies and Teds. The Rockabillies would listen to R&B and anything '50s, but the Teds—it was Carl Perkins and Charlie Feathers." She attended one such music festival in Great Yarmouth where every night kids dressed to the hilt and jitterbugged until the wee hours of the morning. "The girls wore petticoats that they made themselves, and the guys wore drapes, like Jerry Lee Lewis used to wear. They were cut long, fingertip length, with velvet on the lapel and smile pockets—sometimes they would have four smile pockets in a row."

Katy brought this style back to America, dressing Teds and Rockabillies in authentic drapes constructed by a British tailor in a London shop called Ted's Corner. She also began experimenting with designing and sewing petticoats and 1950s-style Western dresses. On a road trip to Florida, she and her mother stopped in a North Carolina square dance shop—an experience that opened up a new world to Katy. "I didn't know such things existed! There were the dresses and petticoats that I was trying to make just sitting there! I looked at the label—Sam's Manufacturing—and when I got back to New York I called." She talked the owner into manufacturing 1950s-style tea-length petticoats, a dozen at a time. Her designs

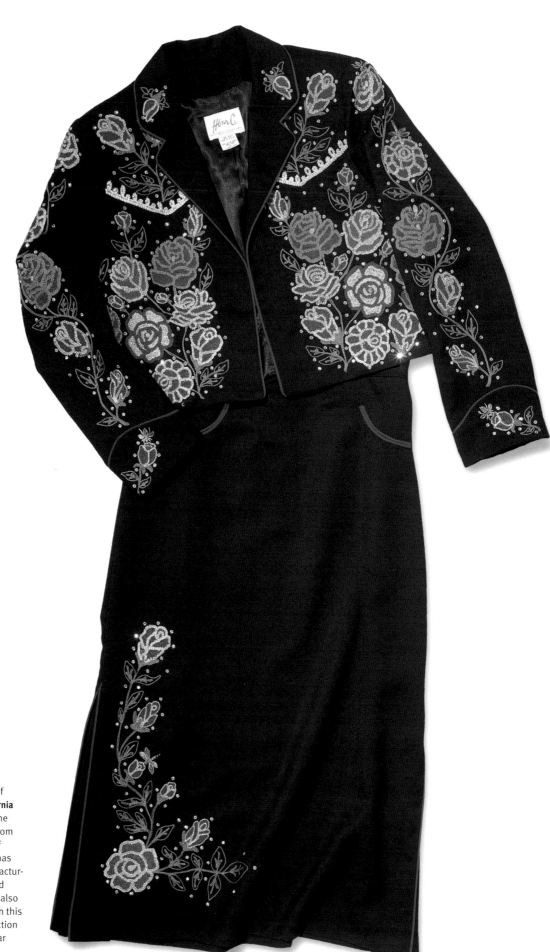

Surviving the ups and downs of fad and fashion, **H Bar C/California Ranchwear** has blossomed in the last couple of years. Drawing from the considerable experience of Margaret Miele, the company has proven itself capable of manufacturing not only the mass-produced goods it is best known for, but also master works of fashion as with this award winning example. Collection of H Bar C/California Ranchwear

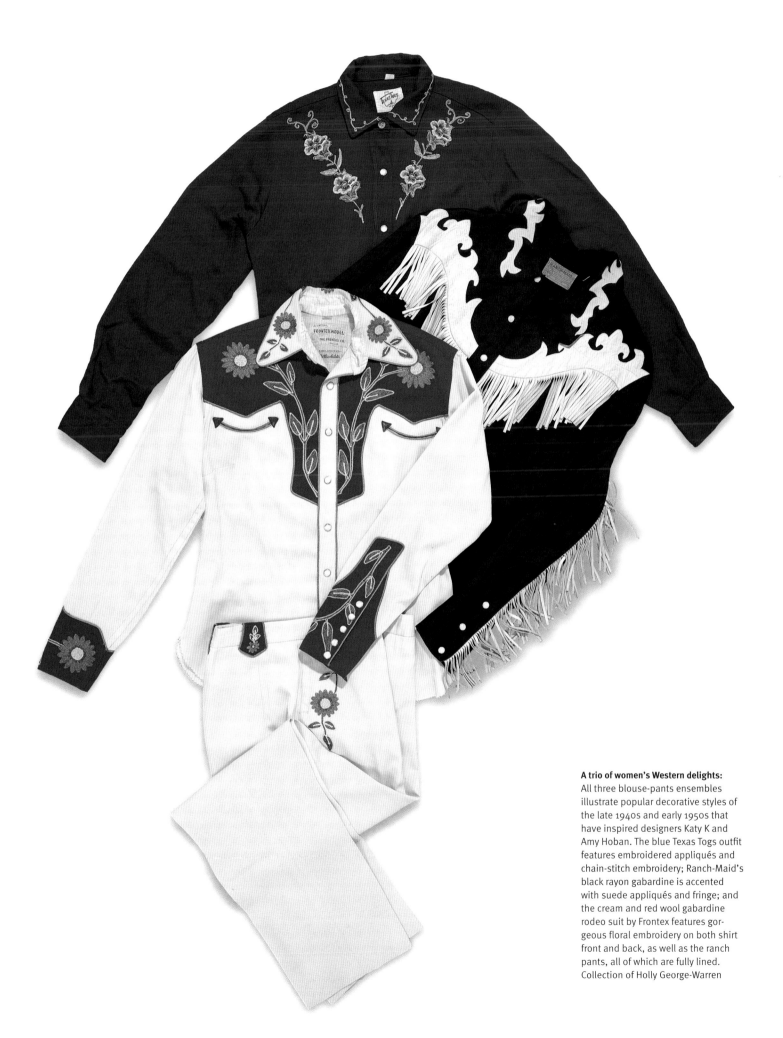

A trio of women's Western delights:
All three blouse-pants ensembles illustrate popular decorative styles of the late 1940s and early 1950s that have inspired designers Katy K and Amy Hoban. The blue Texas Togs outfit features embroidered appliqués and chain-stitch embroidery; Ranch-Maid's black rayon gabardine is accented with suede appliqués and fringe; and the cream and red wool gabardine rodeo suit by Frontex features gorgeous floral embroidery on both shirt front and back, as well as the ranch pants, all of which are fully lined. Collection of Holly George-Warren

became a big hit with the club crowd and people started wearing them to hot spots like Studio 54. Occasionally Katy K herself would perform there in some of her wildest cowgirl designs—skin-tight, white-fringed-leatherette creations with big white Dolly Parton–style wigs to match.

These designs began finding their way into the hands of Nashville's new stars. Katy K also met Manuel, who encouraged her to relocate to Nashville in 1993. One reason for Katy K's success, according to Ron Tassley, coowner of Buffalo Chips, a Western specialty store in New York City, was that "the acceptance of Western wear by the European market has greatly influenced American taste." He also told the menswear trade magazine *DNR* [*Daily News Record*] in 1989, "The Europeans have accepted the Western look. It's flying over there. It's like what happened with blue jeans. And now the Americans are going after Western wear because the Europeans are so into it."

While the new guard flirted with Western looks, the established Western wear companies struggled to regain their footing and recapture their hold on the fickle market, now moving faster than ever before. By 1992, what was once a small regional business had become a $12 billion international industry. Established companies such as Panhandle Slim, H Bar C/California Ranchwear, Karman, Rockmount Ranch Wear, Lee & Wrangler (as of 1986, under the VF corporate umbrella), and Levi Strauss, sought to appeal to their traditional Western wear customers as well as the latest, trend-conscious crossover consumer. Gary Karlin, national sales manager of Denver's Karman, Inc., told *DNR* in 1989, "Western clothing is more updated and fashionable today, in better fabrics, and not the anomaly it was in the early '80s. I don't see this trend as mere phenomenon. It is more lifestyle dressing, and thus will last longer. Western is becoming an aspect of everyone's wardrobe."

Adding to its popularity was yet another Western-themed box-office smash, 1990s *Dances with Wolves*, as well as the phenomenal success of contemporary country whose stars ignited fashion trends with their personal styles. New audiences introduced to Western fashion for the first time during these trend years began to wear modern versions of the classic Western shirts, jeans, boots, and hats.

Then internationally acclaimed designers Thierry Mugler, Jean Paul Gaultier, Rifat Ozbek, and Gianni Versace all embraced Western as a theme for their 1992–93 collections. "A vast part of the Paris collections—the ready-to-wear and even couture—resembled the aftermath of a major explosion on a Hollywood backlot in which the costume archives of all the Westerns ever made were hurled into the air," Leslie Cunliffe reported in the May 1992 British *Vogue*. Versace told British *Vogue* that he felt "nothing in the world is more American than a wild Western look. The great Wild West revival we are experiencing probably depends on America's need to take possession of its roots again, while Europe feels a great attraction toward the refreshing Western myth—and toward a look that speaks of wide-open spaces in traditional ways. What is certain is that the Wild West re-revival isn't simply retro. It is a panacea for something that has been ailing us for a long time—the late twentieth century."

The traditions of Rockmount Ranch Wear continue to evolve. **"Diamond" snap buttons, sawtooth pockets, and slim-fit styling** have been combined with washed-denim fabric and new products, including this broomstick skirt, shadow-plaid man's shirt, and stylish concha belt. Collection of Rockmount Ranch Wear Mfg. Co., Denver, Colorado

The January 15, 1992, cover of *DNR* proclaimed, "Versace Saddles Up!" and showed two male models dressed in "wild West looks crossed with Miami glitz." His men's collection included piped Western-style shirts, designer denim jeans and jackets, embroidered vests, silver-studded leather belts, and fancy Western boots. For women he showed denim shirts with jeans that traced out the shape of chaps with silver rivets. "Now the glamour that a good necklace used to add to a black sheath has been replaced by a Western accessory," he concluded. "A pair of cowboy boots can have the same chic as a pair of Chanel shoes. A Western belt buckle gives the same quiet nonchalance to an outfit as a baroque chain."

"John Wayne would turn in his grave!" wrote Rosie Martin for British *Vogue* in January 1992 about Thierry Mugler's collection, which featured bejewelled chaps and a skirt that flipped up at the side like a Stetson. Mugler embraced a Western fantasy theme for his collection, and told British *Vogue* that he was attracted to "the arrogance of the total look in fringed leather parodying the Western: a profusion of feathers on the trouser chaps, stolen from the cowboys of cabaret saloons." Rifat Ozbek's line, inspired by *Dances with Wolves*, paid homage to Native American costume with his pony-print pants, long slim dresses, and fringed washed silk that resembled soft buttery suede. Rosie Martin wrote that Ozbek's collection looked like "some of his squaws had messed with General Custer's boys and wore their military jackets with stripes and regimental rows of resin 'bones.'"

All this had a profound effect on the American Western apparel industry. Faced with a dichotomy of changing tastes among their faithful Western customers and a thirst for old-style Western wear among those discovering it for the first time, the Western-apparel industry was challenged to merge into the mainstream. "I think our customer has become more sophisticated, more aware of fashion trends in general. I also see more of a willingness to change on the part of the consumer," Miller Stockman executive vice-president Juliet Wright told *DNR* in 1994. "Years ago he was adamant—'This is what I like and this is what I want'—and nobody could change that customer's mind. Now I see him becoming much more open to trying new things—different styles, different colors. . . . Years ago, a new style wouldn't have appealed to them. Now, the Western industry needs to follow the mainstream apparel industry in color, basic silhouette and styling features."

Additionally, American fashion designers found inspiration in traditional Western-wear styles. Ralph Lauren continued to expand on his Western wear business, launching in the early 1990s the Double RL line, rugged clothing that looked old, as a response to the popularity of vintage Western. In 1993, he opened a second store across from his flagship Polo Ralph Lauren shop in the Rhinelander mansion on Madison Avenue to house his Polo sport line and the Double RL collection. The mezzanine was a Western zealot's fantasy trading post—Pendleton blankets, Beacon robes, embroidered Western shirts, leather jackets, chaps, and boots—no tumbling tumbleweed was left unturned! His collection featured special garment washes and dyeing techniques that made the clothing look antiqued and worn, which often rendered the new merchandise difficult to distinguish from the vintage pieces.

Other New York–based designers flirted with Western motifs for their 1995 spring collections. Texan Todd Oldham's line had a 1940s vintage Western wear feel. He showed short-sleeved Western shirts with pointed yokes, fancy piping, and embroidered cabbage roses worn with matching cigarette pants. (Ironically, Oldham became the designer for the Dixie Chicks after they became hugely successful in 1998–99, having given up their cowgirl clothes for a "modern" look to more easily cross over to mainstream country success.) Cynthia Rowley, another New York designer inspired by Western wear, showed a white sleeveless dress with black piped S-curve smile pockets, and Marc Jacobs, formerly head designer for

For her coronation as Miss Rodeo California in 1999, Brandy DeJongh wore this **leather outfit designed by Julie Ewing,** who specializes in formal and rodeo wear in Fresno, California. The seamstress was Edith Alexander, who creates rodeo clothing "Fit for a Queen" in Kingsboro, California. DeJongh went on to be crowned 1999's Miss Rodeo America and wore another outfit crafted by the same duo. Collection of Brandy DeJongh

Chandler Liberty's exquisitely **embroidered logo**. Courtesy of Liberty Westerns

Perry Ellis, featured a Western-style ankle-length satin "shirt dress" with contrasting embroidered yokes, piping, and pearl snaps.

Bits of this look also trickled into the collections of sportswear companies that were not "official" Western-wear companies, such as DKNY, Tommy Hilfiger, Guess?, Replay, Diesel, even The Gap. Not only did this further the appeal of Western wear in a market that had disregarded it, but it also bridged the gap to the ardent Western-wear customer who had previously only worn well-known Western wear brands. Reacting to the changing market, Western wear specialty shops began to branch out and incorporate these brands into their merchandise mix. Jim McClure, vice-president and cofounder of the 55,000-square-foot Western emporium Drysdales in Tulsa, Oklahoma, told *DNR* in 1997 that "Western wear customers have diversified their wardrobe in the last few years and most have multiple brands in their closet." He cited denim brands Guess?, Calvin Klein, Girbaud, Polo Jeans, and Doc Martens as mainstream labels that appeal to his Western "crossover customers and weekend warriors."

Another niche in Western-wear design being filled in the 1990s was the custom tailor. Jaime Castañeda worked as a pant cutter for Nudie, then as Manuel's assistant for sixteen years in his shop in North Hollywood. Born in 1955 in Equanajuatillo La Blanca, Zacatecas, Mexico, Jaime started sewing men's pants and jackets as a tailor's apprentice when he was just twelve years old. At nineteen, Jaime ventured to the United States, where on a recommendation from a friend he approached Nudie for a job. His fellow tailors in the back room at Nudie's used to tease him because he didn't recognize the famous customers: "I saw a lot of important people, but I never knew who they were," he admits. "The people in the shop would say to me, 'Do you know who that person is—he made that movie,' but I never met them in person [back then]."

When Manuel moved to Nashville in 1992, Jaime stayed behind and started his own business, initially doing custom Western tailoring. "In the beginning I worked in my garage," he recalls. Jaime and his wife Maria, along with machine operator Juan Corzo, now run a shop in a modest storefront at 5623 1/2 Lankershim Boulevard. Jaime works exclusively with Rose Clements for his embroidered pieces, and has created clothing for Marty Stuart, Dwight Yoakam, Johnny Cash, Riders in the Sky, ZZ Top, and actor Steven Seagal. A shy, reserved fellow, he lights up when he flips through a photograph album of garments he created for his bevy of high-profile clients. "This is what Dwight wore at the White House," he says as he proudly points to an elegantly piped gabardine jacket. One of his specialties is fringed leatherwork, including the sexy palomino buckskin outfit Yoakam wears on the cover of his 1995 album *This Time*. Jaime collaborated with Marty Stuart and Rose Clements on an elaborate embroidered wall hanging that adorns Stuart's Nashville office, and recreated several vintage pieces, such as a jacket embroidered with an about-to-be-crucified Jesus that belonged to Johnny Dollar.

Other custom designers inspired by Nudie, Turk, Rodeo Ben, and Manuel have carved out spots for themselves in areas where traditional C&W and roots rock thrive. A seamstress since the age of eleven, Texanne, also known as Carla Worley, opened a shop called West of Heaven, in Atlanta, Georgia, in 1992. There she took orders for one-of-a-kind embroidered, appliquéd, and piped shirts, jackets, pants and cowgirl outfits. Popular among the rockabilly crowd were her flame-and-dice embroidered and appliquéd garb. "Texas Girl," as Manuel likes to call her, credits fellow designer Katy K with inspiring her to go into business for herself. "I thought she was heaven sent," says Texanne. "I kept saying, 'I just can't bring myself to quit my day job and do this full time,' but she really encouraged me to do it." Texanne prides herself on never repeating a design. She occasionally has to tell her customers, "I don't make things twice. I'll make what you want, but we need to work with the colors a little bit or think of something to make it different." Her unique creations have been seen on the backs

of Billy Corgan and James Icu of Smashing Pumpkins and on members of the Mavericks. In the late 1990s, Texanne began operating her custom-design business out of her home and from her Web site.

Chandler Liberty, a Midwesterner who moved to New York at sixteen to study ballet and ended up in a roots-rock band, now runs a custom Western wear business from her home in Sante Fe, New Mexico, after relocating from Austin, Texas. Originally making Western stagewear for herself and her husband, she specializes in vintage-inspired intricately embroidered Western wear. Perhaps she takes after her mother, who was once offered a job working at Nudie's doing hand embroidery. Liberty spent nearly three years searching for a used Cornely chainstitch-embroidery machine and then taught herself to operate it without a manual. Taking a break from her busy schedule, Liberty shed light on the state of custom embroidery in 2000: "The thing that's complicated [with machine embroidery] is that there are really not that many operators anymore. If you do happen to come across some of the old-school operators, they are reluctant to pass on their knowledge because in their heyday the competition was steep. In the 1930s, there were three hundred embroidery shops in New York City alone . . . and now there are only three in the country that I know of." Liberty also notes that many of the old embroidery machines have ended up in Africa, where they are used for decorative stitching on dashikis.

Among Liberty's more whimsical designs is a Las Vegas theme outfit with a complete roulette game embroidered on a circle skirt and matching bustier. A recent feather in her cap was doing embroidered costumes for the Broadway revival of *Annie Get Your Gun* starring Bernadette Peters and Tom Wopat, for whom she designed several shirts. Other Liberty Western embroidery designs are based on everything from a 1947 McCall's sewing pattern to a Buffalo Bill Wild West Show poster. Liberty has also collaborated on design projects with the Rocketbuster Boot Company.

Regional clothing companies, too, became successful making unique Western styles in the 1990s. Amy Hoban of California Wear in Los Angeles, and Cheryl McMullen Matusek of Double D Ranchwear in Yoakum, Texas, are two designers who have led the pack. Hoban's retro designs are popular in Los Angeles and Santa Fe Western-wear shops, and one of her custom cowgirl outfits can be seen on country singer Connie Smith (who's married to Marty Stuart) on the cover of her 1998 album. Matusek designs the clothing for her family's business, and has had her luxurious apparel featured in Robert Redford's *Sundance* catalogue as well as in high-end Western specialty shops in resort towns such as Vail, Colorado, and Santa Fe. Her designs incorporate authentic details of traditional Western wear and Native American costume—rich crushed velvet dresses adorned with silver studs, embroidered fringed leather and suede outfits, and swirling soutache-embellished wool jackets—for which she looks to museums and flea markets for inspiration.

Matusek is humble about her talent, which she says she comes by naturally. "Ignorance has its advantages," she told Reid Slaughter for the September 1997 *Cowboys and Indians* magazine. "If I had been classically trained at design school, then I would know the production limitations. I would know that you're not supposed to put three hundred studs on a velvet dress. Fortunately, I never learned about limits!" Her father, Doug McMullen, serves as president of Double D (which stands for Doug and Daughters) and, along with his wife, Margie, and daughters, Hedy, Audry, and Cheryl, won the prestigious Manufacturer of the Year Western Image award in 1996.

Chandler Liberty designed a series of **Day of the Dead cowboy shirts and jackets,** complete with guitar-playing-cowboy skeletons on horseback, for her Liberty Westerns line. Courtesy of Liberty Westerns

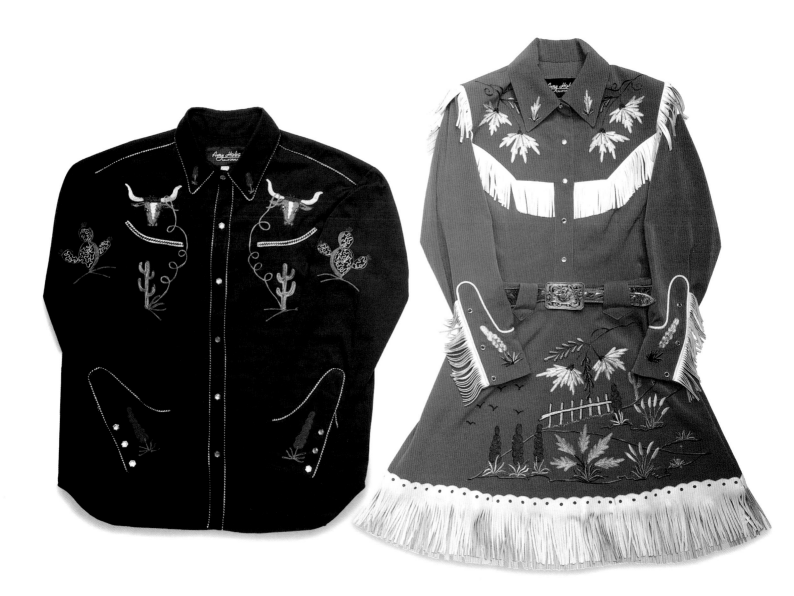

Above: Amy Hoban is a master at **reinterpreting the Western classics** from the golden age of Western wear in the 1940s and 1950s. Her two-piece fringed suit is aptly named the Ultimate Hollywood Cowgirl Outfit. Courtesy of Amy Hoban

Opposite page: **Lone stars and longhorns,** the motifs on this Amy Hoban fancy ranch ensemble, are reminiscent of those that decorated the garb worn by Texas cowgirl Dale Evans for her numerous appearances on television and in movies and in comic books. Embroidery on these Hoban products is by veteran artist Rose Clements.

Though the Western influence goes in and out of favor among mainstream haute couture, a handful of iconoclastic American designers have proudly stuck by the style, making it their own through thick and thin. Though small and grassroots compared to international couture houses, Katy K, Jaime, Amy Hoban, Chandler Liberty, and Texanne have played an important role in keeping the look alive. Now as proprietor of the Nashville shop Ranch Dressing, Katy K outfits the next group of young Western trend setters such as members of BR-549, as they ride off into the dawn of the twenty-first century. In fact, Nashville's famed radio station WSM, home of the Grand Ole Opry, broadcasts a catchy jingle that symbolizes the style's appeal:

I was lookin' in my closet/feeling mighty blue
Go see Katy K/She'll know what to do
That's fashion/Katy K's Ranch Dressing
You look smashing
Katy K's Ranch Dressing

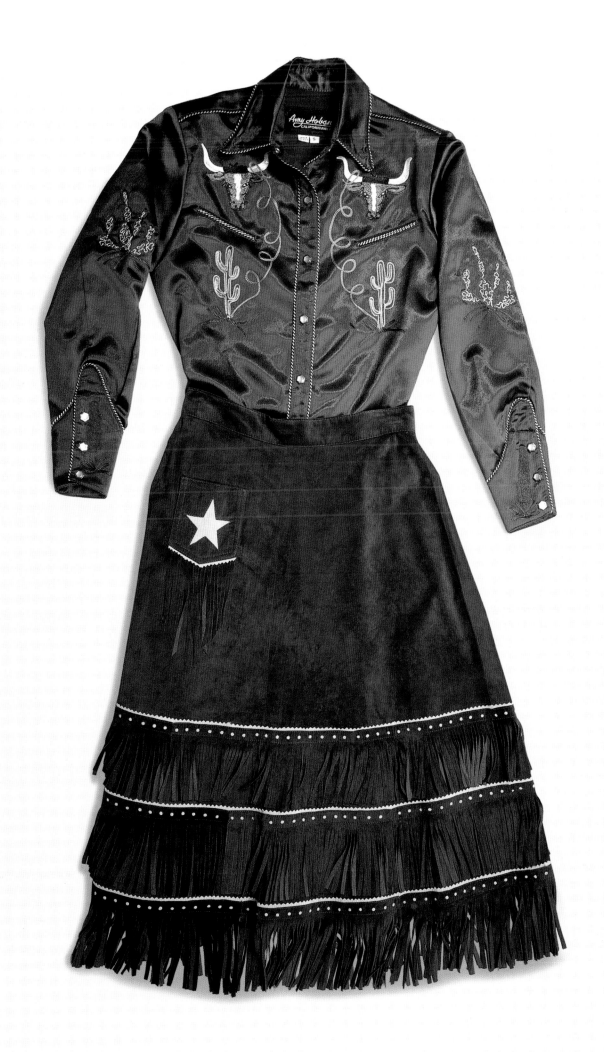

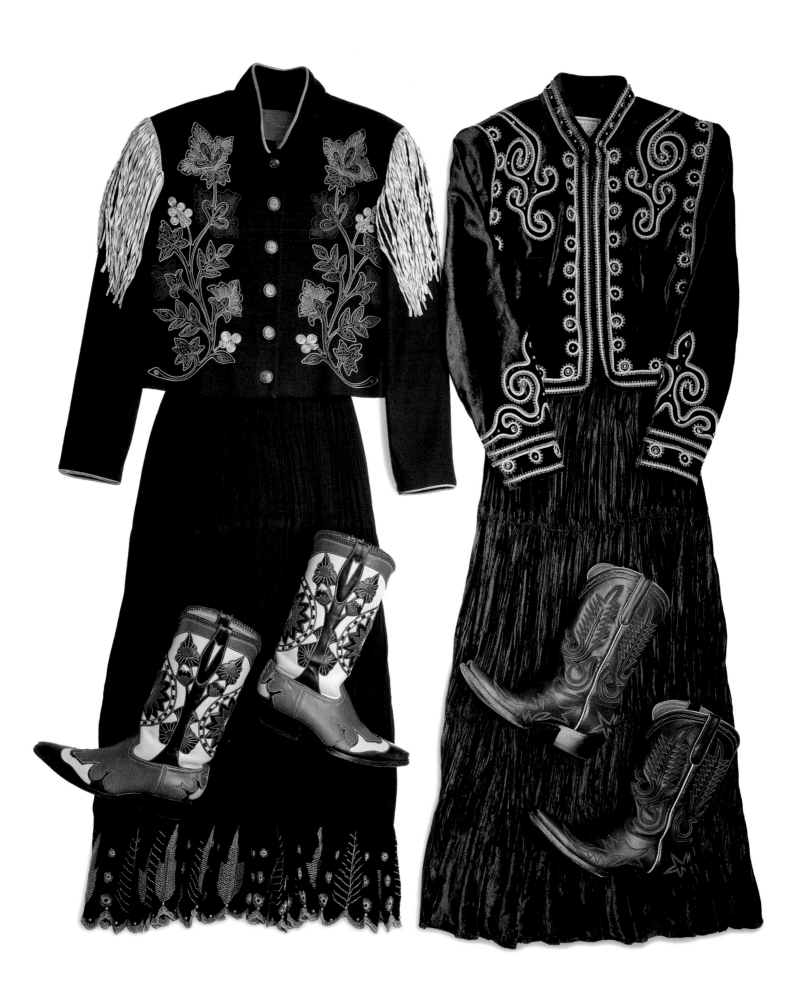

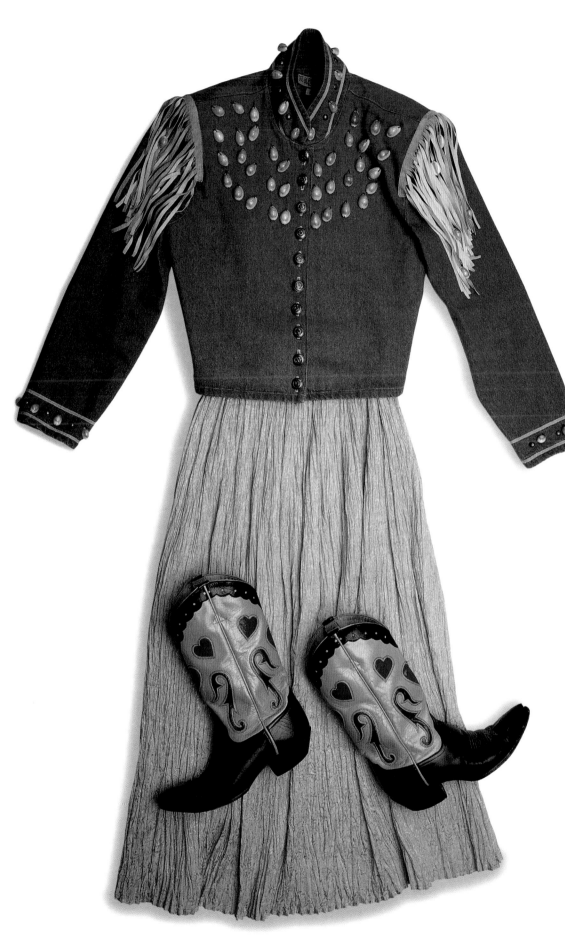

Left: According to Double D Ranch Wear owner **Cheryl Matusek,** blending Native American design and nineteenth-century military inspirations with modern cuts and styles has helped create a look that appeals to both traditional Westernwear customers and mainstream fashion lovers. Courtesy of Bobbi Bell

Opposite page: This **pair of Double D outfits** epitomizes the new era in Southwestern high style. Courtesy of Bobbi Bell

The Last Round-Up:

THE OLD BECOMES NEW
IN THE TWENTY-FIRST CENTURY

The mood was somber in Victorville, California, on Saturday, July 12, 1998, as Dusty Rogers and other members of the Rogers clan huddled atop the fort-style roof of the Roy Rogers–Dale Evans Museum. From there, they could survey the throngs of fans who had gathered to bid farewell to Roy Rogers, who had died five days earlier. Despite the scorching 106-degree heat, many folks had come to pay their respects. As the hearse bearing Rogers's body—his famous white cowboy hat perched on the dashboard—entered the museum's circular driveway, men of all ages dressed in nineteenth-century-style Western attire helped to direct vehicular and pedestrian traffic. Wearing woolen frock coats and matching vests, white frontier shirts, and black broad-brimmed hats, they were members of the Single Action Shooting Society (SASS), an organization of antique gun enthusiasts favored by the Rogers family. As the funeral procession circled the museum, these men of the West off took their hats in honor of their hero. At sunset, Rogers was laid to rest in a private ceremony at the Sunset Hills Memorial Park.

As his name indicates, **Hank Williams III is a third-generation Nudie-suit-wearing singer.** This outfit originally belonged to his father, Hank Williams Jr., and was inspired by the famous musical-notes suit worn by Hank Sr.

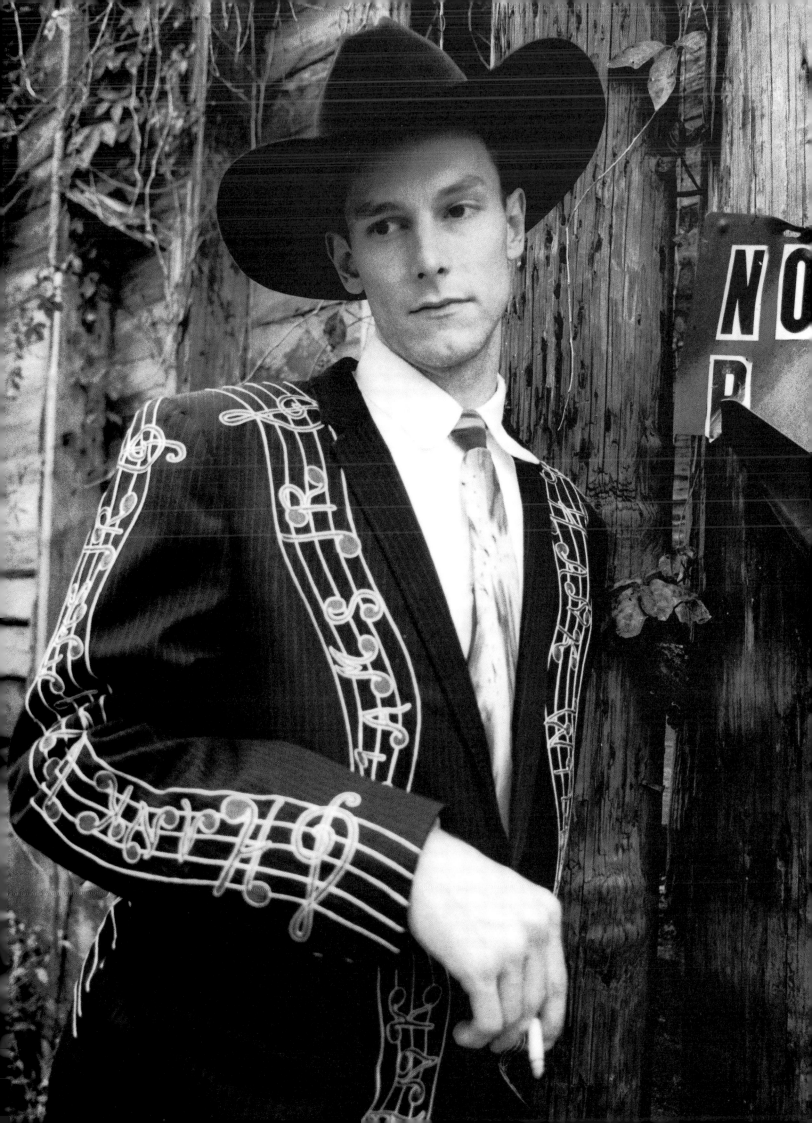

A new brand of cinema realism, **the 1994 movie Maverick copied the fashion styles of its namesake television series** of the late 1950s, mixed in with 1990s notions of the authentic Old West. Autry Museum of Western Heritage, Los Angeles

Six months later, Dusty Rogers is spending the afternoon meticulously sorting through and archiving his dad's vast wardrobe at the museum of which he is the director. A plethora of Nudie, Rodeo Ben, and Turk suits hang in plastic bags still emblazoned with the Chatsworth Dry Cleaners logo, virtually untouched and unworn for at least thirty years. This dimly lit area also holds several of the costumes Roy Rogers and Dale Evans wore in their movies, for personal appearances, and on their television series. Many others are on display in the museum. "Dad saved everything," says Dusty, "but occasionally I caught him about to throw out some of his old clothes because they had moth holes. I rescued them—and here they are."

A few items belong to Dusty, including a fancy rhinestoned and embroidered Nudie shirt made for the cover of an album he recorded in the late 1960s. This shirt is an anomaly for Dusty, however. While he has a great respect for the flashy styles his mother and father helped to popularize, his taste in Western wear leans more toward the simple styles of the early American cowboys.

Dusty Rogers is typical of many aficionados of the Old West, who treasure the style portrayed by Western movies and dime novels that helped to mythologize the nineteenth-century cowboy. In addition to belonging to groups such as SASS, these enthusiasts flock to cowboy poetry gatherings, B-Western film festivals, and Western music concerts, often attired in styles popular in nineteenth-century outposts like Laredo, Texas and Tucson, Arizona. A string of popular new Westerns, ranging from big-screen remakes of 1960s television shows *Maverick* and *The Wild, Wild West* to made-for-television-movies *The Virginian* and *Lonesome Dove* and its sequel, to features films like *All the Pretty Horses* and *City Slickers* and its sequel, to multipart television documentaries on the Old West, has encouraged this trend.

Meanwhile, a totally different camp of Western-style enthusiasts treasures the outrageous look of the fringed, rhinestone-studded, and embroidered cowboy look made popular by Roy Rogers and his peers. These fans attend high-priced Western auctions, buy and sell fancy Western wear on the internet, shop in vintage boutiques, and stay in touch with dealers who specialize in custom-tailored rodeo suits. The Western-wear journey has come full circle, with original nineteenth-century styles being recreated and the increasingly rare custom-tailored twentieth-century Western designs becoming highly sought after.

Dusty Rogers, who acted in a few film and television Westerns in the 1960s, gets to recreate such dramas in events like SASS's annual End of the Trail cowboy action shooting competition. The organization, which in 2000 had thirty thousand registered members, holds the event on a thirty-acre portion of California's Prado Dam recreation area. SASS members are required to register their Western identities, and dress accordingly, to compete in the shooting contests, which are a series of scenarios based on events from history, Western movies, and Western television series. Additionally, there are costume contests to choose the best dressed "Westerners" and competitions among silver-screen-hero lookalikes. Many celebrities have attended these events, including SASS's tallest member, Kareem Abdul-Jabar. He has his clothing custom made because "they don't have any his size," according to Rogers. "His moniker is Trinidad Slim. Dad saw him once at the event and said, 'My God, that's a big man!'"

When he participates in the weekend-long get-togethers, Dusty Rogers keeps his own Western outfits simple. "I don't have custom cowboy clothing made for myself for the event because I tear 'em up," he says with a laugh. "You get to shooting and you're falling down or crawling through something or riding horses. . . . You don't want to wear a pair of $500 gambler pants and get horse sweat all over them! I'm a down-and-dirty-in-the-trench shooter and I'm very competitive. I love to get out there all day around manure, so I buy $60 off-the-shelf boots. Some of the guys put all their money into their outfits and either buy custom or go back and find the old uniforms. They are ferreting them out all over the place. It's nothing for some of these guys to go back and buy [authentic antique Army] uniforms. They'll spend thousands of dollars to have everything look just right."

More than thirty thousand members of **the Single Action Shooting Society** (SASS) nationwide, including celebrities like Kareem Abdul-Jabbar (right), participate in monthly gatherings, showing off their shooting skills and their fancy outfits. Their clothing reflects both the real West of the late nineteenth century and the make-believe dress of the movie cowboy and cowgirl. Groups such as this have spawned a cottage industry that supplies everything from boots to hats. Courtesy of the Single Action Shooting Society

Several companies have sprung up to serve SASS members and fans who want to look the part at cowboy poetry gatherings and other Western-themed events. The Old Frontier Clothing Company in Los Angeles boasts customers such as Dusty Rogers, Michael Martin Murphey, Randy Travis, and the Mavericks. Another company that strives to create historically accurate reproduction Western wear is Wah Maker of Arizona. Founded by Allen Wah in 1986, and currently owned by one-hundred-year-old leather-goods manufacturer Scully Enterprises, Inc., Wah Maker produces a complete line of vintage-look menswear, accessories, and hats made from authentic-style fabrics from the post–Civil War era through 1910. "There are certain features on all these garments that have a reason for being," Wah told *DNR* in 1994. "We try not to make things up that didn't exist. As a result, going through the product line is like getting a history lesson. For example, vests made of herringbone wool and canvas were worn as outerwear so arm movement would not be restricted. Most had four pockets to hold all the necessities: pocket watch, pocket knife, silver dollars."

The Wah Maker line also includes frock coats; cotton shirts; canvas and corduroy pants with back waist cinchers, with such names as the Dodge City, Buck cord, and Cowtown pant; leather suspenders; silk brocade vests called Mariposa and Spanish Rose; string ties, short neckties, and "wild rags" (scarves); leather cuffs, belts, and hat bands; and sleeve garters.

Wah, who grew up on the Yuma Quechan Indian reservation, likes to point out that as a child he "played cowboys and Indians with real Indians." A lifelong love for the West inspired him to create a line of vintage-styled apparel, which he did after a thirty-year career as an executive in the mainstream apparel industry. "When I first came out with this line," Wah recalls, "it was a big gamble because the whole industry didn't understand that this is what the Old West really was and this is what the working cowboy actually wore." In addition to serving as an official sponsor of the SASS End of the Trail event, Wah Makers' designs have appeared in thirty-plus feature films, including popular 1990s Westerns such as *Unforgiven, Wyatt Earp, Geronimo,* and *Tombstone,* and television shows like *Dr. Quinn, Medicine Woman, Posse,* and *The Young Riders.*

For those who prefer the even-earlier frontier look of the West, manufacturers exist to meet such retro clothing needs. Mountainmen and black-powder enthusiasts want to look the part in a pre-1840s wardrobe to attend rifle and "buckskinner" events. They can purchase garments from companies such as the Barkertown Sutlers, which feature entire ensembles for the "long hunter look" and the "highlander look." The Cabinet Mountain Leather Works Company in Troy, Montana, also caters to buckskinners with clothing styles "taken from the mountain men and trappers museums across the Western half of the United States." Among their assortment is an authentic-style "squaw" dress with fringe and beadwork, a three-quarter-length Northern Plains duster, a mountain man fringed buckskin pants and lace-front shirt outfit, and Plains Indian knee-high boots. The company's catalogue explains that "mountain men seldom wore Indian-style garments because they were poorly tailored, long, open-front buckskin jackets. But mountain men's clothing was elaborate and showy, a style all their own. They made their clothing for work, but also for rendezvous, when they would bring their furs to trade." All of Cabinet Mountain Leather Works' products are sewn by hand, using traditional methods, by local artisans and craftsmen.

Men are not the only fans of nineteenth-century Western attire; a growing number of women have begun participating in groups like SASS, where "outdated" styles are the norm. "There are a lot more women [in SASS] now," says Dusty Rogers, "and I think they are into it because of the clothing." In the late 1800s a few women who chose to ride and shoot with the men wore leather split skirts, full blouses, vests, and oversized Western hats, a look frequently adopted by women who belong to the riding faction of SASS. One company that caters to this look is Cattle Kate, Inc. in Jackson Hole, Wyoming. Its "cattlelog" features "contemporary clothing with the look and feel of the Old West," designed by Kathy "Kate" Bressler. Such items include an 1800s cotton twill split riding skirt with a front button flap, a barn dancer dress complete with a ruffled eyelet petticoat, town outfits, buggy coats, and a cowgirl wedding ensemble.

Not all nineteenth-century Western-wear enthusiasts go for "storebought" clothing— some sew their own garments. And some hardcore frontiersmen-wannabes make their buckskin outfits from animal skins they've procured through hunting, stitching the pants and shirts by hand with buckskin lacing.

Americans are not the only ones caught up in the Old West. Western enthusiasts from other countries belong to groups like SASS and participate in activities in the United States. "We have guys come over from Germany, Sweden, Denmark, and Asia for SASS events," says Dusty. This is hardly surprising since the West has been popular internationally since Buffalo Bill and others took their galloping troupes abroad in the nineteenth century. International collectors of Western costumes, artifacts, and memorabilia have fueled escalating prices for such items. Many vintage clothing dealers, in fact, credit their overseas customers with some of their highest-ticket-item sales.

Above: This **custom-made Nathan Turk ensemble from the 1940s** was found at a vintage clothing stall at a collectibles show in New York City. The pony-fur handbag was a yard-sale score. Collection of Holly George-Warren

Opposite page: Popular 1950s souvenirs, **Mexican wool-felt jackets** are reasonably priced items that show a range of embroidered motifs and can be found at flea markets and on eBay. Collection of Holly George-Warren

In the 1990s, collectors have flocked to "scavenger" antique shows such as the Triple Pier Expo in New York City, Brimfield in Massachusetts, the Rose Bowl flea market in Pasadena, California, and the Cow Palace Antiques and Collectibles Expo in San Francisco, in hopes of happening upon a Western-wear treasure. Coveted items include old store-stock items with their original tags, embroidered rayon-gabardine Western shirts by such makers as H Bar C/California Ranchwear and Rockmount Ranch Wear, and the rare embroidered Nudie, Turk, or Rodeo Ben shirt or suit. The craze for vintage has motivated H Bar C and Rockmount to reproduce their earlier styles in rayon garbardine. H Bar C has even introduced a few "collectors" shirts based on favorite styles worn in the 1950s by Roy Rogers.

For decades, collectors have hunted for nineteenth- and twentieth-century chaps, boots, spurs, and hats, which have all appreciated in value. In 2000, Sotheby's conducted an online auction of Lone Ranger clothing and memorabilia from the estate of Clayton Moore. Increasingly popular are movie memorabilia, licensed products, and paper ephemera such as catalogues, postcards, and magazine clippings. A lucky find may be a scrapbook of pictures, movie stubs, and newspaper articles kept by a star-struck teenager in the 1940s in honor of her favorite country star or silver-screen hero, or a child's Dale Evans costume still in its original box.

Tyler Beard, a vintage Western boot and apparel dealer since 1985, knows how volatile and competitive the market can be. "I remember when I used to drive to Fort Worth in the 1980s and there was just a tremendous amount of stuff in the pawn shops, at the Goodwill, and at the Salvation Army," Beard recalls. "That was the height of the market, and people were really looking and digging. I'd run ads in the Fort Worth papers that would say things like, 'Your grandmother might have a $10,000 suit in her closet—go look!' and then we'd list all this stuff that would get people's attention. Since then, the market has tapered off a bit, and there aren't as many people bothering to look."

Beard frequently hears from people looking for Nudie catalogues. While it is possible for such items to surface, a real "score" is rare and exciting. "I found a Buck Bernie suit at a flea market in Texas," Beard says. "I had never seen anything like it. It was a beautiful ivory gabardine, and it had a really wild rodeo scene embroidered on the back of the jacket. What was neat about it was that all the designs continued right from the jacket to the trousers—you could see a cactus from the bottom of the jacket going right into the belt loops and down over the seat of the pants. It was very colorful and it had ropes and flowers and all this stuff just trailing all the way down.

"It's a relatively small amount of people [who are serious collectors]," Beard opines. "I'm a dealer as much as I am a collector. I only keep the stuff that I can't live without, and that stuff changes from time to time." In the early 1990s, for example, Beard and his wife, Teresa, were buying eight hundred to one thousand pairs of vintage cowboy boots a month catering to a huge demand. After Beard's *The Cowboy Boot Book* was published in 1992, the hunger grew even more for fancy vintage boots and new custom boots based on old styles.

Some of the Beards' collection was sold at the January 2000 Wild West Antique Collectors Show and Auction, the tenth annual gathering in Mesa, Arizona, sponsored by High Noon Western Collectibles. High Noon's longtime Western antiques dealers and consultants Linda Kohn and Joseph Sherwood wrote in the auction catalogue: "Over the past decade we have witnessed both dramatic change and unparalleled growth in the field of Western Americana fueled by unprecedented collector demand.

Opposite page: "No attempt is made to keep abreast of modern fashion trends displayed by the man on the street," wrote Fay E. Ward in his 1958 book *The Cowboy at Work*. And no holds were barred on this resplendent outfit he **designed for a Western musician in the 1950s.** Renewed interest in Ward is evidenced at auctions and collector gatherings from Mesa, Arizona, to Los Angeles, California, to Cody, Wyoming, to New York City. Autry Museum of Western Heritage, Los Angeles

Below: Beginning in the 1920s, the outstanding trick rider and roper Montie Montana performed frequently in rodeos, movies, fairs, and parades. These three shirts comprised **Lot 3296 of a San Francisco Butterfield's auction of his estate** in February 2000. The auction house, which also deals in antique firearms and Western Americana, prominently featured one of Montana's custom-made Nathan Turk parade suits on its catalogue cover. The plaid wool gabardine shirt is by Turk; the blue gabardine bib-front is by Nudie; and the red embroidered bib-front was created by Johns of Arizona. Autry Museum of Western Heritage, Los Angeles

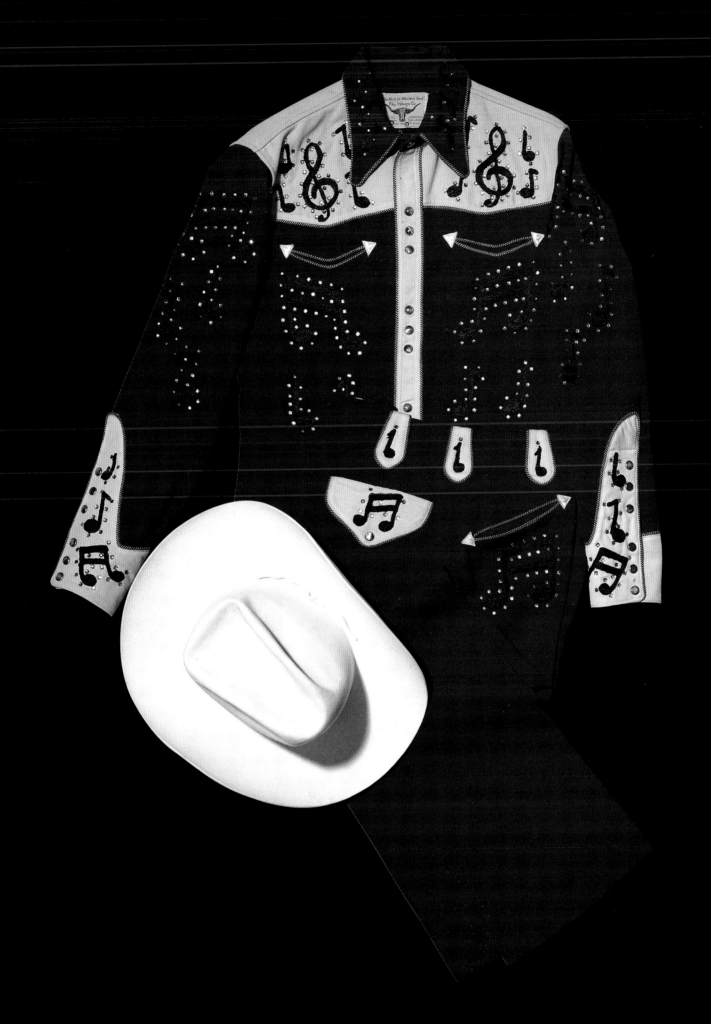

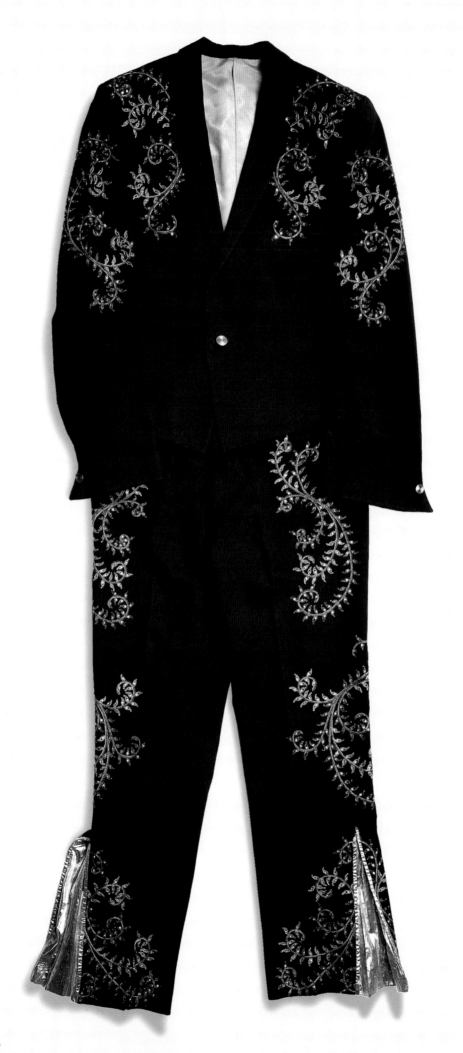

Cowboy artifacts have inched their way from the tack room to the living room, confirming, once and for all, their status as true, indigenous American folk art." The most recent Wild West show featured nearly two hundred dealers, more than triple the number present at the first such auction in 1991.

Many dealers and collectors belong to the National Spur and Bit Association, which also caters to the Western collectible market, organizes shows in cities such as Amarillo, Texas, and Cody, Wyoming, and publishes a newsletter in which collectors and dealers can advertise. Beard, a member of the organization, points to the fairly recent trend of buying and selling Western collectibles on Internet auction sites, such as eBay and Amazon.com, as another indicator of high interest in vintage cowboy boots and Western suits.

John "Doggie" Hughes is one such collector who has built a large vintage collection of Turk, Nudie, Rodeo Ben, and Formann garments, primarily through shopping on eBay. The forty-year-old drummer/vocalist of the Dark Horses grew up in Canada listening to country music, dreaming of wearing suits like those of his heroes George Jones, Porter Wagoner, and Gram Parsons. After landing in New York City, he combed vintage shops for decorative, embroidered cowboy shirts, but really struck gold after becoming a regular browser on eBay in 1999. "All these incredible clothes that I could never find," says Hughes, "suddenly could be mine, thanks to the Internet! When I got my first Nudie, I couldn't believe it!" His girlfriend, Kiko Ishii, who moved from Tokyo to New Jersey in 1990, also shops on eBay for vintage Western attire, including cowgirl outfits made by Viola Grae, Marge Riley, Turk, and Vaquero. Her interest has led her to begin making the ensembles herself; she recently purchased a chainstitch machine and now looks on eBay for vintage Western patterns.

Both Hughes and Ishii wear all the things they buy. Other collectors, such as San Diego attorney Tom Sims, acquire Western outfits for their historical value. Sims has been passionately collecting country and western memorabilia, photography, and recordings since 1973, and began purchasing retired C&W musicians' stagewear in 1993. Among the hundreds of garments in his collection are outfits that belonged to the California-based Maddox Brothers, Fiddlin' Kate, and Carrot Top Anderson. On the East Coast, designer Katy K frequently deals in vintage costumes owned by stars such as Hank Snow, Bill Anderson, Judy Lynn, and Lynn Anderson, which she sells primarily through her Web site.

Not only is the Internet changing the way people shop, it is also widening the accessibility of Western wear—both vintage and brand-new-made-to-look-old—internationally. Just as

Above: Inspired by fashions of the late 1880s, Allen Wah founded **Wah Maker clothing** in order to re-create the styles of old. His clientele includes devotees of the Old West and advocates of cowboy action shooting. Wah's clothes have also made their way to dance clubs and ranching communities. Autry Museum of Western Heritage, Los Angeles

Opposite page: It was probably in the late 1960s that Viola Grae created this **custom-made lined, wool gabardine bolero jacket with matching pants**. The ensemble, featuring Austrian crystal rhinestones, delicate filigree embroidery, and silver lamé pant-leg inserts, was purchased via eBay in early 2000 from a seller who had found it in mint condition at a Goodwill store in Spokane, Washington. Collection of Holly George-Warren

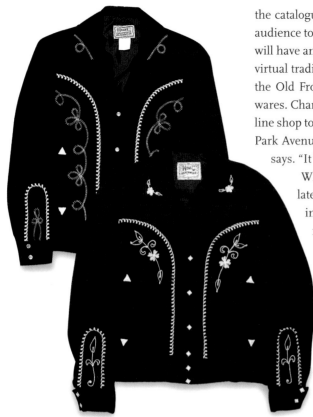

the catalogue business helped spread interest in Western apparel, taking it from a regional audience to a national and eventually an international marketplace, undoubtedly the Internet will have an even greater effect. Like the post office a century ago, the Internet is becoming a virtual trading post for Western wear. Many of the catalogue companies, like Cattle Kate and the Old Frontier Clothing Company, have Web sites where customers can purchase their wares. Charles Kauffman, proprietor of Kauffman's in New York City, recently created an on-line shop to replace his family's 150-year-old business that stood on the corner of Manhattan's Park Avenue and 24th Street for seventy years. "It's a new generation, it's a new world," he says. "It's a YAHOO world!"

While mail order, the most prevalent method used to purchase Western wear in the late nineteenth and early twentieth centuries, is giving way to the Internet as an international marketplace, the identity of this clothing as definitively "American" remains constant. Just as the Wild West shows took the idea of the American West to other countries in the nineteenth century, so does a pair of twenty-first-century denim jeans, Stetson hat, cowboy boots, and Western shirt proclaim "America," no matter where or by whom they are worn. Thus, U.S. athletes donning cowboy hats for the opening processional of the Olympic Games every four years has become a tradition. When China's premier was presented with one upon his first visit to the States in 1999, he smiled broadly as he placed it on his head. "That's the way you show your affinity with America— you put on a cowboy hat," *Cowboy Catalog* author Sandra Kauffman has pointed out.

For the most part, these articles of clothing transcend the vagaries of fashion, but elements of Western style return to the runways and fashion magazines nearly every year. At the spring 2000 fashion shows in New York, for example, the models in the Tommy Hilfiger presentation nearly all sported "renditions of a rowdy Western theme," including fancy cowboy boots with their "flame licked leather pants, floral yoke cowboy shirts, and trophy belt buckles," according to the *New York Times*. Hilfiger was duded up in a piped cowboy shirt with a contrasting print-fabric yoke. Many of those attending the shows wore cowboy hats of all types, and throughout 2000, New York street vendors sold them by the dozen—in faux pony hide and leopard, as well as black and brown.

The years 1999 and 2000 saw blue jeans decorated with embroidery, rhinestones, and trim, à la the 1970s. "Blue denim triumphed on and off the runways during the spring 2000 shows . . . inject[ing] a note of reality into the usual fashion frivolities," the *Times* also reported. And in early 2000, Calvin Klein introduced, at $78 a pair, "dirty denim"—jeans that have been "beaten, bruised and tinted to look as though they'd been worn for years," according to *Women's Wear Daily*. The jeans' hangtags proudly proclaim, "Dirty denim looks and feels like it walked a thousand miles, then crawled a few more. Lived a lifetime on horseback" Sounds like a description of cowboy clothes.

Many musicians in the 1950s favored short jackets like the ones above. The style again became sought after at flea markets beginning in the 1970s and increased in popularity as the decades passed. To meet the demand, H Bar C resumed the manufacture of these jackets in the 1990s. Two examples from the reproduction line are shown here. Collection of H Bar C/California Ranchwear (above) and Holly George-Warren (at top)

As the iconographic symbol of the cowboy, this clothing represents independence, freedom, and individuality. And as more and more people spend time chained to their computers, there will probably arise an even greater need for this sensibility in what they wear: If they can't roam the range, they can at least dress as if they were going to.

Though the number of actual working ranch hands and wranglers has dwindled, the look and idea of the cowboy continues. The practical nature of the traditional cowboy's clothes has been passed along to its present-day counterparts: rugged denim jeans (dirty or not), sturdy boots and hats, and snug Western-cut shirt. "Cowboy clothes are enduring and wonderfully reassuring," Michael Stern has theorized, "because they originally were tools of what was considered an honorable trade. No matter how totally duded up they got and no

matter how far from any usefulness they move, they still have echoes of the sense that this is not frivolous fashion."

What makes these clothes perennial, then, is that they are more than just a fashion statement. Yes, Western clothing is associated with themes, its design components, and its connections with personalities. It is carried in a cultural suit bag that has plenty of room for expansion and growth. From playing cowboy to collecting cowboy, we dance between preserving and possessing dress of the West and wanting to be a part of the West.

Sometimes the Western theme is just an illusion. Those members of the Single Action Shooting Society are wearing late-nineteenth-century everyday clothing—those styles were not limited to the West. They add boots, hats, guns, and badges, though, and the image is secure. Performers and line dancers don clothes created by designers ranging from Katy K to Manuel, whose products are part nostalgia and part art. Even though they are not always clearly Western in their motifs, they are always associated with the West. The illusions, however, have been with us for a long time. Showman "Doc" Carver, in about 1890, just added quilled fringe and beadwork to a man's suit, and voila! It was unmistakably Western.

Just as the bullfighter's suit of lights provides an unmistakable view of a person and his profession, the Nudie suit and its rhinestones, the Manuel suit with its embroidery, or the Buffalo Bill suit with beads and quillwork is each in its own case a suit of lights. It conveys something, if not of profession, at least of quality and image; it says, "Western." For wearers, it is a matter of display and association and style. For Western aficionados worldwide, these suits of light shine upon perceptions of the West and of America.

As the iconographic symbol of the cowboy, this clothing represents independence, freedom, and individuality. And as more and more people spend time chained to their computers, there will probably arise an even greater need for this sensibility in what they wear: if they can't roam the range, they can at least dress as if they were going to. The popularity of—and desire for—the look of the cowboy is definitely not going to go away. It seems, in fact, that a new generation of children are falling in love with the style thanks to today's pop-culture Zeitgeist—just as the boomers did who were raised on Hoppy and Howdy Doody. The success of *Toy Story* and particularly *Toy Story 2* introducing new cowboy and cowgirl heroes, Woody and Jessie, has reacquainted consumers with children's Western clothes, toys, books, and recordings. The Jessie doll, dressed in hat, yoked and fringed Western shirt, jeans, trophy buckle, and pony chaps, comes packaged in a box with a banner guaranteeing, "With real Western wear from the movie!" Kids' suede chaps, boleros, and cowboy hats are back in the catalogues too. And no less a trend setter than Madonna modeled glitzy Western wear on her 2000 *Music* album cover, publicity photographs, and videos.

After all, cowboy clothes personify America's melting-pot character. The resulting style born of so many cultures—Spanish, American Indian, Mexican, and Eastern European— continues to transmogrify, blending with twenty-first-century fashion sense. The scene one February 2000 night at New York City's Rodeo Bar is a good example. Faux Chimayó weavings decorate the walls of the packed watering hole where Hank Williams III, grandson of the Nudie-wearing country legend, took the stage. The lean, tattooed twenty-seven-year-old was decked out in a battered straw Stetson, vintage two-tone cowboy boots held together with duct tape, a lariat-style bolo tied taut around his neck, and a red-gauze silkscreened Western shirt, worn open over a torn T-shirt with a punk band emblazoned on its front. The effect was Mad Max meets rhinestone cowboy.

With hybrids like this turning up on today's young entertainers, who knows what fashion trails Western wear will blaze in the future? One thing is certain, though: There will be plenty of buckaroos along for the ride.

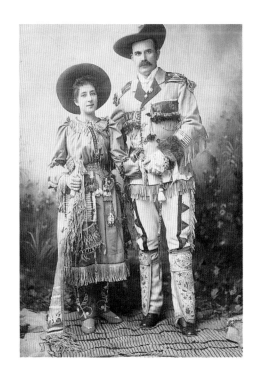

Above: Beneath the quill- and beadwork by American Indian artisans, the **Wild West costume** of Gordon W. Lillie (known as Pawnee Bill) was based on a simple man's coat. The accessories are what give it its distinctive Western air. His partner's outfit also represents a mix of many different elements. The shooting, riding, and roping acts of this pair identified them as Westerners; so did the embellishments of their clothing. Autry Museum of Western Heritage, Los Angeles

Overleaf: Just as a bullfighter might enter the arena in a "suit of lights," **Hank Snow would step up to the microphone in his gold or pink floral Nudie suit**. His ballads sometimes recounted mournful tales, but his clothes turned his appearance into pure entertainment. Collection of Marty Stuart

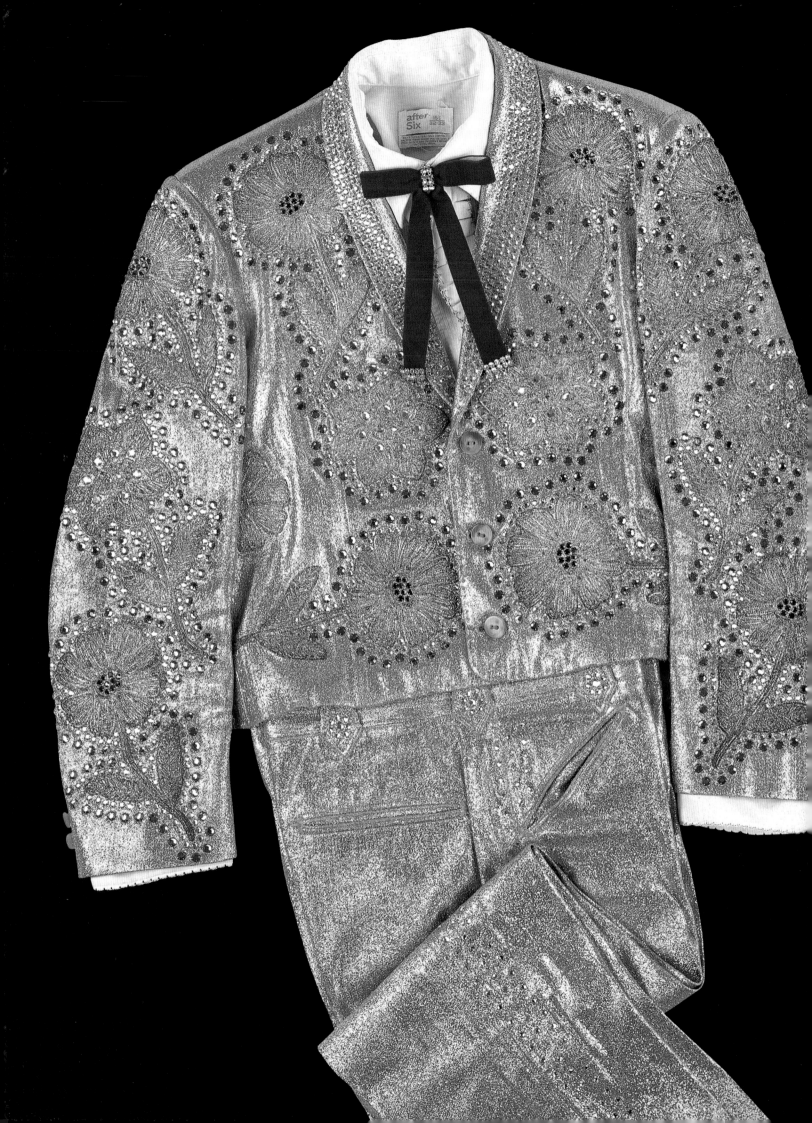

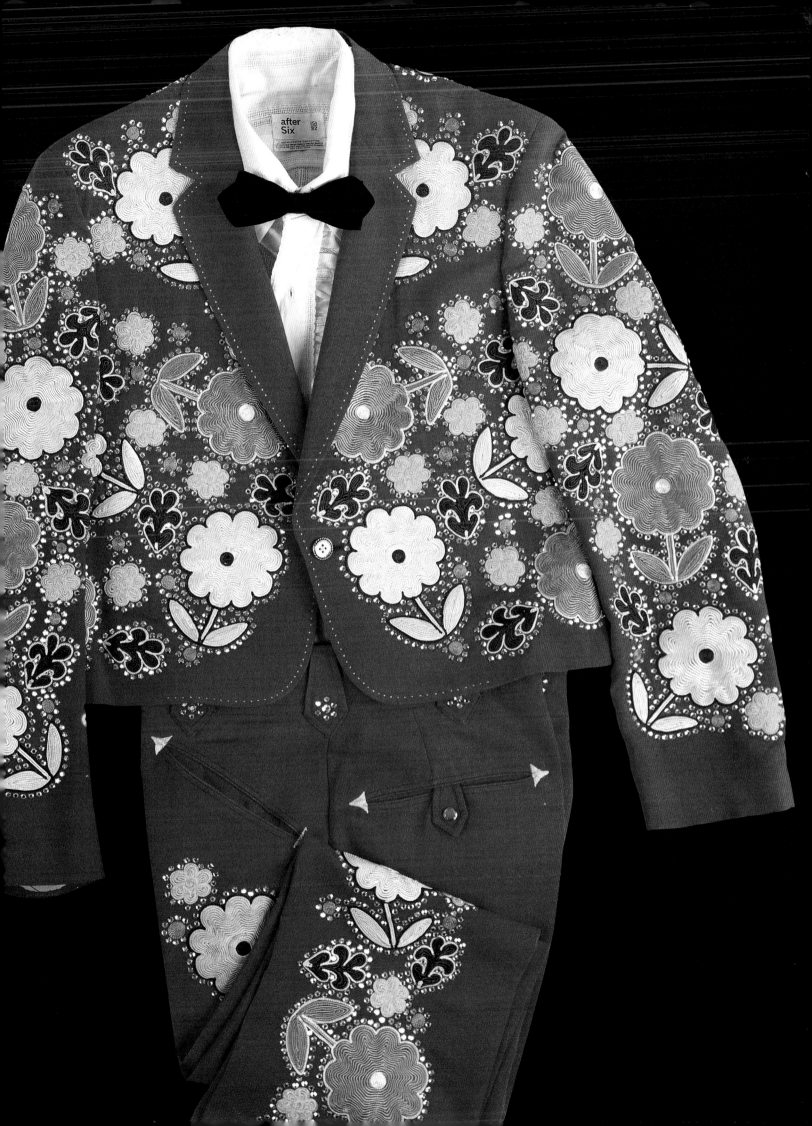

Notes on Sources

INTRODUCTION

Clues to the history of clothing in the nineteenth-century West are found in a wide range of primary and secondary sources. The Research Center of the Autry Museum of Western Heritage, which holds well over one thousand product catalogues with significant information on clothing and gear of the working cowboy and the fictional Westerner, is an important resource. The most significant sources are always the objects themselves. Clothing collections at the Autry Museum, Buffalo Bill Historical Center in Cody, Wyoming, the Kansas Museum of History in Topeka, Kansas, and elsewhere have been essential to our efforts.

An extensive bibliography of sources on the fur trade and overland migration is available. The most useful sources for the present study have included publications of the Museum of the Fur Trade in Chadron, Nebraska. See also, *Journal of a Trapper*, by Osborne Russell, edited by Aubrey L. Haines (Lincoln: University of Nebraska Press, 1986); and *Scotsman in Buckskin, Sir William Drummond Stewart and the Rocky Mountain Fur Trade*, by Mae Reed Porter and Odessa Davenport (New York: Hastings House, 1963). Numerous overland narratives have been published, and both diaries and letters provide important insight on what people wore. The most telling interpretive sources in this field are *Women and Men on the Overland Trail*, by John Mack Faragher (New Haven: Yale University Press, 1979); *The Plains Across*, by John D. Unruh, Jr. (Urbana: University of Illinois Press, 1979); and *The Great Platte River Road*, by Merrill J. Mattes (Lincoln: Nebraska State Historical Society, 1969).

A voluminous bibliography has grown up around the history of Wild West shows and their performers. Primary sources, including photography examined for this book, are in many private and public collections, but especially the Autry Museum of Western Heritage and the Buffalo Bill Historical Center. The best biography of William F. Cody is still *The Lives and Legends of Buffalo Bill*, by Don Russell (Norman: University of Oklahoma Press, 1960). See also, *The Life and Legacy of Annie Oakley*, by Glenda Riley (Norman: University of Okla-

homa Press, 1994); *The Real Wild West: The 101 Ranch and the Creation of the American West*, by Michael Wallis (New York: St. Martin's Press, 1999); and *Buffalo Bill's Wild West, An American Legend*, by R. L. Wilson with Greg Martin (New York: Random House, 1998).

Theodore Roosevelt's writings are found in *Ranch Life and the Hunting Trail*, published in various editions since 1887. Other accounts that describe cowboy dress include *We Pointed Them North, Recollections of a Cowpuncher*, by E. C. Abbott and Helena Huntington Smith (Norman: University of Oklahoma Press, 1955); *Pulling Leather*, by Reuben B. Mullins (Glendo: High Plains Press, 1988); and the best history of working cowboy clothing, *I See by Your Outfit: Historic Cowboy Gear of the Northern Plains*, by Tom Lindmier and Steve Mount (Glendo: High Plains Press, 1996). General studies of cowboy and Western clothing and gear also include *The Look of the Old West*, by Foster-Harris (New York: The Viking Press, 1955); *The Cowboy at Work*, by Fay E. Ward (New York: Hastings House, 1958); and *Cowboys and the Trappings of the Old West*, by William Manns and Elizabeth Clair Flood (Santa Fe: Zon International Publishing Company, 1997). —J.N.

Nearly one hundred original interviews were conducted by the authors for *How the West Was Worn*. They are cited below in each chapter for which the information and quotes were gleaned, along with the major books, magazines, and other archival materials that were consulted:

DRESSING THE EARLY WESTERNER

1897 Sears Roebuck Catalogue (New York: Chelsea House, 1968); various Western mail-order catalogues; "El Vaquero's Wearing Apparel," by Luis B. Ortega, *Western Horseman*, Jan.–Feb. 1947; "Tops in Tailoring," by Irvin Farman, *Western Horseman*, May 1953.

CHAPTER 1

Grace Boyd interview, Oct. 1999; Jerry Campbell interview, Oct. 1999; Bud Norris interview, Oct. 1999; Edgar Wyatt interview, Oct. 1999; Alex Gordon interview, July 1998;

"There's No Business Like Show Business and No Show Business Like Western Costume Company," Western Costume Company, Autry Archives, undated; "A Change of Scenery for Western Costume," by Lynn Simross, *Los Angeles Times*, April 12, 1990; "Notes from a Conversation with Mrs. Buck (Dell) Jones," by James Nottage, May 3, 1992; notes from the clothing collection at the Tom Mix Museum, Dewey, OK, Peggy Barryhill, curator, Oct. 16, 1999; *The Complete Films of William S. Hart: A Pictorial Record*, by Diane Kaiser Koszarski (New York: Dover, 1980); "The Silver Screen," by George Turner, in *That's Country*, Jan. 1994; *The West That Never Was: Hollywood's Vision of the Cowboys and the Gunfighters*, by Tony Thomas (New York: A Citadel Press Book published by Carol Communications, 1989); *The Western: From Silents to Cinerama*, by George N. Fenin and William K. Everson (New York: The Orion Press, 1962); *Edith Head's Hollywood*, by Edith Head and Paddy Calistro (New York: E. P. Dutton, Inc., 1983); "Buck Jones, The Screen's Greatest Outdoor Star," by M. J. Van Deventer, in *Cowboys and Country*, spring/summer 1996; "The King of the Silent Film Cowboys: Tom Mix," by M. J. Van Deventer, *Cowboys and Country*, fall 1995/winter 1996; *King Cowboy: Tom Mix and the Movies*, by Robert S. Birchard (Burbank, CA: Riverwood Press, 1993); *Tom Mix Portrait of a Superstar: A Pictorial and Documentary Anthology*, by Dr. Richard F. Seiverling (Hershey, PA: Keystone Enterprises, 1991); *Tom Mix: A Heavily Illustrated Biography of the Western Star*, by Paul E. Mix (NC: McFarland & Company, Inc., 1995); *The Life and Legend of Tom Mix*, by Paul E. Mix (New Jersey: A. S. Barnes and Co., Inc., 1972); *West-Fever*, by Brian W. Dippie (Los Angeles and Seattle: Autry Museum of Western Heritage in association with University of Washington Press, 1998); *Way Out West*, by Jane and Michael Stern (New York: HarperCollins Publishers, 1993); *The War, the West, the Wilderness*, by Kevin Brownlow (New York: Knopf, 1978); interview with John Gilman and Robert Heide, May 1999; *Cowboys and the Wild West: An A-Z Guide from the Chisholm Trail to the Silver Screen*, by Don Cusic (New York: Facts on File, 1994); *Box-Office Buckaroos: The Cowboy Hero from the*

Wild West to the Silver Screen, by Robert Heide and John Gilman (New York: Abbeville Press, 1982, 1989); Michael Wayne interview, Oct. 2000.

CHAPTER 2

Ellis Chernoff interview, Aug. 1999; Jean Simon interview, Aug. 1999; Pearl Schulman interview, Aug. 1999; Bessie Turk, via Jean Simon, interview, Sept. 1999; Hank Thompson interview, Aug. 1999; "Nathan Turk: The Cowboy's Tailor," by Barbara Hirschberg-Lituchy, in *That's Country,* Jan. 1994; Manuel interview, April 1997, Aug. 1998; Dale Evans interview, Feb, 1999; Mark Volman interview, March–Apr. 2000; Buck Owens interview, Jan. 1999; Johnny Western interview, Aug. 1999; Johnny LePekis profile, Autry Museum archives; "Rodeo Ben," *The Western Horseman,* May 1958; five Rodeo Ben catalogues, undated; Ben and Hannah Lichtenstein interview, Sept. 1999; *Way Out West;* "Western Preview," by Ruth Schoner, in *The Western Horseman,* June 1962; Jim Shoulders interview, Mar. 1999; "Jim Shoulders: He Put the 'Rode' in Rodeo," by Lee Pits, in *Cowboys and Country,* winter 1994/spring 1995; *100 Years of Western Wear,* by Tyler Beard (Salt Lake City: Gibbs-Smith, 1993); Little Jimmy Dickens interview, Aug. 1998.

CHAPTER 3

Various undated newspaper and fan magazine clippings from a scrapbook, c. 1947; *The Gene Autry Book,* by Daniel Rothel (NC: Empire Publishing Co., 1998); Gene Autry interview, Mar. 1997; *Gene Autry's Sensational Collection of Famous Original Cowboy Songs and Mountain Ballads* (M. M. Cole, 1934); Karla Buhlman interview, July 1998; Johnny Western interview, Aug. 1999; Jerry Scoggins interview, July 1998; Fred Martin interview, July 1998; "Gene's Wardrobe," in *Rodeo Program,* undated; Gordon interview, March 1997, July 1998; Douglas B. Green interview, Jan., Oct. 1998; Dale Evans interview, Feb. 1999; Dusty Rogers interview, Feb. 1999; Cheryl Rogers-Barnett interview, Feb. 1999; "Roy Rogers: Still King of the Cowboys," by Chuck Varney, in *That's Country,* spring 1993; Simon interview; Schulman interview; *Happy Trails: Our Life Story,* by Roy Rogers and Dale Evans with Jane and Michael Stern (New York: Fireside, 1994); *Way Out West,* Stern; "The Singing Cowboy: An American Dream," by Douglas B. Green, in *Journal of Country Music,* vol. 7,

no. 2; Mel Marion interview, July 1999; *100 Years of Western Wear,* Beard; *Growing Up with Roy and Dale,* by Roy Rogers, Jr., with Karen Ann Wojahn (CA: Regal, 1986); *The Roy Rogers Book,* by David Rothel (NC: Empire, 1996); *Tex Ritter: America's Most Beloved Cowboy,* by Bill O'Neal (TX: Eakin Press, 1998); Bobbie Nudie Cohn interview, July 1998; Jamie Barrigan interview, July 1998.

CHAPTER 4

Unpublished manuscript by Nudie Cohn with Trina Mitchum, 1979; Cohn interview; Barrigan interview; Owens interview; Evans interview; Rogers interview; Scoggins interview; Martin interview; *Nudie's Rodeo Tailors Western Style Roundup,* number 4, undated; "Nudie," by Jerry Hopkins, in *Rolling Stone,* June 28, 1969; Marion interview; Monte Hale interview, July 1998; Hank Thompson interview, Aug. 1999; Western interview; Rose Clements interview, March 1997; Dec. 1998; "The Original Rhinestone Cowboy," by Ben Pesta, in *TWA Ambassador,* Oct. 1976; interview with Nudie, uncredited, press release/bio of Nudie, "Western Stars to Fete Nudie at Testimonial," all from Country Music Hall of Fame and Museum research library, undated; "Where'd You Get the Suit," by John Lachuk, in *TV and Movie Western,* Aug. 1959; Nudie customer files, various photographs, undated/untitled clippings, Autry Museum of Western Heritage Research Center; "Hollywood's Most Colorful Character," by Johnny Western, in *Western Horseman,* May 1961; "Sagebrush Dior 'Beefs' TV Stars," *St. Paul Dispatch,* Aug. 18, 1961; Viola Grae advertisement, *Western Horseman,* May 1965; *100 Years of Western Wear,* Beard; "Hollywood: Brooklyn Cowboy," *Time,* Aug. 17, 1959; "Nudie: The Man Who Makes Those 'Sparkling' Suits," by RVS, in *Western News,* April 1969; "Hollywood," by Steven Parker, in *Western Wear and Equipment Magazine,* July 1979; "Showmanship Proves Its Worth to Western Wear Dealer," *Tack Merchandising,* undated; "Nudie Tailors Styles for Stars," by Stephen Fox, in *Fort Worth Star Telegram,* April 27, 1976; "Western Wear Designer," *North Hollywood Star,* Oct. 4, 1979; "The Cowboys," by Judy Lunn, in *Houston Post,* March 4, 1976; "Star Stitchery," by Stephen Fox, in *Washington Post,* April 25, 1976; "Nudie's Sequins Glitter in Country-Western," by Linda Heffley, in *Dayton Daily News,* Oct. 3, 1971; "Free Feed for Nudie the Tailor," by Erskine

Johnson, in *Variety,* Nov. 5, 1954; "Resplendent Rex Allen Has New Gimmick," *The Leaksville News,* June 17, 1954; "Legacy of a Rhinestone Cowboy," by Frank Manning, in *Los Angeles Times,* May 13, 1984 "The Cowboy's Couturier," by Meriel McCooey, in *London Sunday Times,* April 1, 1970; "California Youth Trend: Country & Western," *Fashion Week,* Los Angeles, Feb. 3, 1969; "Rhinestone Cowboys on the Sunset Boulevard Trail Can Buy Those Fancy Duds at Nudie's," by S. J. Diamond, in *People,* Oct. 25, 1976; "If You've Got Enough Cash, He'll Supply Enough Flash," by Al Martinez, in *Los Angeles Times,* June 24, 1979; "Nudie Buried as He Lived: Flamboyantly," by Pat Morrison, in *Los Angeles Times,* May 13, 1984; "Nudie, Dresser of Rhinestone Cowboys, Dies," by Burt A. Folkart, in *Los Angeles Times,* May 11, 1984.

CHAPTER 5

The Encyclopedia of Country Music, compiled by the staff of the Country Music Hall of Fame and Museum (New York: Oxford University Press, 1998); Nudie customer files; *Jimmie Rodgers,* by Nolan Porterfield (Champaign/Urbana: University of Illinois Press, 1979; 1992); "The Ranch Romance of Louise Massey & the Westerners," by Wayne W. Daniel, in *Journal of Country Music,* vol. 20, no. 3; "WLS Family Album," 1934; "WLS Family Album," 1936; "WLS Family Album," 1938; *A Good-Natured Riot: The Birth of the Grand Ole Opry,* by Charles K. Wolfe (Nashville: Country Music Foundation Press and Vanderbilt University Press, 1999); *Ramblin' Rose: The Life and Career of Rose Maddox,* by Jonny Whiteside (Nashville: Country Music Foundation Press & Vanderbilt University Press, 1997); *Workin' Man Blues: Country Music in California,* by Gerald W. Haslam with Alexandra Haslam Russell and Richard Chon (Berkeley: University of California Press, 1999); Scoggins interview; Martin interview; *Hank Williams: The Biography,* by Colin Escott with George Merritt and William MacEwen (Boston/New York: Little, Brown and Company, 1994); unpublished manuscript by Cohn/Mitchum; *Country: The Music and the Musicians,* by the Country Music Foundation (New York: Abbeville Press, 1988); *Hellbent for Music: The Life of Pee Wee King,* by Wade Hall (Lexington: University Press of Kentucky, 1996); *Minnie Pearl: An Autobiography,* by Minnie Pearl with Joan Dew (New York: Simon and Schuster, 1980); *The Hank*

Snow Story, by Hank Snow with Jack Owenby and Bob Burris (Champaign/Urbana: University of Illinois Press, 1994); Clements interview, March 1997, Dec. 1998; Thompson interview; Owens interview; Porter Wagoner interview, Aug. 1998; Jimmy C. Newman interview, Aug. 1998; Dickens interview; Marty Stuart interview, Aug. 1998; Bill Anderson interview, Aug. 1998; Brenda Colladay interview, Aug. 1998; *Bob Wills Remembered*, by Rosetta Wills (New York: Billboard Books, 1998); various correspondence/Nudie files, Autry Museum archives; *Ernest Tubb: The Texas Troubadour*, by Ronnie Pugh (Durham, NC: Duke University Press, 1996); *Lefty Frizzell: The Honky-Tonk Life of Country Music's Greatest Singer*, by Daniel Cooper (Boston/New York: Little Brown & Company, 1995); *Patsy: The Life and Times of Patsy Cline*, by Margaret Jones (New York: HarperCollins, 1994); *A Satisfied Mind: The Country Music Life of Porter Wagoner*, by Steve Eng (Nashville: Rutledge Hill Press, 1992); June Carter Cash interview, April 1999; "The Three Decade Night of the Sundowners," by Dave Hoekstra, in *The Journal of Country Music*, vol. 20, no. 1; "Nudie's Sequins Glitter in Country-Western," by Linda Heffley, in *Dayton Daily News*, Oct. 3, 1971; unpublished manuscript by Cohn/Mitchum; Cohn interview; Barrigan interview; Carl Smith interview, Oct. 1998; Goldie Hill interview, Oct. 1998; "Judy Lynn: America's Western Sweetheart," *The Western Horseman*, May 1964; Nudie's Rodeo Tailors Western Style Roundup, number 4, undated; "Hollywood," by Steven Parker, in *Western Wear and Equipment Magazine*, July 1979.

CHAPTER 6

Jack Weil interview, Jan. 1991; Steve Weil interview, April 1999; Kevin Swillin interview, April 1999; Seymour Christenfeld interview, April 1992; Paul Christenfeld interview, April 1992; Stanley Christenfeld interview, August 1992; "Wear 'Em Cowboy!" by Michelle Freedman, in *Country Collectibles*, spring 1993; Elizabeth Wallenius interview, July 1998; "H Bar C" by Elizabeth Wallenius, in *Western Horseman*, May 1997; "Wrangler Is Cowboy Cut," by Jim Jennings, in *Quarter Horse Journal*, Sept. 1989; "The History of Wrangler 13MWZ Cowboy Cut Jeans," Wrangler Company; *Jeans: The Stuff of American History*, by Regine Van Damme (London: Puffin, 1995); Charles Kauffman interview, July 1999; Sandra

Kauffman interview, July 1999; *Cult: A Visual History of Jeanswear*, by William Gilchrist and Robert Manzotti (Zug, Switzerland: Sportswear International, 1992); various Western mail-order catalogues; *The Cowboy at Work*, Ward; "Fay Ward," by Keith Walters, in *Persimmon Hill*, date unavailable; Bob Boyd interview, March 1999; Fay Ward catalogue, undated; Martha Ward interview, June, Aug. 1999; *Hoofs and Horns*, May 1944; *Rodeo Cowboys in the North American Imagination*, by Michael Allen (Lincoln: University of Nevada Press, 1998); *Cowgirl Legends from the Cowgirl Hall of Fame*, by Kathy Lynn Wills and Virginia Artho (Salt Lake City: Gibbs-Smith, 1995); *Cowgirls: Early Images and Collectibles*, by Judy Crandall (PA: Schiffer, 1994); *Cowgirls*, by Candace Savage (Berkeley: Ten Speed Press, 1996); *Way Out West*, Stern; "Meet the Ranch Girls," by Will C. Murphey, in *Rodeo* magazine, 1940; Tyler Beard interview, July, Sept. 1999; Marion interview; *Hi Stranger! The Complete Guide to Dude Ranches*, by Arthur Carhart (New York: Ziff Davis, 1949); Linda Ronstadt interview, July 1999; "Dude Ranch Style," *Life*, April 22, 1940; various dude-ranch brochures; various fiesta brochures; "They Tell Me I Was an Easterner," by Stan Adler, in *Arizona Highway*, Sept. 1947; Margaret Miele interview, July 1998; Jane Stern interview, May 1999; Bill Hervey interview, May 1999; "The Western Store: Today's Trading Post," *The Western Horseman*, May 1965; *Language of the Robe: American Indian Trade Blankets*, by Robert W. Kapoun (UT: Gibbs Smith, 1992); "Pioneer of the Industry," by Hope T. Crooks and Linda Winter, in *Western Wear and Equipment Magazine*, June 1979; *Ranch Dressing: The Story of Westernwear*, by M. Jean Greenlaw (New York: Dutton, 1993).

CHAPTER 7

Clare Butler interview, Oct. 1999; Robert Reynolds interview, Oct. 1999; "Western Wear for Ladies," by Pat Pierce, in *The Western Horseman*, May 1954; "Denim Gets Dressy: Bye, Bye Blue!" *Life*, May 11, 1953; *The Western Horseman*, Jan.–Feb. 1947: Marshall Field advertisement, Rio Grande jacket advertisement; *The Book of Cowboys*, by Holling C. Holling (New York: Platt & Munk Co., 1936); Gilman/Heide interview; *Way Out West*, Stern; "They Live with Their Boots On," by Bettie McMillen, in *The Western Horseman*, May 1958; "Arizona Origi-

nals," by Robert B. Harkness, ibid; "Western Shirts," ibid; *The Cowboy Boot Book*, by Tyler Beard (Salt Lake City: Gibbs-Smith, 1992); *Box-Office Buckaroos*, Heide/Gilman; "King of the Cowboy Collectors," by Holly George-Warren, in *Country Collectibles*, spring 1993; Rogers interview, Feb. 1993, Jan. 1999; *Fabulous Fabrics of the '50s*, by Gideon Bosker, Michel Mancini, and John Gramstad (San Francisco: Chronicle, 1992); *Hake's Guide to Cowboy Character Collectibles*, by Ted Hake (PA: Wallace-Homestead, 1994); Diana Sassy interview, Oct. 1992; *McCall's Needlework* magazine, 1947; "Oregon Federation of Square Dancers Club" newsletter, March 1964; various sewing patterns.

CHAPTER 8

Johnny Cash interview, March 1997; *Last Train to Memphis: The Rise of Elvis Presley*, by Peter Guralnick (Boston/New York: Little, Brown & Company, 1994); *Careless Love: The Unmaking of Elvis Presley*, by Peter Guralnick (Boston/New York: Little, Brown & Company, 1998); *The King on the Record*, by Robert Gordon (London: Hamlyn, 1996); Cohn interview; Barrigan interview; Owens interview; unpublished manuscript by Cohn/Mitchum; *Man in Black*, by Johnny Cash (Grand Rapids: Zondervan Publishing House, 1975); *Cash: The Autobiography*, by Johnny Cash with Patrick Carr (San Francisco: HarperSan Francisco, 1997); Wanda Jackson interview, Sept. 1999; Nellie Jackson interview, Sept. 1999; "Mother's Work Dresses Up Daughter's Career," by Bernice McShane, in *The Sunday Oklahoman*, March 23, 1997; *I Want to Take You Higher*, by Parke Puterbaugh and James Henke (San Francisco: Chronicle, 1998); Clements interview; *Nudie's Rodeo Tailors Western Style Roundup*, number 4, undated; "Star Stitchery," by Stephen Fox, *Washington Post*, April 25, 1970; various Nudie customer files; *Hickory Wind: The Life and Times of Gram Parsons*, by Ben Fong-Torres (New York: St. Martin's Press/Griffin, 1998); Chris Hillman interview, Aug. 1999; Ronstadt interview; Michael Ochs interview, May 1999; Western interview; "Judy Lynn: America's Western Sweetheart," *The Western Horseman*, May 1964; "If You've Got Enough Cash," by Al Martinez, in *Los Angeles Times*, June 24, 1979; "Rhinestone Cowboys on the Sunset Boulevard Trail Can Buy Those Fancy Duds at Nudie's," S. J. Diamond, in *People*, Oct. 25, 1976; "Showmanship Proves Its Worth to Western Dealer," *Tack Merchan-*

dising, undated; Nudie files, Autry archives; "Nudie, Western Glitz Meister," by Jamie Alison Cohen, in *Los Angeles Herald Examiner,* May 10, 1984; "Nudie," by Burt A. Folkart, in *Los Angeles Times,* May 11, 1984; "Nudie Buried," by Pat Morrison, in *Los Angeles Times,* May 13, 1984; *Getting It On: The Clothing of Rock & Roll,* by Mablen Jones (Cross River Press, 1987); Volman interview; Tom Petty interview, April 2000; Bob Neuwirth interview, April 2000; Pamela Des Barres interview, April 2000; Diane Carr interview, April 2000.

Chapter 9
Manuel interview, 1997, Aug. 1998; Marty Stuart interview; interview with Riders in the Sky: Doug Green, Too Slim, and Woody Paul, Oct. 1998; *Nudie's Rodeo Tailors Western Style Roundup,* number 4, undated; Wagoner interview; Dickens interview; Hale interview; "Manuel's Dynamite Duds," by Nina Malkin, in *That's Country,* spring 1993; "All Duded Up," by Tanya Indiana, in *New York Press,* Nov. 18, 1988; "Gonna Dress You Up," by Jennifer Conlin, in *Rolling Stone,* April 29, 1989; "Manuel, King of Cowboy Couture, Is Riding High," by Michele Seipp, in *Los Angeles Times,* April 13, 1989; "Western Image Maker," by Anne Lang, *Western Styles,* Dec. 1995; "When C&W Stars Go Shopping, They Look for Manuel Cuevas's Glittery Duds for Dudes," by Tim Allis, in *People,* April 16, 1990; *Sound Tracks: A Musical ABC,* by Micheal Jarrett (PA: Temple University Press, 1998); "Marty Stuart Style," by Christopher Burkhardt, in *That's Country,* Nov. 1993; *100 Years of Western Wear,* Beard; Anderson interview; Ronstadt interview; Clements interview.

Chapter 10
Charles Kauffman interview; Sandra Kauffman interview; Gloria Gresham interview, Oct. 1999; Jack Weil interview; Steve Weil interview; *The Cowboy Catalog,* by Sandra Kauffman (New York: Clarkson N. Potter, 1980); "Looking for Love," by Gregory Curtis, in *Texas Monthly,* Nov. 1998; "The Ballad of the Urban Cowboy: America's Search for True Grit," by Aaron Latham, in *Esquire,* Sept. 1978; "Urban Cowboy Clothes," by Suzanne Slesin, in *Esquire,* Sept. 1978; "Texas Spirit," by Rosemary Kent, in *Harper's Bazaar,* July 1981; "The Look of Lauren," in *Harper's Bazaar,* Sept. 1982; "Lauren: American Fantasies for Fall," *WWD,* April

24, 1978; "Lauren's Prairie Gypsy," *WWD,* March 31, 1981; "New York Goes Western Too," by Bill Cunningham, in *New York Times,* June 20, 1978; *Ralph Lauren: The Man Behind the Mystique,* by Jeffrey A. Trachtenberg (Boston/New York: Little, Brown, & Company, 1988); "Western Preview," by Pat Close, *The Western Horseman,* July–Aug. 1979, June–July 1980, Oct. 1980, Jan. 1981; "True Grit Tenderfoot," by Timothy White, in *Rolling Stone,* July 10, 1980; "The Night I Nearly Killed an Urban Cowboy," by William Martin, in *Esquire,* July 3–19, 1979; "Sunbelt Saturday Night," by Richard Schickel, in *Time,* June 9, 1980; *Mickey Gilley* (Los Angeles: The Brokaw Company, 1997); "Boots for Suits," by Max Evans, in *Esquire,* May 1978; "John Travolta: Back on Track," *Newsweek,* June 9, 1980; "Attitude Cowboys," by Aaron Latham, in *Esquire,* Aug. 1993; Lichtenstein interview; Marion interview; Brad Popick interview, May 1999; Kevin Scullen interview, May 1999; "Western Preview," by Pat Close, in *The Western Horseman,* July 1980.

Chapter 11
Katy K interviews, Jan. 1992, June 1999; Dave Alvin interview, April 1998; Marty Stuart interview; "Marty Stuart Style," by Christopher Burkhardt, in *That's Country,* Nov. 1993; "Marty Stuart and Carlene Carter: Hillbilly Hip," ibid.; "All Duded Up," by Tanya Indiana, in *New York Press,* Nov. 18, 1988; "Gonna Dress You Up," by Jennifer Conlin, *Rolling Stone,* April 29, 1989; Chuck Mead interview, Sept. 1998; Dale Watson interview, April 1997; Tony Villanueva interview, April 1997; *k.d. lang: All You Get Is Me,* by Victoria Starr (New York: St. Martin's Press, 1994); Riders in the Sky interview; Mike Mills interview, Aug. 1999; Reynolds interview; "Brooks & Dunn," *Country America,* Sept. 1993; "Kix Brooks & Ronnie Dunn Burnin' Their Candle at Both Ends," by Justin Case, in *That's Country,* Jan. 1994; "Duo Puts Stamp on Foot-Stompin'," by David Zimmerman, in *USA Today,* March 10, 1993; Ronnie Dunn interview, Jan. 1994; Kix Brooks interview, Jan. 1994; Petty interview.

Chapter 12
Jaime Castañeda interview, Jan. 1998; Riders in the Sky interview; Katy K interview, Jan. 1992; Oct. 1998; June 1999; Liberty Westerns catalogue, undated; Chandler Liberty interview, March 2000; Texanne inter-

view, Oct. 1999; *The Art of Zandra Rhodes,* by Zandra Rhodes and Anne Knight (Boston: Houghton Mifflin, 1985); "Cheryl Matusak," by Reid Slaughter, in *Cowboys & Indians,* Sept. 1997; "Annie Get Your Gun: The Fashion Bandwagon Is Rolling West," by Leslie Cunliffe, in *British Vogue,* May 1992; "Rosie Martin Says, 'Let's Play Cowboys and Indians!'", by Rosie Martin, in *British Vogue,* Jan. 1992; "Playing Cowboys, Indians," *DNR,* Jan. 1992; "Winning the West," by Diane M. Pagoda, in *WWD,* May 1992; "The Dude Is Back in Town," by Phil Patton, in *New York Times,* April 18, 1993.

Chapter 13
"Who's News," by Lorrie Lynch, in *USA Weekend,* Nov. 26–28, 1999; "Why the West Has Lassoed the Imagination," by Ann Trebbe, in *USA Today,* May 19, 1993; "Again That Hankering," by Deanne Stillman, in *New York Times,* Aug. 22, 1993; "We're Wild About the West Again," by Janny Scott, *Los Angeles Times,* May 5, 1993; interview with James Nottage, March 1997; interview with Michael Stern, April 1997; "Yee-Hah! Why Every Girl Needs a Cowboy" by Anita Chaudhuri, in *The Sunday London Times Style,* Nov. 1997; "City Slicker Gals Go West," by Barbara De Witt, in *Los Angeles Daily News,* March 11, 1999; Beard interview, Sept. 1999; *Art of the Boot,* Beard; "Pardners Who Ride the Crosstown Bus," by Bill Cunningham, in *New York Times,* Sept. 12, 1999; "How the East Was Won Over," by Bill Cunningham, in *New York Times,* Sept. 19, 1999; "Rock 'n' Frock," *Women's Wear Daily,* Sept. 16, 1999; "Calvin Klein: Dirty Does It," ibid; "Overstaged Hilfiger Upstaged by Improvs," *New York Times,* Cathy Horyn, Sept. 16, 1999; "10th Annual Wild West Auction" catalogue, High Noon, Jan. 22, 2000; "Fine Arms & Western Americana featuring the Estate of Montie Montana" catalogue, Butterfield's, Feb. 2000; *Hake's Guide to Cowboy Character Collectibles,* Hake; Tom Sims interview, Sept. 2000; John "Doggie" Hughes interview, March 2000; Kiko Ishii interview, March 2000; S. Kauffman interview.

—H.G-W., M.F.

Index

Numbers refer to page numbers. Numbers in *italics* refer to pages with illustrations or captions.

Photograph Credits

The authors and publisher would like to thank the museums, galleries, and private collectors named in the illustration captions for supplying photographs for reproduction. Additional photograph credits are listed below. Numbers refer to page numbers.

Acknowledgments

Just as it takes hundreds of stitches to create an embroidered Western shirt, so were numerous individuals responsible for making *How the West Was Worn* a reality. We're especially grateful to the incredible team at the Autry Museum of Western Heritage: our skillful and persevering editor, Suzanne G. Fox; that fount of knowledge and enthusiasm, James H. Nottage; and the ever-helpful and encouraging Kevin Mulroy, Michael Fox, Marva Felchlin, Leah Arroyo, Sandra Odor, Laurie German, Evelyn Davis, Chris Keledjian, and Susan Van de Vyvere, as well as the support of executive director and CEO John L. Gray and retired president and CEO Joanne D. Hale. Our utmost gratitude also goes to Karla Buhlman, Alex Gordon, and Maxine Hansen at the Gene Autry office, who originally introduced us to our future colleagues at the Autry Museum. Of course, if not for Gene and Jackie Autry, we would never have had the good fortune to meet all the aforementioned folks—and without the aid of Western enthusiast and incredible *kemosabe* James Austin, of Rhino Records, we wouldn't have gotten our boots in the door. Thanks to Fletcher Roberts and Jon Pareles at the *New York Times* for the initial assignment. And going back to 1991, *muchas gracias* to Jon Graboff and Robert Warren, who got the two of us together by spreading the word of our mutual-admiration society for Nudie suits. Our agent, Sarah Lazin, also believed in the project from the beginning, and the enthusiastic team at Harry N. Abrams, Inc.—our talented editor, Harriet Whelchel, and innovative designer, Ellen Nygaard Ford, and their colleagues—have brought it to fruition: a curtsy and a bow to them.

So many people unselfishly shared their time, memories, and incredible wardrobes for our research. We are particularly indebted to Bobbie Nudie Cohn, Jamie Barrigan, Jean Simon, Pearl Schulman, Ellis Chernoff, Bessie Turk, Martha Ward, Gerson and Hannah Lichtenstein, Manuel, Morelia Cuevas, Jaime and his staff, Rose Clements, Gene Autry, Dale Evans, Dusty Rogers, Cheryl Rogers-Barnett, Buck Owens, Jim Shaw, Porter Wagoner, Monte Hale, Marty Stuart, "Ranger" Doug Green, Too Slim, Woody Paul, Robert Reynolds, Mike Mills, Kevin O'Neill, Chuck Mead, Brenda Colladay, Katy K, Chandler Liberty, Texanne, Clare Butler, Cindi St. Clair, Billy Voiers, Goldie Hill, Carl Smith, Bill Anderson, Robbie Wakowski, Little Jimmy Dickens, Jimmy C. Newman, Linda Ronstadt, Tom Petty, Johnny Cash, June Carter Cash, Cass Country Boys Jerry Scoggins and Fred Martin, Grace Boyd, Sundowner Bob Boyd, Tyler and Teresa Beard, Jon Langford, Ray Benson, Diane Carr, Chris Hillman, Ronnie Brooks, Wanda Jackson, Wendell Goodman, Nellie Jackson, Hank Thompson, Johnny Western, Jim Shoulders, Mel Marion, Pamela Des Barres, Mark Volman, Bob Neuwirth, Steve Soles, Kix Dunn, Dale Watson, Dave Alvin, Tony Villaneuva, Jack Weil Sr., Jack Weil Jr., Steve Weil, Jane Stern, Michael Stern, Robert Heide, John Gilman, Jerry Campbell, Edgar Wyatt, Bud Norris, Sandra Kauffman, Charles Kauffman, Seymour Christenfeld, Paul Christenfeld, Elizabeth Wallenius, Roger Cook, Margaret Miele, Betty Williams, Gloria Gresham, Bill Hervey, Lila Wilson, Kevin Scullin, Brad Popick, Peggy Barryhill, Jerry Campbell, Edgar Wyatt, Gerry Severe, Kelly Burns, Eddie Bransetter, Marcia Spark, Doggie & Kiko, Buddy Love, Dan Howell, Amy Hoban, Michael Ochs, Helen Ashford, Bob Williams, Mark Metzger, Mark Medley, Chris Dickinson, Laura Garrard, Margie Greve, Ronnie Pugh, Deb Parker, Jean Laughton, Jeff Reidel, Jeff Jankelow, Joe Nick Patoski, Evelyn Shriver, Raeanne Rubenstein, Bonnie Garner, Lance Cowan, Genna Radke, Deb Leland, Chas Leland, Robert Vickers, Maria Elena, Craig Inciardi, Diana Sassy, Mary Bonifer, Charlotte Berney, Stephanie Chernikowski, Jeremy Tepper, Laura Levine, Ann Abel, Carrie Smith, Andrew Simon, Giles Moon, Linda Kohn, Baron Wolman, Michael Wayne, *Western Horseman* staffers Pat Close and Butch Morgan, Bill Eveleigh at the Walnut St. Gallery, and our pals at eBay Anonymous.

Accommodations and other logistical help were graciously provided by Katy Kattelman, John McCormick, Mary Loving, Kristi Rose and Fats Kaplan, Ben and Dianne Fong-Torres, Robert K. Oermann and Mark Bufwack, Jennie Fennel, Jasmine Stratos, Stumptown Coffee, and Pamela Freedman. Writer/historian Daniel Cooper went the extra mile for us, doing research on our behalf in Colorado (we owe you a really cool vintage cowboy shirt!).

If not for the love, understanding, and support of Robert Burke Warren, li'l buckaroo Jack Warren, Tod Morrisey, and li'l buckarette Lili Morrisey, *How the West Was Worn* would never have made it out of the corral. And, of course, we can't thank enough those responsible for originally providing our very first cowgirl outfits: Gail and Duane Wangenheim and the late Martha and Alvis George. Most of all, we're eternally grateful to all those cowboys and cowboy couturiers who pioneered Western style. Long may you ride!

Holly George-Warren and Michelle Freedman

Dedicated to the memory of Alvis Owen George, Jr. (1929–2001),
and Martha Holland George (1930–2001) —H.G.-W.

For my parents —M.F.

This book was published in conjunction with an exhibition
organized by the Autry Museum of Western Heritage and
held there from October 20, 2001, through January 21, 2002.

Editors: Suzanne G. Fox (Autry Museum)
and Harriet Whelchel (Abrams)
Designer: Ellen Nygaard Ford

Library of Congress Cataloging-in-Publication Data

George-Warren, Holly.
 How the West was worn / Holly George-Warren and Michelle
Freedman ;
foreword by Marty Stuart ; introduction by James H. Nottage.
 p. cm.
Includes bibliographical references.
ISBN 0–8109–0615–5 (hardcover)
ISBN 0–8109–2137–5 (paperback)
 1. Costume—West (U.S.)—History—20th century. I. Freedman,
Michelle. II. Title.
 GT617.W47 G46 2001
 391'.00978—dc21

 2001001264

Published in 2001 by Harry N. Abrams, Incorporated, New York
No part of the contents of this book may be reproduced without
the written permission of the publisher

Printed and bound in Hong Kong

Harry N. Abrams, Inc.
100 Fifth Avenue
New York, N.Y. 10011
www.abramsbooks.com

END PAGES: A cavalcade of bedazzling embroidery patterns,
this sampler, displayed at Nudie's Rodeo Tailors, served as a
treasure map to such famous costumes as Ray Price's Indian
headdress outfit, Jimmy C. Newman's alligator garb, and Porter
Wagoner's wagon wheel attire. Autry Museum of Western
Heritage, Los Angeles

PAGE 1: Inspired by Gram Parsons's Sin City suit, Manuel
made this custom outfit for Mavericks bassist Robert Reynolds.
Collection of Robert Reynolds

PAGES 2–3: Nathan Turk created several cowgirl ensembles for Dale
Evans, including this one in gabardine. Courtesy of the Roy Rogers
and Dale Evans Museum, Victorville, California